Ruskin's Poetic Argument

RUSKIN'S POETIC ARGUMENT

The Design of the Major Works

PAUL L. SAWYER

CORNELL UNIVERSITY PRESS

Ithaca and London

THIS BOOK HAS BEEN PUBLISHED WITH THE AID OF A GRANT FROM
THE HULL MEMORIAL PUBLICATION FUND OF CORNELL UNIVERSITY.

THE PREPARATION OF THIS VOLUME WAS MADE POSSIBLE IN PART
BY A GRANT FROM THE NATIONAL ENDOWMENT FOR THE
HUMANITIES, AN INDEPENDENT FEDERAL AGENCY.

First published 1985 by Cornell University Press.

Library of Congress Cataloging in Publication Data

Sawyer, Paul L., 1945–
 Ruskin's poetic argument.

 Includes index.
 1. Ruskin, John, 1819–1900—Criticism and interpretation. I. Title.
PR5264.S26 1985 828'.809 84–45801
ISBN 0–8014–1739–2 (alk. paper)

*The paper in this book is acid-free and meets the guidelines for
permanence and durability of the Committee on Production Guidelines
for Book Longevity of the Council on Library Resources.*

FOR MY MOTHER

Day unto day uttereth speech, and night unto night showeth knowledge.

There is no speech nor language, where their voice is not heard.

—Psalms 19:2–3

The foxglove blossom,—a third part bud, a third part past, a third part in full bloom,—is a type of the life of this world.

—John Ruskin, "The Nature of Gothic"

nature
includes too much
and art can't include enough

—A. R. Ammons, "An Improvisation for the Stately Dwelling"

Contents

Preface 9

Part I / Transcendental Aesthetics

1. The Golden Waters 17
2. The Language of Sense 34
3. The Lamp of Power 56

Part II / The Legend of Time

4. The Lamp of Love 77
5. "Paradise of Cities" 90
6. The Natural History of the Imagination 127

Part III / Wealth and Life

7. The Economy of Beauty 161
8. The Economy of Life 194

Part IV / The Structure of Myth

9. The Currency of Meaning 227
10. The Goddess and the Child 242

Part V / Works and Days

11. Olympian Lightning 263
12. "Ruskin's Apocalypse" 292
13. Time Present and Time Past 309

Index 333

Preface

Students of Ruskin are fond of recalling that the young prodigy of Herne Hill once planned an epic poem on the universe, to be called "Eudosia." Ruskin abandoned the poem but kept the subject: he never became, as he was expected to, a poet or a painter or a naturalist or a preacher, but he was true to all of these callings in his fashion, composing the prose epic of his complete works in a medium suited to his genius and his temperament—his love, especially, of plunging into subjects, puzzling out problems, praising and recording, forming impressions and proofs, and finally conveying his thoughts with an urgency and spontaneity possible only in a prose of direct address. In the course of a half century as critic and polemicist, Ruskin also bared his heart to his public in the manner of a romantic poet, but this mixture of expression and exposition, along with the unsteadiness of his mind and the sheer bulk of his work, ensured that for the first half of the twentieth century the Ruskinian corpus remained essentially unread. Then, sometime in the 1950s or afterward, it became generally possible not only to read him again but to sense him as an inevitable discovery. For early modern readers, the complete works were brilliant in episode but dense, wayward, and unchartable in the whole. More recent readers, however, have found not only a subtle and broad-ranging body of thought but also a multivalent prose texture peculiar to Ruskin, in which a tissue of private allusions, far-spun associations, wordplays, and digressions often forms an implicit counterpoint to the announced subject and its development. Both the pleasures and the challenges inherent in this polysemy may be suggested by a caricature.

Let us imagine that Keats, instead of writing an ode on a Grecian urn, plunged into a study of classical art, took voluminous notes and sketches in the British Museum, then set out to write a definitive work proving that Greek painting is the greatest the world has ever seen and using a particular urn as his crowning example. In the course of a long

book, he provides chapters on courtship (advising modern couples to defer marriage because of the pleasures of self-denial), on ancient rituals, and on various theories of the imagination, including also some footnotes proposing a restructuring of the British Museum, and, finally, suggesting that we turn to the Arcadians for models of our social institutions. Let us also assume that the individual points are made in the form of general assertions, some of them evidently hyperbolical, so that we would not at first, perhaps, trust the voice and would need to sort out the statements and reconcile them afterward. Somewhere along the way would appear the sentence "Beauty is truth, truth beauty," as if spontaneously but with great emphasis. Finally, let us assume that Keats wrote prose assiduously for over fifty years and that the present example is typical of his style of organization.

Once such a body of works has been taken seriously in its entirety and not in colorful excerpts alone, its interpretation might follow separate stages. The first would be an attempt to grasp the essential coherence and the stylistic achievements (meeting the usual charges of eccentricity and inconsistency). Then would follow a closer study, first of its place in the history of ideas, with particular attention to theoretical problems, and second, of the characteristics of the complete works as literary texts—their genre, imagery, biographical references, rhetorical strategy, and so forth. The specialized approaches would of course have to omit certain features. The intellectual historian, for example (to return to the Keatsian prototype), would focus on the implications of equating beauty with truth and asserting that this equation is *all* we know on earth and all we *need* to know, but he would pass over digressions, such as the one about courtship, and would treat the imagery as essentially illustrative. The literary scholar would focus on precisely the digressions and images that the intellectual historian passes by, grasping connections such as those between time, imagination, and the "sylvan historian," or between the "still unravished bride" and the panting lover, and seeing the complete structure of imagery in relationship, finally, to the concluding statement.

The best of the many recent works on Ruskin—works that have constituted perhaps the most remarkable of our century's scholarly rehabilitations of its Victorian forebears—integrate the responses I have somewhat artificially distinguished, although the most thorough work has been necessarily concerned with the main outlines of Ruskin's thought. Along with these books and articles have appeared many letter collections (a minor industry in itself) and the fine biography these have made possible, John Dixon Hunt's *The Wider Sea* (1982). The flood of knowledge has helped us to see how much is left to explore and what problems of synthesis remain. One of these problems

deserves particular note. The turmoil of Ruskin's emotional life, complicated by the onset of organic illness late in his career, raises in acute form an old and justified concern—that biographical readings will undermine the value of the ideas by referring them to private, perhaps morbid conditions. This problem may be stated in its near converse. Some critics of the Victorian Sages have suggested that we read them as creators of verbal structures that refer not to an external world of action and prescription but to the subjective unity of a private sensibility, but with this approach we risk abandoning our interest in the ideas and their context, our interest above all in their life and cogency.

In this book I attempt a fresh look at Ruskin's career as a whole by reading particular texts in a way that will integrate personal and public concerns—their double claim on us as both intellectual arguments and poetic expressions. Ruskin once remarked of his books on art that they bring their subject to "a root in human passion or human hope." My assumption is that his keenest contributions to our understanding of the world derive precisely from his own passions and hopes, which he was able at his most creative to transform into convincing metaphors of his culture's spiritual contradictions and possibilities. With each text, then, I begin with the man himself at certain moments of his concrete life experience, then attempt with tact and sympathy to locate the places where structures of thought and feeling reinforce each other in the most interesting ways.

My particular readings will emerge in the pages that follow, but part of the general shape I attribute to Ruskin's career may be briefly suggested. Most simply, that shape resembles the three-part model of human development that M. H. Abrams and others have noticed in romantic poetry—the movement from paradisal innocence to a period of catastrophic doubt and estrangement, concluding in a qualified reaffirmation of the marriage of mind and nature that is also a partial return to the first stage. Ruskin's career begins with an affirmation of romantic innocence as an earned position (even though his first major work followed the kind of emotional crisis that might have catapulted him into the second, fallen stage). In one of the early *Letters to a College Friend*, he claimed that there was death in the garden of Eden but that "man in Eden was a growing and perfectible animal" who, had he not fallen, would have been "translated or changed," leaving the earth without pain. In the years following *Modern Painters* 1, Ruskin assumed the possibility of an original spiritual energy persisting through growth and change, a wealth that is also life, traces of which he found in the fallen world of human history as ruins, an ambiguous category signifying both persistence and decline. The year 1860 is usually taken as the turning point of his career because he shifted from art criticism to

social criticism, but it also represents the climax of a new movement of thought and feeling that Ruskin compared to Carlyle's Everlasting Nay. This heroic acceptance of the Fall—a tragic humanism unsupported by traditional religious assurances—was an excruciating release from nostalgia, a break that in the troubled subsequent decades he qualified in two basic ways—by creating a child world, centering on the symbol of Rose La Touche and unchanged by time and sin, and by imagining heroic combat in a world given over, for the moment, to the laws of Fate—until at last he reachieved a vision of transcendence expressed as the narrative of his own past.

To cover such a large and complex body of work I have been necessarily selective. I rely only on published material and use the most recently published letters only occasionally. I have chosen books that seemed to me particularly representative of separate stages of development, including some of the best-known books and a few, such as *Deucalion* and *The Ethics of the Dust*, that are all but unknown today. I hope that these selections will disclose through their connectedness the outlines of a single, massive intellectual enterprise, at once the most ambitious self-portrait in Victorian literature and the most comprehensive presentation of Victorian life as a moment in the spiritual history of humankind.

The notes to this book record my debts; I wish here to record some gifts—personal and scholarly benefactions that have made possible whatever of value this work contains. Such a record must begin with John D. Rosenberg, the true begetter of modern Ruskin studies. For me as for many, *The Darkening Glass* and the anthology *The Genius of John Ruskin* were the indispensable introductions to Ruskin's works. Like many others, I have benefited from Rosenberg's continual generosity and help as teacher, adviser, and friend. The manuscript of this book has gained invaluably at various stages from readings by M. H. Abrams, Elizabeth Helsinger, George P. Landow, Dorothy Mermin, and John Rosenberg. It also shows the indirect influence of friends who entered my life at crucial moments in the past decade: Rachel Dickinson, Robert Farrell, Nancy Kaplan, Santina LaCava, Thomas Merwin, George Miller, William Wright. Last of all, I record my deepest gratitude to my colleagues in the English department of Cornell University.

PAUL L. SAWYER

Ithaca, New York

TRANSCENDENTAL AESTHETICS

1 /

The Golden Waters

Look in the terrible mirror of the sky
And not in this dead glass. . . .

Look in the terrible mirror of the sky.
See how the absent moon waits in a glade
Of your dark self, and how the wings of stars,
Upward, from unimagined coverts, fly.
 —Wallace Stevens, "Blanche McCarthy"

In Scott's *The Monastery*, a monk is riding through a Scottish glen sometime in the late Renaissance. As the representative of a corrupted and oppressive Catholicism, he has just confiscated a Bible that was kept by a dying noblewoman in contravention of the Church's edict. He is about to ford a river when he notices a beautiful lady in the twilight, sitting on the shore and singing. He attempts to carry her across on his mule, but in the center of the river the water becomes dangerously deep, the woman's singing grows ominous, and he is overcome by a vague terror. All but losing consciousness, he finds himself on the opposite side. The woman and the Bible have vanished. Shortly afterward, Halbert, a poor relative in the house recently visited by the monk, sets out to recover the Bible. He climbs up the side of a ravine to a cloven rock from which springs one of the rivulets feeding the valley; the hour is noon and the "unwonted reflection of the sun was dancing in the pellucid fountain." Trembling with fear, his hair standing on end, the youth recites an incantation, and instantly there appears before him a woman clothed in white. "In the name of God, what art thou?" he cries. The White Lady replies:

> "What I am I must not show,
> What I am thou couldst not know.
> Something betwixt heaven and hell,
> Something that neither stood nor fell,
> Something that through thy wit or will

May work thee good, may work thee ill.
Neither substance quite, nor shadow,
Haunting lonely moor and meadow,
Dancing by the haunted spring,
Riding on the whirlwind's wing;
Aping in fantastic fashion
Every change of human passion,
While o'er our frozen minds they pass
Like shadows from the mirror'd glass."[1]

Undeterred, the youth enters into dangerous alliance with the spirit power, first recovering the Bible she has concealed in a cavern beneath the earth, then learning to speak like a gentleman, then moving through various struggles in love and arms.

Ruskin said in after years that *The Monastery* was his favorite childhood book; its effect upon him is certainly beyond question. At age ten or eleven he began a verse synopsis that has survived, and he named his own mule "Shagram," after the beast that walked skittishly through the marsh the first time the White Lady appears (appropriately, to the child in the group). Themes from the novel reappear throughout Ruskin's work. In the repressive monks and the lewd, affected courtier, we recognize crude prototypes of the Ruskinian Renaissance, whom Scott pitted against the pious Protestant family devoted to the "Black Book." In Halbert, the youthful propitiator, we recognize Ruskin's own turning to the hills for their mysterious sources of comfort and strength. We find the ethereal maiden in many guises—as the fairy city of Venice, persisting like a shadow above her own ruin (as the White Lady, fading through the ages, lives as long as the aristocratic family of which she is the guardian); as Athena, whom Ruskin viewed as the animate concentration of her native element; and, at the last, as the child Rose walking beside the crystal stream in *Praeterita*. And in *Modern Painters* III Ruskin twice cites the White Lady in relation to his ideas of imagination. In defining the grotesque, he writes that even healthy manifestations of the fancy, as in Ariel, Titania, and the White Lady, are hardly ever free "from some slight taint of the inclination to evil," but in the famous chapter on the landscape feeling, he associates the White Lady with the birth of his religious instinct. Scotland, he writes, was enchanted for him by "a general presence of White Lady everywhere." His boyish instinct, though without definite religious content, nevertheless rested on a "continual perception of Sanctity in the whole of nature, from the slightest thing to the vastest;—an instinctive awe, mixed with delight; an indefinable thrill, such as we sometimes imagine to indicate the presence of a disembodied spirit it would often make me shiv-

[1]Sir Walter Scott, *Works* (Boston: Houghton Mifflin, 1913), XVII, 138 (chap. 17).

er from head to foot with the joy and fear of it . . . , a sort of heart-hunger, satisfied with the presence of a Great and Holy Spirit." It was a joy greater than any other he knew, "comparable for intensity only to the joy of a lover in being near a noble and kind mistress, but no more explicable or definable than that feeling of love itself."[2]

Yet this "sanctity" Ruskin also knew through books and local history, by association. The land he visited with his parents was the Scotland of the *Waverley* novels that his father read aloud at the fireplace and the dwelling place also of John's ancestors and relatives—including his beloved Jessie, who had ceased sporting on the banks of the Tay when John was only eight. Europe, more obviously, was already vivid before the family saw it with memories of Rogers, Turner's vignettes, and the dashing deeds of Byron's outlaw-heroes. In later years he was fond of challenging the value of all such human representations, quoting as Shakespeare's judgment on art Theseus' words, "The best in this kind are but shadows"; but he may just as often have had in mind Theseus' more famous speech from *A Midsummer Night's Dream:*

> "Lovers and madmen have such seething brains,
> Such shaping fantasies, that apprehend
> More than cool reason ever comprehends. . . .
> Such tricks hath strong imagination,
> That if it would but apprehend some joy,
> It comprehends some bringer of that joy;
> Or in the night, imagining some fear,
> How easy is a bush supposed a bear!"
>
> [v, i, 4–22]

And yet Ruskin, in whom the energies of the poet, the lunatic, and the lover were peculiarly strong and difficult to separate, devoted his career to ascertaining the grounds of imaginative veracity, fashioning for himself a dream like Adam's, from which a person wakes to find it true. The boy who brought a cyanometer with him to the Alps to measure the blueness of the sky and who returned with the most tangible specimens of that great world outside Herne Hill became the man who forever sought beyond the dreams of poets the primal love, as he put it, of the things for their own sake. Surely he is right to locate in the boy's sense of presence—erotic, primordial, and uncanny—some instinct prior to all books and histories, and to locate in the Scotland of his earliest vacations a region where the membrane separating this world and the next, the past and the present, the conscious life and the

[2]John Ruskin, *Works,* ed. E. T. Cook and Alexander Wedderburn (London: George Allen, 1903–1912, 39 vols.), v, 131, 365–368. All subsequent citations of Ruskin's works refer to this edition unless otherwise noted.

archaic energies beneath, was transparent. In a well-known portrait, to which he contributed a detailed foreground rock, he stands in formal black by the cascade of Glenfinlas, with a gaze dreamy and intense, as though to contemplate some shape rising in the mist.

The ecstasies of Ruskin's childhood suggested the vision of total desire that his books continually attempt to realize. But the childhood that provided such opportunities also bequeathed him emotional contradictions that crippled him to the end yet at the same time generated the peculiar restlessness on which his greatness depends, an unceasing drive to synthesize and revise and synthesize again. He was, in other words, forever reconceiving the legend of his own childhood, which he projected onto both the personal and the historical past in a shape similar to Wordsworth's Immortality Ode. But as in all Fall myths, the disruptive element is also profoundly ambiguous: generally it enters late upon the scene yet sometimes seems to inhere within it from the start. To understand Ruskin, we need to understand the structure of that myth in relation to our knowledge of his childhood. Our major sources are his own writings—*Praeterita,* dating from the end of his career, and the productions of his precocious adolescence.

A brief account of Ruskin's childhood as scholars generally describe it might run as follows. In his parents' life the struggle with sin and the struggle with poverty were both won by effort and denial. But the child born into wealth and leisure had to divide his allegiance between a religious ideology that professed duty, work, and a contempt for sexuality and a social ideology that located self-affirmation in the symbols of material wealth. Deeper even than these cultural contradictions were the contradictions of a narcissistic parental love. Overencouraged for every effort yet overregulated by an anxious watchfulness, Ruskin was both prematurely an adult and too long a child, bred up to be at once a great man and the instrument of his parents' wishes. This family romance, so to speak, suffered no serious intrusions: marked out for a special but undefined destiny, John had little way of understanding who he was concretely—in regard, for example, to others of his age— and so remained overconfident yet uncertain, forever afterward preferring relationships of carefully defined subordination. Throughout life he remained haunted by his primal relationship with parents to whom he could not entirely submit and from whom he could never free himself, bound as he was to the dream of a sheltered and protected past, the gifts of which could be enjoyed only by relinquishing the changing world without—the world of independence and struggle and failure and a slow passage toward inexorable loss.

This account differs in some ways from the famous childhood chapters of *Praeterita.* Scholars have detailed some of the inaccuracies and distortions of that book; we must therefore come to terms all the more

clearly with the emotional meaning of those distortions. In the pages of *Praeterita*, Ruskin presents his boyhood chiefly as a pattern of release and restraint—the release of childhood vacations and romping by paradisal meadows and streams and the restraint of the Herne Hill regimen, with its well-known images of denial: the fruit in the garden that it was forbidden to touch, the child sitting at evenings in a niche tracing the patterns on the carpet, and above all the severe figure of Margaret Ruskin, instructing the boy in daily Bible lessons and struggling three weeks over the emphasis on a particular syllable of verse. In a late lecture, he recalled that she shut him in an upstairs room with some bits of wood and a bunch of keys and told him, "John, if you make a noise, you shall be whipped" (xx, 372). He was also whipped for crying, for not doing as he was bid, and for tumbling on the stairs (xxxv, 21). We know now from the family letters that the real situation was more complicated; there were toys and companions after all and, in the boy's own letters, a greater exuberance and variety of pleasures than we would expect from the studious and complacent child of *Praeterita*.[3] But Ruskin does not reproach his parents for their discipline, which he found strict yet consistent and predictable. Instead, he lists four "calamities" of a different nature. First, he had nothing to love, so that "when affection did come, it came with violence utterly rampant and unmanageable, at least by me, who never before had anything to manage." Second, he had nothing to endure ("my strength was never exercised, my patience never tried, and my courage never fortified"). Third, he was taught no sociable manners. Fourth and chiefly, "the bridle and blinkers were never taken off me": "the little creature should be very early put for periods of practice in complete command of itself; set on the barebacked horse of its own will, and left to break it by its own strength. But the ceaseless authority exercised over my youth left me, when cast out at last into the world, unable for some time to do more than drift with its vortices" (xxxv, 45–46). At least three of these calamities center on the power of self-regulation, an emphasis consistent with Ruskin's mature conception of the moral life. For him wisdom is always essentially the channeling of spiritual energies in such a way that love, courage, and the experience of selfhood achieve their greatest fulfillment. The complaint in *Praeterita* is that the boy could not internalize his parents' predictable succession of pleasures and tasks before he was "cast out" into the vortices—a problem understandable enough in an overindulged child who was made abnormally dependent on parental protection. Only by implication, though clearly enough for all that, does Ruskin suggest that his parents starved his

[3]See the introduction to *The Ruskin Family Letters*, ed. Van Akin Burd, 2 vols. (Ithaca: Cornell University Press, 1973).

affections and thwarted his will. Given the aim and mode of the book, we would expect him to blunt the force of his resentment; what is perhaps surprising is that he blunts the force of his love. He writes early on that he took his parents' presence for granted, as if they had been forces of nature. Throughout the memoir, we see them as kindly though erring people, whose son loved them dutifully and who now in old age offers them the garland of filial tribute. But the boy's first letters and poems, sent to cheer his father during the lonely trips through the country on which the elder Ruskin took orders for sherry, are excited and spontaneous in their affection—early evidence for the contention by Ruskin's editors that John James was his son's best friend. The father was also literary agent, adviser, intellectual companion, and receiver (before Charles Eliot Norton) of the son's frankest confidences. The father, in short, was the originator and guardian of the son's best self and so an overpowering as well as a beloved figure. But the emotional patterning of *Praeterita* placed serenity and order within the family unit, power of passion beyond it—in the travels and visits—until, that is, an adolescent girl suddenly appeared at Herne Hill. Then John learned that the enclosed world of Herne Hill was but an inexact symbol of the world outside: like the Lady of Shalott, when he turned to face the realities and not the shadows, he found himself under a prohibition he would never fully understand. To see that prohibition more clearly and not simply as a failure of "regulation," we must understand some of the emotional forces within Herne Hill that Ruskin dramatized through his love for Adèle Domecq.

John fell in love with Adèle, the eldest daughter of his father's Catholic partner, when she visited Herne Hill with her three sisters. John courted her in the only way he knew—by discoursing on provocative subjects (Waterloo, the Spanish Armada, and Transubstantiation)—which left him humiliated and mortified by his real or supposed social ineptness. As he explains with semicomic detachment in *Praeterita:* "I was thrown, bound hand and foot, in my unaccomplished simplicity, into the fiery furnace, or fiery cross, of these four girls,—who of course reduced me to a mere heap of white ashes in four days." Mrs. Ruskin found the prospect of this marriage impossible even to contemplate but was rather annoyed (to continue the fire image), "as she would have been if one of her chimneys had begun smoking,—but had not the slightest notion her house was on fire." The father, on the other hand, seemed to encourage the fancy and began publishing his son's romantic poems—as well as the prose tale "Leoni," which represented, Ruskin says, "what my own sanguinary and adventurous disposition would have been had I been brought up a bandit." He was no bandit, of course; what struck him the most in remembering the incident was that "I had neither the resolution to win Adèle, the courage to do without

her, the sense to consider what was at last to come of it all, or the grace to think how disagreeable I was making myself at the time to everybody about me" (xxxv, 183). Every feature of this affair—the exotic and unattainable object, the need to abstract and idealize her as a symbol, the excruciating emotion along with its prolongation, and the release of feelings through writing—suggests that, at this stage at least, the boy's aim was less to win Adèle than to construct a drama: on the one hand, the reenactment, or rather reendurance, of an earlier loss in love and, on the other, a signal of his need to his parents (to show them, for example, that the house is really on fire).

No sooner did Adèle depart than Ruskin set out to celebrate her with a fit memorial, "a tragedy on a Venetian subject . . . : the fair heroine, Bianca, was to be endowed with the perfections of Desdemona and the brightness of Juliet,—and Venice and Love were to be described, as never had been thought of before" (xxxv, 182). The world knows Ruskin's "white one" as the unfallen city of *The Stones of Venice*. The adolescent fragment, nameless in *Praeterita* and unpublished during his lifetime, is nevertheless the most remarkable of his attempts at verse and one of the most revealing works he ever wrote. Compared with the slightness and conventionality of the rest of his juvenilia, *Marcolini* is intricate in texture and richly imagined, developing in a way we can already recognize as Ruskinian. That is to say, it is densely unified yet appears to ramble; the writing proceeds not according to a preconceived plan (Ruskin obviously never worked out the plot in advance) but like a line drawing that circles back and back upon itself, gradually disclosing the features of the facade it is tracing.

The plot, too intricate to be described in detail, shows how much the boy absorbed of Byron, Shelley, and Shakespeare, especially the last. Count Orsino is in love with Bianca, but his plans are secretly undermined by the villainous Friuli, who attempts to destroy him by way of avenging his own father's death at the hands of Orsino's father. These themes suggest a fusion of *Othello*, *Romeo and Juliet*, and *Hamlet*, but if the setting is ostensibly Venice, the spiritual atmosphere is closer to Elsinore. Ruskin's Venice is a nightmarish region of duplicity and seeming in which every conversation is closely observed, every friend a potential traitor; as one character (a cynical melancholic named Giuseppe—the name recalls Shakespeare's Jaques) puts it, "half the world / Is in sharp enmity with the other half" (II, 490). Even thoughts are known: Friuli's intentions appear as vague presentiments to Orsino ("I fear my father's guilt") and as vivid dreams:

> "A face looks out upon me, angry-eyed—
> The face of an old man, always the same,
> Motionless, marble-like, with severe lip,

As it would speak, yet silent . . . and sometimes beside
A countenance of a boy, exceeding pale,
And sad, so sad, and it looks ever on me."

[II, 481]

Friuli, the false friend, is the shadow of the unexpiated past upon the present, yet no one in this play is quite what he or she seems. Ruskin's twist is to add the title character, a witty, Mercutio-like figure who is Orsino's best friend yet secretly in love with Bianca and troubled by dreams of stabbing the count. Once again Giuseppe makes insinuations about the obscure, omnipresent evil that threatens Venice: "'Tis the work of a lighter hand—of a finger that had entangled as many friendships—as it has scorched hearts—and killed flies like you, my merry Sphinx Atropos" (II, 513–514). The more the movement of the play centers on Bianca and Marcolini, the closer they move to the consummation of their love and the deaths that almost certainly await it, and the darker become the implications of Giuseppe's loose tongue. By the obscure phrase "Sphinx Atropos," Giuseppe seems to fuse Marcolini's hidden self with the dark powers of a woman (perhaps Bianca's hidden self). Three pages later, at the scene when Bianca's mother determines to prevent her marriage to Marcolini, the fragment ends. There is no wonder that Ruskin chooses not to read that riddle and instead shears it off.

The wrathful Friuli, the dashing Orsino, the melancholy Giuseppe, and especially the amiable and witty Marcolini (who, like his author, is safe as long as he remains merely lovesick) all bear some resemblance to Ruskin himself, yet no character, as I have suggested, is really distinguishable from the others; the play's center and focus is the disordered world of Venice, unredeemable by Bianca and divided against itself. Among other things, its psychic dynamics suggest that Ruskin's "Puritan" execrations—against idleness and vulgarity and sensuality and corruption—will be ways of combating the terrors and secret guilts of *Marcolini*, converting them into a foulness that can be expelled. The morbidity and disorder of the play's milieu further suggest why Ruskin so strongly needed a helping hand from without, in the present case through alliance with a supportive father who in the unconscious past had played quite another role.[4]

[4]In the same year Ruskin published a tale, "Leoni," the structure of which resembles *Marcolini*. The bandit Leoni, who robs from the rich and gives to the poor, is the outlaw self of one Francesco, who for years has wooed Giulietta; in order to win Giulietta, however, "Francesco" must reveal his identity as Leoni, take her away from her aged father, and bring upon himself the wrath of her wicked brother, Garcio. To her father Giulietta is all that is left of life—an angel, a light, a sun; and she is life to Leoni as well: "For withered as the autumn leaf, and vain as the ocean spray, and desolating and feared as the influence of the fires of the night, shall I be, Giulietta, when parted from thee" (I,

Not surprisingly, when Ruskin began publishing *The Poetry of Architecture* more than a year later—in the fall of 1837—he announced as his ruling aesthetic principle "unity of feeling, the basis of all grace, the essence of all beauty" (1, 9). In moving from the morbid introspection of romantic tragedy to the brighter mode of architectural criticism, the young author retains a similar conceptual schema: instead of a city presented as secretive, divided self, he presents buildings and their settings as expressions of unified character in the dimension of time. For Ruskin cottages, expressing "national" character, and the villa, the castle, the fortress, and other forms, expressing "individual" character, correspond to two stages of development, childhood and adulthood, the former standing for a period of primal modesty and harmony. (In announcing his section on villas he writes, "We shall have less to do with natural feeling, and more with human passion; we are coming out of stillness into turbulence, out of seclusion into the multitude, out of the wilderness into the world" [1, 73].) Ruskin, of course, is writing from this same transitional stage during his first and second years at Oxford, but the problem of harmony is not, as with *Marcolini*, the reconciliation of incompatible emotional impulses but the adjustment of disparate moral and intellectual interests into a defined, independent self. In one long, mocking paragraph Ruskin satirizes the eclectic taste of an English nouveau riche builder by proposing a list of "ideas and materials" that includes a garden with dancing nymphs, an American wigwam for the front door, Egyptian hieroglyphics for the windows, and a section like Kenilworth Castle with a room at the top for drying plums, all for one building (1, 129).[5] Inevitably one senses a relationship between the cacophonous villa and the heterogeneous interests with which Ruskin was forever cramming his mind (to say nothing of *The Poetry of Architecture* itself which contains a long chapter about chimneys in its discussion of cottage styles) and more seriously, the bewildering multiplicity of possibilities produced by his parents' ambition.

In *Praeterita* he recalls that in his father's eyes John was to "enter at

296n)—rather like the wicked brother, who is all darkness, storm, and pestilence and indeed like the entire landscape after her death. Thus either Leoni or the old father must die for love of Giuletta. (By the end of the tale everyone is dead except Leoni, who becomes a raving maniac.) Narrative collapses into landscape, or rather into a pair of antithetical landscapes of which the bright one is pervaded by the spirit of Giulietta, just as in *Marcolini* narrative collapses, so to speak, into cityscape.

[5]A useful recent article on this early work and its context is Charles T. Dougherty, "A Study of *The Poetry of Architecture*" in *Studies in Ruskin*, ed. Robert Rhodes and Del Ivan Janik (Athens: Ohio University Press, 1982). Dougherty argues that Ruskin's praise of a neoclassical villa at Lake Como is ironic, in view of his later assaults on the mechanical regularity of this style. But there is really no irony: Ruskin cites approvingly Aristotle's description of the contemplative life, and he clearly associates the neoclassical villa with the higher life of the mind such as he had begun to experience at Oxford.

college into the best society, take all the prizes every year, and a double first to finish with; marry Lady Clara Vere de Vere; write poetry as good as Byron's, only pious; preach sermons as good as Bossuet's, only Protestant; be made, at forty, Bishop of Winchester, and at fifty, Primate of England" (xxxv, 185). But what was this amazingly gifted, overencouraged, intellectually omnivorous young man to become in fact? Part of that self in formation would surely be a young man worthy of an ideal love like Adèle. It turned out, soon enough, that Ruskin almost failed to graduate at all (although he did win the Newdigate upon a third try) and that he lost Adèle to boot. In 1839 he saw Adèle again at Herne Hill and his passion flared up with renewed pain and longing. No doubt the increased pressure at Oxford and the renewed attachment to an old affection were related, but instead of receiving the pledge of her love, he was cut off from her irrevocably (she was already engaged to a young baron) and repressed his grief by returning to an increasingly desperate struggle for academic distinction. A poignant record of this conflict is his decision to divide the diary for 1840 into separate headings for Head and Heart. For the first time there opened up a double breach between his parents' wishes—the intellectual and social ambitions that were his own as well—and his heart's deepest need. He developed a hemorrhage of the lungs, and in spring of 1840 his doctor ordered him and his family to Italy.

He overcame his despair in the manner that was to become characteristic of him, by gradual purgation. His Italian diary shows him using sexual disgust and religious bigotry to work out a struggle between desire and relinquishment. In Rome, the historical center of Adèle's religion, the attitude in the diary shifts page by page and sometimes sentence by sentence: "Gorgon-haired wretches crawling about the gate of the chapel. . . . I shall take care to be at our own English service next Sunday." "I felt more completely on hallowed ground than I have yet. Hallowed!—built over with masses of bad brick by a set of brutes and sensualists—what next!" On his last day in Rome, he wrote of feeling surprising regret at leaving, "more so than I thought—there is something about it which will make me dread to return. Farewell, Rome mia!" But when the family arrived in Venice the agitation of Rome dramatically subsided:

> Thank God I am here! It is the Paradise of cities. . . . I am happier than I have been these five years—so happy—happier than in all probability I shall ever be again in my life. I feel fresh and young when my foot is on these pavements, and the outlines of St. Mark's thrill me as if they had been traced by Adele's hand. This and Chamouni have become my two bournes of earth; there might have been another but that has become all pain. Thank God I am here![6]

[6]*The Diaries of John Ruskin,* ed. Joan Evans and John Howard Whitehouse, 3 vols. (Oxford: Oxford University Press, 1956), I, 129–130.

The city of ruined grandeur, the ambiguous seat of love and death and beauty and corruption—the Venice of Byron and Rogers, of *Marcolini* and later of *The Stones of Venice* and *Praeterita*—here loses one-half of its nature to Rome in order to merge with the "glory and the freshness of a dream," a geographical split corresponding to Ruskin's splitting of Adèle herself. Thus purged, Adèle could now be possessed as a virginal spirit, or rather as an architectural world. This moment is the turning point of Ruskin's cure. In the next years, he took up the cause of Turner, and through him returned to the nonhuman world of nature, a world where the analytical eye could leave the sorrows of the heart behind and where the spirit could feel once again its native freedom and strength. But the breach within Herne Hill was never really healed. In *Praeterita* he described the deaths of his playmates, making us understand that their losses were also losses of parts of himself: "While the course of my education was thus daily gathering the growth of me into a stubborn little standard bush, various frost-stroke was stripping away from me the poor little flowers—or herbs—of the forest, that had once grown, happily for me, at my side" (xxxv, 86). In the symbolic structure of that book, these deaths culminate in the loss of Adèle, which in turn represents the final loss of Ruskin's child self, marking once and for all the division between the undisturbed, harmonious life of childhood and the turbulent, aimless life of adulthood. The loss of Adèle became the pattern for later, less tangible frustrations, until Ruskin at last directed the full force of his desolation against the very parent he had once revered so much, in a letter he wrote near the end of his father's life: "Men ought to be severely disciplined and exercised in the sternest way in daily life . . . , but they should never have their hearts broken. . . . Mama and you . . . fed me effeminately and luxuriously . . . , but you thwarted me in all the earnest fire of passion and life" (xxxvi, 461). But this interpretation too arose from a particular experience, which we will consider again in its place.

To an obsessive degree, Ruskin experienced life in terms of a past that was serene and intact, a future fulfillment that was forever about to be, and a present forever embodying the gap between fulfillment and desire—a present, moreover, that had to be lived in a fallen world of corrupted passions, vain ambitions, and the presence of death. I assume the ultimate cause of that melancholy to be an experience of unassuageable deprivation too early for us to seek, except in the landscape hunger Ruskin describes so poignantly, but it first dramatized itself in his love for Adèle. My reading of that experience has focused on two interpretations by Ruskin himself, one a memoir and the other a fiction that, though full of borrowed conventions, is probably no less autobiographical. *Marcolini* describes a complexly divided world in which the impulses of desire are checked by multiple conflicts and are darkened by the imminence of death. *Praeterita* describes the youth's

love as both an overwhelming need and a catastrophe visited from without—like an illness or a fire someone has set, in either case a symptom that the family finally cures with mixed success. The same book attributes that catastrophe in part to a failure to shepherd his desires and to incorporate the regulated pattern his parents had set for him, but we can recognize that what the boy could not incorporate was a set of conflicts, conscious and unconscious, built into the structure of the very childhood he afterward mourned as a period of simplicity and serenity.

Yet there is a sense in which that serenity was no mere fantasy. "That which [a man] projects ahead of him as his ideal," Freud wrote, "is merely his substitute for the lost narcissism of his childhood—the time when he was his own ideal."[7] In several texts, of which *The Stones of Venice* is the most important, Ruskin opposes the self-fulfillment of childhood to the vain cravings of adulthood which he usually calls "pride" or "knowledge." We can locate in his actual past a time when he felt loved for himself and not for what he had to achieve as a condition of that love, a time, therefore, in which he was already his parents' ideal—that is, as a child, which was also the time before his parents' will and his heart's need were drastically opposed. The chief emotional task his work expresses is the problem of how such a self can be recaptured in the world of adult experience. That peculiar restless vacillation by which he moved from position to position and from project to project, that perpetual shifting of the mind and feelings without center or determinate definition, reflect the pursuit of an ideal self before which he would forever feel inadequate, such as Turner or his own symbol of St. George, and the pursuit also of an ideal sexual other without whom he would forever feel incomplete. Most people learn to live with a "good" self sufficient to master inner reproaches and destructive wishes; Ruskin, in whom those darker energies raged with unusual force, did indeed, I believe, live with a sufficient self for most of his career partly because of overwhelming experiences of imaginative ecstasy that he could occasionally recapture in the purgative rhythms of his emotional life. He could not of course ever become St. George or possess Rose, because these are figures of his imagination. But even these wishes express symbolically a more general desire. We saw that fulfillment is impossible in *Marcolini* because its human elements contradict each other, like the discordant villa that has no "harmony of feeling." I suggest generally that the internal contradictions Ruskin inherited were so harsh and complex that he could not affirm or become himself except by ceaseless additions and internal alliances, strengthening

[7] Sigmund Freud, "On Narcissism: An Introduction" (1914), in *Collected Papers*, ed. Joan Rivière (London, International Psycho-Analytical Press, 1949), IV, 58.

some elements and expelling others; and that he sought to incorporate this ideal of psychic integration, projected in the form of a world-as-a-self, with a hunger primitive in its intensity and spiritual in its exaltation—an ideal that also drove him to see human objects of desire abstractly, as symbols of a self to be completed.

One of my concerns in the pages that follow will be to read Ruskin's works as profound analyses of psychic discordance and passionate visions of psychic integration, visions that are not only the aims the books champion but also the process they enact. In this view of his achievement, the adolescent poet, who populated a fanciful world with melodramatic exploits and fair heroines, is father to the great critic of art and society. The mature work constructs personas in the form of schools of art, nations, buildings, and general "spirits" or tendencies until, in the later mythopoeic books, they resume their original form as personifications. Ruskin's contributions to the cultural life of his nation are energized precisely by the fact that his internal contradictions are cultural as well, as he himself noticed with the clarity of moral genius. (For example, earthly goods are temptations, yet devoutly to be desired; God's will is to be obeyed, yet the approval of society is worth more than gold; we must give to the poor, yet we must labor to be rich; virtue is inward, yet the fruits of it are material and open to display). And he was able to reshape so many areas of thought because of his astonishing mental absorptiveness, his capacity to ingest the exhaustless stream of the phenomenal world into the surprisingly consistent structures of his thought and feeling.

The totality of the incorporable world, divinely infused and integrated, is of course Nature, Ruskin's first and last subject. Selfhood can always be known through communion with the divine world, which is also a self, but under the temporal conditions of life, that communion can only be an *event*, recaptured and lost again. In the Wordsworthian poem that provided Ruskin with the myth of his own childhood, a special connection once prevailed between self and world that was not subject to temporality in this way. The child who could sense the White Lady everywhere in the dales and rising mists and glittering streams of Scotland was himself compact of what Arnold said adults experience as a "buried life," which for Ruskin was possible in its pure form only in youth: "for all care, regret, or knowledge of evil destroys it; and it requires also the . . . conscious strength of heart, and hope" (xxxv, 219). But a "fallen" experience of nature succeeded to this first mistress imitating the structure of Ruskin's lovesickness for Adèle, when the object is lost almost in the very act of possession and so is made precious and poignant by the imminence of its vanishment. Instances of this feeling are as numerous in Ruskin as they are well known. An early diary entry, for example, remarks: "I was tormented with vague

desires of possessing all the beauty that I saw, of keeping every outline and colour in my mind, and pained at the knowledge that I must forget it all; that in a year or two I should have no more of that landscape left about me than a confused impression of cupola and pine. The present glory is of no use to me; it hurts me from my fear of leaving it and losing it."[8] In *Modern Painters* III he asks his readers to imagine what they would not give for "the power of arresting the fairest scenes . . . to stay the cloud in its fading, the leaf in its trembling, and the shadows in their changing; to bid the fitful foam be fixed upon the river, and the ripples be everlasting upon the lake; and then to bear away with him no darkened or feeble sunstain . . . but a counterfeit which should seem no counterfeit—the true and perfect image of life indeed" (v, 40). Two recurrent images show how this desire, a mere fancy in itself, can be made good—treasure and water.

Every reader of *Praeterita* knows that the fruit at Herne Hill, first-described as jewels ("clustered pearl and pendant ruby joyfully discoverable under the large leaves that looked like vine"), was forbidden, but that the flower could be "devoured" or possessed visually, so that "my chief prayer for the kindness of heaven, in its flowerful seasons, was that the frost might not touch the almond blossom" (xxxv, 36, 50). Visual possession had advantages more than compensatory: we enjoy something without exhausting it, appropriating it as something other than ourselves yet part of ourselves. Pleasure and therefore the feelings are regulated. Thus, in his adolescence, Ruskin took to incorporating the natural world by reproducing and gathering its fragments (as minerals and flowers and ferns, as sketches and poems preserved as memoranda), constructing from transient experiences an ego territory or gilded environment. To treasure the world, therefore, is to see it perpetually in symbolic terms. But he had learned from the Bible that there are good and bad forms of treasure and that Mammon, the ruler of the present world, opposes the pearl without price, which is immortal life. The crucial thesis for Ruskinian economy, the economics both of passions and of nations, is that all treasure is a true or false symbol, and that some true symbols are good in themselves. One class of such symbols is aesthetic objects, but natural phenomena are the primary class, whose preciousness Ruskin described in one of his central symbolic conceptions, the idea of Purity. According to *Modern Painters* II, purity in nature is the type or characteristic manifestation of divine energy, which may be conceived as an organic structure of cooperating parts or as the divine inherence that sustains the structure. The crystal is the paradigmatic example of the pure object because it is the simplest form of organic life and because it shines forth with a particularly pellucid form of light, the agency of creation. Other examples are

[8]*Diaries*, I, 437.

crystal streams, snowy peaks, the glow of a maiden's healthy skin. The antithesis of purity is all objects foul, dis-integrated, and vacant of the divine inherence. It follows that every precious thing is a tangible embodiment, the "true and perfect image of life itself." But in the course of temporal change, even the most precious of objects "harden" or lose their context. Life in itself is not static, like an image, but a released energy continuous with time, a correspondent power that can truly possess—its usual manifestation in nature is water, the element that nourishes. The experience of Being therefore has a double manifestation, neither the self alone nor the possessed other alone. Its emblem would be both treasure and energy, something to be both beheld and absorbed, an *aurum potabile*. The aim toward which Ruskin's work perpetually strives is a vision of spiritual integration so profound that the treasures of the earth may be enjoyed as an essential manifestation of the "fire of passion and life." If such an integration could be achieved and all contraries resolved—the contraries, for example, of duty and desire, giving and receiving, heart and head, loving and being loved— then past and present would also meet: the motto "To-day" would be realized.

Ruskin wrote his first major work after turning, as he did more than once, from frustrated love to a new infusion of spiritual energies and consolations coming from nature. By the unerring instinct for his true subjects that is one mark of his genius (there are, in his parti-colored career, no real dead ends, no permanently botched projects), he proceeded to gather and "finish" his Alpine diaries in order to construct a massive polemical defense of Turner. The completed book contained poetry as good as Byron's but pious and sermons as good as Bossuet's but Protestant. By seeing nature through Turner's eyes Ruskin achieves vicariously the experience of a supremely integrated consciousness, whose works in turn integrate the works of the Infinite Consciousness. Turner becomes, in other words, a kind of spiritual ideal or guardian whose fleshly counterpart is Ruskin's own father, the generator and guardian of his son's public self,[9] and *Modern Painters* 1 is the lovingly

[9]By means of an idealized figure like Turner, Ruskin could circumvent the unconscious anxiety of trying to compete with his own father, an anxiety dramatized in *Marcolini* and "Leoni." The nurturing aspect of John James Ruskin's relationship with his son has been insufficiently recognized, however. My remarks here are partly suggested by Erik Erikson's generalizations about fatherhood and religious communion. For example: "Children become aware of the attributes of maleness . . . at about the time when they have the first courage for an autonomous existence—autonomous from the maternal matrix in which they only *seem* to want to remain forever. Fathers, if they know how to hold and guide a child, function somewhat like guardians of the child's autonomous existence. Something passes from the man's bodily presence into the child's budding self—and I believe that the idea of *communion*, that is, of partaking of a man's body, would not be such a simple and reassuring matter for so many were it not for that early experience" (*Young Man Luther* [New York, W. W. Norton, 1958], 124).

detailed explication of the divine face, executed through the verbal equivalent of communion with Turner. Communion is also the subject of the tale he wrote, it is tempting to say, as a miniature prelude to the grand task at hand. The tale is too well known to detain us long, but we will find it doing duty as a gay, grotesque emblem of a career as consistent with its origins as it is manifold in its turnings.

Ruskin wrote *Marcolini* in the high, serious style befitting a Byronic poet and tragic lover. He wrote *The King of the Golden River* (appropriately) during his water cure at Leamington in 1841, as a childlike gesture for Effie Gray, the child then staying at his parents' house. Gluck, the young hero, lives in an Alpine valley so rich in fruit that it is called the Treasure Valley, irrigated by a cascade so bright in the sunlight that it is called the Golden River—like Herne Hill, irrigated by the sherry trade, where the fruit is also like treasure. But Treasure Valley is poor, because the wicked brothers who own it hoard its riches, charging usurious rates to the poor and starving people, and enslave the youngest brother, whom they beat in drunken rages. Provoked by this miserliness, the West Wind (whom Gluck inadvertently admits into the cottage) afflicts the valley and dries up the streams. The poverty and succeeding storm correspond to emotional repression and the ravages of passion in Ruskin's life, a problem, once again, of regulation. Clearly a new economy must be found for Treasure Valley. The solution comes in the form of Gluck's favorite mug, with a grinning face encased in gold, which the cruel brothers have cast into the hearth. Gluck is pondering by himself, thinking that it would be better if the river had been real gold, when a voice appears from the "crucible." "No it wouldn't, Gluck, my boy," repeats the implike figure that emerges, over and over again. He turns out to be the King, or embodied essence, of the Golden River, set free from imprisonment in the cup. He assigns Gluck the task of shedding three drops of holy water into the source of the river so that it will flow again. Gluck sets out on his arduous journey (unlike Ruskin he has a chance to test his cloistered virtue), but on the way he gives all the water to thirsty supplicants, who, it turns out, are forms of the king himself (just as all men in need are forms of Christ). Earlier, the wicked brothers had attempted the same task but refused the pleas, and so were turned into black stones for their pains—Ruskin's emblem, forever after, of disobedience, hoarding, and expulsion. But for Gluck the miracle is accomplished, because water given in charity is holy water indeed. With a quality like that of mercy, it returns to its source, blessing both giver and receiver.

Instead of a White Lady atop a waterfall, Ruskin invents a benevolent Rumpelstiltskin, who leads Gluck back, through the act of a sacrifice, to the source of life, there to be reborn as hero and ruler of the valley. With the bad elements expelled, the economy of the valley is

purified and reintegrated—the natural, social, and emotional systems become corollaries of one another. The pious moral, with its lesson of obedience and Christian charity, has obvious enough significance for a young man about to divert the energies of frustrated love into the old landscape hunger, specifically by championing Turner as Nature's Priest. What we have to notice particularly is the tale's symbol of transformation. Gluck learns to transform a disordered economy into a regulated economy by absorbing the king's power and by solving the riddle of true and false wealth. The golden goblet is neither one nor the other but a symbol mediating between the two: as a golden object it cannot be drunk, but like a communion cup, it contains the life of the god, himself the personification of the element that truly nourishes, as both wealth and water. Gluck's achievement is the restoration of unmediated communion, and the cup is the means of converting physical sustenance into spiritual power. It is also an image we will meet again in various forms—the precious object that transforms the world for its bearer into a world-as-a-self.

In 1849, after a year of marriage, Ruskin went on a Continental tour alone with his parents, which included a stop at the city where Adèle had been lost to him forever through marriage. He entered the Louvre and paused at Veronese's *The Wedding Feast at Cana*, there to be convinced of the final superiority of painting to poetry as a representation of "awful and inconceivable intellect." Christ's first miracle sanctified married love by sanctifying the waters. "I felt," he wrote in his diary, "as if I had been plunged into a sea of wine of thought, and must drink to drowning."[10] If he could indeed have drunk to drowning, there would have been, after that rebirth, no second death.

[10]*Diaries*, II, 437.

The Language of Sense

Knowledge enormous makes a god of me.
—John Keats, *Hyperion*

Ruskin's letter to Osborne Gordon on the origins of *Modern Painters* I describes his new career in art criticism as an alternative to the ministry. His aim, he writes, was to communicate "the love and knowledge . . . , not of technicalities and fancies of men, but of the universal system of nature—as interpreted and rendered stable by art." He then recalls that, on a Sunday in 1842, while traveling in Geneva, he read a hostile review of Turner: "It put me in a rage, and that forenoon in church (it's an odd thing, but all my resolutions of which anything is to come are invariably formed, whether I will or no, in church—I scheme all thro' the litany)—that forenoon, I say, I determined to write a pamphlet and blow the critics out of the water." But the pamphlet grew into "a complete treatise on landscape art." "Then came the question, what is the real end of landscape art? and then the conviction . . . that it might become an instrument of gigantic moral power, and that the demonstration of this high function, and the elevation of the careless sketch or conventional composition into the studied sermon and inspired poem, was an end worthy of my utmost labour" (III, 665–666).[1] The confusion in the final sentence is richly suggestive. Nothing can elevate a conventional composition to an inspired poem; Ruskin must have in mind the writing of his own treatise, his continuing hopes as an artist, or the effect of his prose on other modern painters. The sentence does convey with accuracy his newly discovered sense of moral and verbal power, which fuses the ecstatic emotions induced by landscape, the "swelling" that Burke attributes to ambition, and the moral

[1]John Dixon Hunt in *The Wider Sea: A Life of John Ruskin* (New York: Viking, 1982), 127, questions the accuracy of Ruskin's memory regarding the circumstances. There is no mention of the church service in the diaries, and at any rate Gordon was with the Ruskins at about the time the event was supposed to have occurred; but, as always, Ruskin's memories bear an emotional, if not a factual, accuracy.

aggressiveness of the inspired preacher. Ruskin's first book is at once a pamphlet to end all pamphlets and arguably the longest sermon in English, but the mingling, in the passage that I have quoted, of "composition," "sketch," and "poem" suggests that Ruskin, viewing paintings as sermons and language as paint, reconceives the experience of seeing as he revolutionizes the rhetorical modes that he mixes so surprisingly.

The golden-tongued preacher strikes out characteristically in passages like the summary attack on the Old Masters, which in the first edition immediately precedes Ruskin's introduction of Turner:

> A man accustomed to the broad wild sea-shore, with its . . . eternal sensation of tameless power, can scarcely but be angered when Claude bids him stand still on some paltry chipped and chiselled quay, with porters and wheelbarrows running against him, to watch a weak, rippling, bound and barriered water. . . . A man accustomed to the grace and infinity of nature's foliage, with every vista a cathedral, and every bough a revelation, can scarcely but be angered when Poussin mocks him with a black round mass of impenetrable paint, diverging into feathers instead of leaves, and supported on a stick instead of a trunk. The fact is, there is one thing wanting in all the doing of these men, and that is the very virtue by which the work of human mind chiefly rises above that of the daguerreotype or calotype, or any other mechanical means that ever have been or may be invented, Love. There is no evidence of their ever having gone to nature with any thirst, or received from her such emotion as could make them . . . lose sight of themselves; there is in them neither earnestness nor humility; there is no simple or honest record of any single truth; none of the plain words or straight efforts that men speak and make when they once feel. [III, 168–169]

Although Ruskin's endeavor, as he wrote to Gordon, was to reach "all classes," he describes the love of the sublime here in the language of class contempt: grand scenes and grand natures are set off against small minds and the activities of tradesmen. With naive literalness, the passage makes sublimity the spiritual symbol of bourgeois aspiration, the aspiration of the same class that found vicarious fulfillment in the grand gestures of Byron's romances. Then at an imperceptible point, the class polemic shifts to religious polemic. In addition to being puny and vulgar, the Old Masters are also a school of errors and falsehoods, while the sudden new generation of Englishmen, consummating the history of art forever, it would seem, stands as a group of heroes of Protestant history, endowed with Protestant virtues—humility, earnestness, simplicity, and plain speaking. They are nature's gentlemen, whereas the conceited Continentals are the real vulgarians; and most important, they are "self-forgetful." Already in his career, Ruskin asso-

ciates "mechanical means" with the acts and products of a mind in self-isolation and "Love" with the acts and products of a mind that has lost itself in a greater whole. The core of constructive thought in the passage is that great art is not necessarily more or less accurate than bad art, but it invariably springs from an act of communion and bears recognizable traces of that communion in a kind of Wordsworthian overflow of speech, natural and spontaneous—"the plain words. . .that men speak. . .when once they feel." But since bad art really has no audience, it can neither commune nor communicate.

And so for nearly six hundred pages more, polemic and rhapsody, praise and assault make themselves heard through one of the most mercurial voices a writer has ever fashioned for himself. The incongruities stem in part from the contradictions in the young man's heritage—his parents' religion of piety and the religious intensity of their social ambitions—which express themselves in the book as the paradox of sublime experience, the soul's losing itself in order to find itself, elevated and glorified. In other words, Ruskin studies the paradoxes of power in bourgeois Protestantism. But this feature of Ruskin's project is inseparable from the revolution in seeing that has been classically described by Graham Hough: "The neglected faculties must be released from their archaic existence in the unconscious and set free to function in the daylight. This is what Ruskin is trying to do for the sense of sight—to release it from the bondage to utility and convention and to set it free to operate in its own way; he is vindicating the rights of the senses."[2] This vindication takes the form of a new account of the aesthetic transaction, or what is really the same thing, a description of the world as it appears to the great artist—to the man who has seen God's face.

Sermons in Paint

How does the world look to the pure in heart? To justify the objective validity of his way of seeing, Ruskin included a long theoretical apparatus that led Browning to call the book "inconsequent in some of the reasoning . . . and rather flashy than full in the metaphysics."[3] The book's genuine metaphysical interest lies, rather, in the descriptive mode that many of Ruskin's students have called "phenomenological," an accurate enough term though potentially misleading. I will use "phenomenology" to mean a method, not an ontological position, that avoids taking as its ground either an assumption about the limits of

[2]Graham Hough, *The Last Romantics* (London: Duckworth, 1947; pbk), 12.

[3]Quoted in Derrick Leon, *Ruskin, the Great Victorian* (London: Routledge and Kegan Paul, 1949), 82.

human knowledge or an assumption about things in themselves, setting the subject-object distinction aside in favor of a description of the sensory manifold capable of intuitive validation by the experiences of others. For Ruskin such a description grows out of the empiricist tradition yet is subtly and crucially different. He opens *Modern Painters* I with a Lockean definition of sensory ideas and insists that these ideas constitute the limits of our knowledge, yet his very first description transcends by implication the simpler forms of associationism. In his account of Landseer's *The Old Shepherd's Chief-Mourner,* he notes first the visual details—the careful execution of the dog's hair, the wood of the coffin, and so forth, which he calls "language"—and then the emotional connotations of the details, which he calls "poetry." The crucial point is that he already conceives of seeing as reading, an act of knowledge by which the whole exceeds the sum of the parts, since the parts adhere by virtue of an organizing syntax. His next and greatest task is to demonstrate that nature itself may be read by means of an inherent, intuitive grasp of syntax, even when we lack the familiar associations to guide us that we have in the case of the Landseer. In a letter of 1844 to Henry Liddell, he wrote that great modern paintings are "crowded with facts entirely unknown to the observer—types with which his imagination has never been familiarised, and which therefore have no effect whatever by association . . . , hence they excite the passions little and have no historical effect. . . . they are the world as it was and is, not our *ideas* of things past away—and they appeal only to the sense of pure—inherent beauty, a sense nearly, if not altogether, wanting in most men" (III, 676). Ruskin arouses this "neglected faculty" in his readers by giving unprecedented clarity of attention to particular phenomena. As Patricia Ball has acutely remarked, "Seeing clearly . . . means reading deeply into the object, recognizing the comprehensiveness of its self-expression, as it demonstrates its energies, displays the formal laws of its being, and sums up its past and its potential simply by the impact of its visual presence";[4] and this impact *is* beauty for Ruskin. In other words, he passes from the school of Locke to the school of Coleridge—or, more accurately, to a kind of vitalistic Aristotelianism; for the "science" of *Modern Painters* I is a science of essences, and its debt is to Aristotle, not as the father of the inductive method—for Ruskin always hated and feared the "greyness" of general categories—but as the discoverer of the concrete universal, the revelation of the universal through the particular essence of the individual.[5] This view of things corresponds to the lesson of Ruskin's

[4]Patricia Ball, *The Science of Aspects* (London: Athlone Press, 1971), 69. This book remains one of the finest discussions of Ruskinian seeing in print.

[5]Rudolph Arnheim discusses this point in his *Visual Thinking* (Berkeley: University of California Press, 1969). According to him, Aristotle conceives of the "universal char-

first drawing master, who, he tells us in *Praeterita*, taught him "the habit of looking for the essential points in the things drawn, so as to abstract them decisively" (xxxv, 77). The sophistication of aesthetic discrimination implied in such simple advice already surpasses a simple associationism. *Modern Painters* 1 implicitly reconciles the contradiction between the language used by practicing artists and the language of philosophical empiricism, and it does so by a descriptive technique that enacts a fiction of "deep seeing," a fiction by which surfaces disclose essences and the factual becomes affective.

Probably the clearest example of deep seeing is a passage on waterfalls that characteristically describes both an actual scene and Turner's representation of it ("The Upper Fall of the Tees" in the series *England and Wales*). Ruskin begins with the idea of "form," which he has earlier distinguished from mere shape or outline. Foam, for example, may be suggested by lightly rubbed paper; "but nature gives more than foam, she shows beneath it, and through it, a peculiar character of exquisitely studied form bestowed on every wave and line of fall; and it is this variety of definite character which Turner always aims at." Form, or "character," then, is a law of activity manifested differently in different moments—in a "variety of definite character." How does Turner achieve the character, not simply an undifferentiated effect? The answer comes from physics rather than from the rules of drawing. The water in a cascade is both swift-moving and heavy. Most painters use parabolic curves to indicate swiftness, but they sacrifice the sense of weight; Turner, on the other hand, uses catenary lines:

> Now water will leap a little way, it will leap down a weir or over a stone, but it *tumbles* over a high fall like this; and it is when we have lost the parabolic line, and arrived at the catenary, when we have lost the *spring* of the fall, and arrived at the *plunge* of it, that we begin really to feel its weight and wildness. Where water takes its first leap from the top, it is cool and collected, and uninteresting, and mathematical; but it is when it finds that it has got into a scrape, and has farther to go than it thought, that its character comes out: it is then that it begins to writhe, and twist, and sweep out, zone after zone, in wilder stretching as it falls; and to send down the rocket-like, lance-pointed, whizzing shafts at its sides, sounding for the bottom. And it is this prostration, this hopeless abandonment of its ponderous power to the air, which is always peculiarly expressed by Turner. [III, 553–554]

acter" of an object "directly perceived in it as its essence rather than indirectly collected through the search of common elements in the various specimens of a species or genus" (p. 12). Robert Hewison discusses Ruskin and Arnheim in his *John Ruskin: The Argument of the Eye* (Princeton: Princeton University Press, 1976), 208–209—and see all of the important concluding chapter.

Like the physicist, the painter observes carefully and frequently enough to discover the law of visible expression that persists through changes. Again like the physicist, the artist is interested in changeable sense data for the sake of the properties and energies of a thing and so focuses on the sign that contains within itself the most information. Most generally, Ruskinian seeing is a set of conversions—from surface phenomena to essences or qualities to energies and finally to a pervasive sentient energy or mind of which all things are manifestations. Ruskin's verbs gather force in a carefully arranged sequence, from "plunge," "spring," and "tumble," which seem to be objective distinctions, to "writhe, and twist, and seep out," to the final "hopeless abandonment of its ponderous power," only the last of which is clearly an example of pathetic fallacy. By an apparently casual fancifulness the description demonstrates the impossibility of fixing a definite point at which perception becomes conception and thought becomes feeling—a double wedding that, though explicit in Coleridge, was by no means a commonplace in contemporary epistemology. This yielding of perception to conception and thought to feeling I take to be the distinguishing character of Ruskinian phenomenology, succinctly adumbrated in the well-known phrase "intellectual lens and moral [that is, emotional] retina" (IV, 36). First, perception becomes conception, because the details of things leap into life, so to speak, as a gestalt. Again and again in his works, Ruskin "spells" the parts, such as leaves on a tree, until the whole discloses itself all at once.[6] Second, thought becomes feeling because the sudden disclosure of essences is an affective experience; we no longer see but, in ordinary language, sense or feel the heaviness of a stone or the thrust of a blade of grass. What we sense corresponds to the ultimate object of artistic representation, which for Ruskin is not a static image but "qualities . . . emotions, impressions, and thoughts." Thus Ruskin avoids using the word "imitate" (which applies to a mechanical copy), preferring verbs like "state," "induce the effect of," "has reference to"—we would add "express," the romantic term that perfectly describes the transcendence of subject and object implied in

[6]See Elizabeth Helsinger, *Ruskin and the Art of the Beholder* (Cambridge: Harvard University Press, 1982), chap. 3. In *Praeterita* Ruskin recalls the peculiar way he set about to learn reading: "I absolutely declined to learn to read by syllables; but would get an entire sentence by heart with great facility, and point with accuracy to every word in the page as I repeated it. As, however, when the words were once displaced, I had no more to say, my mother gave up, for the time, the endeavour to teach me to read" (xxxv, 23). This ability to register unities all at once, as in a photograph, resembles Ruskin's procedure in prose of providing descriptive details in terms of a preconceived unity of impression. Until an initial apprehension is made, no fragment is meaningful. Each descriptive detail then, corresponds to the words rather than to the syllables, since the words for the child were the smallest possible units of apprehension. In perceptual terms, sense data are recognized by the eye only after the eye can organize them into significant unities. Such a unity is a "word" or primary gestalt.

Ruskinian seeing. If the truest experience of nature is affective and the truest record of nature expressive, it follows that the most "characteristic" subject (that is, the most sublime) would reveal nature at her most "passionate" moment—for nature "has a body and a soul like man; but her soul is the Deity" (III, 148). Although this metaphor is an unwarranted extension of pure Lockean empiricism, it is a consistent extension of Ruskinian reading, according to which particulars can be grasped only in terms of the whole that renders them intelligible, as the features, viewed together, become the expression of a face.

In Ruskinian seeing, then, the oppositions inherent in traditional epistemology—the oppositions of objective to subjective, appearance to essence, surface to depth, sensations to powers, perception to conception, seeing to feeling, are united in a visual process by which the first term of each pair shifts into the second, "truer" term. Moreover, by alternating accounts of painting with accounts of landscape, Ruskin's book produces an analogy between the coherence of a human artifact and the coherence of the natural world: the observed facts of the natural world become the standard for correcting or approving art, while at the same time a painter's skillful abstracting provides clues to a more complete reading of the natural world. The analogy does not amount to a proof that things "really" exist as we see them, or that there is an absolute standard of intersubjective validity. Yet the ability of such comparisons to induce even a degree of intuitive assent challenges the resources of traditional skepticism and marks Ruskin's book as a participant, however unconscious, in the current of thought made possible by German idealism and, in England, by Coleridge—a participant, moreover, in the romantic drive to justify intellectually our primitive delight in the presentness and substantiality of a world greater than us yet made for us, in which we can lose ourselves in order to know ourselves more truly than before. Since this communion rests on the power to see affectively, the inability to see means the deterioration of feeling. Against that calamity nature stands (to alter Mill's famous phrase) as the permanent possibility of emotional experience; and the aim of representation is to increase our power to incorporate that experience.

The paintings Ruskin reads are generally of two kinds that are distinct in every way except for the active response required of the viewer: topographical realism, which demands a loving scrutiny of detail, and visionary expressionism, which stimulates an imaginative reconstruction of elements suggested or evoked. An example among a great many of the first kind is, once again, the *Upper Fall of the Tees:* "With this drawing before him a geologist could give a lecture upon the whole system of aqueous erosion, and speculate as safely upon the past and

future states of this very spot, as if he were standing and getting wet with the spray" (III, 488). Nothing could be farther removed from contemporary interests than the geological lecture Ruskin then provides, yet such passages are among the most wonderful of his aids to the student of Turner, showing how the painter could convert a set of facts into miniature ecologies at once energized and interdependent. To feel the force of a storm-swollen river, or to notice the angle of branches bent in the wind, or to locate the source of the storm in a departing veil of mist in the distance is to grasp connections and intuit emphases that no purely formal analysis of line and color can suggest.

A characteristic example from the other end of the spectrum, the Turner of visionary indistinctness, is the word painting of Turnerian Venice, the tour de force by which Ruskin introduces his hero to his readers. (The passage was suppressed after the first edition in order not to give offense to other living painters.) The rhetorical strategy is to describe hypothetical views of the same subject by different painters. As in *The King of the Golden River*, each contestant is given a task which only the last one truly fulfills—in effect, to make the living waters flow. The worst of the group is Canaletto, who is at once too slovenly and too literal—he gives us only "heaps of earth and mortar, with water between." "But what more there is in Venice than bricks and stone—what there is of mystery and death, and memory and beauty—what there is to be learned or lamented, to be loved or wept—we look for to Canaletti in vain." Turner's vision breaks upon us as an epiphany, an explosion of space and light: "Thank heaven, we are in sunshine again,—and what sunshine! . . . white, flashing fulness of dazzling light, which the waves drink and the clouds breathe, bounding and burning in intensity of joy. That sky,—it is a very visible infinity,—liquid, measureless, unfathomable, panting and melting through the chasms in the long fields of snow-white, flaked, slow-moving vapour, that guide the eye along their multitudinous waves down to the islanded rest of the Euganean hills." Ruskin then moves to details—a gondola advancing in the foreground in full distinctness, the line of buildings in the background sketched in suggestively—then back to the whole again: "Detail after detail, thought beyond thought, you find and feel them through the radiant mystery, inexhaustible as indistinct, beautiful, but never all revealed; secret in fulness, confused in symmetry, as nature herself is to the bewildered and foiled glance, giving out of that indistinctness, and through that confusion, the perpetual newness of the infinite, and the beautiful" (III, 255–257). Here in a few words is the Ruskinian sublime, with a characteristic three-part movement: first an undifferentiated sensuous delight, when everything seems liquid light; then a lingering over suggestive details, which accumulate to the point at which enumeration is impossible; then a reconstitution of the whole,

this time grasped imaginatively as an infinite sum of particulars that can be read as long as we like. The sudden overflow of light and water turns out to be a boundless supply unexhausted by boundless giving. Canaletto, Prout, and Stanfield had given marks on a canvas that never quite cohered into "poetry" (Canaletto had given only lifeless matter, of the sort that the "bargeman" and "bricklayer" would notice), and so the affective energies of the viewer could not be released. But in Turner the compositional elements become objective correlatives, so to speak, of the mind struggling to absorb what is too much for it, while the sunlight and water of the bay become synecdoches of nature herself, "the exhaustless living energy with which the universe is filled" (III, 383).

Such is the world as it is seen by the Wordsworthian child. The Ruskinian sublime, that is to say, is Wordsworthian rather than Burkean. Ruskin avoids the term because he rejects it as a useful category. "Anything which elevates the mind is sublime," he writes; it is therefore "not distinct from what is beautiful . . . but is only a particular mode and manifestation" of the sources of pleasure in art (III, 128, 130). The phrase is ambiguous with regard to subject or object: the sublime is neither an experience of the viewer alone nor a quality of the thing seen alone but a "particular mode or manifestation." The relentless attention throughout the book to sublime beholding permits Ruskin to reconceive the elements of the aesthetic transaction—nature, artist, audience, and artifact—according to a model of religious experience.

His conception of the first element, nature, depends upon the most childlike suspension of disbelief: the canvas should always seem a real place to be entered, the universe should always be a system "out there." In this fiction of radical outness, the internal is completely externalized, so that nature becomes the sum of all intellectual and affective energies, inscribed on an infinite sensory manifold. "Beauty" is simply the agent of the affective bond between eye and nature—not specifically a set of formal qualities but rather the divine energy made visible and received by the pure in heart. But "the moment that we trust to ourselves, we repeat ourselves, and therefore the moment we see in a work of any kind whatsoever the expression of infinity, we may be certain the workman has gone to nature for it" (III, 387). The task of the illusionistic painter is so to tap into this divine multitude, so to absorb the essential laws of things, that he can abstract from the infinite to make it comprehensible as the sublime. The untutored viewer sees lazily and unselectively. Instead of confusion, the artist gives him system; instead of blankness, the beginnings of detail; instead of dullness, freshness of sensation; instead of dead copies, life. But a painting is in itself only a single version or transcript. This is the point of Ruskin's one extended comparison between painters and preachers, both of whom

have space only for a single "text": "Both are commentators on infinity, and the duty of both is to take for each discourse one essential truth . . . and to impress that, and that alone, upon those whom they address" (III, 157). A work of art is not the shadow of a shadow but a particular enhancement or clarification of the supreme reality, an assumption by which Ruskin implicitly overthrows our traditional insistence on the autonomy of the individual work. Always his readings go beyond the particular canvas or sketch (sometimes noticing only a corner of it) in order to recapture the primal act of beholding of which the artifact is only a trace. This approach is consistent with the peculiar division of his book into natural categories—Earth, Skies, Water, and Vegetation—which are for him the artist's vocabulary of forms analogous to Northrop Frye's vocabulary of archetypal imagery.

No wonder Ruskin had no space for a theory of "creative" imagination. But although he later moves to a more expressionist emphasis, *Modern Painters* I does not ignore the second element of the aesthetic transaction, the artist. On the contrary, by rejecting the imagination as a separate principle in aesthetic activity, Ruskin makes possible an extreme theory of inspiration by which the great artist becomes the world before which he annihilates himself. Wordsworth had expressed a dream widespread among romantic poets when he hoped to show in *The Recluse* the "creation" that the mind and the world "with blended might / Accomplish," but the Wordsworthian project is problematical indeed, resting on the polarity of an autonomous human power and the sensory presence of nature and on the struggle to translate the language of sense into a system of verbal signs. Ruskin's radical simplification of these problems arises, most obviously, from the experience of sketching, a kind of automatic writing that reproduces objects in a system of nonarbitrary signs that resemble them. The amateur sketch may stand as a purer paradigm even than a great poem of (in Coleridge's phrase) nature made into thought and thought made into nature,[7] for as the concrete record of an action, lines on paper "express" both the object and the moving hand.

What we normally call sublime art is simply a special case, for Ruskin, of this trancelike self-forgetfulness, as he makes clear in his section on technical mastery. According to him, the largeness and difficulty of the subject make correspondingly large demands on the artist, until technical control shades over into a power of comprehension equal to the

[7]The phrase is from a lecture of 1818 that captures much of Ruskin's intent as I read it: "Now so to place these [images] of nature totalized, and fitted to the limits of the human mind, as to elicit from, and to superinduce upon, the forms themselves the moral reflections to which they approximate, to make the external internal, the internal external, to make nature thought, and thought nature,—this is the mystery of genius in the Fine Arts." (*Biographia Literaria*, ed. J. Shawcross [Oxford: Oxford University Press, 1907], II, 258).

power of the sensations that flood the expanding lens of the artist's eye. A very great power of comprehension or absorption is genius, such as that of Turner, who pervades even his most complex compositions as an abstract principle of order. This view, of course, is simply a restatement in pictorial terms of romantic theories of impersonal genius, but in Ruskinian phenomenology, since Turner represents the farthest possible reach of human perception, what he gives us *is* nature as far as we are concerned, with indications in the form of blank or sketchy areas of the point at which even his senses fail. This theory of inspiration, along with the form of Ruskin's exemplary readings, implies a fiction of beholding that emerges clearly enough even though Ruskin never describes it in detail. According to this fiction, the artist loses himself by being blinded or temporarily annihilated as a separate ego. Then the seer is restored to himself with a heightened sense of an access of separate power and of his place in nature. The sublime experience is a power exchange (metaphorically, a drinking in or a breathing in, an inspiring) ending in stability, which also leaves a trace in the viewer's memory—a shorthand "possession" of part of the whole. Finally, the seer converts his experience into a set of signs resembling the visible signs by which nature expresses the divine energy but now organized according to the unity of his own apprehension. This whole account may be reduced to a single sentence if we adopt the metaphor of speech: the inspired painter is a prophet, and the "I" of that painter is the divine "I" as spoken through the prophet's lips.

The effect of this ventriloquism on the viewer, the third element of the aesthetic transaction, is not so much to convey messages as to induce a nearly equivalent experience of communion. In a well-known passage describing the storm in Turner's *Long Ships Lighthouse, Land's End*, Ruskin writes:

> It is this untraceable, unconnected, yet perpetual form, this fulness of character absorbed in universal energy, which distinguish nature and Turner from all their imitators. . . . to mark the independent passion, the tumultuous separate existence, of every wreath of writhing vapour, yet swept away and overpowered by one omnipotence of storm, and thus to bid us
>
> > "Be as a presence or a motion—one
> > Among the many there. . . ."
>
> this belongs only to nature and to him. [III, 404–405]

The passage gathers detail upon detail until the local storm becomes a paradigm of all particular manifestations in their relation to the cosmos. Ruskin's voice correspondingly rises in degree of intensity until it bursts forth in the verses of Wordsworth's Wanderer, as though to

underscore the universality of Turner's vision and incidentally to re-
peat, by means of the embedded quotation, the effect of the several
participating in the one. We are "thus" bid, as the syntax implies, to
participate through our own fullness of character in the universal ener-
gy, which for Ruskin is the supreme experience of selfhood. An odd
feature in Ruskin's own readings reinforces this sense. He is often
drawn to scenes in which a human artifact named in the title—
Llanthony Abbey, a steamer, a slave ship, Babylon—is surrounded by
atmospheric tumult, yet he often omits mention of the presumed cen-
ter of attention. It is as though by omitting reference to the human
marker, he destroys all trace of the endistancing mirror relationship,
subtly permitting his viewers to reconstitute themselves at the center of
the scene—as the organizing energy of the artist does.

Meaning in the visual arts is for Ruskin a dynamic interaction most
suitably described in metaphors of speech. The artist is an interpreter
in relation to his subject, a prophet (or bidder) in relation to his au-
dience, and an inspired medium or oracle in relation to his own experi-
ence. The painting, which is the nexus of these relationships, generally
disappears from Ruskin's accounts, since it must seem to annihilate
itself in order to achieve immediacy, but when he does consider the
work of art in itself, he uses metaphors of speech once again—a "stud-
ied sermon and inspired poem," for example. But "sermon" and
"poem" are both too general and too specific to convey the root idea of
Ruskinian aesthetics. "All great art," he wrote many times, "is praise."

In a jumbled passage from the preface to his second edition, Ruskin
introduces his theory of unconscious genius in commonplace Longi-
nian terms:

> The artist has done nothing till he has concealed himself; the art is imper-
> fect which is visible. . . . In the reading of a great poem, in the hearing of a
> noble oration, it is the subject of the writer, and not his skill, his passion,
> not his power, on which our minds are fixed. We see as he sees, but we see
> not him. We become part of him, feel with him, judge, behold with him;
> but we think *of* him as little as of our ourselves. . . . The power of the
> masters is shown by their self-annihilation. . . . The harp of the minstrel is
> untruly touched, if his own glory is all that it records. Every great writer
> may be at once known by his guiding the mind far from himself, to the
> beauty which is not of his creation, and the knowledge which is past his
> finding out. [III, 22–23]

The unconscious artist is the precondition of an aesthetic interaction so
immediate that the other elements fuse together: by his silence, his
creations speak and his audience becomes "part of him" and beholds
with him. But how silent is he really? Ruskin's many examples of "un-
consciousness" include an orator (whose effects are studied and whose

presence is highly visible), a minstrel singing of his love, an absent genius such as Shakespeare, a sublime poet such as Turner or Wordsworth—and, we might add, a preacher and an oracle. Essentially, Ruskin has confused a genuinely impersonal author with a charismatic speaker. In both cases we may "see as he sees," but Ruskin is clearly interested above all else in the *power* of the utterer, even as he claims that an audience is unaware of it. His rhetoric of praise, then, is also a charismatic rhetoric, as his conception of Turner and his own highly polished idiom make clear.

For Ruskin the oldest and probably most immediate paradigms of sublime speech are the Old Testament prophets and psalmists (the latter are probably implied above by the minstrel and his harp), both related to the romantic bardic tradition and the overtly classical form of the romantic ode. What is the rhetorical structure of such utterances? Most simply, the prophet "faces" an audience, delivering the work of God to the community, while the psalmist speaks in his own voice to God. When the psalm (and sometimes the prophecy) has a personal or lyric voice, we "overhear" him, to use the term with which Mill defines the lyric relationship. But insofar as the utterance loses its personal voice in an activity of invocation, we are neither addressed, as in the case of an orator, nor permitted to eavesdrop, as in the case of a meditation or complaint. Rather we begin to identify ourselves with the speaker in his beholding, in the way Ruskin describes. The identification of the reader and author becomes complete in ritual speech, when the congregation utters the words not as recitals of someone else's composition but as verbal actions—the action of reaffirming the divine covenant. The imprecise notion that psalms are poems of praise, when in fact they vary greatly in form and intention, is therefore true in the sense that psalms are affirmations of relationship, the simplest form of which is the ritual naming of God's works as an act of praise—and this, of course, is true also of the romantic ode, which, as Harold Bloom has written of Shelley, places the poet in an I-Thou relationship to nature.[8] The preacher, who in Ruskin's phrase comments on infinity, also participates in a ritual affirmation.

In this way, I believe, Ruskin comes close to the heart of Turner's art. His attempt to square Turner with Evangelical pieties is of course bathetic and proved embarrassing to the painter (it is more accurately Ruskin's construction of an ideal self that would reconcile the demands of earnestness and desire). Yet the immediacy of experience induced by Turner's technical and iconographic inventions resembles the affirmation that Ruskin captures well in his own word paintings. The paint-

[8]Harold Bloom, *Shelley's Mythmaking* (New Haven: Yale University Press, 1959), passim.

er's very muteness, his inability to distinguish himself from the objects he presents or to make unambiguous statements, brings Turner close to the primitive power of ritual invocation, for his works may be viewed as various enactments—in fierceness, in defiance, in deep calm—of the words attributed to him on his deathbed: "The Sun is God." The celebratory mood of *Modern Painters* I does not correspond to the emotional range of that art, but in later years, when Ruskin's pessimism came to match Turner's own, he could still turn in his books to psalmlike affirmations of relationship that transcend the contradictions so baffling to the mind of faith. In the early book, the medium of praise is a translation of paint into words, both of which are viewed as modes of a single form of incantatory poetry. To describe painting with reference to language is to render explicit the dynamic of communication between viewer and artist while at the same time teaching a visually illiterate audience to read the language of sense. And to return again and again to the primacy of painting is to collapse the distance between subject and object embedded in the simplest forms of grammar, thus reinstating the immediacy of communion that only the eye can know and the effect that only a silent speaker can induce. And finally the audience of reverent viewers, which the book partly assumes and partly creates, resembles a congregation in worship, who by uniting themselves with the artist make each act of beholding a ritual utterance of their own.

Should painting really be expected to achieve this? As always with Ruskin, his specific subject is but the vehicle for an ideal it can never quite match, an ideal better expressed, perhaps, by Ruskin's own medium of eloquent prose. In that medium at least, he resolves some of the paradoxes attending the doctrine of artistic unselfconsciousness.

Painting in Words

In a late preface to *Modern Painters* II, Ruskin acknowledges his theoretical debt to Aristotle by translating the passage he had earlier left in the original Greek: "And perfect happiness is some sort of energy of Contemplation, for all the life of the gods is (therein) glad; and that of men, glad in the degree in which some likeness to the gods in this energy belongs to them" (IV, 7). The quotation concludes Ruskin's central argument that men delight only in "whatever is a type or semblance of divine attributes" and that this delight "seems a promise of a communion ultimately deep, close, and conscious" with God (IV, 144). "Energy," not "contemplation," is the key term of Ruskin's dynamic Aristotelianism and of his paganized Christianity, for the complementary statements express the central idea of his early religious aesthetics,

that the full visual experience of God's handiwork is eucharistic. His rendering of Aristotle underscores the relationship of Christian sacraments to older mythological materials: the eucharist and baptism, types of an ultimate communion and an everlasting life, are the fulfillment of the promise denied in Eden ("Ye shall be as gods, knowing good and evil"), now offered to the Christian in magnified but paradoxical terms—that the lowest will be exalted, that the last will be first, and that only the pure in heart shall see God.

When we add to this Ruskin's youthful enthusiasm for Shelley (we know that he read *Prometheus Unbound,* "The Sensitive Plant," "Julian and Maddalo," "Epipsychidion," and no doubt more during the first summer of his love for Adèle), it is not surprising that in *Modern Painters* 1 he should write the notorious passage that his critics immediately seized upon as blasphemous:

> [Turner is] glorious in conception—unfathomable in knowledge—solitary in power—with the elements waiting upon his will, and the night and the morning obedient to his call, sent as a prophet of God to reveal to men the mysteries of His universe, standing like the great angel of the Apocalypse, clothed with a cloud, and with a rainbow upon his head, and with the sun and stars given into his hand. [III, 254]

The metaphor may be extravagant but is perfectly consistent with Ruskin's underlying pattern of imagery. These words bring to its climax a paragraph of praise for the lesser English artists, each of whom is described in ascending order, according to the range of natural phenomena he incorporates and so represents in paint. Turner, whose mind is coextensive with all of visible nature, appropriately takes the form of an intermediary between God and the material creation. Literally, his mastery of the elements means simply that he can paint any subject, but metaphorically, it means that enormous power has made a god of him. The same implication attends Ruskin's advice to young painters to begin by studying nature: they must first keep to quiet colors and be "humble and earnest in following" nature's steps, until such time as they may "take up the scarlet and the gold" and "give the reins to their fancy. . . . We will [then] follow them wherever they choose to lead" (III, 623–624). Literally, to take up the scarlet and gold means simply to begin using bolder colors; metaphorically, it means to become as the sun god. Once again, the Protestant ethic of deferral yields to pagan dreams of glory. What of Ruskin's own position as Turner's imitator in words? His belief that verbal language and visual language are differing "modes of Poetry" opens the way for his voice and Turner's to merge and for translation to become incorporation. Ruskin's role then parallels Turner's by analogy: Turner, having seen

God's face, speaks to men as Messenger and interpreter; Ruskin, having studied nature through Turner, speaks to men as Turner's champion and exponent. The Archangel passage may bear a hidden allusion to the second mission, since, in the Book of Revelations, the Angel of the Apocalypse is pictured bearing a scroll and saying to the prophet John, "Take it and eat; it will be bitter to your stomach, but sweet as honey in your mouth" (Rev. 10:9).

In the metaphorical structure of the book, then, Turner is the type of the redeemed, that is, the seeing man, and is appropriately figured as a union of human and natural elements; he is also the personalized form of all that Ruskin, and therefore all that we, can love in nature and art—a fiction similar to what Ruskin would later call a "companionable deity" in his study of Greek myths. The difficulty, of course, is that Ruskin's moral argument rests upon an antithesis between the Christian concepts of pride and humility, which leads him into deep perplexity. The power of the impersonal self, coming through surrender to God, also elevates Turner the man above all men. The book fails to distinguish between landscape feelings, which Ruskin's religious conscience would approve as a form of worship, and the experience of superiority over others, which his religious conscience would condemn as pride. As though recognizing this omission, Ruskin attacks the selfishness and vanity of the bad painters by allying himself with one greater than he and so falls into unconscious comedy—Turner, of all people, becomes the type of artistic humility. Most obviously Ruskin's problem is the problem of the religious culture he inherited from his parents—we have seen how the language of class contempt can shift quickly into a polemic on religious humility. But when, either in society or in art, does humility before God become pride before men? Can anyone consciously strive to be unself-conscious? Part of Ruskin's problem is semantic, or rather a confusion of artistic and social personality, with the result that the words "pride" and "humility" have force as polemical counters, not as critical terms. The epic voice of Homer, for example, neither has nor lacks pride, yet by describing the impersonality of art as a Christian virtue, Ruskin confuses formal characteristics and ethical values as well as spiritual virtues and social virtues—in the latter sense "pride" and "humility" are close to the modern sense of "conceit" and "modesty." Moreover, "annihilation" was for Ruskin himself a delicious experience of visual self-forgetfulness, not the self-abnegation taught by the Scriptures. These contradictions are no doubt one reason he fell back so often on the fiction of Wordsworthian childhood, the only time when omnipotence can come through true unself-consciousness.

Yet Ruskin's project is redeemed by the authenticity of the experience he had to communicate, however clumsily encapsulated in a po-

lemical structure, and by the language he invented for that purpose. His problem is to argue for a bardic theory of art and also to democratize sublime experience—to defend Turner as an inspired prophet yet to spread his vision among "all classes of men." Ruskin risks bathos, but so did Wordsworth when he sought to construct a voice with double functions—a voice conveying the elevation of the bard yet also speaking as a man to other men.[9] Ruskin knew Wordsworth's claim that poetic language is a spontaneous and unaffected overflow of powerful feeling, and he knew the sermonic speech of Wordsworth's Wanderer. The one voice is presumably artless, the other deliberately elevated, but we have seen that Ruskin is not sensitive to this distinction, and at any rate, Wordsworth had claimed that the language of unaffected passion could rise even in unlettered people to the dignity of poetry. And so Ruskin develops for *Modern Painters* 1 a mode at once "artless" and elevated, appropriate to the mediator who speaks to other humans of a high and privileged experience. This explanation would justify Ruskin's preparation for a reading audience of the diary passages he gathered for the book, themselves composed without thought of an audience though not indeed in complete spontaneity. In addition to the finished style we notice another, not wholly separable, voice, the oracular voice of Shelley. In a poem like the "Ode to the West Wind," Shelley dramatized the relationship of ode to oracular utterance by a language that achieves the oracular condition he demands of the wind as the source of his inspiration. The same excitement infuses Ruskinian descriptions. By fusing these influences into his own idiom, Ruskin becomes in the truest sense a preacher—not because of his occasionally sanctimonious tone but because of the shifting multiplicity of his rhetorical gestures, now praising and castigating, now explicating and examining, now exhorting and praying. His finest "sermons" constitute his first permanent contribution to English literature, as a few examples suffice to show.

The best-known version of Ruskinian sublime simulates a burst of joyous, almost childlike energy, in which the words seem dictated by a force outside the viewer. The passage on Venice excerpted above is the first such moment in the book, which, following upon Turner's apotheosis as Angel of the Apocalypse, seems a veritable City of God:

> That sky . . . parting and melting through the chasms in the long fields of snow-white, flaked, slow-moving vapour . . . to the islanded rest of the Euganean hills. Do we dream, or does the white forked sail drift nearer, and nearer yet, diminishing the blue sea between us with the fulness of its

[9]M. H. Abrams argues that Wordsworthian diction is a poetic form of the divine *accommodatio*. See "English Romanticism and the Spirit of the Age," in *Romanticism and Consciousness*, ed. Harold Bloom (New York: W. W. Norton, 1970), 117; see also Abrams, *Natural Supernaturalism* (New York: W. W. Norton, 1971), 395–399.

wings? It pauses now; but the quivering of its bright reflection troubles the shadows of the sea, those azure, fathomless depths of crystal mystery, on which the swiftness of the poised gondola floats double, its black beak lifted like the crest of a dark ocean bird, its scarlet draperies flashed back from the kindling surface, and its bent oar breaking the radiant water into a dust of gold. Dreamlike and dim, but glorious, the unnumbered palaces lift their shafts out of the hollow sea,—pale ranks of motionless flame,— their mighty towers sent up to heaven like tongues of more eager fire,— their grey domes looming vast and dark, like eclipsed worlds,—their sculptured arabesques and purple marble fading farther and fainter, league beyond league, lost in the light of distance. [III, 257]

Here Ruskin, like the Angel, seems to summon up all the elements at once and give them life. As readers have often noticed, he does not denote objects but instead renders them and their connections as energies even when they are generally motionless: the boat, for example, drifts, pauses, quivers, poises, lifts, flashes, and so on. The motion depicted is not hectic like a storm but tremendous in its variety—an ordinary day, so to speak, in the cosmos. Remarkably, the superflux of energy is counterbalanced by an even greater stress on essence, which Ruskin conveys by the characteristic grammatical device of linking indefinite nouns with definite adjectives in prepositional phrases: thus, not light or wings but "fullness of light," "fullness of wings"; not mysterious crystal but "crystal mystery"; not the gondola floating but the "poised swiftness" floating; not islands and hills but "islanded rest of the Euganean hills." Grammatically, things are subordinated to the ideas of things. The imitator gives us sails, clouds, hills, and light; Turner gives us fullness, mystery, rest, poised swiftness, making any scene not only the epitome of infinite energy but also the transience of infinite essence in concrete particulars, or in Coleridge's phrase, the *translucence* of the general in the specific.

Similes, which normally direct our attention away from the objects, serve here to intensify their presence. In a passage cited earlier, Ruskin describes Poussin's leaves as feathers and his trunk as a stick (the tree shrinks), whereas in nature, we are told, every bough is "a revelation." In the present passage, the crest of a boat is a bird's beak, its sides are draperies, and towers are tongues, but the effect is to expand the objects. Ruskin's similes work to expand or contract according to context, with the truly rendered object resembling something oversized or overenergized—in this case we "see" enormous and therefore sublime birds, draperies, and tongues. In yet another example from elsewhere in the book, Ruskin compares bad and good depictions of lightning to "zigzag fortifications" and "dreadful irregularity of streaming fire" (III, 413). The first comparison shrinks lightning to something static and conventionalized, the second expands it to an energy or quality that is boundless because beyond size—the actual phrase is more frightening

and vivid than "fire that streams irregularly and dreadfully" because "irregularity" is indefinite (a point Ruskin makes himself in his next volume).

In perhaps the best-known word painting in the book, Ruskin's reading of *The Slave Ship*, similes and metaphors once again suggest the universal in the particular, this time by evoking a symbolic vision:

> Purple and blue, the lurid shadows of the hollow breakers are cast upon the mist of night, which gathers cold and low, advancing like the shadow of death upon the guilty ship as it labours amidst the lightning of the sea, its thin masts written upon the sky in lines of blood, girded with condemnation in the fearful hue which signs the sky with horror, and mixes its flaming flood with the sunlight, and, cast far along the desolate heave of the sepulchral waves, incarnadines the multitudinous sea. [III, 572]

This famous sentence is perhaps the book's most complete sinking of thought into sensuous description. As Elizabeth Helsinger observes, Ruskin here "guides the mind through a temporal process of imaginative association which is inseparable from a temporal experience of tracing formal visual relationships, especially of light and color"; the painting becomes "not just the occasion for mental process but the embodiment of it."[10] The canvas as first beheld is a central burst of red and gold that diffuses itself into darkness and mist, while shadowy hieroglyphs of fish and men rise and fall in the chaos of foreground water. Ruskin brings order to this impression of incoherent energy, using a set of intricately connected clauses that march with fierce inevitability from object to object and from color to color in a gradual accumulation of moral signification. The three climactic clauses take "fearful hue" as their subject and disclose (along with a previous clause linking it with the ship) four separate activities of redness—girding with condemnation, signing the sky, mixing its flood, and incarnadining the sea. The phrases unpack one by one the meanings concentrated by Turner into a single focus. Allusions mingle with specific denotations to create a fantasia on themes from the Apocalypse—skies raining blood, seas burning, darkness of night, and the ocean that delivers up its dead, climactically linked with Macbeth's murders. Phrases like "condemnation," "flaming flood," and "sepulchral waves" are therefore cosmic in their generality, and "incarnadines the multitudinous sea" culminates this binding of the many and the one (many deaths and one redness), a binding which is of course the function of allegorical signs. The visible form of this union is the masts of the ship, which become the mark of its guilt (like Lady Macbeth's hand) and also the bond connecting the ship to the center of an elemental disturbance,

[10]Helsinger, 189.

like a cause tied to its indefinitely radiating effects. Turner as Archangel here gives the last of his revelations, which is a visual antithesis of himself: the "red and gold" are here antithetical to the raiment of the prophet-painter, since the ship does not take on the colors of the sun but rather inbues the cosmos with its own bloodguilt and the shadow of its own death. Ruskin identifies the slaver only in a footnote, as though to keep a pious distance (the ship drops to the bottom of the page like its own cargo), and maintains a particularly endistanced rhetoric. The order of grammatically connected clauses imitates the inevitability and the tone of judgment by means of a regular rhythm in which nearly every word demands stress. In their effect the elegiac incantation and sermonic denunciation anticipate the famous beating waves at the beginning of *The Stones of Venice*.

The passage in the book that became the most popular during Ruskin's lifetime is also the most representative of his rapturous sermonic style. At the conclusion of the section on truth of skies, Ruskin bids the reader stand in the Alps for twenty-four hours beginning just before dawn, in order to observe the diurnal water cycle. Starting with the burning away of mists before the rising sun, the sentences move through a perpetually shifting symphony of light and mist and water, describing a circle from east to west to east again as the sun prepares for its second ascent. At each atmospheric phase, Ruskin punctuates his divisions with "Has Claude given this?" until at the end, the completion of the revelation is signaled by a sudden shift to supernatural imagery, the apotheosis of both gods of Nature: "until the whole heaven, one scarlet canopy, is interwoven with a roof of waving flame, and tossing, vault beyond vault, as with the drifted wings of many companies of angels: and then, when you can look no more for gladness, and when you are bowed down with fear and love of the Maker and Doer of this, tell me who has best delivered this His message unto men!" (III, 418–419). This is sublime preaching at its most deliberate—the repeated bidding and querying of an audience until the lesson is consummated, and the appearance of losing the self in an exalted subject. It imitates as well the form of the psalm by invoking the deity through his works and thereby overthrowing his rivals—God's rivals, that is, and Turner's. For as divine Messenger, Turner shares the attributes of God and man. However bathetic the effect, Ruskin's incorporation of aesthetic polemic into religion consummates the general agon of his book, the conflict between the two spiritual states of light and darkness.

The language of this passage, and of the book as a whole, owes more to Shelley, finally, than to Wordsworth. The description of Venice is suffused with Shelleyan diction—"liquid," "snow-white," "flaked," "azure," "crystal," "dim," "flamed," "fading" are examples—and its sustained ecstasy of beholding imitates the protean energy of Shelley's "spontaneous gladness." This is the language the Wordsworthian child

might speak if he wrote poetry, and the broad project of Ruskin's sermonic style, touching as it does on ode, psalm, and apparently thoughtless inspiration, may be usefully understood as absorbing the child's hunger of delight into a disciplined seeing capable of renewing the energies of the adult too long buried beneath a weight of custom. The Alpine passage is particularly suggestive in this regard, since the vantage point is the same as that of Asia and Panthea in *Prometheus Unbound* immediately before they descend to the cave of Demogorgon. Asia's speech concludes as follows:

> "Hark! the rushing snow!
> The sun-awakened avalanche! whose mass,
> Thrice sifted by the storm, had gathered there
> Flake after flake, in Heaven-defying minds
> As thought by thought is piled, till some great truth
> Is loosened, and the nations echo round
> Shaken to their roots: as do the mountains now."
> [III, ii 36–42]

Ruskin's psalm begins with "the flakes of light falling every moment faster and broader among the starry spires, as the wreathed surges break and vanish above them, and the confused crests and ridges of the dark hills shorten their gray shadows upon the plain" (III, 416). Although Ruskin is more paratactic here than Shelley (the repeated "and's" imitate the psalmist's naming as well as the preacher's rhythmic regularity), in general he has learned from Shelley how to merge grammatical with visual movement: both writers connect visual ideas by strings of similes and relative clauses, and both read particular elements of an ill-defined space that continually form and dissolve, veil and reveal, recreating the experience of beholding rather than the beheld objects themselves.

The odd connection between the earnest young Evangelical and the radical freethinker with the scandalous biography goes deeper than stylistic influence and the dreamy excitedness they shared by temperament. It extends to the characteristic structure of their visionary moments. At the close of Asia's speech, her comparison of the avalanche with "Heaven-defying minds" soon yields to a vision of "thin shapes within the mist" presaging a radical transformation of the human social spirit. At the climax of his peroration Ruskin sees the heavens fill with troops of angels in vaults that remind us of the palaces of Turner's Venice ("pale ranks of motionless flame,—their mighty towers sent up to heaven like tongues of more eager fire"). Philosophically, of course, the passages are radically opposed: Shelley's natural imagery enacts the One Mind's power to refashion political and therefore phenomenal reality, whereas Ruskin's ode renders stable the "system of nature" in a reverent rather than a heaven-defying spirit. Yet Ruskin's mature aes-

thetics is closer to Shelley than to any other romantic theorist, and this early passage shows why. For both men nature is the sum of affective possibility projected outward; for both human reality *is* the farthest reach of a poet-prophet's vision; for both metaphors appear to grow out of enraptured contemplation. Nature, that is, becomes supernatural, trembling into the image of human forms and human artifacts. It is an extraordinary move so late in a book on realistic landscape, pushing as it does beyond the limits of observable nature, perhaps even beyond the limits of painting. Ruskin makes no considered claim to the superiority of poetry over visual representation, yet his mature theory, as the present passage indicates, will attempt a comprehensive exploration of metaphor in the sister arts, an exploration that is at once a grammar of figurative connections in space and time and a vocabulary drawing upon both books of revelation, Nature and the Scriptures. Already in the second volume of *Modern Painters* he set himself to that attempt.[11]

[11]Paul de Man's interpretation of such discrepancies has become an influential challenge to older interpretations of the romantic marriage of mind to nature. According to de Man, "The dialectic between subject and object does not designate the main romantic experience, but only one passing moment in a dialectic, and a negative one at that, since it represents a temptation that has to be overcome." The Coleridgean symbol represents the "negative" moment of the romantic dialectic; the positive moment is allegory, a system of signs in which the relation of a sign to signified is superseded by the relation of signifier to signifier in a temporal sequence. "Whereas the symbol postulates the possibility of an identity or identification, allegory designates primarily a distance in relation to its own origin, and, renouncing the nostalgia and the desire to coincide, it establishes its language in the void of this temporal difference" ("The Rhetoric of Temporality," in *Interpretation,* ed. Charles S. Singleton [Baltimore: John Hopkins University Press, 1969], 188, 191). I have argued that Ruskin's defense of naturalistic representation represents an extreme form of the wish to marry mind and nature, the wish that de Man calls a temptation to be overcome, and that he marries the two by supplementing romantic epistemology through an analysis of visual rather than verbal signs—signs, that is, which do in some sense resemble the objects they represent. In brief summary: deep seeing and therefore great art based on such seeing can really give access to the quidditas of things, to their "characteristic" essences and energies, because the eye takes in particulars by forming coherent wholes greater than the sum of the parts; because certain parts or signs can be recognized as particularly meaningful even by people who do not have enough experience to form constant associations; and because the eye can intuitively judge between "genuine" representations and mere copies. Signs, in other words, are synecdochic of a whole, and this character can be verified by experience; representations can therefore be objectively valid, though never complete in their account of reality. The most interesting critique of such a view is E. H. Gombrich's theory of making and matching (*Art and Illusion* [New York: Bollingen Foundation, Pantheon, 1960]), which holds that the gestalt itself rests on conventional knowledge, not on a biological predisposition. But Ruskin also implies that physical energies are manifestations of divine, that is, spiritual or "moral" energies, and this belief allows him to view landscape art as a literal incorporation of divine power. He reinforces his view by constantly referring words to pictures and pictures back to words (his books contain illustrations of the subjects he describes, and of course his readers are invited to go to the actual scenes themselves), but the theory holds good only for literal representations and requires the denial of subjective elements such as association and an independent faculty of imagination. The crux of Ruskinian aesthetics is his treatment of figurative representation; and here, as we will see, he holds that metaphors further enhance our perception of natural and spiritual powers. For the relationship of his later theory to de Man's argument, see Chapter 6, n. 10.

The Lamp of Power

And for the sublime,—if we consider what are the cares that occupy
the passing day, and how remote is the practice and the course of life
from the sources of sublimity, in the soul of Man, can it be wondered
that there is little existing preparation for a poet charged with a new
mission to extend its kingdom, and to augment and spread its
enjoyments?
—William Wordsworth, Essay Supplementary to the Preface of 1815

Ruskin's is remarkable among romantic careers by beginning
with an affirmation of Wordsworthian joy not as a child's unconscious
condition but as a condition formulated in adulthood—as an earned
position. *Modern Painters* I banishes the poor, paltry self along with its
sense of the past, even so much as a nostalgic sense, by constructing
overwhelming experiences of seeing so immediate and unselfconscious
that they are virtually preimaginative. Although, for example, Ruskin
associated Venice with Adèle, making the city a monument to the joy
and anguish of the past, the Venice of the book is a burst of Turnerian
light burning away, as it were, the "lurid, gloomy, plague-like oppres-
sion" of Canaletto and converting ships, buildings, and atmosphere
into a chain of archetypes in an eternal present. Innocence requires
forgetfulness.

In *Modern Painters* II Ruskin takes up the subject of maturity in a self-
conscious way but tries to imagine the end of life as a continuous
development from the beginning, a "philosophic calm" accruing from
no experiences of loss or catastrophic self-education. In his first book,
he says at one point, he had perhaps indulged a youthful preference
for scenery that induces "wild, impetuous, and enthusiastic" emotions,
ignoring what was "peaceful, humble, meditative, and solemn." Every
age has its season: "We must advance, as we live on, from what is
brilliant to what is pure, and from what is promised to what is fulfilled,
and from what is our strength to what is our crown" (IV, 75). The first
book had been a polemic proving that Turner could represent nature

truthfully. The second would be nothing less than a complete system of aesthetics based on the assumption of an instinct for beauty divinely implanted in the human heart. This instinct he calls the "theoretic faculty," a Greek version, so to speak, of the beatitude, "Blessed are the pure in heart; for they shall see God." For more than two hundred pages Ruskin forges his way, adopting the elevated style of Hooker and ranging all beautiful objects under two categories—"typical beauty," representing objects that manifest God's characteristic "modes of being," and "vital beauty," representing living objects that bear the appearance of a "felicitous fulfillment of function." True to his word, he tends to choose examples that are ordered and meditative rather than wild and impetuous. But as Ruskin approached the subject of vital beauty in Man, the one creature marked by a fall from its original state, he apparently put his work aside and embarked for Italy—the first and most momentous of many such journeys without his parents.[1]

In one sense he made the journey in search of maturity. As late as October 1844, Ruskin wrote a letter to Henry Liddell quoting "Tintern Abbey" to suggest that he still viewed himself as a Wordsworthian child: "I am yet as much at my ease as I was ten years ago, leading still the quiet life of mere feeling and reverie, 'That hath no need of a remoter charm / By thought supplied, or any interest / Unborrowed from the eye'"(III, 671). These are hardly the words of a man ready to will himself away from what is "brilliant" and "promised." This letter and other unpublished writings from the same years clarify the emotional and intellectual difficulties facing Ruskin as man and writer, problems that were related and would await their symbolic solution in his discovery of Italian Renaissance painting.

Romantic Italy

Ruskin's letter to Liddell sets out with striking frankness the nature of his task as he then saw it. His first book, he admits, was in the "pamphleteer" style: "There is a nasty, snappish, impatient, half-famil-

[1] On the manuscript of the first draft of *Modern Painters* II, see the introduction to Harold I. Shapiro, ed., *Ruskin in Italy* (London: Clarendon Press, 1972), to which I shall henceforth refer in text as "Shapiro." For the standard account of Ruskin's theories of beauty and the critical traditions to which they belong, see George P. Landow, *The Aesthetic and Critical Theories of John Ruskin* (Princeton: Princeton University Press, 1971), chap. 2. Landow argues that typical beauty and vital beauty derive from separate critical traditions, one neoclassical and the other emotionalist, and so form a "bifurcated aesthetic." Other writers have suggested ways of reconciling the bifurcation. I would stress that Ruskin's neoclassicism also draws heavily from Neoplatonic tradition, and perhaps from readings in Plato suggested to him by Liddell, as part of his project of defending the early Renaissance school.

iar, half-claptrap web of young-mannishness everywhere. . . . I am going to try for better things; for a serious, quiet, earnest, and simple manner, like the execution I want in art." The new book will introduce a new subject as well as a new style:

> As soon as I began to throw my positions respecting the beautiful into form, I found myself necessarily thrown on the human figure for great part of my illustrations; and at last, after having held off in fear and trembling as long as I could, I saw there was no help for it, and that it must be taken up to purpose. . . . I don't think, with my heart full of Fra Angelico, and my eyes of Titian, that I shall fall back into the pamphleteer style again.

But he adds immediately, "Don't suppose, however, with all this, that I am going to lose Turner." The chief problem he stresses is lack of knowledge: he had grown up well acquainted with "pure, wild, solitary, natural scenery" but not with "general or human knowledge"—we may assume he also means acquaintance with human affections. He then asks Liddell where he can look, in Plato or elsewhere, for a theory of imagination, presumably to help him come to terms with the luminous visions of Fra Angelico, the Bellinis, and other Old Masters he had briefly seen in Venice and Paris (III, 668–670). In this self-portrait addressed to an intellectual mentor, Ruskin presents himself as a precocious youth about to become an earnest young man: he is bound to Turner by his boyish rambles in "pure, wild, solitary" landscape, but he denigrates his defense of that painter as both vulgar and immature—a mistake he will not repeat after absorption in religious painters, which, he also implies, might ease him from the "fear and trembling" of considering the human figure. The experience that these painters provide might also bring him spiritual maturity (it would save him from the pamphleteer style) and would perhaps make good his youthful sacrifice of human experiences for knowledge of nature, but what then will become of the pleasures peculiar to the child?

Another, very different document would seem to point the way to one of the aims he expresses to Liddell—the proof that "the principles of beauty are the same in all things, that its characters are typical of the Deity, and of the relations which in a perfect state we are to hold with him." In an oft-quoted fragment composed in 1843 or 1844 and apparently intended for the new work in progress, Ruskin recalls an evening spent by the fountain of the Brevent, a stream that flows into the Arve, when he experienced the coming of darkness and storm in overtly Apocalyptic terms: "It was as if the sun had been taken away from the world, and the life of the earth were ebbing away, groan by groan." Suddenly, in the midst of blackness, the clouds part, revealing the

upper peaks bathed in the fire of sunset: "the mighty pyramids stood calmly—in the very heart of the high heaven—a celestial city with walls of amethyst and gates of gold—filled with the light and clothed with the Peace of God." Ruskin cries out in the ecstasy of complete submission to the Divine:

> It was only then that I understood that to become nothing might be to become more than Man;—how without desire—without memory—without sense even of existence—the very sense of its own lost in the perception of a mightier—the immortal soul might be held forever—impotent as a leaf—yet greater than tongue can tell—wrapt in the one contemplation of the Infinite God.

The Beautiful, Ruskin concludes, belongs only to the types of God's attributes—to anything that "can turn the human soul from gazing on itself . . . and fix the spirit—in all humility—on the types of that which is to be its food for eternity" (IV, 363–365).

The passage perfectly exemplifies the three-part movement of sublime experience as described by Thomas Weiskel: a period of intense anticipation, then an overburdening of the senses in which the relation of signifier to signified becomes indeterminate, then a return to a normal state of perception, leaving the "trace" of the experience in a metaphor[2]—with an access of power in the beholder that typically follows upon such disruption of the subject-object relationship. And just as typically for Ruskin, the metaphor intensifies the mountain by hyperbole—it becomes a City oversized and overlustrous. The prose differs from ecsatic passages in *Modern Painters* I in its infusion of Burkean fear, but in other ways it seems to form the perfect bridge between the Alpine psalm in the first book and the new interests facing Ruskin: by converting loss of self into a transfigured self, loss of time into a vision of eternity, and landscape ecstasy into symbolic vision, it sets forth in miniature the project of a comprehensive grammar of imagery for religious poetry and art and a fusion of natural and biblical typology. Finally, the haunting but unobtrusive image of the Brevent, the emblem, it would seem, of the viewer's persistent selfhood, combines with the extreme experience of weakness ("the life of the earth . . . ebbing away") to suggest that Ruskin masters through endurance of terror his own dread of spiritual diminishment through time.

But the greatest interest of this passage for us lies in the fact that Ruskin never published it. We cannot know why he did not, but strong suggestions occur in certain poems of the early 1840s in which similar

[2]Thomas Weiskel, *The Romantic Sublime* (Baltimore: Johns Hopkins University Press, 1976), 24–26.

images of solitary ecstasy appear in a radically unsatisfying light. The richest of these is "A Walk in Chamouni," possibly written in the same year as the Brevent fragment. The same imagery recurs but with an odd discontinuity, as though to suggest states of mind rather than scenes from a walking tour: we see first a bubbling brook, then a dark grove, then a gushing torrent, then the luminous aiguilles of the lower mountains, and finally, the higher peaks, rising "as pure as if the breath / Of God had called them newly into light, / Free from all stamp of sin, or shade of death." But the poem takes a surprising turn. Although the mountains are "inly bright," "Serene and universal as the night," they are "comfortless" and "cold" because removed from humanity—"passionless and pure, but all unblest":

> Corruption—must it root the brightest birth?
> And is the life that bears its fruitage best,
> One neither of supremacy nor rest?

The dilemma is unmitigated: supremacy and rest belong only to the mountains, but life and gladness only to the earth. A subtler contradiction is suggested in the poem's oxymoronic imagery of time: old trees covered with white moss, for example, are "interwoven signs / Of dateless age and deathless infancy," and more startlingly, the "azure arch" from which springs the Arveron creates a moaning like the "angels' wail" after the Expulsion (II, 222–226). Purity and corruption, freshness and mourning, infancy and age, are oddly conjoined—timelessly in the glade, painfully in the torrent and mountain—in natural images that appear as emblems of the poet's own mixed state. Another poem, though of less interest, deepens these contradictions. In "The Arve at Cluse," Ruskin compares himself to a river "proud, / Impatient, and pollute" that has forgotten in "unhallowed rage" the pureness of its "mountain parentage"; for he, like the river, was born near Heaven yet has lost his "heritage of peace." The prayer is for a new baptism through seeing, a receiving of

> The radiance of that world where all is stilled
> In worship, and the sacred mountains build
> Their brightness of stability in Heaven.

The remaining paradox, however, occurs in the lines, "I would not see / Thy force less fatal, or thy path less free" (II, 236). In these and other examples, a lower world of vice, wrath, or agitated energy is pitted against an upper world of purity, serenity, and motionless strength, usually associated with a source or a fresh birth.[3]

[3]The best discussion of Ruskin's poetry that I have found is Wendell Stacy Johnson, "Memory, Landscape, Love: John Ruskin's Poetry and Poetic Criticism," *Victorian Poetry* 19 (1981), 19–34.

Such are the conflicts Ruskin brought with him on the Italian journey of 1845, a journey planned for purely scholarly purposes but which eventually confirmed him in a vocation that was at first still undefined. As his editors correctly note, he had not yet given up poetry or painting; but he had at least a tentative spiritual model in mind when he departed. The model was Herbert, as we know from an incident confirming that Ruskin had no intentions of abandoning his youthful religiosity before Italian sensuality. In a letter to his mother from Switzerland, he attacks the volume she put in his satchel (Bunyan's *Grace Abounding to the Chief of Sinners*) because the author's "morbid fancies" amount at times to "pure insanity"—in marked contrast, he observes, to Herbert: "There is as much difference between the writings & feelings of the two men as between the high bred, keen, severe, thoughtful countenance of the one—and the fat, vacant, vulgar, boy's *face* of the other." And in a later letter he calls Bunyan's book dangerous, partly because "to people of a turn of mind like mine, but who have less stability of opinion, it would at once suggest the idea of all religion being nothing more than a particular phase of indigestion coupled with a good imagination & bad conscience"; Herbert, on the contrary, is "full of faith & love, regardless of himself, outpouring his affection in all circumstances & at all times, and never *fearing*, though often weeping" (Shapiro, 17–18, 33–34). Here Ruskin excoriates part of his own negative identity (and perhaps the "morbidity" he had suffered as a result of Adèle), taking the part of the Anglican gentleman against the Puritan tradesman, attacking his mother's religion while flattering her class prejudices, and repeating in religious terms his parents' own class ambitions. Most important, Ruskin has begun to distinguish his internalized ideals from his parents', at least from his mother's. We can hardly exaggerate his need at this time for a sense of steadiness and purity of mind and for a gentility of manner to match his gentility of privilege: what sounds like the making of a young prig is also an attempt to overcome his own "snappish young-mannishness." Yet he displayed a great deal of morbidity and snappishness during the disturbing months that followed.

While fortifying himself with Herbertian asceticism and self-control, Ruskin soon discovered in Italy, after a few hesitations, sensuous rapture, an experience that mingled beauty and religious devotion similar to that which he had known in the mountains but now charged with human meaning. In Lucca, for example, was God's plenty: the jeweled facade of San Michele, the burning hills of Carrara and olive woods and vineyards, the dying flush of twilight off the eyes of Ilaria di Caretto in her eternal trance of repose, the candles burning in shrines to the Madonna, the clearness of the sky "something miraculous. No romance can be too high flown for it—it passes fable." On Sundays he could choose between the music of the mass and the military bands,

sometimes blending ("everything comes on me like music"). In Pistoia he first mentions fireflies, mysteriously emblematic of all natural sanctity: "[They] flash, as you know, exactly like stars on the sea, and the impression to the eye is as if one were walking on water." Everywhere the spiritual seemed vivified in the senses, the senses made glorious in the spiritual. In Florence the Franciscans kept the best spice cellar in the city and managed also to combine work and worship. He spent a day reaping hay with them on the mount of Fiesole, then descended, once again, amid the gathering of fireflies in the dusk. But most remarkable in these early months of the tour were the frescoes in Lucca and in the Campo Santo of Pisa, whose images Ruskin experienced like living and actual presences: "I never believed the patriarchal history before, but I do now, for I have seen it. . . . one comes away, like the women from the Sepulchre, 'having seen a vision of angels which said that he was Alive.'" In Benozzo Gozzoli's fresco in Pisa, three angels hover over Abram departing from Sodom, who "turns away, with his hands folded in entire faith & resignation, but with such a quivering distress about the lips and appeal for pity in the eye, that I have had the tears in mine over & over again while I was drawing it." A similar subject was the conversion of St. Ranieri: the saint is watching a circle of dancing maidens when the angel appears, and he accepts the sign— "ungentlemanly in the extreme," Ruskin remarks half-jokingly (Shapiro, 55, 60, 85, 67–68, 65). There is no wonder that these subjects in particular—a renunciation of the past for the future, and of the flesh for a spiritual calling—should have affected him so strongly.

But almost from the start, Ruskin's experience of human beings in Italy was as disturbing as his experience of art was exalting. In Lucca he saw a beggar drinking water from a font while at the same time the beggar's dog made water at the base of the font, prompting Ruskin to tell his father, "I cannot make up my mind whether the poetry or prose of life be its humbug, whether, seeing truly, there be most to feel, or most to laugh at [The scene] was a perfect epitome of Italy as she *is*. One hardly knows which hath upper hand in her, saint—beggar— or beast" (Shapiro, 57–58). What begins as traveler's annoyances such as weather and delays and jostling crowds builds into hysteria aimed chiefly at the restorers. Driven by a misguided hunger for "improvements," these people tear down old stonework, cover up frescoes with plaster, throw up gaslamps and interlace old cities with railroad bridges. The pitch and insistence of Ruskin's rage create the vision of an entire nation pillaging its past, destroying all it has of beauty and power and spirit. Italy, in short, is the picture of human time since the Fall.

It is also the image of Ruskin's own fear of losing the past, that is, the power of feeling, a fear repressed by his resolutions of religious ear-

nestness. He partly recognized this emotion is a letter to his father from Parma. John James (whose favorite authors were Byron and Scott) had complained that his son's latest verses lacked "the fervour & fury & passion of true poetry"; Ruskin responds that he is not surprised but "I do not think I have lost power. I have only lost the exciting circumstances. The life I lead is far too comfortable & regular, too luxurious, too hardening. I see nothing of human life, but waiters, doganiere—& beggars. I . . . am subject to *no* species of excitement except that arising from art, which I conceive to be too abstract in its nature to become productive of poetry unless combined with experience of living passion." And so he has ended up "treating all distress more as picturesque than as real. . . . Yesterday, I came on a poor little child lying flat on the pavement in Bologna—sleeping like a corpse—possibly from too little food. I pulled up immediately—not in pity, but in *delight* at the folds of its poor little ragged chemise over the thin bosom." As for poetry, "if I were again under such morbid excitement, I might write as strongly. . . . I believe however the time for it has past." And so, apparently, has the time for enjoying Italy: "All the romance of it is gone, and nothing that I see ever makes me forget that I am in the 19th century" (Shapiro, 142–143). The unconvincing incident of the sleeping child presumably shows that Ruskin has lost the power of charity and, more obscurely, the power of erotic excitement, which he must divert by sketching. Covertly, he reenacts the emotional repression following the loss of Adèle, the woman his father had forbidden him to marry, this time blaming the loss of the heart's affections on luxury and the habits of the critical intellect.

His aim at the present, he writes in another letter, is to preserve, in words and sketches, the beauty now vanishing beneath the chisels and plaster of the restorers. Then, surprisingly enough, he claims that he is unable even to enjoy a distant sight of the Appenines because they are not already familiar to him. In late July he acts out this second disillusionment in a series of letters from Alpine towns, which he visited in order to escape his anger and disgust with the cities of the plain and to do sketches for the Turner part of his book. "Here I am at last in my *own* country," he writes from the secluded and nearly inaccessible village of Macugnaga; it is "a perfect Paradise for *feeling*," the "realization of all my childs [*sic*] ideas of felicity." Yet even Macugnaga fails him as he realizes it is childhood and not a particular place that he longs for— "the charm of early association, the home feeling that I have at Chamonix . . . for however childhood may suffer, it is a period of entire trust, hope, & insouciance, approaching nearer to a state of perfect felicity than any other of life. . . . I feel life going. . . . Life seems infinite to the child, and what he chooses not to do today he hopes to do tomorrow. Probably he does more, according to his strength, in this

way, than the *man,* who measures his time" (Shapiro, 160, 159, 161, 163). Once again he asserts his devotion to Turner and the pure, high pursuit of natural fact—at the same time, significantly, taking up the study of Italian history.

Most of the emotional dialectic that determined the course of Ruskin's career is now in place. The exaltation of "life," the original and pure energy of being whose source is childhood, is weakened by ambivalent and agitated emotion, by the awareness of suffering and poverty and loss, by repression through mental labor, by the approach of death; but to remain in childhood is to cling to a dream valley whose timeless ease and solitude will also weaken the primal energy, which requires human love as well as the love of stones. Ruskin needed a conception of spiritual energy strong enough to embrace the entire human experience, including suffering and loss and the braving of death—and he sought it in a theory of imagination that would explain the function of the human subject in art. Ruskin's last stop in Italy was Venice, the city he had associated with his lost love. He found Venice, as he expected, a sacrifice to decay, depredations, and railroads, but he also found what he had perhaps unconsciously been hoping for all along:

> I never was so utterly crushed to the earth before by any human intellect as I was today, before Tintoret. . . . he lashes out like a leviathan, and heaven and earth come together. . . . And such a resurrection as there is— the rocks of the sepulchre crashed all to pieces & roaring down upon you, while the Christ soars forth into a torrent of angels, whirled up into heaven till you are lost ten times over. [Shapiro, 211–212]

From Turner to Tintoretto is but a small step: "Fresh from the stormy grandeur of the St. Gothard, he found the lurid skies and looming giants of the Visitation, or the Baptism, or the Crucifixion, re-echoing the subjects of Turner as 'deep answering to deep.' "[4] The torrential energies are the same, except that the signs of them have changed. Ruskin of course already knew the giant forms of Michelangelo. The overwhelming response to Tintoretto depended on the precise moment in his mental history and on his claim to a personal discovery (confirmed, one assumes, by the parallel response of J. D. Harding, the painter, who accompanied him to Venice)—but it depended on formal qualities as well. Comparing Tintoretto's *Judgment* with Michelangelo's, Ruskin wrote his father that even Michelangelo "cannot hurl figures into space as he does, nor did M Angelo ever paint space itself which would not look like a nutshell besides Tintoret's"; and in his notebook he wrote that, in Tintoretto but not in the older

[4]R. G. Collingwood, *The Life and Work of John Ruskin* (London, 1893), quoted in IV, xlv.

painters, "no *emotions* are represented, nothing but the great *sensation* of re-awakened life," and that the scene, instead of being general or typical, is a definite "spot of earth" (IV, xxxvi). These baroque elements Tintoretto shares with the landscape sublime but not with Michelangelo. Leaving his background indefinite, Michelangelo achieves a statuesque energy in respose, removed from a particular moment or place; Tintoretto sacrifices serenity for a tumultuous immediacy made possible because space and therefore time becomes itself an expressive element. The skewed angels, extreme closeups, exaggerated chiaroscuro, and forms that soar and tumble completely undermine the stability of Renaissance perspective space (as Turner's vortical compositions destroy the focal point), with the result that space, instead of existing "outside" the artist's imagination, becomes the expression of a mental energy that is almost physical.

For Ruskin and Harding, to behold such an art was to experience sublime annihilation: "Harding said that if he had been a figure painter, he never could have touched a brush again, and that he felt more like a flogged schoolboy than a man—and no wonder." But the next day Ruskin wrote his father that studying the painter again "made me feel bigger—taken up into him as it were. I am in a great hurry now to try my hand at painting a real, downright, big oil picture" (Shaprio, 212–213). Ruskin's memory of the experience, printed as an addendum to the 1883 edition of *Modern Painters* II, is slightly different: "I, not having been at school so long as [Harding], felt only that a new world was opened to me, that I had seen that day the Art of Man in its full majesty for the first time; and that there was also a strange and precious gift in myself enabling me to recognize it, and therein ennobling, not crushing me. That sense of my own gift and function as an interpreter strengthed as I grew older" (IV, 354). The letters are typical of the young Ruskin, still wishing to emulate every genius he encounters, while the memoir is typical of the elder Ruskin, disclaiming with unconscious egotism the young man's ambition. But the memory is undoubtedly correct in spirit: after months of copying the great painters and feeling his relative inadequacy, he eventually accepted a new relationship based not on competition but on difference—his special gift as an interpreter. As he wrote in *Modern Painters* II, "The Love of the human race is increased by their individual differences, and the Unity of the creature . . . made perfect by each having something to bestow and to receive . . . , humility in each rejoicing to admire in his fellow that which he finds not in himself, and each being in some respect the complement of his race" (IV, 183). His complete response to Tintoretto, then, parallels the experience at the fount of the Brevent: a sudden revelation, a temporary annihilation, then a return of selfhood strengthened and clarified, with the fountain itself corresponding to

the "precious gift." The original energy has not been lost. But never again would Ruskin repudiate all beauty mingled with "associations of humanity—the exertion of human power—the action of human mind."

"The Soul's Metropolis"

In the "Essay Supplementary" to the Preface of 1815, Wordsworth described the task of great poetry in his time as extending into regions of sublimity unexplored before, and he described also the audience, fit though few, capable of following him—a group who, "never having suffered their youthful love of poetry to remit much of its force, have applied to the consideration of the laws of this art the best power of their understandings." These readers, if not already misguided, may acquire a new taste conferred upon them by the great and original poet, taste being itself a "power, of which knowledge is the effect."[5] Ruskin may have found in this essay the confirmation and perhaps also the literary model of his experience with Tintoretto. He had begun *Modern Painters* II by trumpeting other themes from Wordsworth in tones loud enough to set the teeth on edge. The opening blast is an Evangelical attack on an effeminate nation sunk in corrupt uses of pleasure, ignorant of the sublime kingdom of God's domain without. The times are Babylonian: "The Nebuchadnezzar curse, that sends men to grass like oxen, seems to follow but too closely on the excess or continuance of national power and peace" (IV, 30). His aim, on the other hand, is "to summon the moral energies of a nation to a forgotten duty, to display the use, force, and function of a great body of neglected sympathies and desires" (IV, 28). Every gesture here is conventional, particularly the attack on mechanism, although Ruskin manages at least one startling image: the railroads, a synecdoche for the war of commerce against nature, he compares to a "great net. . .drawing and twitching the ancient frame and strength together, contracting all its various life, its rocky arms and rural heart, into a narrow, finite, calculating metropolis of manufactures" (IV, 30–31). This self-strangling, an active counterpart to the soul's sleep, contributes to a social portrait that is doubly paradoxical: the soul of the nation is both overfed and famished, at once softening into luxury and contracting into iron. Ruskin will deepen these paradoxes by 1860 into a profound critique of the English soul under industrialism, but here they seem shrill and irrelevant, particularly in the context of the hungry forties;

[5]William Wordsworth, *Prose Works*, ed. W. J. B. Owen and Jane W. Smyser, 3 vols. (Oxford: Oxford University Press, 1974), III, 66, 82.

and yet they certainly reflect the condition of Ruskin's own soul as he described it in Italy ("I do not think I have lost power. . . .The life I lead is far too comfortable and regular, too luxurious, too hardening"). When he returned from Italy, he took up again the defense of the "neglected sympathies and desires," this time in terms not of the landscape sublime but of the human sublime represented by Tintoretto and the powers he calls forth in his viewers.

The theory of imagination that dominates the second half of *Modern Painters* ii divides hydralike into three heads, with their complementary forms of fancy: imagination associative, which brings particulars together into an organic composition; imagination penetrative, which grasps the indwelling principles of things as an organic unity; and imagination contemplative, which embodies indistinct ideas in distinct form in the manner of reverie and which is somewhat unclearly related to mystical vision. These heads look stable at first but quickly dissolve into associative clusters, by which Ruskin tried to join his recent readings in Wordsworth and Leigh Hunt with examples from Italian painting; the result is the kind of rich confusion that was to become characteristic of him, a confusion he calls in one passage an "undercurrent of meaning" which, when traced carefully, discloses an emotional rather than an intellectual unity. The details of Ruskin's theoretical exposition will not detain us; our concern will be with the undercurrent of meaning in the section on penetrative imagination, where the experience of Tintoretto bears its richest fruit.

Ruskin spoke of the imagination as an intuitive grasp or *Anschauung* of the essence of an object, a going out from the self that leaves its trace in metaphors, visual or verbal.[6] In a letter from Milan, Ruskin had

[6]Ruskin's three-headed theory of imagination has been called conservative, since it revives the preromantic view of imagination as a picture-making faculty. His visual bias is probably inevitable, considering his training as an art critic, but it is also necessary if, as I have suggested, Ruskin's project is to construct a comprehensive grammar of visual and poetic imagery. His procedure is clumsy and confusing, but the following overview briefly outlines his attempt. For Ruskin, the poet may present things all at once or may suggest them by the accumulation of images. The first case is simply pathetic fallacy (for example, "the rathe primrose, that forsaken dies"), which seems to prove that the penetrative imagination grasps the "inmost soul" of, for example, a flower. The additive examples are poetic descriptions of lips (some borrowed from Leigh Hunt's treatise), beginning with a direct description and ending with Hamlet's address to the lipless skull of Yorick: "Here hung those lips that I have kissed, I know not how oft. Where be your gibes now, your gambols, your songs, your flashes of merriment that were wont to set the table on a roar?" "There," Ruskin remarks, "is the essence of lip" (iv, 255). There, one wants to interpose, is the essence of loss—which is also one of the "undercurrents" of the book. The point is to overturn a theory of beauty based on mere association by a description of the imaginative act as a penetration to the essence of something, leaving associations afterward as a residue of integrated surface features, something like Coleridge's doctrine of expanded metaphor. For Ruskin on the imagination, see also W. David Shaw, "'The Very Central Fiery Heart': Ruskin's Theories of the Imagination," *Journal of English and Germanic Philology* 80 (1981), 199–255 (on *Modern Painters* ii); Robert

drawn for his father four sketches of hailstones, showing how one flowerlike stone revealed "its beautiful internal structure" through stages of melting and how a second stone was really two fused fragments growing from a white crescent and circle that formed its "root" (Shapiro, 150). The hailstone may symbolize for us the object of the penetrative imagination, whose activity Ruskin describes in an uncontrolled stream of metaphor: it "ploughs aside" "crusts or ashes, or outward images of any kind," "plunges to the very central fiery heart . . . , gets within all fence, cuts down to the root, drinks the very vital sap of that it deals with"; it is a "piercing, pholas-like mind's tongue, that works and tastes into the very rock heart"; and so forth (IV, 250–251). The mind here is the ravisher, not God; having so drunk, the artist achieves a steadiness that transcends both agitation and passionlessness: "At the heart of things [the imagination] poises herself there, and is still, quiet, and brooding, comprehending all around her with her fixed look" (IV, 258).

The referent of these extravagant metaphors, as Ruskin made clear in a footnote of 1883, is the delineation of a hero's *mind*. The metaphors, in other words, transfer to the "art of man" the destruction of the subject-object relationship in sublime seeing and the reformation of the artist's identity in the "shape" of his creation. The most clotted passage in this exposition is for our purposes the central one. The imagination, Ruskin writes, is

> the Open Sesame of a huge, obscure, endless cave, with inexhaustible treasure of pure gold scattered in it; the wandering about and gathering the pieces may be left to any of us, all can accomplish that; but the first opening of that invisible door in the rock is of the imagination only. [In] every word set down by the imaginative mind [is] an awful under-current of meaning. . . . if we choose to dwell upon it and trace it, it will lead us always securely back to that metropolis of the soul's dominion from which we may follow out all the ways and tracks to its farthest coasts. [IV, 252]

In this kaleidoscopic cluster (the rocky cave, depths, undercurrent, and metropolis all seem to recall "Kubla Khan," a favorite poem of Ruskin's), the cave door seems to suggest the viewer's first rapture of discovery, the country of the secure wisdom that follows upon tracing

Hewison, *John Ruskin: The Argument of the Eye* (Princeton: Princeton University Press, 1976), chap. 4; and Elizabeth Helsinger, *Ruskin and the Art of the Beholder* (Cambridge: Harvard University Press, 1982), chap. 3. Shaw interestingly finds an epistemology corresponding to Ruskin's in John Grote's *Exploratio Philosophica*. Grote calls "attention" a way of conceiving entities as simultaneously natural and symbolic. Ruskin's conversion of "the mere seeing of a visual impression of sensation into a more enduring and mastered idea of sensation"—the process I have called "deep seeing"—is the visual analogue of Grote's faculty of attention (p. 219).

the ramifications of meaning (the "word" meanwhile dissolves and metamorphoses into an "undercurrent" that may be traced); the cave imagery then reverses itself, and the viewer occupies a "soul's metropolis" from which he or she may safely voyage to regions opened up by the pioneering artist.

What would such an art look like? Ruskin's chief instances are his well-known inconographic readings of Tintoretto, with their sudden symbolic juxtapositions (as in the *Crucifixion*, which depicts an ass eating withered palm-leaves), and Turner's *Jason*, in which only a few coils of the serpent are disclosed. In each case the painter induces "occult and far-sought sympathies in every minor detail" (IV, 262), a sudden apprehension of supernatural Presence that roils, as it were, like Leviathan, at the outermost edges of our seeing. In such cases, "the mind of the beholder is forced to act in a certain mode, and feels itself overpowered and borne away by that of the painter, and not able to defend itself, nor go which way it will"; but that response is not possible except to "a mind of some corresponding power" (IV, 259–262). The idiom of this last phrase is Wordsworthian (the parallel expressions in the "Essay" are "a co-operating power" and "a corresponding energy"), but the experience described throughout the section on Imagination Penetrative is no longer the sweet surrender and self-forgetful exaltation of the romantic sublime. As in *Modern Painters* I, the aesthetic transaction is immediate and intense, but the imagery of the theoretical exposition, like the embedded examples, draws upon the charged and violent oppositions of Tintoretto's baroque: subject, artist, and viewer present themselves through verbs of entering, devouring, and fusing, of being cast down and lifted up again. In short, Ruskin achieves his chief theoretical aim—the justification of an "art of man"—by transferring the structure of the Burkean sublime, along with much of the imagery of wild, desolate, and savage landscapes, to representations of the human soul "fearfully and wonderfully made," and this solution answers an emotional need as well as an intellectual problem. For the dominant spatial configuration of Ruskin's text is not the open skies and vistas of his first book but an enclosed space which, when entered, becomes infinite—the Mind of Man, which Wordsworth called in the Prospectus to *The Recluse* "my haunt, and the main region of my song."

The "shape" of a sufficient selfhood, which was the true object of Ruskin's travels in Italy, emerges most clearly in the climactic exposition of Michelangelo. Ruskin writes: "Mino stopped at the human nature; he saw the soul, but not the ghostly presences about it; it was reserved for Michel Angelo to pierce deeper yet, and to see the indwelling angels. No man's soul is alone; Laocöon or Tobit, the serpent has it by the heart or the angel by the hand . . . that bodily form with Buonarotti . . . is invariably felt as the instrument or the habitation of

some infinite, invisible power." The hailstones of Milan here become
the human body with its angelic center by way of the unsculptured rock
that for Michelangelo (as Ruskin notes) already contains the soul that
"governs" the body of its chiseled surface. The angels, interestingly,
are both the souls of particular bodies—"some infinite, invisible
power" that inhabits the flesh (just as an indistinct energy inhibits a
concrete shape in metaphor)—and external presences, connecting the
soul with a community by means of guidance or temptation. But the
interfusion of human and spiritual also has a temporal dimension. The
prophets and sibyls of the Sistine ceiling all gaze at the Last Judgment,
"silent, foreseeing, faithful," and so are caught by that gaze between a
mortal and an immortal state, but Ruskin evokes the moment of resur-
rection most forcefully by juxtaposing the four allegorical statues in the
Laurentian Chapel: "ineffable types, not of darkness nor of day—not
of morning nor of evening, but of the departure and the resurrection,
the twilight and the dawn of the souls of men" (IV, 280–282). Like the
stunning fusions of Tintoretto's paintings of Christ, which juxtapose
birth and burial, baptism and crucifixion, victory and agony, Ruskin's
reading of the Laurentian figures fuses the comings and going of all
human life. By this point, his hurried glimpses of Renaissance masters
push his argument beyond the range of aesthetic theory toward re-
ligious vision, a visual oxymoron by which the mixed state of human
life is mastered by transcendent hope. (That mastery is probably the
aim, obscurely, of the temporal juxtapositions in "A Walk in Cham-
ouni.") This is also the strength of the angelic center, the soul that
knows it is never alone.

These pages provide in effect a corollary in the visual arts to Words-
worth's statement in the "Essay Supplementary" that great poetry pro-
duces an "accord of sublimated humanity, which is at once a history of
the remote past and a prophetic enunciation of the remotest future."[7] I
have suggested that Ruskin drew from this essay a confirmation of his
own vocation, both as critic and evangelist of art, by recognizing in
himself a "power" continuous with the original energy of youth—in
this sense Wordsworth taught him, as he taught so many others, to feel.
Details from Ruskin's theory of metaphor suggest that he also bor-
rowed from a related Wordsworthian text, the Preface of 1815. There
Wordsworth gives as an example of the abstracting and modifying
power of imagination his own poem, "The Old Cumberland Beggar":
"The stone," he writes, "is endowed with something of the power of life
to approximate it to the sea-beast, and the sea-beast stripped of some of
its vital qualities to assimilate it to the stone."[8] At the confluence of the

[7]Wordsworth, "Essay Supplementary," *Prose Works*, III, 66.
[8]Wordsworth, Preface of 1815, *Prose Works*, III, 33.

human and the natural rises, for Wordsworth, this particular figure of aged and devastated endurance. It is a dramatic instance of what M. H. Abrams has called Wordsworth's wish to produce "an egalitarian revolution of the spirit . . . so that . . . [his upper-class readers] may share his revelation of the equivalence of the souls, the heroic dimensions of common life, and the grandeur of the ordinary and the trivial in Nature."[9] But to Ruskin in the 1840s such a reading of Wordsworth could have made sense only if translated into conventional expressions of charity and humility. Characteristically, his own example of the abstracting and modifying imagination is a heroic figure from Milton: "Satan endowed with godlike strength and endurance in that mighty line, 'Like Teneriff or Atlas, unremoved'" (IV, 292). Ruskin's religion taught him that felicity had been forfeited with the Fall, but the competing religion to which he gave prior allegiance, the religion of romance, taught him to seek evidences of the first estate in a sensuous ideal—a pursuit that committed him, in Italy at least, to extremes of ecstasy and disillusionment, since his overwhelmingly picturesque viewing of life excluded the actual and the ordinary as an interesting category. "As for the beauty of the inhabitants," he wrote from Macugnaga, his "Rasselas-valley," "poverty & labo[ur] set the same marks pretty fairly all over the world, & I hav'nt yet found the place where the 'village maidens' dress in satin, or the peasants in fancy jackets & conical hats" (Shapiro, 163). The note of self-irony is rueful nevertheless. But to experience the Cumberland beggar as neither a picturesque ornament nor an object of pity, rather to "confer being" on him, as Wordsworth does[10]—that is, as a fierce and tragic acceptance of human destiny—is precisely to face the mortality that the romantic dream is designed to avoid.

It would be too much, of course, to expect such an acceptance from a young man brought up as Ruskin was, inexperienced, overprotected, and educated in a vulgar snobbery and a sanctimonious piety; nor can we expect of *Modern Painters* II what Ruskin expected of it in the ache of his ambition at twenty-six years—a mature and coherent aesthetic theory. What that book presents is not intellectual or emotional maturity but a terrible need for love laboring to overcome a terrible fear of humans and a precociously acute response to art laboring to overcome an aesthetic detachment from experience by an intense communion with the symbols of art. These symbols, he believed, could provide the equivalent of spiritual experience because they summoned up within

[9]M. H. Abrams, "English Romanticism and the Spirit of the Age," in *Romanticism and Consciousness*, ed. Harold Bloom (New York: W. W. Norton, 1970), 117.

[10]The phrase appears in Lionel Trilling's "Wordsworth and the Iron Time," in *Wordsworth: A Collection of Critical Essays*, ed. M. H. Abrams (Englewood Cliffs: Prentice-Hall, 1972).

him an imperishable corresponding power. The images of "sublimated humanity" he discovered in Tintoretto and Michelangelo, the images even of death and suffering and sacrifice, transcend ordinary humanity as surely as the romantic dream evades it, yet they point the way to the remarkable moral and intellectual development of the decade to come. The assurance of redemption depends upon the assurance of spiritual power—the angelic presence within the body and accompanying the body; and from that strength follows an acceptance of growth and change, the exaltation of the humble, and the courage to confront death and loss.

Ruskin believed that in Venice in 1845 he accepted his mission as an interpreter. In fact he not only accepted that vocation; he had already transformed it. Historically, we can understand the emergence of Ruskinian art criticism as part of a general shift in English nonfiction prose that G. Robert Stange has called the shift from cognitive to expressionist writing.[11] We can also understand it as a response to a new audience, the now-dominant urban middle class hungry for culture and guidance, with means to buy and travel. That class, consequently, brought about a revolution in the older relationship between artist and audience, partly because of its demand for reproductions. Photography played a crucial role in broadening the dispersion of culture. The new invention served Ruskin well in Venice when he needed records of architectural details, just as engravings, which are also reproduced mechanically, served him well as a complement to his own text—and so did the *Liber Studiorum* itself. This collection of engravings from Turner, supervised by the artist as a means to reach a vast popular audience, strikingly illustrates the development described by Walter Benjamin in "The Work of Art in the Age of Mechanical Reproduction." The relevance of this famous essay to an understanding of Ruskin lies in a pair of oppositions: the contradiction between the widespread use of reproduction made possible by an advanced capitalist mode of distribution and what Benjamin calls the "aura" of a work of art, its "authenticity" deriving from "its presence in time and space, its unique existence at the place where it happens to be"; and a corresponding contradiction between the "appearance value" of a work and its "cult value," or in historical terms, the evolution of art from a religious object protected and even concealed by a priestly class to the extreme opposite, the sacrifice of that unique subject to a demand for mechanical reproductions. That sacrifice is for Benjamin a good thing, for it also overthrows an attachment to tradition and authority and to

[11]G. Robert Stange, "Art Criticism as a Prose Genre," in *The Art of Victorian Prose*, ed. George Levine and William Madden (New York: Oxford University Press, 1968), 50.

such related concepts as "creativity and genius, eternal value and mystery."[12]

The values Benjamin relegates to the old order are precisely the values Ruskin struggled to defend, yet Benjamin's conceptual oppositions illuminate a deep ambiguity in Ruskin's apostolic role as mediator between artist and audience. His own interpretations are a form of reproduction, substituting for the original object an experience that recurs with each act of reading, perhaps in one's own living room, a reproduction that may very likely outlast the object itself. Ruskin's method further violates the "aura" of individual works by subsuming them under general categories, such as "Truth of Skies," or by considering the complete works of Turner as a single disconnected commentary on the Book of Nature. The sublime genius is himself but an interpreter, great to the extent that he reveals a glory greater than his own. Yet the paradox of the genius at once exalted and erased simply exemplifies the larger paradox of Ruskin's own interpretations. For behind the verbal reproductions lies the sacred object, or at least its memory, which keeps the act of reading Ruskin incomplete and open-ended. The mediator is both the familiar guide near at hand and the voyager from afar. In the first volume, Turner is alive and well in London, but the Alps remain the cult objects, difficult of access yet not beyond the reach of a traveling audience; in the second volume the paintings themselves resemble cult objects in the special sense that they are little known, hard to find, and out of fashion. Insofar as the interpretation is a version and never a complete likeness, it cannot wholly usurp the aura of the object. Thus the new art criticism affirms both cult value and appearance value, sanctifying the aesthetic object by rendering it homage yet tending also to displace it as an alternative expression, in a different medium, of an ultimate object of representation. This is the logos itself, the infinity of divine energy and human spirituality, whose manifestations must be at once rare and available to all.

Culture, the totality of all representations, is therefore both hierarchical and dispersible, just as Ruskin is himself both an evangelist of art and its specialized "priest." The experience of great art and of the natural sublime is on the one hand part of the human birthright, yet it must not on the other hand become too frequent, or art and nature would lose their aura or "novelty." Moreover, certain works of art—buildings in particular—are a social and not only an individual expression, so that their meaning depends precisely on their authenticity, their power to embody tradition and cultural authority. For both Rus-

[12]Walter Benjamin, "The Work of Art in the Age of Mechanical Reproduction," in *Illuminations*, ed. Hannah Arendt (New York: Schocken Books, 1969), 218–220, 221. See also Helsinger's discussion of Benjamin in *Ruskin and the Art of the Beholder*, 138.

kin and Benjamin (rightly for one, wrongly for the other), sanctity reinforces adherence to the forms and structure of a conservative hierarchy. The paradoxes that Ruskin challenges a modern reader to face, in the phase of his career that we trace next, are, first, that the symbols sanctifying the authority of the past also embody the forms of radical social renewal and, second, that the remembrance that binds us to obedience binds us also to a reverence for all the works of human hands, visible signs of that great community of the living and the dead in the love of which alone we can find meaning in our own separate lives.

PART II /

THE LEGEND
OF TIME

4 /

The Lamp of Love

The generations of men run on in the
tide of Time
But leave their destined lineaments
permanent forever & ever.
—William Blake, *Milton*

Modern Painters I abolishes art history and proposes aesthetic experience as a way of transcending time. *The Stones of Venice,* begun only seven years later, conceives of art in historical terms and history in terms of ineluctable loss. This shift exemplifies the more general distinction that Gerald Bruns has made between romantic and Victorian thinking—the distinction between "a synchronic world of systematic relations" and "a diachronic world of processes and events."[1] In this transition *Modern Painters* II does not quite belong to either world. The Christian revelation as Ruskin reads it in Renaissance art is a revelation of timeless truth, since the events represented in that art exist in time yet are typical or emblematic and so are not parts of an historical process. Nor does he discuss the history of style—the Italian painters seem to exist (as the letters from Italy show) in a separate imaginative and spiritual dimension from the present, in a mythological rather than a historical past.

Yet the same letters show that time, both personal and historical, was Ruskin's major, indeed his obsessive, preoccupation during his months away from home: we have seen him studying Sismondi, mourning the

[1]Gerald Bruns, "The Formal Nature of Victorian Thinking," *PMLA* 90 (1975), 905. For Bruns, Ruskin's shift in interest from nature to culture between 1846 and 1851 mirrors the shift in his own thought from romantic art criticism to the "more typically Victorian habit of regarding art in relation to the period of its making." In *The Seven Lamps of Architecture,* Bruns argues, history itself becomes a source of meaning: "any phenomenon that possesses history possesses on that account a power of signification which it is the business of the historian to actualize" (p. 915). Bruns does not discuss Ruskin's interest in memory and biblical history as it develops in *Modern Painters* II, a conception of time that I take to be still romantic in Bruns's terms.

loss of childhood, and watching the daily deterioration of Italy's natural and human heritage. His passion for landscape in some sense obliterated the sufferings associated with human losses. Wendell Stacy Johnson has shown, for example, that in the poems about Adèle, natural imagery appears to relieve the pain of sexual conflict,[2] and something of the same purpose no doubt underlay Ruskin's advocacy, in the letter to Liddell, of painters who "excite the passions little and have no historical effect;—no carrying back into past time" (III, 676). But to remember is also to do the work of mourning in the sweetly painful experience of having and not having. In the diary he divided into Intellect and Feeling, for example, Ruskin occasionally mentioned Adèle in the first part (which he did not destroy) when a significant anniversary arrived, and so he dealt with her memory partly by suppression, partly by ritualizing. The theme of nostalgic memory makes its way into *Modern Painters* II in the section on contemplative imagination: "There is an unfailing charm in the memory and anticipation of things beautiful, more sunny and spiritual than attaches to their presence; for with their presence it is possible to be sated, and even wearied, but with the imagination of them never; in so far that it needs some self discipline to prevent the mind from falling into a morbid condition of dissatisfaction with all that it immediately possesses and continual longing for things absent" (IV, 289). "Beautiful" and "imagination" signal the relationship between the emotional and the theoretical issues. The imagination is the capacity for seeing what is not present, yet Ruskin also defines it as a "mode of regard" that "colours" what it so carefully contemplates. That coloring is presumably not the same as the "added" charm of remembered association. Earlier, Ruskin had insisted on the objective character of beauty wholly separate from mere personal or subjective fancies, and to do so he had invented the theoretic faculty. His difficulty appears in a letter he wrote his friend Henry Acland: "All this while, I am not denying the power—the great power—of association. It is twenty times more powerful than beauty, but it is *not* beauty" (XXXVI, 59).

To love both landscape art and human art, therefore, means for Ruskin to resolve the contradictions between inherent beauty and the pleasures of association, and between escape from time into transcendent realities and the immersion in time with its human love and losses. This resolution means an understanding of the emotional and epis-

[2]Wendell Stacy Johnson argues a more specific interpretation based on the poems: "For Ruskin, the merging of human feeling into natural object becomes necessary just because the remembrance of love's promise, too deeply or directly confronted, the realization of a sexual feeling smothered by his parents—in effect, by his father—is too painful" ("Memory, Landscape, Love: John Ruskin's Poetry and Poetic Criticism," *Victorian Poetry* 19 [1981], 24).

temological character of memory. And so the themes of time and memory ripple powerfully through *Modern Painters* II, sometimes on the surface and sometimes not, so that a book that began as a discourse on landscape ends as a prelude to the study of buildings, artifacts whose character changes with time. The book achieves no satisfactory reconciliation of the theoretical problem, but it does present a pair of symbolic reconciliations in the two schools of art that dominate his discussion of imagination, of which we have only discussed the first so far: the school represented by Tintoretto, chiefly associated with penetrative imagination, and the school represented by Angelico, associated with the contemplative imagination. To understand Ruskin's conception of architecture as an art of memory, we must begin with his idea of contemplation and the kind of beauty associated with it.

The Mother of Beauty

In a letter to his father of July 1845, Ruskin describes the two schools of Renaissance art as belonging to the separate regions of thought and feeling. In the first school ("Pure Religious art. The School of Love") he includes Angelico, Perugino, the early Raphael, Bellini, and others; in the second ("The School of the *Great* Men. The School of Intellect"), he includes Michelangelo, Giotto, Benozzo Gozzoli, and others. (After his discovery of Tintoretto, he inserted that name, underscored, immediately below Michelangelo [Shapiro, 144–145].) This letter follows by one day Ruskin's complaint about the hardening of his feelings and the description of the starving child, inserted to show (implicitly) that the critical mind stifles both charity and sexuality. The suppression of memory and desire is one cause of the loss of the child's sentiment of being, but the experience of too powerfully disturbing desires signals a more devastating loss of the pristine energy. The first resolution of this contradiction Ruskin found in the school of Tintoretto: the works of a painter equal in intellectual strength to Turner but whose subject is human released a corresponding power of sympathetic *identification*, through symbols that collapse human time into powerful oxymorons. The second resolution he found in an art chaste, serene, brilliant in color, and rigid in form: the works of the saintly Angelico sublimate the affections, inducing the experience of sympathetic *contemplation* through symbols of beatified calm that transcend change.

An example of the second form of beholding is Ruskin's discovery of the tomb of Ilaria di Caretto, an event that, although treated briefly in the letters, grew in importance during the rest of his life. In Lucca, we may recall, he spent several moments every evening beside the fifteenth-century effigy. In the book she appears at the end of "Repose,

or the Type of Divine Permanence," where Ruskin writes, "There is that about [the lips] which is not death nor sleep, but the pure image of both" (IV, 123). Unlike Ruskin's usual word paintings of this period, the present passage focuses carefully on detail instead of impression, conveying in its passionless factuality a different kind of absorption. Although she is but motionless stone, at each sunset she seems to die anew—rather, she seems still alive; she is the "pure image" of sleep or death because Jacopo della Quercia had sculpted her neither rudely, which would destroy the illusion altogether, nor too precisely, which would create the illusion of actual death. As an *idea* she is timeless—four hundred years old yet fresh—and so yields to the daily vigil by which, as in the repetition compulsion, Ruskin can ritualize loss. Her "dwelling is the light of setting suns."

Ruskin wanted to show that the same laws of beauty that pervade the natural world also inform the human figure, yet he approached that subject, he wrote Liddell, in "fear and trembling." The idealization of the female body consorts poorly with Ruskin's inherited Evangelicalism, yet his attempt to reconcile the two accords with a movement of thought and feeling general in Victorian culture—a movement from what Walter Houghton called an ethic of earnestness to an ethic of aspiration. In the second beginning of *Modern Painters* II, the chapter on vital beauty in man, Ruskin shifts from the chastening imagery of sinfulness to the idealized imagery of aspiration, arguing that the aim of religious art is the restoration of fallen human nature. "Wrecked we are," he writes, "and nearly all to pieces; but that little good *by which we are to redeem ourselves* is to be got out *of* the old wreck, beaten about and full of sand though it be . . . , and so the only restoration of the body that we can reach is not to be coined out of our fancies, but to be collected out of such uninjured and bright vestiges of the old seal as we can find and set together" (IV, 177). Fresh from his visit to Italy, where false "restorers" had everywhere set up their scaffolds, chisels, and walls of plaster, Ruskin now proposes a genuine and spiritual restoration through the study of great art; yet the most forceful image of that project, for Ruskin, is not a vestige or remnant but a changeless female figure, the type of human permanence. Tintoretto's *Annunciation* provides a central example. In this well-known passage, Ruskin draws attention to the Virgin sitting amid a mass of shattered brickwork (much like that which Tintoretto could have found in "the ruins of his own Venice") and a line of light formed by a carpenter's square that draws the viewer's eye to the cornerstone of the original building. "The ruined house is the Jewish dispensation; that obscurely arising in the dawning of the sky is the Christian; but the corner-stone of the old building remains, though the builders' tools lie idle beside it, and the stone which the builder refused is become the Headstone of the Corner" (IV, 264–265). As George P.

Landow has pointed out, Ruskin's typological reading crucially influenced Hunt and Millais in the early years of the Pre-Raphaelite Brotherhood.[3] Biblical types—Old Testament events and figures that achieve symbolic "fulfillment" in the life of Christ—bridge disparate epochs of time by shadowing forth evidences of a coherent divine intention in history; but the expectant Virgin is herself a bridge, giving birth to a religion of Love founded on the rock of the law. In a similar way, the paradox of physical ruin and spiritual persistence determines the dramatic structure of *The Stones of Venice,* as we will see shortly.

The acceptance of human imperfection produces the vision of a transcendent feminine Other. Clearly enough, religious, emotional, and theoretical issues fuse with remarkable complexity in the question of the female figure in art and particularly in the kind of experience Ruskin associated with the "School of Love." What would be the poetics of a School of Love? And what will be its relation to the Protestant sublime described in Ruskin's first volume and in the chapter on penetrative imagination? Unfortunately, the attempt to answer these questions in *Modern Painters* II is indirect, hasty, and incomplete. The two concluding chapters, on contemplative imagination and on the "supernatural ideal," together present a potpourri of superficially unrelated topics, including a few comments on associative reverie (partly drawn from the theories of Alison), a description of early Renaissance stylistic conventions, and a concluding gallery of images collected from the whole range of the "pure religious" school. Yet these pages are indispensable to an understanding of the great work to follow once we are able to grasp their underlying unity—the subject of the feminine ideal as an object of nostalgic desire and religious devotion. In effect Ruskin gives us a fantasia on themes from Wordsworth and Dante. "Tintern Abbey," the poem that provided him with a paradigmatic description of boyish delight, also contains a paradigm of mature joy, a meditation on memory and time that is consummated in the poet's address to an idealized sister. More directly, Ruskin's move from nostalgia to vision parallels Dante's in the book he carried with him throughout Italy, which consummates the loss of a mortal love in the beatification of a heavenly one.

For Ruskin the activity of the contemplative imagination grows out of an essentially passive mental state, the state of reverie when remembered events blend together into simpler forms abstracted of their

[3]George P. Landow, *Victorian Types, Victorian Shadows* (London: Routledge and Kegan Paul, 1980), 122–123. For Ruskin and the Pre-Raphaelites see also Herbert Sussman, *Fact into Figure* (Columbus: Ohio State University Press, 1979); for his defense of Fra Angelico and his subsequent rejection of Angelico's "purism," see Richard Dellamora, "The Revival of 'Christian' Art: Ruskin's Appreciation of Fra Angelico 1845–1860," *University of Toronto Quarterly* 13 (1974), 143–150.

disturbing elements. Similarly, the artistic imagination "depriv[es] the subject of material and bodily shape, and regarding such of its qualities only as it chooses for particular purpose . . . forges these qualities together . . . and gives to their abstract being consistency and reality, by striking them as it were with the die of an image belonging to other matter" (IV, 291). Ideal beauty, Ruskin implies—as shown, for example, in the clear, simple, and luminous forms of Angelico—takes a shape akin to memory (just as, for Plato, the recognition of beautiful forms is in fact recollection). These remarks, which combine a theory of vision with a theory of metaphor, closely suggest Ruskin's own habit of projecting onto the external world the shapes of his own desire, sublimating his lost love in idealized imagery—as, for example, when he invested Venice with the presence of Adèle. Shelley, whom Ruskin knew well, described this process in his doctrine of the epipsyche. Ruskin only goes as far as to suggest some correspondence between the loved object and the lover's own best self that is similar to the "corresponding power" necessary to the viewer of sublime Art. In the section on vital beauty in man he writes, "the ideal of the good and perfect soul" is grasped only "by seeing and reaching forth of the better part of the soul to that of which it must first know the sweetness and goodness in itself" (IV, 177).

Sweetness and strength, love and power, belong to the ideal of an integrated self, which, I have suggested, Ruskin sought in the emblems of Italian art; in terms of aesthetic theory, they correspond to the categories of contemplation and sublimity, the "pure vision" of Angelico and the "wild thought" of Tintoretto (IV, 264). What Ruskin called "Intellect" and "Love," in other words, are really two forms of passionate experience, two modes of apprehension, and this polarity represents a dramatic expansion of Ruskin's aesthetic responses. The art of Angelico goes beyond what Ruskin usually means by "imagination," as I have suggested above: of Angelico's *Annunciation,* for example, Ruskin writes, "All is exquisite in feeling, but not inventive or imaginative" (IV, 264). We know from his letters that he did not rank Angelico high in execution, but a deeper reason for this judgment is Ruskin's tendency to think of sublime experience as alone "truly imaginative," since the artist reconstitutes his own power as the organizing center of his creations. Tintoretto "speaks out" his works, as Carlyle would say, from within him, while Angelico seems to contemplate rather than inhabit the work of his hands, existing therefore as a saintly temperament, not as a charismatic presence. And so one art is "thought," the other "vision." Ruskin's fascination with the jeweled coloring of early Renaissance art heightens this distinction. I previously defined beauty in Ruskin's thought as divine energy made visible, but Ruskin was also attracted to the neoclassical view that color is an adven-

titious quality in things and is therefore freely granted by the Creator: in his notes in Venice he calls it "ennobling to all things," "an abstract quality, equally great wherever it occurs" (IV, 305n), and much later he calls it the sanctifying element in art, the type of Love. Burke had distinguished between the rough and masculine power of the sublime and the pleasing, gentle, feminine character of the beautiful. For Ruskin, sublime art induces identification with masculine energy, visionary art contemplation of the beautiful as an object; in religious terms one form of art is "taken in" like the eucharist, the other beheld as an icon or memorial. This complex dichotomy dominates Ruskin's mature career as an art critic.

As I have implied, the dichotomy also corresponds to two alternate descriptions of the physical universe. In one account, devised to defend an art faithful to observed fact, the kinetic vitality of things predominates over their containing forms; the "character" of each object is a mode of energy disclosed by surface features and joined to an infinite system of energies that is the perpetual activity of the divine mind; mortality and loss are overcome by the inexhaustibility of natural abundance. In the other account, devised to defend an art faithful to supernatural truths, the forms of things predominate over their kinetic activity; the inertia of matter is refined away by the contemplative eye until "ideal" nature reveals itself as a world of changeless objects suffused by radiance. Mortality and loss are overcome by the symbolism of a final transfiguration that redeems the purity of the original state of beings now fallen. In the first account, all living things, including fallen man, define themselves by struggling toward fulfillment. In the second the world is seen as it will appear in eternity, with all humans connected by the presence of God in each. In *Modern Painters* II this cosmological account appears first in the section on Purity, the Type of Divine Energy, which attempts to explain why certain objects, such as crystals and the glowing health of the human face, strike us as inherently more beautiful than other objects. By adding to matter the purity of this energy, the artist "may in some measure spiritualize even matter itself." The best-known example of such a "spiritualized" vision of matter is of course the City of God, where "the river of the water of life . . . is clear as crystal, and the pavement of the city is pure gold 'like unto clear glass'" (IV, 133–134).[4]

The portmanteau idea provides a pseudophysical basis for the familiar theological oppositions between light and dark, life and death, and purity and corruption while also permitting Ruskin to combine the romantic doctrine of organic form (the "vital and energetic connec-

[4]James Clark Sherburne has admirably discussed the importance of Purity to Ruskin's thought in general in *John Ruskin; or, The Ambiguities of Abundance* (Cambridge: Harvard University Press, 1972), chap. 1.

tion" of parts) with the Neoplatonic radiance. He could also reconcile ideal beauty with biblical imagery and so equate idealization in art with prophecy—all the while preparing the way for a defense of the school of Angelico, with its reduction of objects to luminous, jewellike surfaces and accents of gold. All these joinings are consummated in the last paragraphs of the book, which present in climactic sequence a gallery of apocalyptic pictures: first the Archangel Michael, a bodily form converted into the habitation of infinite power ("vessel and instrument of Omnipotence, filled like a cloud with the victor light"); then the Madonnas and martyrs in rapt contemplation ("in whom the hues of the morning and the solemnity of eve, the gladness in accomplished promise, and sorrow of the sword-pierced heart, are gathered into one human Lamp of ineffable love"); and finally the angel choirs of Angelico, "listening in the pauses of alternate song, for the prolonging of the trumpet blast, and the answering of psaltery and cymbal, throughout the endless deep, and from all the star shores of heaven" (IV, 330–332). The temporal dimension of this vision is a single pulse of expectation—literally the moment between the sounds of the final trump, the instant between promise and fulfillment. But the spatial dimension is Dantean in its completeness, for the sound encircles the cosmos. The solitary mount by the Brevent is transformed into a pyramid of "sublimated humanity."

Like the vision in the Alps in Ruskin's first volume, the conclusion of his second strains beyond its subject, this time toward the idea of a *Gesamtkunstwerk* multitudinous in its unity, embodying all the forms of human perfection including intellectual grasp and purity of spirit, huge as an epic poem yet frozen in time like a painting, acting in fact not as the expression of a single great mind only but as a beacon or lamp to fallen human nature. From the solitary and timeless ecstasies of *Modern Painters* I Ruskin turns at last to architecture, the most collective of all art forms and the means by which humans most literally strive to imitate the City of God. A great church, inscribed in what Ruskin called the language of types, conveys a transtemporal vision of redemption, yet as a material object it also participates in the history of mankind fallen, struggling, and triumphing.

The Meaning of Architecture

Ruskin opens *The Seven Lamps of Architecture* with the charge that in architecture, as in society, material concerns have usurped spiritual concerns as the body has tended to supersede the soul. By "material" he means technical innovations, which have responded so rapidly to the "necessities of the day" that they threaten to overwhelm all consid-

ered thinking about the great ends of architecture—unless, that is, we first determine "some constant, general, and irrefragable laws of right." Now, the relationship of technique to idea is organic: practical laws are always "exponents of moral ones," "the actual expression of some ultimate nerve or fibre of the mighty laws which govern the moral world" (VIII, 20–21, 22). Material forms in fact have a double reference, exemplifying both the "spirit" of a building and also the moral condition of the workman, behind whom stands the moral condition of the society that produced him. Ruskin's aim, then, is to understand spiritual reality through a logic of evolving forms in order to determine the beneficial course of those forms. Ultimately, to describe the soul and body of architecture in their ideal relationship is to describe the soul and body of a society in their ideal relationship.

Fortunately for his argument, Ruskin ends up treating his principles as "spirits" rather than laws. Instead of another book structured by a clumsy system of deductive categories, *The Seven Lamps of Architecture* is lucidly and ingeniously arranged according to intuitively unified subjects that complement one another. The "lamps" are in fact the various modes by which architecture produces meaning. He had intended to use the word "spirits" for his title (as though to offer the spirit rather than the letter of moral laws), which would also imply the secondary sense of angels or guilding lights. The word he finally chose makes the secondary sense primary and enriches the metaphorical suggestions. John's first vision in Revelations is the seven lampstands representing the seven original Christian churches, which visually echo the images of redemption later in the book, particularly the resplendent City of God. To this implied nexus Ruskin adds the association of "lamp" with "word" and "law" ("The Law is light"; "Thy Word is a lamp unto my feet" [VIII, 22]). As Christ is the Word incarnate and the Law fulfilled, so is the church the spiritual body of Christ, of which all communicants are members. The imagery of guidance and illumination is continuous, then, with the seraphs and human lamps of *Modern Painters* II. And so Ruskin's seven lamps spread before us like beacons, or yet again, like seven virtues in an allegorical frieze.

The switch from painting to architecture transcends the principal dichotomies of Ruskin's early theories of art. In "The Lamp of Power" he writes that the interest of a great building depends upon "the impression it receives from human power" and "the image it bears of the natural creation" (VIII, 138), but in a famous passage from "The Lamp of Memory," he seriously called into question the value he had once attributed to the pleasure of natural objects. During a stroll in Champagnole, he writes, he discovered that the scene lost its charm the moment he imagined it as an uninhabited forest: "A heaviness in the boughs of the darkened forest showed how much of their former

power had been dependent upon a life which was not theirs" (VIII, 223)—the life, that is, of human dwellers and their history. Whether this recognition in fact overthrows Ruskin's previous insistence on the inherent character of beauty is open to debate.[5] The point for our purposes is that the contradiction is reconciled in the shape of a Gothic cathedral. Some buildings, he writes elsewhere, possess "an exceeding preciousness and delicacy," while others have a "mysterious majesty. . . . like that felt at the presence and operation of some great Spiritual Power"; but the sources of the beautiful and the sublime are the reverse of what we might expect, the beautiful deriving from sculptural imitation of natural forms, the sublime from "the expression of the power" of *human* mind (VIII, 100–101). Unlike a painting, a cathedral can be literally entered, for humans have designed the cope of this heaven and the range of its vistas; they incorporate nature in decorative form as the mind itself incorporates the garlands of its happiest memories, while leaving the shape of power in one sense unaltered— for vaults and chapels are the "original" appearance of the heavens

[5]This passage has been rightly recognized as a crucial turning point in Ruskin's aesthetics. Pierre Fontaney, however, stresses Ruskin's apprehension of *life* in nature rather than the power of association, arguing that the shift from the aesthetics of *Modern Painters* I to that of *The Seven Lamps of Architecture* is a shift in emphasis, not an inconsistency. The function of the passage, he writes, "does not consist (*pace* Professor Landow) in working out the preliminaries of some new (let alone incompatible) theory of beauty— indeed, it is about sublimity, life, and memory as much as beauty" ("Death and Champagnole: A Contribution to the Reading of *The Seven Lamps of Architecture*," *University of Toronto Quarterly* 13 [1974], 141). Fontaney is right to underscore the complexity of the passage, but surely Landow is right in arguing for a substantial change: the statement in the Brevent fragment is clearly incompatible, for example, with the attribution of Power to human agency in "The Lamp of Power." In a letter to Henry Acland, written while he was composing *Modern Painters* II, Ruskin gives a good glimpse of his struggle over the issue of associations (XXXVI, 59). The inherent qualities of things and our instinctive responses to them, Ruskin argues there, are distinguishable from emotional attitudes toward them based on a particular person's accidental associations, but there is also such a thing, he continues, as "constant association" (for example, the association of black with melancholy, which he assumes to be universal among all cultures), although even this he distinguishes from inherent beauty. Ultimately, "constant associations" give way in Ruskin's theory to the natural hieroglyphic and the universal symbols of natural myth. The problem, as Landow notes, rests in a confusion between beauty as a sensuous quality in an object and beauty as an emotional response based on knowledge or association (such as the perception that a flower bears the appearance of felicity), and this definition leads Landow to call the theory of Typical and Vital Beauty a "bifurcated" theory. My reading of the theory of penetrative imagination would suggest how the transition from the two positions that Fontaney attempts to reconcile (that beauty is independent of associations and that beauty depends on the presence of human associations in landscape) may be grasped visually as well as theoretically. In *Modern Painters* I, Ruskin (and the artist) enters the natural world, which is the visible form of the divine mind. In *Modern Painters* II, the artist enters the world of a human mind and the viewer enters the world of the artist's mind, which resembles a landscape. In *The Seven Lamps of Architecture*, the viewer enters a building, which is the visible form of a human mind decorated with images of natural beauty, which become, as it were, the pleasant associations and memories of the human builder. In all cases mental power is viewed as a structure to be entered.

when seen in prophetic ecstasy. Mind and feeling, power and memory, fact and metaphor are inscribed together upon the same enclosing sensorium, which will retain forever the strength and sweetness of an unfading human presence. It is the type of the perfect relation of God and man.

The synthesis is only possible because buildings are temporal artifacts; in Gerald Bruns's words, they are for Ruskin "events as well as structures."[6] In "The Lamp of Sacrifice," Ruskin describes the event of construction as a commemorative activity. In "The Lamp of Memory" he describes the event of temporal survival as a hallowing activity, the activity by which the building embodies the collective memory of a society. In the first lamp Ruskin argues that the function of a rich sacrifice of labor and craft and materials is not to compel religious awe by means of splendor but to demonstrate an inward condition of the spirit. God demanded the tabernacle as a sign of the continuance of the covenant in response to the visible sign that God had already manifested; that testimony would be not only the firstling of the flock but the tithe "of all treasures of wisdom and beauty; of the thought that invents, and the hand that labours; of wealth of wood, and weight of stone; of the strength of iron, and the light of gold." Ruskin's emphasis, then, is on the builder and his act: "It is not the church we want, but the sacrifice; not the emotion of admiration [in a human congregation], but the act of adoration; not the gift, but the giving." Of such a sacrifice, it is pointless to ask the use in human terms. An object given up or set aside is therefore "useless" or sacred (the root *sacr-*, which produces "sacrifice," "consecrate," "sacred," and "sacrament," contains the sense of "giving"). And so, as landscape art is for Ruskin an act of psalmic praise, architecture is an act of sacramental praise, the human reaffirmation of the Covenant. Ruskin's biblical allusions make precise the nature of the covenantal bond: as the Levitical sacrifice of the firstborn and David's sacrifice of the water at Adullam are types of Christ's supreme sacrifice, so the sacrifice of materials in architecture reconstitutes in material form the body given up on the cross.

Architecture, then, is an expressive art, not in the sense that an emotion is an expression but in the sense that a sign is an expression. The building erected as a memorial to the covenant becomes in time the living memorial of a community persisting through many generations. Ruskin's penultimate chapter, "The Lamp of Memory," reaches its climax in one of the most famous paragraphs he ever wrote:

Therefore, when we build, let us think that we build for ever. . . . For, indeed, the greatest glory of a building is not in its stones, nor in its gold.

[6]Bruns, 912.

Its glory is in its Age, and in that deep sense of voicefulness, of stern watching, or mysterious sympathy, nay, even of approval or condemnation, which we feel in walls that have long been washed by the passing waves of humanity. It is in their lasting witness against men, in their quiet contrast with the transitional character of all things, in the strength which . . . maintains its sculptured shapeliness for a time insuperable, connects forgotten and following ages with each other, and half constitutes the identity, as it concentrates the sympathy, of nations: it is in that golden stain of time, that we are to look for the real light, and colour, and preciousness of architecture; and it is not until a building has assumed this character, till it has been entrusted with the fame, and hallowed by the deeds of men, till its walls have been witnesses of suffering, and its pillars rise out of the shadows of death, that its existence, more lasting as it is than that of the natural objects of the world around it, can be gifted with even so much as these possess, of language and of life. [VIII, 233–234]

Once again, to lose oneself is to find oneself. The builder who loses his time to labor turns out from the prospect of history to have redeemed time. In the first chapter Ruskin wrote, "Wealth, and length of days, and peace, were the promised and experienced rewards of [the Hebrew's] sacrifice, though they were not to be the objects of it" (VIII, 42). The language is the language of capitalist accumulation, but what for Marx would be the alienation of human work in favor of "the gods" turns into a fully humanized artifact, one that concentrates sympathy rather than personal ambition and acts as both an emblem and a virtual agent of social cohesion. Ruskinian architecture also translates into communal terms the structure of erotic sublimation. To abjure a loved object, to remember it and weave about it the "added charm" of happy associations, is to substitute the pleasures of imagination, the sweet ache of possessing and not possessing; but in architecture the remembered sympathy of a nation receives concrete and imperishable form. Time is redeemed: the "golden stain" recalls the Keatsian trope of time as a thickening substance, an autumnal ripening, which for Ruskin also renders the inorganic organic. In his physics of purity, the Heavenly City is the image of matter spiritualized, since the translucence of its elements is simply the organic energy of their internal relationships; but in the Earthly City, history, the accumulation of human actions, gives to stones both life and language, so that humans by the works of their hands can also "spiritualize matter."[7] A great building becomes a lamp of ineffable love.

[7]Coleridge provides a similar view of religious art in *The Statesman's Manual*, using his particular vocabulary. According to Coleridge, religion considers the individual in the universal (thus sympathizing with both the understanding and the reason) and therefore has always been the "parent and fosterer of the Fine Arts, as of Poetry, Music, Painting, &c. the common essence of which consists in a similar union of the Universal and the Individual. In this union, moreover, is contained the true sense of the IDEAL. Under the

Here surely is the metropolis of the soul's dominion. "The Lamp of Memory" is perhaps Ruskin's first truly great utterance as a theorist of art, connecting him with other great episodes in the romantic tradition—for example with Los's vision in *Milton* and with the aesthetics of Stevens, for whom the supreme fiction returns to humans their own image, rendered stranger and more true. Ruskin's vision of architecture also recalls a nearly contemporaneous phrase of Marx's—the organic body of man and the humanized body of nature. The politics on which Ruskin's book rests are of course anything but Marxian, as appears most clearly in the shrill denunciation of revolution with which Ruskin concludes his final chapter. Unable at this or any point of his career to see that the "cooperative" relationships of society might simply disguise the relationships of class oppression, Ruskin could only understand the Revolutions of 1848 as particularly wretched symptoms of a weakened center, a dissipation and a forgetting of those sympathies that great architecture helps to concentrate. In one sense that response confirms Walter Benjamin's diagnosis: to invest art objects with authenticity is to reaffirm the prerogatives of bourgeois authority. Yet the resonances of Ruskin's symbols elude the ultra-Toryist principles he shared with his father[8] or indeed any fixed political program; for great buildings are also a "lasting witness against" us, recalling us not only to the past but also to the idea toward which human history must strive.

old Law the altar, the curtains, the priestly vestments, and whatever else was to represent the BEAUTY OF HOLINESS, had an *ideal* character: and the Temple itself was a master-piece of Ideal Beauty" (*Lay Sermons*, ed. R. J. White, in *Collected Works*, ed. Kathleen Coburn, 16 vols. [Princeton: Princeton University Press, 1969–], VI, 62). This Neoplatonic notion of ideal beauty is clearly what Ruskin means by "ideal" in *Modern Painters* II. Landow and others have noted that Ruskin's instances of "typical beauty" in that volume reflect a neoclassical taste for rationalized calm and emotional order, a taste in conflict with his crude attacks on neoclassical theory (he describes neoclassical art as a heterogeneous pasting together of choice parts into a single composition). But typical beauty for Ruskin is probably closer to the Coleridgean radiance than to neoclassical notions, as is suggested by the pervasive use of the biblical imagery of light in that book. For Coleridge's possible influence on Ruskin, see Chapter 5.

[8]Robert Hewison argues that Ruskin was deeply affected by his father's ultra-Toryism. See "Notes on the Construction of *The Stones of Venice*," in *Studies in Ruskin*, ed. Robert Rhodes and Del Ivan Janik (Athens: Ohio University Press, 1982), 131–152.

"Paradise of Cities"

Venice throws a challenge to the discriminator, turns away from the seeker for information, scorns the separator of one thing from another. No Venetian architect stands out like the ones of Florence or Rome; the buildings are not Lombardo's or Longhena's, they are Venetian.

—Robert Harbison, *Eccentric Spaces*

In *Praeterita* Ruskin recalled in wistful terms the first summer of his love for Adèle: "The fair heroine, Bianca, was to be endowed with the perfections of Desdemona and the brightness of Juliet,—and Venice and Love were to be described, as never had been thought of before" (XXXV, 182). Instead, he created a world divided against itself, its fair appearances undermined by hidden watchings and the scheming of a villainous "worm." Then, by September of the same year, he wrote an unpublished defence of Turner's *Juliet and Her Nurse,* which was also a celebration of Turnerian romance, and in the visit of 1841 Venice became the "Paradise of Cities"—a deathless monument to his lost love. In 1845 he found her under heavy "restoration," with a railroad bridge plunging across the bay, but he discovered also the undimmed power of Tintoretto. In 1849, when he arrived again with his wife to begin a magnum opus on Venetian history, he found her newly conquered by the Austrians—the Venice, once again, of *Marcolini.* For the rest of his life this city was the magnet for his most powerful ambivalences, the symbol of the terrible contradictions of human desire.

The Plan: History as Typology

The Ruskins may have been the first English visitors to enter the city after the Austrian siege, the most prolonged of the Revolutions of 1848. The rulers that Ruskin, with some reservations, preferred to the native republicans had shelled the city and even planned to launch

balloons that would explode inside (the inventor, an officer named Paulizza, became Effie's most ardent admirer); now cannon stood beneath the southwest corner of the Ducal Palace, and though crowds gathered daily to hear the military band in St. Mark's Square, it was not unusual for officers to be stabbed in the streets at night. In a letter of January 8, 1850, to the Reverend W. L. Brown, recently published by Jeanne Clegg, Ruskin contrasts the orderliness of Brown's country parish, where things are more or less "all right," with a catalog of Venetian horrors. These include tradesmen selling toys and poultry and holy pictures in St. Mark's; an unemployed workman who murdered the Governor who had fired him, was himself wounded, and then "held up or tied up for form's sake, and properly shot"; a palace used as a coal warehouse; a church installed with a steam engine; and all this the work, he writes, of

> a people—ignorant—incapable of conceiving such a thing as Truth or Honesty—Blasphemous—Murderous—Sensual—Cowardly—A people governed by another; which they hate, merely because they *are* governed by them—Governed severely because they can be no otherwise governed—and the People that govern them; temperate—thoughtful—welltrained [*sic*]—well taught—yet holding their national existence by a mere steel spring which one jar may break;—inflicting oppression automatically, as a nation, while individually they are kind and good.[1]

Repelled and confused by political realities he had neither the flexibility nor the sophistication to grasp, he fell to sketching the monuments and poring through old records in the archives, preparing a definitive work that would contain in stark chiaroscuro both his Venices, the nightmare world of defilement and treachery and the vision of radiant purity.

The polemical aim of *The Stones of Venice* is to show that a nation's art is always the expression of its moral temper, an aim that further supports the argument begun in his last book for a Gothic revival along Protestant rather than Puseyite lines. His proof rests on the hugest and most exhausting scholarly project he ever attempted. Two seasons of researching and recording, of checking dates and measuring positions of columns and tracing the half-effaced details of old churches, produced three massive volumes (the first a treatise on the elements of architecture), along with thirty-nine appendixes and another series, published concurrently, called *Examples of the Architecture of Venice*. Like its subject, the book is cacophonous, jumbling styles and aims: the voice grows patient like a teacher's, rhapsodic like a poet's, and solemn like a

[1]Jeanne Clegg, *Ruskin and Venice* (London: Junction Books, 1981), 82–83. My account of the Ruskins' first winter in Venice is indebted to Clegg's excellent book, which discusses all eleven of Ruskin's visits and their impact on his thought and feelings.

preacher's in the course of an exposition that is at once a textbook, a guidebook, a history, an Evangelical tract—and ultimately the fulfill-ment of his youthful dream of writing a romance, although its subject is no longer Bianca but the city herself. Again like the city, the book rises from a confluence of sources and influences. The historical argument draws upon Lord Lindsay's history of religious art (which first made the distinction between an uncorrupted medieval Christianity and a corrupted Renaissance Catholicism) and from Alexis Rio's *De la poésie chrétienne*. His historical approach draws upon Carlyle's *Past and Present* and also probably upon the visual oppositions of Pugin's *Contrasts*. His form, as Elizabeth Helsinger has observed, draws upon the body of contemporary traveler's guides in which "history is approached through travel, and travel experienced as history."[2] (Such guides in-clude Murray's *Handbook for Travellers in Northern Italy*, Saussure's *Voyages dans les Alpes*, and, I would add, Wordsworth's *Guide to the Lakes*, which proceeds from geology to architecture to the depredations of modern tourism and railroad building.) Preceding all these sources, of course, is the boy's reading in *Childe Harold* and Rogers's *Italy*, with their romantic dream of the fairy city vanished upon the wave.

The Stones of Venice is perhaps the most remarkable of all Ruskin's attempts to anchor his fantasies in tactile details. The evidences are minute and exhaustive, the argument fantastic, the narrative mode characteristically complex. The first volume, opening and closing with famous word paintings of the city in decay, is largely devoted to a survey of the principles of architecture, using the fiction of a narrator and reader who construct a building from the ground up. The title of the second volume, which begins the historical narrative, is deliberately ambiguous, as Richard Stein has observed, since *The Sea-Stories* refers both to the "burning legends" and to the lower floors of the buildings. This ambiguity spreads to the first and last titles—*The Foundations* and *The Fall*—so that the three titles create the metaphor of the state as a building, evoking at once the sweep of history and the collapse of a structure.[3] As tour guide Ruskin takes us from site to site, first by gondola, then on foot, with historical commentary proceeding on two

[2]Elizabeth Helsinger, *Ruskin and the Art of the Beholder* (Cambridge: Harvard University Press, 1982), 140. Arrestingly, Helsinger adds Dante to the list of traveler's guides to Italy. For Ruskin's readings of Byron and Rogers, see, for example, Richard L. Stein, *The Ritual of Interpretation* (Cambridge: Harvard University Press, 1975), 72; and Clegg, 32–37. For Ruskin's relationship to the Gothic Revival and his debts to Rio, Lord Lindsay, and other writers, see Francis G. Townend, *Ruskin and the Landscape Feeling* (Champaign: University of Illinois Press, 1951), and John Rosenberg, *The Darkening Glass* (New York: Columbia University Press, 1961), 47–55.

[3]Stein, *The Ritual of Interpretation*, 75. Stein also argues that the three volumes, in addition to treating different subjects, use three dominant styles—the first technical, the second lyrical, the third sermonic—which correspond to three modes of history: functional, aesthetic, and moral (p. 75).

levels—the political level, in which the actors are doges, senators, bishops, and so forth, and the architectural level, in which one style succeeds another with features of ornament and design carefully noted and compared. But what distinguishes the narrative from that in other traveler's guides is the famous set pieces by which Ruskin animates the buildings through an act of imaginative seeing, the emotional equivalent of historical memory. The result is a continuous movement through four-dimensional space rather than a switching back and forth between past and present, with the result that each site contains within itself the flow of history, while the flow of history, arrested at each site, manifests itself in spots of time. Buildings embody spiritual states that in turn occupy a less displaced level of narrative, the level of romance, which yields to another level of metaphorical condensation in which the city itself, usually personified as a woman, rises like Venus from the sea, becomes queen of the waves, then partly from her own weakness and partly from the temptation of a southern invader, changes into a harlot and expires. This *de casibus* plot Ruskin closely associates with the original of all such plots, the Fall of Man. As John Rosenberg noted, "Medieval Europe became a kind of second Eden, a Christianized Golden Age, a pastoral and holy paradise. . . . One might suppose that men had not fallen from grace until the Renaissance, and that nature had remained uncorrupted until the Industrial Revolution."[4]

The historical claims collapse the moment one starts taking them seriously. Ruskin dates the beginning of the Fall, for example, from 1418 or else from 1423, the date of the first additions to the Gothic Ducal Palace—he even claims to locate the first hammer blow; yet in his view the climax of Venetian art is the oil painting of the sixteenth and seventeenth centuries, the period also of the Roman and Grotesque Renaissance. The generalized type of a French Gothic cathedral (which Ruskin describes as the invention of rude tribesmen rather than the sophisticated circle of Abbot Suger) never really descended to Italy and has little application to Ruskin's prize example, the Ducal Palace, with its Byzantine ornament and long rows of orderly columns. The ruin motif is perhaps the greatest extravagance: with characteristic literalness, he compares Venice's commercial decline with the devastation of Tyre, yet the rocks of this ruin are not so bleached that Ruskin cannot examine them in the company of obliging sextons and officials and spend two winters in comfortable lodgings. But behind the literal Venice and the accumulation of dubious historical connections stands Ruskin's true subject, the locus of a plot that is nothing less than the legend of the European soul. The burden of this plot has been well described by Gerald Bruns as a version of historical dissociation, the

[4]Rosenberg, 54.

conflict between Protestantism and rationalism. Like any historical myth, its interest lies in its explanatory power for the present.

"Since first the dominion of men was asserted over the ocean," Ruskin begins, "three thrones, of mark beyond all others, have been set upon its sands: the thrones of Tyre, Venice, and England. Of the First of these great powers only the memory remains; of the Second, the ruin; the Third, which inherits their greatness, if it forget their example, may be led through prouder eminence to less pitied destruction" (IX, 17). Like Carlyle in his historical works, Ruskin reads the past as a preacher would read the Bible, locating in paradigmatic manifestations of the historical process evidences of a "lasting witness" against the present. But Ruskin hews more strictly than Carlyle to the structure of Old Testament prophecy, in which the destruction visited upon an infidel nation foreshadows Israel's possible fate as well. The relationship of Tyre, Venice, and England is, in other words, a typological relationship.

Typology is a method of biblical interpretation that treats persons and events in the Old Testament as prefigurements of events in the life of Christ, the antitypes through which the Old Testament types are "completed" or "fulfilled." George P. Landow has decisively established the importance of Evangelical typology for Ruskin's art criticism—for his pioneering interpretations of Renaissance art, for his general theory of allegory, and for his reading of the Book of Nature, written, like the Bible, in the language of types and shadows. And as Landow has also shown, Ruskin's method derives directly from his religious education at Herne Hill, both from books and from the sermons of the great Evangelical preacher Henry Melvill, which the family heard on Sundays and which the boy summarized each week in his journal.[5] It also turns out that in 1842 John James Ruskin bought an edition of Coleridge that may have contained Coleridge's chief contribution to the typological tradition, *The Statesman's Manual*. We do not know whether Ruskin read this work, although he did read *The Friend*, passages from which Coleridge incorporated in the Manual.[6] In any

[5]George P. Landow, *The Aesthetic and Critical Theories of John Ruskin* (Princeton: Princeton University Press, 1971), 329–356.

[6]The book purchase is noted in *The Ruskin Family Letters*, ed. Van Akin Burd, 2 vols. (Ithaca: Cornell University Press, 1973), II, 726n. Ruskin's note approving *The Friend* is in the diary for February 1843 (*The Diaries of John Ruskin*, ed. Joan Evans and John Howard Whitehouse 3 vols. [Oxford: Oxford University Press, 1956], I, 242). But sometime in the mid-1850s Ruskin told Charles Eliot Norton that he thought Coleridge vastly overrated as a philosopher and that "his best poems were feverish" (*Letters of Ruskin to Charles Eliot Norton* [Boston: Houghton Mifflin, 1904], I, 21). In the letter asking Henry Liddell for writers on imagination, Ruskin alludes to a certain dispute between Wordsworth and Coleridge concerning that faculty and fancy, but discussion of the dispute makes up only a small part of the *Biographia Literaria*, and there is no evidence that Ruskin knew it directly. It is hard to believe, however, that he would not have been drawn to a book like *The Statesman's Manual*, which purports to show the English intellectual elite how to read

case, Coleridge's argument is essential to our purposes, not only for its many verbal anticipations of Ruskin's work but also for its essential argument, the clearest exposition in romantic literature of Ruskin's method in *The Stones of Venice*.

The chief aim of Coleridge's "lay sermon" is to demonstrate the Bible's supreme practical relevance by means of his well-known distinction between understanding and Reason. He claims that contemporary social science (including Enlightenment philosophers and British utilitarians) necessarily fails to construct principles because it is a science of the mere understanding; limited to the gathering of data, empiricist history can only presuppose mechanistic "causes" or "forces," or more trivially, can merely relate anecdotes about great men. The fact that people consider the Bible irrelevant to contemporary politics—that they see no essential resemblance, for example, between the chaos following the French Revolution and the rebellion of Jeroboam—is a symptom of the very problem that a faithful reading of the Bible will cure; for the Bible teaches us how events may differ in form yet manifest recurrent principles. In Coleridge's reading, the Scriptures provide us with the grounds of all historical understanding, since history is the continuous unfolding of Providence; it is also a paradigm of genuinely philosophical history, since its events, as types, have both a concrete and a general significance; they are the "living *educts* of the Imagination," the faculty mediating between the concrete and the transcendent, the faculty that perceives things as symbols. Biblical history presents

> the stream of time continuous as Life and a symbol of Eternity, inasmuch as the Past and the Future are virtually contained in the present. . . . In the Scriptures therefore both Facts and Persons must of necessity have a two-

the Bible as a guide to national policy. But given Ruskin's habit of obscuring his sources and repudiating tendencies in an influential writer that he did not like in himself, we can suppose that the figure of Coleridge would have been a troubling one. In *Modern Painters* III, Ruskin contrasts a Carlylean hardheadedness with the reprehensible dreaminess of German metaphysicians in a way that recalls Carlyle's famous portrait of Coleridge in the *Life of John Sterling*, published five years before. There was on the one hand the great poet, a friend of Wordsworth, a lover of nature, and a Christian Tory philosopher who waged war with the utilitarians. On the other hand, there was the aging wool gatherer, who spoke and wrote in the kind of obscure style Ruskin could not easily tolerate. My guess is that Ruskin read or reread *The Statesman's Manual* at least before the writing of *The Stones of Venice* (which, like *Unto This Last*, contains strong echoes of the *Manual*). By the middle of the 1850s he had given his emotional allegiance to Carlyle yet retained many of Coleridge's hints and thoughts, if none of his manner.

For another discussion of the possible influence of the *Manual* on Ruskin, see Richard Dellamora, "A Victorian Optic: Translucent Landscape in Coleridge, Ruskin, and Browning," *Prose Studies* 3 (1980), 271–286. Dellamora uses the terms "translucence," "transparency," and "opacity" to derive three categories of imaginative landscape in Victorian writers.

fold significance, a past and a future, a temporary and a perpetual, a particular and a universal application. They must be at once Portraits and Ideals.[7]

Biblical history, in short, is a vision of human freedom through time: "In the Bible every agent appears and acts as a self-substituting individual: each has a life of its own, and yet all are one life. The elements of necessity and free-will are reconciled in the highest power of an omnipresent Providence, that predestinates the whole in the moral freedom of the integral parts. . . . The root is never detached from the ground."[8] In this way Coleridge generalizes biblical typology to the study of all human history, since any event truly understood embodies a recurrent principle in concrete form and so stands at once as a repetition and as a prophecy. This argument provides the context of Coleridge's famous definition of the symbol: "a translucence of the Special in the Individual or of the General in the Especial or of the Universal in the General" and of "the Eternal through and in the Temporal."[9] Although usually taken as aesthetic doctrine, the definition also provides the key to understanding the pattern of historical events and, finally, the structure of all moral actions inspired by what Coleridge calls "enthusiasm." For the heart of his concern in the *Manual* is moral freedom, the human participation in a historical medium whose final purpose transcends human will.

It will be clear at once that *The Stones of Venice* fulfills Coleridge's project in at least two ways, as a sermon and as an act of interpretation. Coleridge is himself a bad preacher: when, for example, he proposes to show specifically how the Bible can teach practical politics, he first postpones his aim, then returns to it later by quoting a denunciation from Isaiah in order to condemn the French Revolution, then retreats again into a description of Reason. But his task is to show how to read the Bible not with understanding only but with the fullness of intuitive assent that he calls Faith, the ground of the possibility of all action and knowledge. Ruskin, on the other hand, induces assent by means of a sermonic style that combines moral fervor with an enraptured evocation of historical events and historical artifacts. And by interpreting events as biblical types, he performs a symbolic abstraction by which history in its recurrent patterns becomes grimly significant for the present.

In this regard he transcends the idea of Coleridgean history on two counts. In the first place, Coleridge conceives of history in terms of

[7]Coleridge, *Collected Works*, ed. Kathleen Coburn, 16 vols. (Princeton: Princeton University Press, 1969–), VI, 29–30.
[8]Ibid., 31–32.
[9]Ibid., 30.

principles but not really in terms of process or change. A comparison of the *Manual* with the histories of Carlyle and Ruskin validates Bruns's distinction between synchronic and diachronic conceptions, since the Victorians interpret typological recurrence as a historical evolution that compels new forms. By grounding the Venetian Gothic, for example, in the circumstances of a particular cultural occasion, Ruskin can also urge a revival of the Gothic because of cultural circumstances in England—the power of enlightened patrons and consumers to create social relations analogous to those of the Gothic builder and his workmen.[10] In the second place, by transferring most of his attention to buildings as events, he enriches the Coleridgean idea of a symbol: his churches, we might say, are portraits and ideals because they are aesthetic representations as well. In *The Seven Lamps of Architecture*, he enumerated seven modes of architectural meaning as though they were virtues, which together describe, as a living spirit, or ethos, the complete moral possibilities of a Christian society. In *The Stones of Venice* Ruskin describes particular variations of architectural expression in time (as he had in *The Poetry of Architecture*), constructing a historical narrative in which the chief "characters" are spirits manifested as styles, styles manifested in particular exemplary monuments. Here rests the originality of this book. Because Ruskin believes art to be the externalization of the artisan's soul, he can read buildings with a psychological complexity that is cogent both as art criticism and as dramatic portraiture.[11]

Ruskin's succession of spirits or styles presents the drama of history in terms at once idealist and typological. But we can also shift perspective and see *The Stones of Venice* as an action centering on a single character, the city itself. In this view, the plot takes the form of a massive Victorian melodrama in which history is predominantly elegiac.

[10]In an ingenious argument, Helsinger shows how Ruskin transforms the privileged audience he addresses, first by treating readers to a conventionally picturesque view of Venice, then by forcing them, through an awareness of history, to recognize their role and their responsibilities as consumers (pp. 159–163).

[11]Because it can be read as inscriptions of its own history or character, Ruskinian architecture resembles what Coleridge calls natural types in the well-known third appendix to *The Statesman's Manual*. A natural type for Coleridge resembles a plant, the emblem on one level of the organic unity of natural processes and on another, of the organic activity of Reason. The plant concentrates and diffuses, drawing in light and air and respiring back into the atmosphere "an air akin to light," and this causes it to grow and change shape through time. It stands, then, for nature herself, which is both a set of relations and a process by virtue of which she "becomes the record and chronicle of her ministerial acts, and inchases the vast unfolded volume of the earth with the hieroglyphics of her history" (pp. 72–73). The consonance between this idea and the emblematic building in "The Lamp of Memory" needs no comment. For a lucid analysis of the Coleridgean passage in relation to the rest of Coleridge's philosophy of nature, see M. H. Abrams, "Coleridge and the Romantic Vision of the World," in *Coleridge's Variety*, ed. John Beer (Pittsburgh: University of Pittsburgh Press, 1974).

History as Nostalgia

From the start of his book, Ruskin strikes a melodramatic tone, converting even biblical allusion into the matter of romance. The prophet's execration against Tyre, Ruskin writes, is to us "as a lovely song," so that we forget, as we watch the bleaching of the rocks between the sunshine and the sea, that they were once "as in Eden, the garden of God." "Her successor, like her in perfection of beauty, though less in endurance of dominion, is still left for our beholding in the final period of her decline: a ghost upon the sands of the sea, so weak—so quiet,—so bereft of all but her loveliness, that we might well doubt, as we watched her faint reflection in the mirage of the lagoon, which was the City, and which the Shadow" (IX, 17). The song and the warning, the sermon and the romance, alternate formally throughout the book, reflecting not only the intercutting from present to past but also profound psychic divisions within Ruskin himself. Many of the book's best-known passages are tirades on the depravity and folly of *all* the actual, living figures that populate Ruskin's landscape of monuments. These gestures of alienation from the human race seem part of the impulse that led him in 1835 to sketch the city empty of people and the gondolas moving without guides, as though they would disrupt his communion with that sublimated humanity embodied in marble (in fact, his wife, Effie, once wrote that he dreaded going to church for fear of the filth of the crowds). The book is morbidly addicted to romance—to the dream of a time perfect because remote. Yet at the same time his aim (as we saw with *Modern Painters* II) is to escape aesthetic detachment from the human through a communion with aesthetic symbols viewed as real forms of love. In his longest and most famous chapter, Ruskin introduces the idea of an art Shakespearean in its acceptance, unbounded in its capacity to sympathize with human beings triumphing and suffering.

Theologically, the impulses to affirm and to condemn center on the paradox of the Fall; emotionally, they center on the paradoxical nature of ruins. Picturesque nostalgia celebrates the shadow of the absent on the present, preserving the lost object by simultaneously possessing and not possessing it. Similarly, Ruskin insists that Venice is a ruin in order to preserve her as the "richer inheritance" of memory. But this paradox is complicated by the more active energy of condemnation, which insists that Venice is a ruin in order to insist on her guilt. In this feminization of time, so to speak, the lost object of desire—in effect, the past itself—persists simultaneously as a goddess and a harlot, but the splitting of the female, in addition to releasing a powerful emotional ambivalence, releases a metaphysical ambiguity as well. If Venice sinned, then her fall can be rationalized as deserved punishment, yet

she survives in the book as Ruskin's capital of the imagination, charged with the fate of all things rare. The mystery of her fall challenges the intelligibility of Providence.

Ruskin's meditation on time, then, is both sentimental and metaphysical. The Venetian legend justifies the ways of God by means of a dialectic that illuminates the spiritual origins and possibilities of nineteenth-century culture, yet it also explores the obscure painfulness of all temporal existence, the mystery of the Lord's giving and the Lord's taking away. The questions it engages are the questions of Job, and they trouble the surface of Ruskin's piety, compelling his argument to deeper resolutions.

Ruskin expressed the anxieties underlying his metaphysical concerns in letters written during the two winters in Venice. These show a new anguish in his obsession with the loss of artistic treasures, since he now regarded that loss in the light of the religious doubts that had begun to assail him. One of these, the letter to Henry Acland of May 1851, contains the phrase that has since become a commonplace in Victorian studies: "[My faith], which was never strong, is being beaten into mere gold leaf, and flutters in weak rags from the letter of its old forms. . . . If only the Geologists would let me alone, I could do very well, but those dreadful Hammers! I hear the clink of them at the end of every cadence of the Bible verses." Our first object, he continues, must be "to find out what we are to believe, and what is to be the future root of our life. . . . [or] we shall only, I think, find out what roots we have got, by the edge of the axe laid to them" (xxxvi, 115). In January 1852, he wrote his father that he had no intellectual difficulties with the matter of religious belief but very many with the "*manner* of revealing it. The *doctrine* is God's affair. But the revelation is *mine*, and it seems to me that from a God of Light and Truth, His creatures have a right to expect plain and clear revelation touching all that concerns their immortal interests. And this is the great question with me—whether the Revelation *be* clear, and Men are blind . . . or whether there be not also some strange darkness in the manner of Revelation itself." He continues, "I would give all the poetry in Isaiah and Ezekiel willingly, for one or two clearer dates" (xxxvi, 127). On Good Friday of 1852 he wrote describing an anxiety attack that he resolved by acting as though the Bible were true, and this gave him peace for a time.

On Easter he wrote again, concerning his need to believe in the afterlife: "It makes *all* the difference whether one regards a vexation as a temporary thing out of which good is to come in future, or a *dead loss* out of a short life." Even art can be denied an afterlife: "But the Venetian Academy repaints a Paul Veronese, and it is as if the painter had not been born" (xxxvi, 138–139). And three days later: "One's days must be either a laying up of treasure or a loss of it; life is either an

ebbing or a flowing tide; and every night one must say, Here is so much of my fortune gone—with nothing to restore it or to be given in exchange for it; or, Here is another day of good service done and interest got, good vineyard digging" (x, xxxix). The antidote to religious doubt is justified work, which will similarly defeat time by converting it into treasure to be saved rather than spent. The loss of human works is the loss of life; analogously, the modern Venetians are time's scythesmen who by "restoring" buildings are destroying the works of the past and are therefore destroying life.

Ruskin most powerfully expresses the idea of paintings as embodied life in two letters of early 1852. Turner had died the year before, and his executors discovered in his garret scores of canvases in bad condition, some of them so deteriorated that the canvas had shrunk from the frame. Ruskin wrote his father:

> You say Turner kept his treasures to rot, not knowing or understanding the good it would be to give me some. Yes, but in the same way, I myself, through sheer ignorance of the mighty power of those Swiss drawings, suffered the opportunity of his chief energy to pass by, and only got the two—St. Gothard and Goldau. . . . But *I knew it not.* . . . This was not *my fault* . . . , yet it had this irrevocably fatal effect—leaving in my heart through my whole life the feeling of irremediable loss, such as would, if I were not to turn my thoughts away from it, become in my "memory a *rooted* sorrow". . . . Men are more evanescent than pictures, yet one sorrows for lost friends, and pictures *are* my friends. I have none others. I am never long enough with men to attach myself to them, and whatever feelings of attachment I have are to material things. [xxxvi, 125–126; x, 436n]

In the second letter Ruskin begs his father to take every chance to buy Turners at auctions, even to the amount of £10,000—because of what they would mean to *him:* "But do you count for nothing the times out of time you see me looking at them morning and evening, and when I take them up to sleep with? I have fifty pounds' worth of pleasure out of every picture in my possession *every week* that I have it. . . . if I should outlive you, the pictures will be with me wherever I am" (xxxvi, 134).

Underlying Ruskin's catalog of losses—the continuing destruction of Italian art, the death of Turner and the missed purchases, his own wasted time and misguided efforts, the threat, above all, of lost faith—stands the irredeemable solitude of a man who has transferred his affections to art. The letters imply moreover that the purchase of paintings had come to symbolize a paternal love purer than what his own father could give him; and as for his marriage, no comment could be more poignant than the claim that pictures were his only friends. In effect he took Venice as his bride, the city once sacred to his early and

forfeited love. The book he devoted to her voices the needs expressed in his letters by means of two intertwined purposes, the reaffirmation of faith and the preservation of life. He sets himself, in the first place, against the three hammers of the geologist, the restorer, and the Renaissance builder. By comparing his own work to geology, he makes clear early on that he sees himself as an archaeologist of the Word, providing clearer dates and harder evidence than Ezekiel and so healing the breach between science and religion opened up by the Renaissance. He sets himself, second, against the false restorers (or whom the Renaissance builders were the first) by restoring the dead stones to life—by his drawings, his careful teaching, and his imaginative resuscitation of the ancient monuments to the condition of their first "good vineyard digging." The Bible of the earth showed the geologists no traces of the Deluge, but if anything, a tale told by an idiot, spanning eons of dead tomorrows. Ruskin, reading the "language of Types" and the articulate stones of the Venetians, gave England a massive commentary on this Bible in marble, recording not the purposeless motions of wind and wave but a sea voyage and a Covenant and the workings of Providence through time.

The passage that expresses most openly the anguish and desire at the heart of *The Stones of Venice* immediately follows a discussion of the Byzantine style. Suddenly Ruskin breaks out in a voice like Job's:

> I do not wonder at what men Suffer, but I wonder often at what they Lose. We may see how good rises out of pain and evil; but the dead, naked, eyeless loss, what good comes of that? . . . the whole majesty of humanity raised to its fulness, and every gift and power necessary for a given purpose, at a given moment, centred in one man, and all this perfected blessing permitted to be refused, perverted, crushed, cast aside by those who need it most, . . . these are the heaviest mysteries in this strange world, and, it seems to me, those which mark its curse the most. And it is true that the power with which this Venice had been entrusted was perverted, when at its highest, in a thousand miserable ways: still, it was possessed by her alone. . . . That mighty Landscape, of dark mountains that guard her horizon with their purple towers . . . that mighty Humanity. . . . the majesty of thoughtful form, on which the dust of gold and flame of jewels are dashed as the sea-spray upon the rock, and still the great Manhood seems to stand bare against the blue sky . . . then judge if so vast, so beneficent a power could indeed have been rooted in dissipation or decay. It was when she wore the ephod of the priest, not the motley of the masquer, that the fire fell upon her from heaven. [x, 178–179]

Ruskin has been concerned to connect the Byzantine love of color with the late school of painters, including Titian, Tintoretto, Bellini, Giorgione, and Veronese, who for him stand at the apex of the Vene-

tian achievement. A single massive sentence enumerates that achievement in parallel clauses (beginning with "that mighty landscape," "that mighty Humanity," "the majesty of thoughtful form," "that mighty Mythology," and summed up by "the compass of that field of creation"), which are then followed by an affirmation. The complete paragraph, beginning with the colorists and ending with the religious origins of the city, establishes an unbroken genealogy, symbolized by the body of perfected Manhood, which is the shape of the city. Two other images of the city follow: the priest's garment set with stones, which symbolizes the discovery of color and is therefore the type of sanctified beauty, and the masker's garment, which is the type of unsanctified sensuousness. The imagery of the passage associates Venice with both genders yet also links the city to its cultural achievements as a pure mother to her sons, in which case the image and its suggestion—the continuity of generations amid apparent ruin—repeat the design of Tintoretto's *Annunciation*. Against this image Ruskin pits his anguished questions, which correspond to various statements in his letters, particularly those that express his mourning for the lost Turner drawings and those that assert the uniqueness of his need and his mission. The passage therefore counteracts fears of loss and separation with a fantasy of nurturing, but it cannot rationally resolve the contradictions Ruskin has raised: he does not know why loss is permitted or why the city turned harlot, nor can be answer them with a simple biblical faith. The Fall myth, however, suggests a symbolic resolution.

In *The Symbolism of Evil*, Paul Ricoeur describes myth as a means of achieving through narrative what cannot be expressed logically. In the case of the Fall story, what cannot be expressed logically is a contradiction: humans are sinful and sin is within us, yet at the same time sin is not our natural and complete condition. The Fall story, then, asserts the externality of sin and the "priority" of innocence to sin.[12] Ruskin's working out of moral dilemmas in his book is precisely of this sort: by means of a central paradox—that Venice is fallen and yet unfallen—he denies the priority of Original Sin. The unconscious wish concealed in the present passage is the fantasy of continued union with the undefiled mother,[13] but by transferring the wish onto cultural history,

[12]Paul Ricoeur, *The Symbolism of Evil*, trans. Emerson Buchanan (Boston: Beacon Press, 1967).

[13]In a brief psychoanalytic reading, Richard Ellmann suggests that "consummation and defilement were irrevocably united" in Ruskin's mind and that Venice passes from virgin to whore, the transition, presumably, being copulation. He also speculates that Ruskin chose the date of Venice's fall (May 8, 1418) because it preceded his own conception by exactly four hundred years (*The Golden Codgers* [New York: Oxford University Press, 1973] 45–50). These connections may indeed be present, but the interpretation would have to be qualified by the implications of the present passage. My argument is that the general symbolizing structure of ruins, by which the past is defiled yet survives in

Ruskin achieves a genuinely creative myth, with the force to revolutionize nineteenth-century society. For the myth of the pure birth, contained in the imagery of the maiden and the vine (the type, as Ruskin observed, "either of Christ Himself, or of those who were in a state of visible or professed union with Him" [x, 171]), provides symbolic hope: for the individual ego, hope for the survival of the original, pure energy of childhood through accidents and losses; for the historical ego, the survival of great art as a propulsive force for collective renewal, "making the whole infinite future, and imperishable past, a richer inheritance."

The Burning Legends

Ruskin's Fall story provides an emotional mode of viewing the world. The final chapter of the first volume, "The Vestibule," establishes this mode by guiding the reader along the roads and waterways that lead modern travelers to their first view of Venice. His dominant image is corruption, which like sin may perhaps be inevitable to organic life but is not its prior and natural condition. We see, for example, the Brenta, "A muddy volume of yellowish-grey water, that neither hastens nor slackens"; one of the villas on the Brenta, "a glaring, spectral shell of brick and stucco . . . all burning in the thick glow of the feverish sunshine"; another villa of the old Venetian type, "sinking fast into utter ruin, black, and rent, and lonely"; and something else we are not allowed to see ("At last the road turns sharply to the north, and there is an open space covered with bent grass, on the right of it: but do not look that way"). At the inn in Mestre one eats "peculiar white bread, made with oil, and more like knots of flour than bread." The buildings outside are cheerless and conventional. There is a rose arbor nearby, but the air smells of "garlic and crabs, warmed by the smoke of various stands of hot chestnuts." The voyage outward continues:

> we come to a low wharf or quay at the extremity of a canal . . . , which latter we fancy for an instant has become black with stagnation; another glance undeceives us,—it is covered with the black boats of Venice. We enter one of them . . . and glide away; at first feeling as if the water were yielding continually beneath the boat and letting her sink into soft vacancy. It is something clearer than any water we have seen lately, and of a pale green; the banks only two or three feet above it, of mud and rank grass,

spirit, serves also to join together other contradictions, conscious and unconscious—for example, the defilement of the mother alongside the fantasy of her continued purity, the inevitability of sin and the primacy of innocence, and so forth. (As I have mentioned, Ruskin gives several dates for the fall of Venice.)

with here and there a stunted tree; gliding swiftly past the small casement of the gondola, as if they were dragged by upon a painted scene.

The gondola takes us out along the canal, past the torn bastions of an old fort, as the scent of sea air grows and the banks widen to a reedy shore until we see a "low and monotonous dockyard wall . . . the railroad bridge, conspicuous above all things." The brick buildings at the end of it, "but for the many towers which are mingled among them, might be the suburbs of an English manufacturing town": "but the object which first catches the eye is a sullen cloud of black smoke brooding over the northern half of it, and which issues from the belfry of a church. It is Venice" (IX, 412–415).

The buildings crumbling into rents, the plain baking under the sun, the waters thick with weed, the air heavy with garlic and fumes (presumably diabolical) develop a mood of increasingly sinister anticipation, dramatically confirmed by the ironic reversals of the close. We turn out to be on an antithetical pilgrimage: the road leads generally east, but it is a "broad road," concluding in the railroad bridge heading for the mouth of hell rather than the Heavenly City. The line of the bridge guides our eye to the significant object, like a line in Tintoretto, while at the same time displacing its own smoke onto the church, as though to suggest a polluted union of the religious and the mechanical, whose product is blasphemy and darkness. The anticlimax is nevertheless an epiphany: Italy is under a strange curse, of which the cloud is the emblem and the lingering trace.[14]

The complex emotional effect of this passage—one of the most complex Ruskin ever achieved—depends on his use of hypernormal attention to detail to create the impression of memory or dream. Dreams and memories are not, of course, as clear as waking life; attention is simply distributed differently, by agencies other than the pragmatic ego, so that the being of things may take on an unaccustomed power. Here the trope of the leisurely journey ritualizes the order of sensations, making the viewer passive before the procession of scenes. At moments when Ruskin slips into half-playful animation—the scenes "dragging by" or the gondolas black like stagnation—he resembles Dickens and that remarkable experiment in the grotesque, "Childe Roland to the Dark Tower Came," which this passage anticipates by a

[14]Clegg notes that the smoke rises from the belfry because the church is being used as a steam flour mill. On the voyage along the Brenta, Richard Stein comments: "The borders of art and life have dissolved. We are meant to feel the confusion as well as the power of an experience at once fictional and true, vivid and substantial at the same time as it is vague and atmospheric. . . . This mythic journey supports a concept of history, both past and present. The journey motif dramatizes the idea that our world, like that of Venice, is symbolic, one in which every object and experience is endowed with meaning" (p. 88).

few months. More important, the faintly uncanny quality of Ruskin's grotesque resembles a literature still struggling to be born, the urban dreamscape of Baudelaire and his symbolist followers. Things are eerie because they are charged with indeterminable significance: the ordinary becomes *unheimlich,* and the "it" of the final sentence a vaguely apprehended domain of evil by which the past dooms the present.

With this note Ruskin brings down the curtain on the first act of his melodrama. When it rises (after a two-year intermission for his first readers), we find the gondola coursing northward toward Torcello and backward in history to geological time. Like Eden, which is the central point of the world and the meeting of four waters, Venice (whose seat is carefully prepared by minute adjustments of land and water level) is the meeting of powerful historical currents—the Arabian, the Lombardic, and the Roman—that mingle ultimately in the Ducal Palace, the "central building of the world." Since the Council Chamber contains the greatest painting in the world, Tintoretto's *Paradise,* the Venetian empire takes the form of concentric circles, from the united waters to the city, the building, and the room with the picture, the last suggesting that the City of Man has here become the type of the City of God. According to Northrop Frye, the romantics, tending to consider civilized life artificial and debased, reattached value to wilderness and associated human nature not with the life of reason, placed "above," but with forces rising from "below" or "within."[15] Ruskin, recasting the romantic schema in social terms, imagines the relations of man and nature as a complete interpenetration. Cast upon the waters of exile, the Venetian forefathers made the sea their fortune; similarly, the body of their city is literally composed of the precious stones that surround her in the mountains, imitating the forms of waves and flowers and leaves. This organic body is of course the perfect form of purity as described in *Modern Painters* II and as such stands against the inorganic body—the slime and smoke of corruption described in "The Vestibule."

Thus humanized, nature is not "improved," as neoclassical theory would have it, but "interpreted," as Ruskin makes clear in the first volume when he compares the making of buildings with the making of sermons:

This infinite universe is unfathomable, inconceivable, in its whole; every human creature must slowly spell out, and long contemplate, such part of it as may be possible for him to reach; then set forth what he has learned of it for those beneath him . . . and then the human being has to make its power upon his own heart visible also, and to give it the honour of the

[15]Northrop Frye, *A Study of English Romanticism* (New York: Random House, 1968), 32.

good thoughts it has raised up in him, and to write upon it the history of his own soul. [IX, 409–410]

Architecture, then, is the ordering of both the natural flux and human temporal experience, an activity perfectly described by the symbol of weaving. In fact woven decorations are particularly interesting to Ruskin because they figure forth "the intricacy, and alternate rise and fall, subjection and supremacy, of human fortune; the 'Weave the warp, and weave the woof,' of Fate and Time" (x, 163), thereby demonstrating the consonance of human creativity and Providence. In other words, the builders weave the Book of Nature into a Book of Scripture, rendering articulate the words of stones, water, and vegetation in order to repeat and affirm the myth of Redemption. But that myth is also their own spiritual history, the faith defining the cultural unity that is Venice.

The script of that history Ruskin calls the language of types, and from first to last typological imagery structures his vast narrative. In the first glimpse he gives us of the ancient Venetians, we see them fleeing across the waves in boats, with the skies still red from the sacking of their homelands. This crossing by water, an image we will meet again and again, compresses Noah's flood, the flight from Egypt to the Promised Land, and the type of all believers who find their resting place in Christ: the church at Torcello is "an ark of refuge" built "in the midst of a destruction hardly less terrible than that from which the eight souls were saved of old" (x, 34–35). Ruskin here shows human history rising, like the soul itself, from vague and confused memories of a sea of being. The dry land has not quite appeared, and the single work of human hands, more boat than building, shows the race still helpless in the hands of God; yet by virtue of that dependence, men are in unmediated communion with their Creator (x, 35).

The second scene in this book of illuminations is the island of Murano, with the ancient church of San Donato. Using the crumbling stones before him and the childlike legends preserved in dusty volumes, Ruskin imagines the church as it was in ages past—"the Garden of Venice, 'a terrestrial Paradise,—a place of nymphs and demigods!' " The ruins at both Torcello and Murano contain great mosaics of a sorrowing madonna blessing the worshipers and interceding for them on the Day of Judgment. Ruskin praises these mosaics, not, he is careful to point out, in defense of mariolatry, but because they were the emblems of sincere belief, for these early worshipers "*did* honour something out of themselves; they did believe in spiritual presence judging, animating, redeeming them" (x, 65–68). This faith is the mark of innocence as a form of complete, childlike trust. We are still in the childhood of Venetian history, and Mary, the sorrowing intercessor, is both virgin and Mother.

As civilization begins to flourish in Lombardy, Ruskin passes from marshland to island to mainland: the dry land seems to gather itself out of the sea, bearing the new Tyre—the city that was of old "as in Eden, the garden of God" (IX, 17). Ruskin's task is now to define the mature Byzantine style through a detailed account of St. Mark's, the greatest example of the first Venetian school, but the typological narrative continues alongside the exposition on four levels. Out of the waters rose the dry land; after the Deluge rose a rainbow; in the desert beyond the Red Sea rose a Tabernacle; after baptism the believer enters the body of the church. St. Mark's is all these things—a garden, a rainbow, a temple, and also a book and a Bride—yet her body is composed of precious stones. Stones are the dominant image of this region of the book, as water was the dominant image of the first.

The famous paragraph describing the first view of St. Mark's is a catalog of precious substances: the church is "a treasure-heap, it seems" of gold, opal, mother-of-pearl, alabaster like amber and ivory, jasper, porphyry, deep-green serpentine, marble of every color, coral, amethyst. But it is an animate treasure heap, crowded and leaping with life, bearing in its ornament all the innumerable forms of the created world:

> sculpture fantastic and involved, of palm leaves and lilies, and grapes and pomegranates, and birds clinging and fluttering among the branches, all twined together into an endless network of buds and plumes; and, in the midst of it, the solemn form of angels . . . , their figures indistinct among the gleaming of the golden ground through the leaves beside them, interrupted and dim, like the morning light as it faded back among the branches of Eden, when first its gates were angel-guarded long ago.

The eye of the beholder rises and rises, as if scaling an Alp, past the porches and into a "continuous chain of language and of life," then farther still, above the Greek horses and the Lion of St. Mark to a culminating image of complete rapture: "until at last, as if in ecstasy, the crests of the arches break into a marble foam, and toss themselves far into the blue sky in flashes and wreaths of sculptured spray, as if the breakers on the Lido shore had been frost-bound before they fell, and the sea-nymphs had inlaid them with coral and amethyst" (x, 82–83). The body of Venice is woven of stone and water; the body of the church is woven of treasure and energy, representing first animate forms and then, at its highest point, not animate form but, it would seem, the very principle of life, the creative surge of the divine spirit in matter. As traders the Venetians converted the ocean into wealth, and as builders they froze the waves into marble, consecrating the elements, as it were, by rendering up their treasure in the shapes of leaves and birds, wind and water. The church is both the visible form of God's

revelation and the spiritual form of Venetian prosperity; for in this Puritan epic, where prosperity is the outward sign of grace, the sea, the cargo, and the merchant's ledger find their counterpart in the cathedral, whose stones are a type of the kingdom of Heaven, bestowed unto this last: "above the crowd swaying forever to and fro in the restlessness of avarice or thirst of delight, was seen perpetually the glory of the temple, attesting to them . . . that there was one treasure which the merchantman might buy without a price, and one delight better than all others, in the word and the statutes of God" (x, 140).

Ruskin takes us into the church through the baptistry, as every Christian joins the church through baptism, to be washed of sin and return to the estate of our first parents. But the garden inside is dominated by the image of the cross, suggesting, as Ruskin says later on, the "entire dependence of the heavens and the earth upon the work of the Redemption"—for the iconography of the church resembles that of illuminated Bibles where the Creation ends in the Crucifixion, "the work by which all the families of created beings subsist" (x, 167). This is not the Eden of Genesis but the redeemed creation, in which the second Adam and his Bride take the place of our parents who fell. At the same time, the Venetian garden is neither the innocence of childhood nor a noble savagery but the *natural* state of redeemed man, just as the cross, the symbol of redemption, closely imitates the Tree of Life. In the mosaics of the central domes are two more symbols with similar meanings: the Dove of the Holy Spirit amid four streams of Pentecostal fire, and Christ enthroned on the rainbow, the "type of reconciliation" (x, 136). But for Ruskin the whole Creation is a rainbow: "In that heavenly circle which binds the statutes of colour upon the front of the sky, when it became the sign of the covenant of peace, the pure hues of divided light were sanctified to the human heart forever." In imitation of this sacred chord, the Medes built a seven-walled city, with each wall of a different color surrounding the king (who therefore wears, like Joseph—and indeed like God Himself—a coat of many colors) (x, 174–175).

Venice is also a city bright as a rainbow, an appropriate image for an art that is itself the mark of a covenant, since its forms are the works of God's hands inscribed by human thought. The famous "variegated mosaic" of Europe is therefore the perfect introduction to the following chapter, "The Nature of Gothic." As the eye moves from south to north, we see a geographical portrait of two temperaments—the southern races refined and luxurious, the northern hardy and "rude"—that also correspond to the Byzantine and Gothic styles, the one warm and encrusted with jewels, the other roughly carved with branchlike forms. The "reading" of Europe is a fairly subtle addition to Ruskin's typological structure (the continent is here an ordered "chord of colour,"

the view that of a bird's), but bird and rainbow will reappear resonantly at the end of the subsection on Gothic naturalism: "The great Gothic spirit, as we showed it to be noble in its disquietude, is also noble in its hold of nature; it is, indeed, like the dove of Noah, in that she found no rest upon the face of the waters,—but like her in this also, 'LO, IN HER MOUTH WAS AN OLIVE BRANCH, PLUCKED OFF'" (x, 239).

The controlling image of this section is vegetation, with its typological associations—in addition to the olive branch and the garden, the bounteous land that the Israelites entered with the Tabernacle and the Arc of the Covenant, and the vineyard of the Lord, the type at once of Christ and the body of His communicants. If we step back and look at the book in its archetypal design, we would first see children in an ark, then a city rising like a Bride (as a spiritual Jerusalem does in Isaiah and Revelations), then a Man rising beside her to govern, like the Messiah—a partnership we can still see in the Ducal Palace standing beside St. Mark's in the Piazza. Both styles express Venetian spirituality at its zenith, but in complementary ways. Although both take the form of a sculptured garden, Ruskin stresses preciousness in one case and natural imagery in the other; temperamentally, of course, one is southern and the other northern. Morever, since Ruskin had seen few examples of the Byzantine style, he had to limit himself to external description, giving only a few brief conjectures about a "spirit of Byzantine," but the exposition of Gothic is dominated precisely by an account of its spirit or governing ethos. In this respect the chapters on St. Mark's and the Gothic culminate the aesthetic dialectic of *Modern Painters* II, in which the style of Angelico and the style of Tintoretto broaden into a polarity between the beautiful and the imaginative and between purity and strength—very much like the traditional symbol of the eagle and the dove. This I take to be the marriage metaphor at the heart of *The Stones of Venice* (and in the passage I have cited from x, 178–179), identical in structure to the Blakean marriage of Albion and Jerusalem, the soul and its emanations, the creator and his creations. But this myth of complementarity is also a myth of development, as Ruskin's history of Venice to this point suggests, a development marked by three stages in the relationship of the self to nature. In the first the personality is not clearly distinguishable from the waters out of which it rises but remains subordinate to a maternal image. In the second the union of man and nature is set aside in the form of an object, which is rendered up and sanctified; in this stage nature is an objectified anima, but not alienated from the subject. In the third stage the ego emerges as an activity of self-assertion, strengthened by communion with something greater than itself. Nature is the image both of that communion and of the soul's own internal organic relationships.

This is of course the structure of the Ruskinian sublime as well: by submission to an overwhelming vision, the self reconstitutes itself at the center of its own imaginative vision.

The central achievement of "The Nature of Gothic" is to restate in social terms the idea of a great soul whose energies are ordered by an imperishable principle of selfhood. For this purpose it uses the imagery of romantic organism—specifically, the single image of a Gothic cathedral—which acts not simply as an illustration of the argument but as the continuous visible manifestation of the argument at every point: it is thought sunk in sensuous form. The six characteristics of Gothicness (Savagery, Love of Change, Love of Nature, Grotesqueness, Rigidity, Redundancy or Generosity) constitute a specific personality (as everyone has noticed, they describe Ruskin himself), but I will limit my discussion to the first three, since these in particular describe the human spirit in the "Edenic" state—mankind as Milton conceived them and as God intended them.

Savagery and Love of Change, which blend together, express "some great truths" that according to Ruskin the human race must understand "in all their work that they do under the sun." These are "the confession of Imperfection, and the confession of Desire of Change" (x, 214). The key terms of the entire exposition are "perfection" and its opposite, which act as portmanteau words, yoking a group of analogies into the similitude of a single organic conception. To see that conception clearly, along with its ambiguities, we need to distinguish some of its interrelated strands.

"Perfection" and "imperfection" are, first of all, key counters in an argument about artistic styles. In *Modern Painters* I Ruskin said that lack of finish was appropriate to subjects that exceed the artist's mastery, so that "sketchiness" becomes an expressive mark, the mark of the artist's power. In "The Lamp of Life" he said that imperfections characterize the vitality of an art style in its early stages, because at that point the struggle to conceive is of greater importance than subservience to standardized rules—the artistic energy, that is to say, is internal, not imposed, like the energy that distinguishes an organic entity from a mechanical one. This is of course the idea restated by Browning in "Andrea del Sarto" ("A man's reach should exceed his grasp, / Or what's a heaven for?"), yet both writers trivialize that idea in the examples they draw: Browning's Andrea oddly believes that Raphael is an inexpert draftsman, and Ruskin's examples of Gothic "rudeness" are similarly technical imperfections, such as rough carving, which could be corrected in a moment. This kind of imperfection seems beside the point, yet for Ruskin at least the idea fulfills a crucial aim: he wants to make a place for inferior skill in the construction of a church, so that truly to experience Gothic architecture is to experience "the still, sad

music of humanity" in its range of voices ("and then the human being has to make its power upon his own heart visible also, and to give it the honour of the good thoughts it has raised up in him, and to write upon it the history of his own soul" [ix, 410]). The divine revelation, we may conclude, can only be known through the numberless testimonies of fallible but believing hearts.

So far the Ruskinian Gothic appears to be an aesthetic correlative of laissez-faire, in which every effort for an individual good sums up to a society, the greatest good for the greatest number. But for Ruskin, laissez-faire economics really means that each individual good is gained at someone else's loss—and this is precisely the opposite of the Gothic spirit. A second meaning of "imperfection" in the aesthetic argument is that quality of something by virtue of which it gains meaning only as part of a whole. On the purely perceptual level, this quality is individual difference, because when all units are identical, they become superfluous or detachable—the gestalt cannot work, things do not leap together. For this reason, in his discussion of Imagination Associative in *Modern Painters* ii, Ruskin claims that the great artist builds organic wholes in an all-at-once intuition, fusing parts that are in themselves incomplete or imperfect—and this unity, Ruskin says elsewhere in the same book, resembles the unity of the human race itself, which is composed of various excellences that could not be combined in any single person. Because the medieval organization of labor permits every worker the expression of his particular excellence, a Gothic church lives in detail, however unskillful in execution. Each stone bears the mark of a particular human testimony and therefore preserves a human life. This power of architecture to express or deny the spirit of the worker inheres, moreover, in any system of labor exchange. An economy is, for better or worse, traffic in human life—and this fact leads Ruskin to his first rule of humane consumption: "Never encourage the manufacture of any article not absolutely necessary, in the production of which *Invention* has no share" (x, 196).

Because aesthetic qualities are types of moral qualities, Ruskin's aesthetic argument becomes by untraceable shifts an argument for Christian humility: the Gothic, as John Rosenberg put it, confesses the Fall.[16] According to Ruskin, the Christian makes daily admission of "lost power and fallen nature" because it tends, in the end, to "God's greater glory." To every person in her service, "Christianity" exhorts, "Do what you can, and confess frankly what you are unable to do; neither let your effort be shortened for fear of failure, nor your confession silenced for fear of shame." And so the "Gothic schools" receive "the labour of inferior minds; and out of fragments full of imperfec-

16Rosenberg, 96.

tion, and betraying that imperfection in every touch, indulgently raise a stately and unaccusable whole" (x, 190). In the aesthetic argument"perfection" is the tyranny of neoclassical order; in the social argument, an economic tyranny that divides the labor and therefore the souls of human beings into mechanical fragments; in the moral argument, the tyranny of inflexible conscience. To be delivered of that conscience, to be released from the fear of shame and failure, is to enter the Garden again—the garden not of perfection but of spontaneity and exuberance, the unconsciousness which, Carlyle said, is both wholeness and health. Here Ruskin's Fall myth converges with the Wordsworthian myth of childhood, since for Ruskin "perfection" means not only a fall into self-knowledge and self-doubt but also an internalization of the world's demands as well—avarice, pride, ambition, and all the glittering vices associated with the Old Masters in *Modern Painters* i and in the present book with Renaissance builders. But the Gothic makes room for the childlike even though it is not itself childlike: the best architecture, Ruskin writes, is "the expression of the mind of manhood by the hands of childhood" (x, 200). Ruskin's habit of viewing workmen as children—one of the unattractive features of his social thought—suggests on the level of the moral argument that architecture symbolically enacts the continuance of the original, fresh energy by supplying a principle of governance lacking in childhood. In all this, the opposition of perfection and imperfection implies an opposition between two versions of Protestantism, romanticism and Puritanism, with the Gothic representing a casting out of Puritanism, which is then identified with its apparent antithesis, the spirit of secular rationalism.

What permits such variegated parts to form any unity at all? How does the sum of imperfections become "stately and unaccusable"? Ruskin's mediating category is the idea of style as ethos. The physical characters that stamp a building as "Gothic"—pointed arches, pierced window traceries, and so forth—are but the expressions of a particular mode of energy. Throughout Ruskin's exposition, vegetation, the usual symbol of organic unity, is the signature of the mode of energy known as Gothic: in its curling and wreathing and springing, its rigidity, even its prickliness and eccentricity, it is always at liberty because always, so to speak, obeying the laws of its own nature. We have reached yet a third level of the argument, the necessary imperfection of nature. To the romanticist the world is knowable only as process— the burgeoning energy that always creates itself anew, nowhere manifesting itself in the same form. To such a view, neoclassical order (like empirical abstractions) must seem only to reduce this variety to a rigid uniformity imposed from outside and to deny energy altogether. For Ruskin imperfection is "essential to all that we know of life. It is the

sign of life in a mortal body, that is to say, of a state of progress and change. Nothing that lives is, or can be, rigidly perfect; part of it is decaying, part nascent. The foxglove blossom,—a third part bud, a third part past, and a third part in full bloom,—is a type of the life of this world" (x, 203). In this context to confess "lost power and fallen nature" is to confess the human participation in the natural stages of generation and decay. Thus affirmed, mortality can be understood as the condition of growth. Time is the felix culpa, since whatever moves toward death discloses its being in an arc of change, a condition, Ruskin believed, that prevailed in the biblical garden itself.[17] The infinite, original energy of childhood is preserved within the structure of an ego strong enough to accept all that is at enmity with childish joy.

Acceptance is thus the new spirit of Ruskin's naturalism, which reaches its culmination in his exposition of the third characteristic of Gothic, Love of Nature. Here "imperfection" refers not to the workman's powers but to his subject, which in turn defines the Gothic spirit in terms closest to that of an individual human ego. We saw earlier that Ruskin believed his knowledge of the human to be much inferior to his knowledge of nature. His fear was overcome by his sudden and passionate response to the human art of Tintoretto. We saw also that the theory of penetrative imagination provided a fiction of incorporation, which implied that knowledge of the human was possible *through* the study of art. *The Stones of Venice* heals the breach between landscape as a subject and mankind as a subject by showing how the human soul can be inscribed on natural materials through the medium of natural imagery. ("The Lamp of Power" demonstrates the same point.) Moreover, since sculptured flowers and leaves are the Venetians' compensation for a vanished life in nature, architectural ornament becomes a symbol for the incorporation of lost objects, a symbol, that is, for the creation of a self. "The Nature of Gothic" in fact equates the incorporation of natural motifs with the incorporation of the human: Ruskin splices the Gothic love of nature together with a revised theory of the human subject in painting.

Painters, he tells us, can be divided into three categories, according to their characteristic choices of subject—Purists, Sensualists, and Nat-

[17]In one of the early *Letters to a College Friend*, Ruskin concludes that there was death in the Garden, since death is found in the very seed of life: "that which has not in it the beginning and germ of death, is not a tree. . . . the very meaning of the word flower is something to supply *death.*" But at the same time, he believes that "man in Eden was a growing and perfectible animal; that when perfected he was to have been translated or changed, and to leave the earth to his successors without pain. . . . I believe the whole creation was in Eden what it is now, only so subjected to man as only to minister to him—never to hurt him." Even here, Ruskin's conception of Eden is not static or "perfect" (I, 476, 478). Later in his life Ruskin associates the seed with the beginning of death and the flower with fulfillment.

uralists. Members of the third and greatest group, which includes Giotto, Tintoretto, and Turner, "render all that they see in nature unhesitatingly, with a kind of divine grasp or government of the whole, sympathizing with all the good, and yet confessing, permitting, and bringing good out of the evil also" (x, 222). The most obvious shift from *Modern Painters* II is Ruskin's denigration of Angelico and the "School of Love" to a second rank, on the grounds that the Purist withdraws from the world in cloistered virtue and depicts man as similarly withdrawn. But the greatest art takes as its subject all the passions "natural" to human beings: "The passions of which the end is the continuance of the race: the indignation which is to arm it against injustice . . . and the fear which lies at the root of prudence, reverence, and awe, are all honourable and beautiful, so long as man is regarded in his relations of the existing world." A semicolon in place of the colon would probably convey Ruskin's meaning better; the passions are three—sexuality, indignation, and religious dread—from which both the monk and the happy child need protection. The great naturalist, then,

> takes the human being in its wholeness, in its mortal as well as its spiritual strength. Capable of sounding and sympathizing with the whole range of its passions, he brings one majestic harmony out of them all . . . he casts aside the veil from the body, and beholds the mysteries of its form like an angel looking down on an inferior creature: there is nothing which he is reluctant to behold, nothing that he is ashamed to confess; with all that lives, triumphing, falling, or suffering, he claims kindred, either in majesty or in mercy, yet standing, in a sort, afar off, unmoved even in the deepness of his sympathy; for the spirit within him is too thoughtful to be grieved, too brave to be appalled, and too pure to be polluted. [x, 226–227]

This famous and climactic passage turns out to be radically ambiguous. In proclaiming the ideal of a Shakespearean comprehensiveness of sympathy and a Shakespearean omnipotence of judgment, Ruskin must nevertheless imagine the artist himself to be pure, "in a sort, afar off," and the body, though released from shame, nevertheless an inferior object. Is the statement not more Purist than Naturalist? The stance is uncomfortably close to Tennyson's Arthur, in the poem that Ruskin's book so closely anticipates in theme and subject, at the moment when Arthur finishes reviling his fallen queen: "Lo! I forgive thee, as Eternal God / Forgives: do thou for thine own soul the rest" ("Guinevere," 541–542). By our standards Ruskin's specific judgments remain very much in the Purist vein. Murillo, for example, he judges a Sensualist, citing a picture in which two beggar boys devour fruit: "But is there anything else than roguery there, or was it well for the painter

to give his time to the painting of those wicked and repulsive children? Do you feel moved with any charity towards children as you look at them?" (x, 228). Certainly they would have devastated the garden at Herne Hill. Ruskin banishes perfection, along with cloistered virtue, only to let it return in the old figure of the supreme genius, stately and unaccusable, protected by aesthetic distance from the turbulent mortal life he in some sense embraces.

As a moral idea "The Nature of Gothic" remains ambiguous. Ruskin's argument praises a variety of moral qualities, many of them inconsistent: spontaneity, vitality, independence; humility and reverence; generosity, acceptance, mercy; a passion for justice; and also what must appear as rigidity and condescension. Because the Ruskinian Gothic contains a part that governs and forgives and a part that labors and is forgiven, the essay appears to prescribe humility, yet may also be read as a prescription for spiritual pride. It leaves unclear one's precise relationship to one's own failings and one's own sexuality (the word "confession" lets Ruskin have it both ways, since the word implies recognition of a general condition), and it also leaves unclear the line dividing what one may forgive from what one must condemn. But the greatness of "The Nature of Gothic" as a moral idea rests not on the particular values it upholds but on its conception of the conditions of the moral life. The Gothic is, first of all, not a collection of traits only but the organic principle of a community: the stones of a Gothic church are types of the community of the faithful as they will be judged by a merciful God, and its structure is the paradigm of an ideal human economy. But the church is also the body of Christ, and in this regard the Gothic is the spirit of an ideal Christianity. By sinking his moral argument in architectural description, Ruskin mediates between a particular building and an invisible idea, adumbrating at once the values of Protestantism and the power of a religious community to enfold and uplift its communicants. This is perhaps the last text in English romanticism to embody Miltonian Protestantism, with its vigorous independence, its sweetness as well as its strength, and its passionate belief in the idea of a Commonwealth. The Gothic, I have said, is the spirit of man in Eden—as Milton also imagined him—and this statement leads to the second point. The organic structure of Gothic is typical of the structure of the integrated ego, a principle of self-governance that harmonizes all impulses and failings and gives purpose to all moral actions. The symbol of vegetation unifies the two realms of the communal ego and the individual ego by locating the center both within and without.

The rudeness that heaves upward the "iron buttress and rugged wall"; the changefulness that "flickers feverishly around the pinnacles, and frets and fades in labyrinthine knots"; the rigidity "here starting

up into a monster, there germinating into a blossom, anon knitting itself into a branch"; the redundancy, "which feels as if it could never do enough to reach the fulness of its ideal"—these energies circle, so to speak, around a rooted naturalism that draws spiritual nourishment from the "grass of the field which is, at once, the type and the support of human existence" and so is as noble in its "hold of nature" as the Gothic is "noble in its disquietude." Ruskin figures this "hold of nature" as the dove holding the olive branch, a symbol of the coming of Gothic that answers the earlier image of the fugitives fleeing by sea. The olive branch also symbolizes the peace that passeth all understanding; for the dove and olive are typologically related to the Holy Spirit and the vine that is the type of Christ and His believers, "that ancient religious root, in which to abide was life, from which to be severed was annihilation" (XI, 70). This abiding is spiritual nourishment, the condition by which the outside becomes the inside. The moral strength so nourished we might today call ego strength or ego integrity. Ruskin provides a different name but one we have not yet encountered.

Ruskin wrote his father that everything in the first two volumes would come together in the chapter on the Ducal Palace (X, 327n). The plan makes sense: after an exposition of the Gothic spirit, Ruskin would then turn to the "central building of the world," a palace of justice combining all the essential Venetian styles, and would begin reading its stones for the embodied wisdom of this, the climactic moment of European culture. But even Ruskin could not make the damaged ornaments of the Palace bear so much meaning. Instead he gives a tedious account of each of the 8-sided capitals supporting the outer walls—36 capitals in all (including the bad Renaissance copies), 288 sides. But on one of these Ruskin finds an emblem that could represent the thematic cornerstone of his entire work. The subject is Temperance. As he shows in the third volume, this virtue means not "subdued and imperfect energy" nor a "stopping short in any good thing" but rather "the power which governs the most intense energy"—his example is the curvature of a Gothic ornament, expressing a "reserve of resource" in the whole (XI, 7, 9). Having exalted the savagery, rudeness, redundance, and prickly waywardness of Gothic, as though to prove that the road to wisdom is through excess, he now claims that Gothic is really temperate and the Renaissance intemperate, and he does so by picturing temperance as the intense point at which restraint and release become indistinguishable—a Golden Mean whose extremes are the two types of exhaustion exemplified by the Renaissance, repression and dissipation. The move is inevitable, given Ruskin's habit of viewing the virtues as modes of regulating energy—the ethical counterpart, so to speak, of his dynamic Aristotelianism—and as we will see, the theme becomes one of the leitmotifs of his career, from at least as early as "Moderation or the Type of Government by

Law" in *Modern Painters* II (where he calls it the most "essential" attribute of beauty because the "girdle and safeguard" of the rest) through such later books as *Unto This Last* and *The Queen of the Air*, where it is associated with Justice and then with Wisdom, personified by Athena. In the context of Gothic naturalism, Temperance is the "divine government" of the great artist and also that law by which organic beings move and develop according to their inherent nature. In Ruskin's thought this virtue occupies the place that Reason occupies for Blake—as the bound and outward circumference of energy—and so must be distinguished from repression as Blake distinguishes Reason from Urizenic laws.

That Temperance should be the ruling virtue of a writer so well known for his extravagance and his fondness for antitheses ought not to seem as strange as it does. On one hand, he tells us, his cast of mind is medieval in that it defines virtues in terms of opposing vices, but these oppositions often turn into spectrums in which the good acts as the synthesis of tendencies that are bad only in extremes. The tripartite structure sometimes imitates the organic cycle of growth, maturity, and decay, so that the interplay in Ruskin's thought between tripartite arcs and polar oppositions represents (to put it simply) the structural expression of his uneasy synthesis of organic philosophy with Evangelical morality. In *The Stones of Venice* the dialectical structure of paradise and fall accompanies an equally marked set of tripartite patterns: three volumes, three major periods, three zones in the map of Europe, at the center of which stands the Gothic. The Gothic is defined in terms of its antithesis, the Renaissance, but also in terms of its mediating position: it is the midpoint between Purism and Sensualism and also the zenith of Venetian history before Renaissance excess, the point when assertiveness meets reverence in the perfect harmony of self-government. In symbolic terms, the virgin and the strumpet meet in the synthesis I have associated with the Apocalyptic Marriage, which for Ruskin is also the moment when the self fully incorporates the world. *Only at this point of synthesis can the body be accepted,* and the human being taken "in its wholeness, in its mortal as well as its spiritual strength."

The Anatomy of Alienation

Ruskin's Venetian tragedy takes place in five acts, in which the early periods and the Byzantine (with their imagery of water and treasure) correspond to rising action, the Gothic the turning point (since, rather mysteriously, we are told that the Fall issues from a weakening of Gothic strength), and the Roman and Grotesque Renaissance the falling action. Throughout the second volume Ruskin continually reminds us of the Fall by juxtaposing past and present in the mythic and ironic

modes. Venetian piety, on the one hand, is represented by anima fig-
ures—the interceding Virgin of Murano, the Bride of St. Mark's, and
of course the queen of the seas herself—and each has her antithesis. In
Murano the people worship a Romanist idol, a more wretched relative
of the stuffed Pope in *Past and Present:* "With rouged cheeks and
painted brows, the frightful doll stands in wretchedness of rags, black-
ened with the smoke of the votive lamps at its feet." Beneath the origi-
nal figure in the apse stands the inscription, "Whom Eve destroyed, the
pious Virgin Mary redeemed" (x, 68). In "St. Mark's" the shops contain
prints of the Virgin presiding over heaps of produce, while in the
Piazza itself are "vendors of toys and caricatures," the idle middle
classes reading empty journals, and above all the "unregarded chil-
dren" standing before the sculptured Bride, who curse and quarrel,
"clashing their bruised centesimi upon the marble ledges of the church
porch" (x, 84–85). In Murano the rag doll Virgin is a prostitute to
debased religious desires. The Bride of St. Mark's, proclaiming the
treasure of Wisdom, is opposed by the madonna of the melons, an
unredeemed Eve presiding as a goddess of traffic. And the treasure
heap of the church is opposed by the "bruised centesimi," signifying
that the money changers are in the temple—and the pigeons have
nothing to do with the Holy Spirit.[18] The figure of the city herself as
harlot—the image of commerce sexualized—needs no comment. But
the most forceful antithesis of all is the portrait of the bead factory in
"The Nature of Gothic," in which the integrity of spiritual energies in
Gothic—the fulfillment and union of head, heart, and hand—meets its
opposite in the modern workers, "small fragments and crumbs of life,"
who as slaves of labor are condemned to enact not their own sins, like
Dante's lost souls, but the primal sin of Renaissance self-division. All
day they chop glass rods into proliferating bits, "their hands vibrating
with a perpetual and exquisitely timed palsy, and the beads dropping
beneath their vibrations like hail" (x, 196–197).

The Renaissance is for Ruskin primarily a split between head and
heart. In terms of architectural ornament, he imagines this as a split-
ting of the language of types (the union of head and heart) into the
extremes of blank walls and obscene ornament.[19] The first of these

[18]Rosenberg, 91–92.

[19]The example of the Revolutions of 1848 may also inform Ruskin's attack on the
Renaissance, which bears close resemblance, once again, to Coleridge's treatment of the
French Revolution in *The Statesman's Manual.* For Coleridge the revolution represented a
final disorder on the social level of the proper relations between Reason, Religion, and
Will. Reason, "as the science of All as the Whole, must be interpenetrated by a Power,
that represents the concentration of All in Each," that is, by Religion. But when the two
powers are separated (as in Eden, when Reason fell "in itself"), the first tends to visionary
abstraction that appeals to base instincts in order to install a tyranny; the second tends to
an idolatrous preoccupation with the particular: "Arm in arm with sensuality on one side
and self-torture on the other, [it is] followed by a motley group of friars, faquirs,
gamesters, mountebanks and harlots" (pp. 64–65).

expresses what Ruskin calls pride of knowledge. As the six characteristics of Gothic all flow from the first, a confession of imperfection, so do the four characteristics of the Renaissance spirit—Pride of Science, Pride of State, Pride of System, and Infidelity—flow from pride of knowledge. Upon the sweet imperfection of burgeoning forms that was Gothic at its finest (which had, however, started to weaken on its own) descends the unnatural, schoolmasterly restraint of Renaissance perfection—a cold, haughty, joyless spirit without life or virtue or belief. The new architecture overwhelmed the older sculptured gardens with blank pediments and monotonous geometry. The result was a violent reaction in the disordered soul of Venice. Deprived of the pleasures that were natural and innocent, the Venetians loaded down their marble salons with sensual images until, in the late stages of decline, they turned to an art of debauchery and depravity—what Ruskin calls the "Grotesque Renaissance," "a spirit of brutal mockery and insolent jest, which, exhausting itself in deformed and monstrous sculpture, can sometimes be hardly otherwise defined than as the perpetuation in stone of the ribaldries of drunkenness" (xi, 135). To this wreck we owe the modern factory system, the great prisonlike cities, the deadness of neoclassicism in art, and a great many other evils, general and specific.

Ruskin's unifying image of the Renaissance spirit is an organism cut off at the roots (or rather from the nourishment that surrounds it), so that, sapped gradually of its life energy, it makes more and more desperate compensations. The initial loss expresses itself as austerity and infidelity, which express themselves as knowledge. In one passage he compares the first excited acquisition of knowledge to "the casting of that deep sea-line" and the mere possession of information for its own sake as an encumbrance:

> For one effect of knowledge is to deaden the force of the imagination and the original energy of the whole man: under the weight of his knowledge he cannot move so lightly as in the days of his simplicity. . . . And the whole difference between a man of genius and other men . . . is that the first remains in great part a child, seeing with the large eyes of children, in perpetual wonder, not conscious of much knowledge,—conscious, rather, of infinite ignorance, and yet infinite power; a fountain of eternal admiration, delight, and creative force within him, meeting the ocean of visible and governable things around him. [xi, 65–66]

What has been cut off, in other words, is the emotional life, along with the heart and eyes, which are the organs of the spirit. With the feelings destroyed, the reason, working in isolation, becomes "heartless" or aggressive in its relations to the world rather than absorptive. For example, the proud technique of Renaissance painting, founded on the sciences of anatomy and perspective, treats the objects of representation sadistically, as things to be "measured, and handled, dissected and

demonstrated" (IX, 61). Deprived of strength and connection, the self also turns ravenous; but since it can no longer incorporate the world as part of a nourishing whole, it attempts to appropriate things by numbering and possessing, and "knowledge" becomes the mental form of this appropriation. We can notice this point most easily by seeing how images from earlier sections of the book are deformed by the Renaissance mind, particularly the images of food, stones, the word, and the body.

Among the early Venetians, the vine was the type of spiritual nourishment, flowing in instinctive self-regulation. Knowledge is a form of mental food and like all food can be used or abused. The proud man commits the "old Eve-sin," stuffing himself or hoarding like a human "granary," even to the point of starving himself by disuse. The soul ought not to be "dead walls encompassing dead heaps of things known and numbered" but "running waters in the sweet wilderness of things unnumbered and unknown" (XI, 64–66). Paradoxically, to hoard or number is to reduce one's store—to insist on one's territorial isolation from the communal wealth—since to say "mine" is to mark out an infinity that is "not mine." The "dead walls" lead to the second image, stones. Renaissance architecture is mere heaping together of geometrical regularities, but it has decoration of a sort—inscriptions boasting of vain achievements, coats of arms, huge effigies. But the great architecture of Venice spoke through the life and color of its stones, proclaiming no less forcefully than the vine itself the union of man with the works of God. Another kind of stone that men hoard is money. Knowledge, Ruskin says, is like "current coin," of which one may be proud if it is earned. But pride of knowledge is like money begged and collected, not earned—it is a possession not truly one's own, an excrement, and this Ruskin opposes to the child's first discovery of things (XI, 72–73), which is spontaneous and so partakes of the infinite depths. Ruskin does not develop this suggestive contrast, but money is as expressive of the Renaissance spirit as food is, since pride of knowledge is really spiritual miserliness or compensatory avarice—numbering, possessing, hiding, stuffing the things that in themselves cannot nourish or give life.

Third, the Renaissance deforms the nature of words, making grammar the first of the sciences and reducing human knowledge to a series of grammars: "the whole mind of the world was occupied by the exclusive study of Restraints. . . . all the acts, thoughts, and workings of mankind,—poetry, painting, architecture, and philosophy,—were reduced by them merely to so many different forms of fetter-dance" (XI, 115). By considering language as a system of objects to be analyzed and classified, not as a living means of interchange with the world, the Renaissance treats communication as the miser treats money he cannot

spend or the glutton food he cannot digest, once again breaking con-
nections with the infinite. But in her great days Venice was, as I have
said, the meeting point of the natural elements in symbolic human
speech. The antithesis of grammar is the Symbol—the meeting of
finite and infinite.

By recoil, the insatiable hunger turns at last to lust. And so the body
is the fourth and climactic image deformed by the Renaissance. In his
discussion of the language of Types in "Early Renaissance," Ruskin
compares the materials of the builder with the human body: "the
crystalline strength and burning colour of the earth from which we
were born and to which we must return; the earth which, like our own
bodies, though dust in its degradation, is full of splendour when God's
hand gathers its atoms; and which was forever sanctified by
Him. . .when He bade the high priest bear the names of the Children
of Israel on the clear stones of the Breastplate of Judgment" (XI, 41–
42). The human body, like the sanctified earth, is an emblem of purity,
that is, of organic energy, as much as water is and as much as the grass.
These sentences in fact contain the densest metaphorical compression
of the book, rendering water, words, stones, body, and grass or food
into a single entity—a vital circulation moving in and out of death and
life, sustained by God. The ephod bearing stones as names symbolizes
sanctification and covenant, paralleling the image of the rainbow, only
here a man's body bears the type of God's Judgment, as the stones
upon the body are the type of the sanctified community. Each of the
children of God, as it were, is a stone with a meaning, an atom in the
great "chord of colour" that is also the Creation.

The Renaissance version of the sanctified body Ruskin shows to us in
his remarkable history of tomb sculpture. In early times the deceased is
represented in repose upon a simple sarcophagus, with the symbols of
Death and Salvation around him. In later times, when both death and
religion are denied together, the deceased begins to rise and look about
him, the angels disappear, the drapery and ornaments grow heavy and
cumbrous, and the symbols bespeak earthly prowess and power. The
climax of the survey is a sculptural group sixty or seventy feet high, a
pile of yellow and white marble capped by a Dogaressa who is "a con-
summation of grossness, vanity, and ugliness,—the figure of a large
and wrinkled woman, with elaborate curls in stiff projection round her
face, covered from her shoulders to her feet with ruffs, furs, lace,
jewels, and embroidery" (XI, 113). "The soul of the sixteenth century
dared not contemplate its body in death," Ruskin comments (XI, 110),
yet the hideous Dogaressa, stuffed like a puppet, is all death—she is the
new anima of Venice, taking the place of the Virgin. The yellow and
white heap is the antithesis of the facade of St. Mark's, which seems to
recall, in its exuberant animation, the birth of Venice out of the sea.

But to be cut off is to die, and the Renaissance, spiritually defunct, can only affirm the fact of its mortality and more desperately it clings to life.

In the section on the final stage of decline, the "Grotesque Renaissance," Ruskin takes one final glance at the virginal Venice that has vanished forever and provides the most shocking ironic contrast of the book. The Church of Saint Mary the Beautiful was in the Middle Ages the scene of one of the loveliest of Venetian festivals, the Feast of the Maries.[20] The church that today stands on the site is also called Santa Maria Formosa, but it is wholly devoid of religious ornament. Instead, at the base of the tower, there is a frightful image of a head, "—huge, inhuman, and monstrous,—leering in bestial degradation, too foul to be either pictured or described." "This spirit of idiotic mockery" is repeated in many figures throughout the ruinous city; in the head at Santa Maria Formosa, however, "the *teeth* are represented as *decayed*" (XI, 144–145, 162). The decayed teeth are the apotheosis of insatiable and bestial hunger, as the spirit of idiotic mockery descends from the Father of Lies. Venice has been delivered over to the Adversary. The original church of St. Mary had been founded where a prelate had seen a vision of the Virgin descending from a silver cloud. The silver cloud plays, in our memory, upon the black smoke rising from the belfry in "The Vestibule," and we realize all at once that the ruin is complete.

The Legacy

"Joy whose grounds are true": Arnold's powerful phrase captures in an instant the vision toward which the energy of *The Stones of Venice* perpetually moves, as the sentence of a later writer captures the complex mixture of wrath and desire that motivates that energy: "On one of its sides, Victorian history is the story of the English mind employing the energy imparted by Evangelical conviction to rid itself of the restraints which Evangelicalism had laid on the senses and the intellect; on amusement, enjoyment, art; on curiosity, on criticism, on science."[21]

What joy does this book affirm? The simplest answer appears in the resurrected image of Wordsworthian childhood, pictured in Ruskin's conclusion as a kind of Franciscan pastoralism. The modern malaise, he writes, is a disorder in our faculty for delight. The child's pleasures are "true, simple, and instinctive," but the youth is apt to "abandon his

[20]In Venetian tradition the Feast of the Maries was celebrated on February 2, the feast also of the Purification of the Virgin, for on this day all marriages took place. It was also, as Clegg shrewdly observes, the date of the wedding of the elder Ruskins (p. 126).

[21]G. M. Young, *Victorian England, Portrait of an Age* (London: Oxford University Press, 1936; reprint, 1960), 5.

early and true delight for vanities." The English nation has done the same, first by laboring for ambition, second and chiefly by being ashamed of simple pleasures, "especially of the pleasure in sweet colour and form. . . . If we refuse to accept the natural delight which the Deity has thus provided for us, we must either become ascetics, or we must seek for some base and guilty pleasures to replace those of Paradise, which we have denied ourselves" (xi, 222–223). Carlyle electrified his readers by demanding that they become men; Ruskin here succors them by urging them to become good children but with characteristic equivocation. "Natural delight" and "pleasure in sweet colour and form" may possibly include sexuality (the phrases certainly describe the aestheticized eroticism of Ruskin's letters from Winnington, for example), but the sentence seems by its thrust to separate all pleasures into the childlike and the guilty. This "Purist" reading of the book as a whole and of Gothic naturalism in particular is finally inadequate, since the Gothic retains characteristics of the childlike yet transcends the childlike precisely as it transcends Purism: it is the fullest possible development of the ego, able to claim kindred "with all that lives, triumphing, falling, or suffering."

The ambiguity derives from Ruskin's casting the Fall myth in the shape of an arc, the shape both of organic growth and of imperial history. On one hand the binary structure of the book makes the Renaissance Fall seem the fall from a childlike period of innocence, but on the other hand, the tripartite structure places the Gothic at the zenith of life, the place occupied by the blooming center of the foxglove. In one sense this structure hearkens back to the Immortality Ode, in which the mature poet, humanized by suffering, recaptures joy in a deeper, more comprehensive form. Yet Ruskin's narrative departs radically from the three-part structure of the Ode and of the romantic myth of imagination in general, since the book is cast in the form not of a crisis autobiography but of a sermon using the past as an object lesson. The result is that the mature stage, instead of following a fall into despondency and doubt, seems to grow organically from the first without ever really passing through suffering or doubt. But if this conception is more wishful than the Wordsworthian model, it is also more anxious, since it entertains the possibility of a permanent fall—indeed, it invites the possibility, since the decay of Venice also imitates a natural cycle, perhaps an inevitable one. *The Stones of Venice* is therefore an immensely problematical book. Like Wordsworth, Ruskin asserts the priority of innocence, but his preaching stresses a search of the past for its meanings (in which archaeology is a kind of trope for introspection) rather than the educative meaning of suffering—yet those meanings remain disturbingly ambiguous, since the stones everywhere bear the mark of the Fall. Both writers are occupied with the formation of a

mature soul, but Ruskin substitutes for active experience the experi-
ence of reading texts, of absorbing lessons from the symbols of art.

Yet art history is also autobiography, since the themes of the book
reflect the movement of Ruskin's mind in the decade preceding its
publication. We saw that after the emotional breakdown in college
(which, as Ruskin viewed it, followed from the repression of grief
through study), he threw himself into the writing of a book that enunci-
ated his inherited beliefs—Evangelicalism and Wordsworthian natu-
ralism—as earned positions: and in a sense they were earned, since the
moral aesthetic was an attempt to fuse delight and piety in a way that
would preserve the original energy of childhood. That project also
affirmed the unity of his ambitions and his parents' desires, inciden-
tally healing the breach that had temporarily opened up because of his
love for Adèle. Ruskin's marriage seemed also to fulfill the mutual will,
since marriage was expected of him. Yet his diary for 1847, complain-
ing among other things of nameless forebodings and a "horror of great
darkness,"[22] suggests that the forming of a new relationship obscurely
threatened the continuity of past and present, reviving ancient and
painful conflicts—coincidentally, he was married the year of the Revo-
lution in France and the day the Great Charter was delivered to
Parliament.

The sufferings of his marriage were the first instance since his love
for Adèle in which Ruskin could not ask his father for help; a second
was the new form his career was taking. In 1850 he felt compelled to
justify the sternness of his purpose in The Stones of Venice when his
father complained that the first volume might seem tedious to readers.
In 1851 he sent his father for approval three letters addressed to the
Times on education, taxation, and representation that anticipate some
of the radical proposals he printed some years later. His father sup-
pressed them for fear of his son's reputation. The next year Ruskin
wrote, "I began thinking over my past life, and . . . I saw I had always
been working for myself in one way or another . . . or for my own ag-
grandisement and satisfaction of ambition; or else to gratify my affec-
tions in pleasing you and my mother, but that I had never really done
anything for God's service" (x, xxxvii–xxxix). In the conclusion of his
book he wrote: "If the sacrifice is made for man's admiration, and
knowledge is only sought for praise, passion repressed or affected for
praise, and the arts practised for praise, we are feeding on the bitterest

[22]Diaries, 1, 364. More grotesque imagery yet abounds in certain letters Ruskin wrote
Effie during their courtship. For example: "You are like a sweet forest of pleasant glades
and whispering branches—where people wander on and on in its playing shadows they
know not how far—and when they come near the centre of it, it is all cold and impenetra-
ble—and when they would fain turn, lo—they are hedged with briers and thorns and
cannot escape, but all torn and bleeding—" (Admiral Sir William James, John Ruskin and
Effie Gray [New York: Scribner's, 1947], 68).

apples of Sodom" (xi, 222). These indirect reproaches occur at the same time as the letters to his father about buying Turners, letters that show how poignantly Ruskin depended on magical sources of strength and approval—the flow of money, the flow of paintings. In order truly to affirm his legacy from his parents, that is, to identify the grounds of his justification through works, Ruskin had also to repudiate part of the parental will.

The Stones of Venice enacts this conflict by determining what must be preserved and what repudiated in the cultural heritage of Europe. In taking the step of championing Catholic art, Ruskin splits that art into an antithetical pair, the Gothic, which turns out to be the true and original form of Protestantism, and the Renaissance, which covertly traces a life-denying Puritanism to its source in Rome; Ruskin then becomes the true Protestant. This splitting and fusion characterize the entire work, which is therefore the most psychically overdetermined book Ruskin ever wrote. It offers itself only too readily for psychoanalytic interpretation. The major figures of Ruskin's unconscious life seem all to be here: the virginal bride or mother and the harlot wife, the punishing father, the manly hero, all bound together by the pervasive imagery of nourishment and castration, of union and expulsion. In terms of the plot of Marcolini, the hero and heroine consummate their love, only to be destroyed by villainous designs; but who, in both play and book, is this villain? Is Marcolini himself the Sphinx-Atropos and his bride tainted from the start?

The riddle of the Sphinx is unresolved in The Stones of Venice as well, and this is also the reason why the book can yield to no stable psychoanalytic reading. For each figure is both Ruskin and someone else in an ambiguous pattern of shifts and consolations that, however imperfectly, move toward a clear moral aim: the discovery of what in the psychic legacy must be absorbed and what repudiated in order to create a self strong enough to live. In symbolic terms at least, the answer is clear. The Renaissance is the spirit that denies. Cold, isolated, selfish, and ambitious, it resembles parts of Ruskin (which showed themselves in his treatment of Effie) and parts of an internalized father who can never be pleased; more generally, it is the punishing superego that persists historically as the death instinct, manifesting itself outwardly as pure aggressiveness and inwardly as decay. The Gothic, on the other hand, is the spirit that affirms, persisting historically as the life instinct. It resembles other parts of Ruskin and of an internalized approving conscience, manifesting itself as an original self-love capable of incorporating the world and regulating its internal economy as a wise father does his children. In the Gothic the child becomes father of the man, a man capable of fathering others in turn—specifically, the oppressed—just as, in religious terms, justified works are the spon-

taneous overflow of justified faith. At the center of "The Nature of Gothic" and therefore of the book as a whole stands the modern work- er, the devastated victim of a life-denying social system, whose suffer- ings must touch the hearts of Ruskin's readers before the lost past can revive. As a call to action the Gothic gives pulse to life in the present—a source of strength to accept, to give, to flourish, and to create; the strength also to labor, to witness, and to live out an allotted length of days.

6 /

The Natural History
of the Imagination

Note to-day in Bible reading the charge to Abraham, "Walk before me, and *be thou perfect.*" It means "sincere" in marginal reading. In Matthew τέλειος I think means *integer:* loving all men; not only those who love us but loving wholly. Whence Sincerity and Integrity seem to make up the idea of perfection.

—John Ruskin's diary, February 19, 1854

On June 3, 1849, Ruskin wrote in his diary at Vevay, "I walked up this afternoon to Bloney, very happy, and yet full of some sad thought; how perhaps I should not be again among these lovely scenes; as I was now and ever had been, a youth with his parents—it seemed that the sunset of to-day sunk upon me like the departure of youth." The landscape seemed similarly dead and dreary until

I looked at it with the possession-taking grasp of the imagination—the true one; it gilded all the dead walls, and I felt a charm in every vine tendril that hung over them. It required an effort to maintain the feeling; it was poetry while it lasted, and I felt that it was only while under it that one could draw, or invent, or give glory to, any part of such a landscape. I repeated, "I am in *Switzerland*" over and over again, till the name brought back the true group of associations, and I felt I had a soul, like my boy's soul, once again. I have not insisted enough on this source of all great contemplative art.

He continues: "I felt that the human soul was all—the subject nothing. Not so, when I passed 'a little further on' past the low chapel that I drew last time I was here, with its neighboring gate, inscribed 'pense a ta fin' [*sic*]; and came down among the meadows, covered half a fathom deep with the emblem by which God suggests that thought." But the emblem of human transience leads Ruskin instead to an exultant meditation, which he later published as the prose ode to the grass in *Modern*

Painters III: "Bread that strengtheneth man's heart—ah, well may the Psalmist number among God's excellences, 'He maketh grass to grow upon the mountains.'"[1]

In the diary entry Ruskin twice overcomes the fear of death and the loss of the past by an effort of visual will, pictured in each case as a negotiation of energies between mind and nature. A few days later he noted that "an over-supply of food would only be an over-tax upon its energies. This crushing of the mind by overweight is finely given by Forbes."[2] Ruskin moves from "I felt that the human soul was all—the subject nothing" to "this crushing of the mind by overweight"—two extremes that may be mediated by means of the nutritional metaphor: food taken in proper amounts keeps energy from exhausting itself, just as Temperance or Wisdom is the right regulation of the soul's internal economy. In the first of the two recoveries, Ruskin appropriates the scene by repeating a magical phrase that brings past and present together; the lifeless objects become the true Switzerland again and the aging self becomes one with his "true" self, that is, his "boy's soul." (The phrase "I felt I had a soul, like my boy's soul, once again" leaves ambiguous whether there is a soul at all distinct from the boy's.) Whereas for Wordsworth the sense of self rests on historical continuity perceived through a record of changes, for Ruskin emotional associations magically induce a sudden canceling of time and change altogether, and the splendor in the grass returns unchanged. But the meditation also asserts the inadequacy of the imagination to sustain this ecstasy, since the trance is cut short by the rebuke "Pense à ta fin." Visual power, then, invites a double contradiction: the human soul is all, yet there is a power mighty enough to crush me; I have the power to invest objects with life, yet I am mortal. But Ruskin can return to Eden after all. The second recovery transcends both contradictions by substituting a typological reading for the romantic sublime. By inscribing associations onto the landscape— the permanent associations provided by Scripture—he converts the anxiety of visual power into prophetic praise. Death is denied because of the antithetical character of types: grass, the type of human perishability, is also the type of imperishable sustenance. The mountain solitudes, then, become a place of nurture, like home, and also a mount of vision; "Switzerland" becomes any lovely place where grass grows.

The visit to Chamonix in 1849 was Ruskin's first honeymoon, as it were, away from Effie, his wife on one year. We cannot fail to notice that the association of marriage with mortality underlies the desire expressed in the diary to cancel out the present. The relation between

[1]*Diaries*, II, 381–832.
[2]*Diaries*, II, 385.

nostalgia and inscription presents itself soon afterward in *The Stones of Venice*, where the desolated past, hallowed by nostalgic associations, becomes the present as soon as buildings can be read for their inscriptions—the architectural analogues of Ruskin's discovery of grass as a divine hieroglyphic. But the ode to grass was to reappear in a later work, the work of a man sadder yet and wiser than the aging youth of 1849.

When Ruskin returned to Chamonix with his parents in 1854, he was once again flying from something he dreaded: the party left London in May, just after the scandal of the annulment had broken. The weeks that followed seem to have brought him a slow healing, the effects of spiritual and physical exercises, for the diary entries now look forward with subdued hope rather than backward with regret. "My father called me at half-past four this morning at Interlachen," he wrote in one place. "I was out as the clock struck five, and climbed as steadily as I could among the woods north of the valley, for an hour and a half, then emerging on the pure green pasture of the upper mountains. . . . I stood long, praying that these happy hours and holy sights might be of more use to me than they have been, and might be remembered by me in hours of temptation or mortification." "I hope to keep this day a festival for ever," he wrote in July, "having received my third call from God, in answer to much distressful prayer." "Every day here I seem to see further into nature, and into myself—and into futurity." "How little I thought God would bring me here just now; and I am here, stronger in health, higher in hope, deeper in peace, than I have been for years." The entries record a rime of revaluation and rededication in language similar to that of conversion: he prays, for example, for "newness of life" and meditates on the "broken-hearted state" preceding spiritual rebirth.[3] There is no wonder that when he returned to England the social landscape should have seemed reduced and desiccated and the self-repression necessary at Denmark Hill a kind of voluntary interment; yet he had also come home to his next chosen field of work. Humanized by deep distress, he had become freshly aware of the distress of human lives other than his own, even in the Alps that had been so hospitable to him. Soon afterward he plunged into a flood of activities, including teaching at the Working Men's College founded by F. D. Maurice, and he began his close and permanent friendship with Carlyle. The advice he gave a young painter upon his return is typical of his new dedication: "Though works are not the *price* of salvation, they are assuredly the *way* to it, and the only way. . . . Strive always to *do*—acknowledge continually that it is Christ which worketh in you,

[3]*Diaries*, II, 496–498.

both to will and do" (XXXVI, 179–180). The theme also pervades the next two volumes of *Modern Painters*. In these remarkable books, which together comprise Ruskin's profoundest meditation on the evidences and implications of religious faith, he takes up once again the question of aesthetic expression and moral action, as regards not architecture alone but the totality of imaginative acts to which he now gives the name "landscape."

Poetry: A "Feeling for Reality"

Modern Painters III comprises a set of efforts rather than a self-consistent thesis, but its aim is nevertheless consistent and clear: to prove that a person's work for the human good is also a duty to the God of nature and that the child's landscape hunger is the root and support of the adult's yearning for a perfected human community. The subtitle is "Of Many Things." Earlier commentators, not fully cognizant of the Ruskinian unity in multeity, have taken the description at face value, and indeed the separate topics, as topics, are remarkably heterogeneous. The potpourri begins with some chapters on theoretical matters, concluding with the well-known definition of the pathetic fallacy. Ruskin then proceeds to a history of Western landscape, eccentrically using poets rather than painters as examples—Homer, Dante, and Scott chiefly—and next attempts to determine the moral value of the landscape feeling by a tabulation of famous men, including Ruskin. Volume 3 ends by deferring for yet another volume the question of the ultimate value of landscape painting. As though to nod in the direction of his professed topic, Ruskin brings Turner into the final chapter, which simply surveys the landscape technique of the painters he studied most. The book is not only inconclusive; it persistently attacks the very position it ostensibly defends—the moral efficacy of art—and, even more impressively, the dogmatic procedure that Ruskin had made his own in the course of some half dozen volumes. The introduction justifies Ruskin's ten years' interruption of *Modern Painters* by claiming he has spent the time studying in order to "judge rightly" of art as one would "judge rightly" of a science: it is as absurd, he believes, to "speak hesitatingly about laws of painting" as it would be for "Mr. Faraday to announce in a dubious manner that iron had an affinity for oxygen, and to put the question to the vote of his audience" (V, 4–5). Yet the course of the book subtly compromises the claim by shifting from the eternal principles of artistic greatness to a consideration of artistic greatness as the expression of cultural and religious conditions; similarly, the "character" of his great artist changes from an imperson-

al mental power to a distinct cultural personality, of which there are several possibilities—the Greek, for example, or the great but disillusioned modern. By his close, Ruskin brings gravely into doubt the ultimate value of the landscape feeling, which had been his earliest qualification for judging art, and through that feeling has identified himself with men not of "the first order of intellect, but of brilliant imagination, quick sympathy, and undefined religious principle, suffering also usually under strong and ill-governed passions" (v, 360), and consequently (by implication) with the spirit of modern times—its faithlessness, its melancholy, its uncertainty. *Modern Painters* III, then, is the first of Ruskin's books written, so to speak, in the present tense—in a tentative, exploratory mode that dramatizes his own groping for the truth, his own efforts to define selfhood, not primarily as an abstract unity of spiritual energies (although his wish that it were one occupies part of the argument) but as a particular mode of being operating in a particular cultural milieu. It is a book, in short, about spiritual possibilities in an age without faith, and these Ruskin expresses through the unifying trope of seeing.

Most of Ruskin's books are better described in terms of some aspect of the human spirit than in terms of a particular subject. The economic writings, for example, are about the human being as a giving and producing creature; *The Queen of the Air* and the books on science, about a myth-making creature; *Fors Clavigera* about a creature that works and endures; and all of them, as Ruskin said about the books on art, bring "everything to a root in human passion or human hope" (VII, 257). But the books on art are specifically about "the very life of the man, considered as a *seeing* creature" (v, 177). And so the famous pronouncement, "To see clearly is poetry, prophecy, and religion,—all in one" (v, 333) is the thesis of *Modern Painters* III, expressing the conceptual mode of an argument that considers human actions from the point of view of the primary copula of seer and seen. The moral life is a form of seeing, to be evaluated according to what appears on the visual field. Great art is the type of all noble human life, and the various subjects of painting, poetry, landscape, science, prophecy, and religion are variants of one another. Each activity is also the product of a human and a nonhuman contribution. In Ruskin's earlier phenomenology, the visual field is a factual presence primarily, organized by greater or lesser powers of visual conception yet undisturbed by the intrusion of irrelevant "fancies." Supernatural visions remain a special case, unclearly related to the seeing of a great landscape artist. In *The Stones of Venice* he used the analogy of textual interpretation to describe architecture as the fusion of God's works with the record of an artist's joy in receiving these works. *Modern Painters* III expands this cooper-

ative activity to include all seeing, interpreting the visual field as itself an imaginative apprehension inscribed with both facts and fancies.[4]

This position comes clear in the chapter called "The Use of Pictures," which brings the theoretical section of the book to its climax and takes as its point of departure the question "Why paint at all if Nature is always greater than the work that imitates her?" Ruskin begins by relating how he once mistook the glass roof of a Swiss workshop for an unknown Alp. Since the roof and the Alp are nearly identical in visual fact, the greater emotional experience of the Alp must depend on something within the perceiver, which he calls the "penetrating, possession-taking power of the imagination" (v, 176). The emotion upon viewing the Alp depends, then, not only on ocular perception but also

> on a curious web of subtle fancy and imperfect knowledge. First, you have a vague idea of its size, coupled with wonder at the work of the great Builder of its walls and foundations, then an apprehension of its eternity, a pathetic sense of its perpetualness, and your own transientness, as of the grass upon its sides; then, and in this very sadness, a sense of strange companionship with past generations in seeing what they saw.

After these "more solemn imaginations" will come thoughts of the Alpine "gifts and glories"—rivers, fields, homesteads, and so forth—and finally "strange sympathies with all the unknown of human life, and happiness, and death, signified by that narrow white flame of the everlasting snow, seen so far in the morning sky." You may not trace these mental images in your heart, he continues, "for there is a great deal more in your heart, of evil and good, than you ever can trace; they stir and quicken you for all that . . . and, observe, these [images] are nothing more than a greater apprehension of the facts of the thing" (v, 177–178). The "curious web," then, is not the working of the mind only because the rivers, valleys, and homesteads are also linked to the peak, from which they "flow"; the phrase "narrow white flame of the everlasting snow," moreover, attributes permanence and intensity to what is by nature cold and fleeting and therefore to the "gossamer" of thought as well, while at the same time recalling the biblical pillar of fire, the type of divine guidance. The everlasting flame stands for the vital copula of self and other, but in other ways, the landscape fulfills

[4]In her discussion of *Modern Painters* III, Helsinger argues that the Ruskinian alternation between sublime viewing and picturesque or "excursive" viewing corresponds to modes of seeing in Wordsworth. Sublime seeing is an experience restricted to poets, but the excursive or traveler's mode (which dwells on intricacy and variety rather than on the sudden, unified effect of the eighteenth-century sublime) becomes for Ruskin a spectator's sublime available to all, since biblical prophecy and natural scenery can be interpreted as scripture. Thus, in *Modern Painters* III Ruskin criticizes Wordsworth the poet of imagination, but the "excursive" poet of *The Excursion* "continued to be Ruskin's guide" (*Ruskin and the Art of the Beholder*, pp. 92–96).

the function of the ancient building in "The Lamp of Memory." As the building concentrates the sympathy and half constitutes the identity of nations, the Alpine valley—and by extension the natural and human worlds in general—do the same for the perceiver. Through a more comprehensive, more active apprehension of actuality, one knows a self beyond oneself yet centered in the self, otherwise unknowable in isolated introspection.

In one respect, Ruskin's mature epistemology marks a reconciliation with romantic tradition—with the Wordsworthian fitting of mind to nature, or the Shelleyan: "My own, my human mind, which passively / Now renders and receives fast influencings, / Holding an unremitting interchange / With the clear universe of things around." But in his chapter on the pathetic fallacy, Ruskin relegates Wordsworth to a secondary place among the poets. One reason is suggested by Ruskin's new treatment of the realistic imagination, an attention to factuality that he associates with a particular temperament different from Wordsworth's.

Ruskin wrote the first and third volumes of *Modern Painters* in the aftermath of unhappy love affairs, in each case using a stern devotion to facts as an antidote to distracting emotionalism. But in the earlier book, devotion to fact took the form of glad submissiveness, a "purity of heart" untroubled by memories of evil. In the third book, however, Ruskin tells us that the abuse of the imagination lies in shrinking from all unpleasant knowledge and taking refuge in "anything past, future, far off, or somewhere else, rather than in things now, near, and here"; but the honest use of imagination gives "full power and presence to the possible and true" (v, 71–72). The shift seems subtler than it really is, since *Modern Painters* iii contains much familiar material—the praise, for example, of the draftsman's minute attention to detail; but the repeated examples of trunks and branches carry a new connotation. "I cannot," he writes, "hold the beauty, nor be sure of it for a moment, but by feeling for that strong stem" (v, 149–150), the stem, that is, of truth. As in the exposition of Gothic, this image suggests strength and connectedness, but here the "hold on nature" implies a virile tough-mindedness as well: the inspired man is a practical man, a manual laborer, and the naturalist aesthetic is at this point also an Antaean ethic.

But can mere works of the imagination give "full power and presence" to the actual? In his chapter on "Realization" (a word suggesting not representation only but also conceiving or bringing to life), Ruskin dwells on the passage in the *Purgatorio* describing the figured pavement on which the souls must tread in order to learn the lessons of pride. In Carey's translation, which Ruskin uses: "Dead, the dead, / The living seemed alive; with clearer view, / His eye beheld not, who beheld the

truth, / Than mine what I did tread on, while I went / Low bending."
Ruskin comments, "Dante has here clearly no other idea of the highest
art than that it should bring back, as a mirror or vision, the aspect of
things passed or absent," that we might see them "as if the years of the
world had been rolled back" (v, 38). These cantos, celebrating the
revolutionary realism of Dante's friend Giotto, suggest also that to the
eye of faith, the living as living and the dead as dead remain absolutely
distinguished—and this the souls in Purgatory learn when they tread,
touching down, so to speak, on hard realities. (Elsewhere Dante likens
the unrestrained intellect to a defenseless butterfly.) Not didactic
lessons in stone but the *clarity* of moral knowledge, its concrete pres-
ence and humbling efficacy: this is Ruskin's moral theme in the first
half of *Modern Painters* III, a clarity associated with a passionate intensity
that he distinguishes absolutely from enthusiastic delusions.

The distinction informs the chapters that follow, comprising a whirl-
wind survey of modern art history that dramatizes the opposition be-
tween vanity and realism. The target of his attack, as usual, is a vaguely
Frenchified leisure class, surrounded by looking glasses and painted
Cupids, enticed by "giddy reveries of insatiable self-exaltation," "dis-
contented dreams of what might have been or should be," "the entice-
ment of ghostly joys" (v, 100–101). The artistic paradigm of this dis-
solution is Raphael, whom Ruskin condemns (out of party spirit,
perhaps, with the new Pre-Raphaelite Brotherhood) by contrasting the
scene of Christ's appearance to his disciples at Galilee as it really was
with Raphael's treatment of related subjects: on one hand, the "wild,
strange, infinitely stern, infinitely tender, infinitely varied veracities of
the life of Christ," "the questioning wonder and fire of uneducated
apostleship," the "feeble, subtle, suffering, ceaseless energy and humil-
iation of St. Paul"; on the other hand, "vapid fineries," "an antique
mask of philosophical faces," "delicate grace, adopted from dancing
nymphs and rising Auroras" (v, 82). This contrast departs importantly
from *The Stones of Venice,* since Ruskin now blames the triumph of
profane art on the pursuit of the religious ideal—precisely the ideal he
had once praised in Angelico. At its best, he writes, Raphaelesque art
excites "religious dream or reverie," but the enjoyment of it is never
more than a "graceful indulgence of those sensibilities which the habits
of a disciplined life restrain in other direction. Such art is, in a word,
the opera and drama of the monk" (v, 84)—and from the opera and
drama of the monk arise the opera and drama of a dissolute worldli-
ness.

This historical myth represents a fresh attempt to grasp the spiritual
possibilities of Ruskin's inherited Protestantism. His initial advocacy of
landscape art enacted his submission to the parental will by wedding
Evangelical impulses to a Wordsworthian myth of natural innocence.

In *The Stones of Venice* he split the tendencies of Protestantism into a life-denying Puritanism, which he called "Renaissance," and a life-affirming independence of character, which he called "Gothic." Now, in the first book written after the collapse of his marriage, he divides the religious impulse once again, this time into an instinctual repression that manifests itself as dreaminess and an active, practical, and courageous spirit that manifests itself as a religion of works. We cannot fail to notice in this split a searching self-criticism, for under the heading of monkish fantasies, Ruskin rolls into a single ball the tendency of art to feed the erotic impulses while appearing to transcend them, the affectation and luxury of the life in Venice, the worldly ideal his parents were more and more pressing upon him, and also, perhaps, the power of erotic idealization to blot out the realities of human sexual relationships. What is finally in question, of course, is the enterprise of art itself. Great art may be a consummate expression of moral realism, but Ruskin's argument suggests just as strongly that images are always but substitutes for realities—the "realizing" power of Dante's figured pavements being impossible to mere human art. One means of meeting this problem is to imagine art as a form of activity and to repeat the old association of visual precision with moral clear-sightedness. In a footnote he remarks that he was saved from his own tendency to metaphysical abstraction by "use of my hands, eyes, and feet" (v, 334)—that is, by mountain climbing and sketching. In another passage he imagines two people looking at a rapid: a modern German, who spends the rest of the day composing dialogues between "amorous water nymphs and unhappy mariners," and "the man of true invention, power, and sense," who "set[s] himself to consider whether the rocks in the river could have their points knocked off, or the boats upon it be made with stronger bottoms" (v, 100). Silly as it is, this illustration has profound implications, for the symbolic crossing is performed not by a painter but by a practical man whose invention, power, and sense have nothing to do with the aesthetic. Never has Ruskin's distrust of the beautiful "shadows" been so explicit. As a result, *Modern Painters* III constructs overarching schemata that include artistic activity within them: it is seeing, not art, that is poetry, prophecy, and religion all in one, and landscape, as he now defines it, is really the totality of a culture's mode of seeing, believing, and acting. At the same time, his incidental remarks hint at a profound incompatibility between the aesthetic and the active temperaments, a disjunction that signals a gradual but radical shift in Ruskin's conception of his own vocation. It suggests also the new influence on his moral thought of the man he called his second "earthly master."

Carlyle is in a sense the unacknowledged guiding spirit of *Modern Painters* III, acting as a Scottish Virgil to Ruskin's Dantean project of

penitence and self-discovery. More than any other man, Carlyle embodied what Ruskin could affirm in his Scottish Evangelical heritage while providing the model of the practical man gifted with prophetic wisdom—a union Ruskin dramatized in aesthetic terms as the reconciliation of the naturalist ideal and the symbolic grotesque. Amos, the earliest of the prophets, left his flocks in the hills and came down to give his thunderous warnings to a harlot city. Carlyle's career closely followed this prototype and so must have fascinated Ruskin, partly because Ruskin, like his own Turner in "The Two Boyhoods," reversed directions, moving from the harlot city to learn prophecy in the mountains. It makes sense, then, that Ruskin began his close association with the older man after coming down from the high places in 1854. At first sight they were temperamental opposites. Carlyle, Ruskin wrote, was "born in the clouds and struck by the lightning"; "a bottle of beautiful *soda-water* . . . , only with an intellect of ten-fold vivacity," Carlyle wrote of Ruskin—and years later, "I get but little real insight out of him, though he is full of friendliness and aiming as if at the very stars; but his sensitive, flighty nature disqualifies him for earnest conversation and frank communication of his secret thoughts."[5] The one man seemed all sincerity, earnestness, and tragic power, the other "ethereal," mercurial, perhaps not sincere enough. Yet as we have just seen, Ruskin profoundly needed an antidote to the "sensitive, flighty nature" that he had come to see as a tragic weakness, and of course, as Ruskin wrote early in their friendship, the two men seemed instinctively to think alike.

For example, in the essay "The Hero as Poet," Carlyle distinguishes the *vates* prophet from the *vates* poet in a Ruskinian way: "The one we may call a revealer of what we are to do, the other of what we are to love. But indeed these two provinces run into one another, and cannot be disjoined. The Prophet too has his eyes on what we are to love: how else shall he know what it is we are to do?" And in his study of Dante, he remarks (in the biblical diction that Ruskin also affected) that painting comes from "the essential faculty of him": "Find a man whose words paint you a likeness, you have found a man worth something"; for such a man has "sympathy in him to bestow on objects. . . . a man without worth cannot give you the likeness of any object."[6] Like Ruskin in *Modern Painters* III, Carlyle makes the poet's seeing one aspect of a more general heroic quality that characterizes great men throughout the ages—Mohammed, for example, or Dr. Johnson or Napoleon. That quality, of course, is sincerity. We will look later at Carlyle's specific

[5]Quoted in xxxvi, xcv–xcvi. For Ruskin's letter to Carlyle acknowledging his influence, see xxxvi, 184.

[6]Carlyle, *On Heroes, Hero-Worship and the Heroic in History,* Everyman Edition (London: Dent, 1967), 314, 326.

influence on Ruskin's radical politics, but it may be argued that the myth of sincerity, rather than political doctrine, is the most important of Carlyle's intellectual bequests to Ruskin, since it implies so many of the rest. This myth depends on a deep heart coterminous with the universe, on a penetrative vision that is the ocular equivalent of sincerity, and on hands that can wrestle with fact; such seeing and such wrestling are religion, "the thing," Carlyle writes in the lectures on hero worship, "a man does practically lay to heart, and know for certain, concerning his vital relation to this mysterious Universe . . . , the manner it is in which he feels himself to be spiritually related to the Unseen World or No-World." A "great, deep, genuine sincerity, is the first characteristic of all men in any way heroic," yet this quality is apt to be unconscious and involuntary, like inspiration: "he cannot help being sincere! The great Fact of Existence is great to him. Fly as he will, he cannot get out of the awful presence of this Reality." Even Napoleon was sincere in the moments when he had a "feeling for reality," an "instinct of Nature," those phrases being perhaps the most felicitous and succinct adumbration of the whole idea.[7]

When Carlyle says that to the great man "the great Fact of Existence is great," he means also that the fact of a man's own existence is also great—a man's, of course; the heroic ethic is reserved for males. But with this important limitation, Carlyle was nevertheless able to articulate for his age—an age that felt the freedom of the self to be menaced by the new conditions of a secular and industrial society—the possibility of a self radically and indeed absolutely independent of the social charade, a sentiment of being united with the purposive activity of will.[8] The discovery of such a self is at the heart of *Modern Painters* III as well. In Ruskin's word painting of the disciples at Galilee, Christ stands in the morning sun while Peter approaches him: "And poor Simon, not to be outrun this time, tightens his fisher's coat about him, and dashes in, over the nets. One would have liked to see him swim those hundred yards, and stagger to his knees on the beach." In a poignant touch, Ruskin brings "first the Denier, and then the slowest believer, and then the quickest believer" to Christ, making the last the first, and then echoing First Corinthians: "They sit down on the shore face to face with Him" (v, 80). Like many of Ruskin's crossing images, this one suggests a sudden experience of redeemed selfhood so profound that an individual emerges from it as from a baptism, the sight cleansed, the body made strong. This is indeed to see face to face, to

[7]Ibid., 240, 280, 463. For a comparison of Ruskin's and Carlyle's imagery of the mariner and the flood, see George P. Landow, *The Aesthetic and Critical Theories of John Ruskin*, (Princeton: Princeton University Press, 1971), 312–315.

[8]See Lionel Trilling, *Sincerity and Authenticity* (Cambridge: Harvard University Press, 1971), chap. 3.

grasp the stem of truth. Beside it the art of Raphael must seem but the "opera and drama of the monk," but how can any mere human image create the deep feeling for things as they are, that terrific self-creative swim that Carlyle called religion? Instead of providing an answer, Ruskin's argument circles questioningly upon itself. "Has religious art never been of any service to mankind?" he asks rhetorically. "I fear, on the whole, not." "More, I think, has always been done for God by a few words than many pictures, and more by few acts than many words" (v, 85, 86).

Prophecy and Religion: The Ages of Landscape

"The greatest thing a human soul ever does in this world is to *see* something, and tell what it *saw* in a plain way" (v, 333). At stake in Ruskin's skepticism about art is the power of visual representations to induce dramatic spiritual renewal, and this doubt makes all the more urgent the question of religious experience in general. Not surprisingly, for the rest of *Modern Painters* III and the succeeding volume, Ruskin's attention shifts from painted artifacts to seeing and telling—to the texts of great poets, to landscape unmediated by art or poetry, and to his own attempt to enliven what he sees in language that is impassioned and at times confessional. Here again, Ruskin evades the problem of visual representation by imagining both poetry and religion as unmediated, as occurring in the seer's visual field. The honest use of imagination gives "full power and presence to the possible and true," yet the "first" honest use of imagination is to present the supernatural truths of religion (v, 70, 72). For the Carlylean hero, the materials of action—swords, plowshares, men waiting to be transformed into nations—are no less apparent than the great facts of the Invisible and the Divine. Ruskin's new attempt to reconcile fact and symbol results in his mature theory of art as a form of prophetic inspiration, which is also a defense of the religious sensibility.

In his discussion of the grotesque in *The Stones of Venice,* Ruskin hit on the metaphor that reconciles factual truth and religious symbolism—the mediating term of distortion.[9] "And the fallen human soul, at its best," he writes, "must be as a diminishing glass, and that a broken one, to the mighty truths of the universe around it; and the wider the scope of its glance . . . , the more fantastic their distortion is likely to be, as the winds and vapours trouble the field of the telescope most when it reaches farthest" (XI, 181). In *Modern Painters* III he joins

[9]For a comparison of Ruskin's glass image with the Claude glass used by travelers in Europe, see John Dixon Hunt, "'Ut Pictura Poesis,' the Picturesque, and John Ruskin," *Modern Language Notes* 93 (1978), 794–818.

several forms of imaginative expression under the single head of grotesque—the art of fanciful, sometimes incongruous juxtapositions of ideas; the "irregular and accidental contemplation of terrible things"; and religious allegory, the product of divine madness or prophetic inspiration. The mental activity unifying these disparate expressions is, of course, the process of dreaming, which in its "lowest" form is simply the operation of the fancy ungoverned by the daytime censor—and this statement explains why, for Ruskin, the grotesque is never entirely free of some taint of evil ("the imagination, when at play, is curiously like bad children, and likes to play with fire" [v, 181]). The distinction between fancies and genuine visions is that visions are involuntary and ungovernable, coming as a revelatory force from without. Just as clearly, the emphasis on evil and dread distinguishes visions from the serene contemplations of Angelico—the passive seeing that, we have seen, cloisters itself from all disturbing elements and so degenerates into the opera and drama of the monk. The symbolic grotesque is the farthest possible range of comprehension balanced by a power of heart strong enough to bear the full, disintegrating weight of divine revelation: "The truly great man, on whom the Revelations rain till they bear him to the earth with their weight, lays his head in the dust, and speaks thence—often in broken syllables" (xi, 180n).[10]

[10] In passages like this Ruskin acknowledges in the "darkness" of revelation the gap between figural representation and the sources of meaning in nature, an acknowledgement characteristic of what de Man finds heroic in romantic poetry. To what extent in fact does Ruskin renounce the "nostalgia" of the romantic marriage? In a forceful analysis, Michael Sprinker finds in Ruskin a pervasive recognition of the gap, which allowed him to construct "a more comprehensive theory of the imagination than any of Ruskin's Romantic predecessors (save, perhaps, Blake) could have openly or comfortably accepted" ("Ruskin on the Imagination," *Studies in Romanticism* 18 [1979], p. 118)—and this despite the fact, as Sprinker correctly shows, that Ruskin offered contradictory accounts of the mind's power to convey truths of nature. But for Sprinker, Ruskin never ultimately loses sight of the fact that all representation produces a "figural displacement" of an object in the perceptual field: "The imagination is a kind of universal translator that does not so much bridge the gap between reality and figure as disclose the figurative basis of all true perception of reality" (p. 123). And in the theory of the grotesque and of myth, which Sprinker equates with allegory in de Man's sense, Ruskin decisively rejects the Coleridgean symbol: "In other words, the symbol is another version of what Ruskin calls the pathetic fallacy, and it is diametrically opposed to the allegorical art Ruskin values so highly" (p. 134). Now, for Ruskin the purpose of figurative expression is a further enhancement or "expression" of essences and powers not possible to a realistic art. In *Modern Painters* II he writes, "depriving the subject of material and bodily shape, and regarding such of its qualities only as it chooses for particular purpose, it forges these qualities together in such groups and forms as it desires, and gives to their abstract being consistency and reality, by striking them as it were with the die of an image belonging to other matter" (IV, 291). Sprinker comments: "The meaning or value of the image or sign conceived by the imagination is totally independent of the 'material and bodily shape' it assumes in nature. . . . Its meaning as a sign derives from a 'peculiar conjunction' of 'qualities' that the imagination has, seemingly arbitrarily, chosen to bring together" (p. 130). But this statement is incomplete: the choice is not arbitrary because the *quality* must remain the same, the new shape chosen in order to render that quality more vivid (as, for example, when Satan is compared to a comet). The same problem limits Sprinker's

Similar distinctions are at the heart of Ruskin's famous critique of romanticism in "Of the Pathetic Fallacy," a chapter that begins with the question of the modern sentimental love of landscape and develops into a prelude to a survey of landscape through the ages—of "landscape," that is, in the extended sense of religion conceived as a visual field. For Ruskin, the sentimental love of landscape has produced a class of poets who characteristically project their moods onto natural objects. These poets are related to epic poets and genuine religious prophets in an ascending scale of merit, which Ruskin defines according to a characteristic imbalance between the powers of thought and feeling. Poets of the "second type," who express emotions by animating natural objects, feel more strongly than they think and so perceive falsely. Poets of the first type think and feel strongly, but their power of mind is so great that they nevertheless perceive rightly—and consistently. But since there are circumstances in which a person's reason ought to be overmastered, as in prophetic inspiration, there is yet another class of minds who "see in a sort untruly, because what they see is inconceivably above them" (v, 209)—as when, for example, the prophets saw trees clapping their hands for joy, or four giant horsemen riding throught the sky. Always the great mind is "tender to impression at the surface" but possesses "a great centre of reflection and knowledge in which he stands serene, and watches the feeling, as it were, from afar off" (v, 210).

Ruskin's assumption that figures of speech are forms of seeing and that seeing is the inscription of a greater or lesser degree of feeling simply expands his dictum that true seeing is poetry, prophecy, and

comments on myth. As he notes, "Nature is genuinely allegorical (or mythic), but only in the sense that imagination responds to the stimulus of nature by disembodying natural forms and submitting them to the discipline of a system of signs within the myth (or work of art). The myth has reference to the facts of nature (problematic in themselves) only insofar as nature is the source that inspires it, never the order that governs it" (p. 137). This point is well stated, but the phrase "only insofar as nature is the source that inspires it" is a major concession; for at the same time that Ruskin believes myth to be a system of signs (so that "reality" for us is a system of great religious myths), he holds also that those signs refer to real powers that are literally "inspired," that the efficacy of myth depends always on its bringing to us a heightened sense of the world's freshness and immediacy, and that vital forces are part of a physico-spiritual continuum. (In this context see also Elizabeth Helsinger, *Ruskin and the Art of the Beholder* [Cambridge: Harvard University Press, 1982], 241, and Chapters 10–12 below.) Ruskin's declaration of independence cannot so easily be distinguished from romantic nostalgia. His own nostalgia, if that is the right word, consists in a belief not only in myth as the manifestation of an eternal imaginative consciousness in cooperation with nature but also in virtue as a pure essence, like inner light. His thought, in other words, remains radically logocentric. It makes him, in my opinion, a very limited moral philosopher and ultimately carries him beyond the bounds of sanity. But in his theory of imagination, at least, his insistence on the external world as a perpetual source of creative inspiration and his insistence on the genuine communicative possibilities of great art make him a challengingly complex figure, saving him from other sorts of sterilities than the nostalgic marriage with nature.

religion at once. In the field of literary theory, this tenet produces extremely awkward results; his deep concern, however, is not with language but with imagining the nature of experience for a sensibility so powerful and centered that it can distinguish between temporary passions and the great, unchanging world without. Here as always, seeing is Ruskin's trope for experience in general. The clearest example is from Homer: "But them, already, the life-giving earth possessed, there in Lacedaemon, in the dear fatherland." Ruskin comments: "Though Castor and Pollux be dead, yet the earth is our mother still, fruitful, life-giving" (v, 213). Part of his point will be that the modern age has fallen into its "curious web of hesitating sentiment, pathetic fallacy, and wandering fancy" (v, 231) *because* it cannot believe the earth is life-giving and our mother—it has no genuine mythical imagination. Pathetic fallacy is admissible in certain occasions as a figure of speech, but in another sense it is truly pathetic and fallacious because it expresses a wandering, hesitant, sentimental frame of mind. The best of the moderns are without center and without serenity. The great ages dealt with sorrow through a profound emotional connection with the physical world; the modern spirit, by contrast, mourns this lost connection as for a lost mother, and so develops the landscape feeling as a nostalgic compensation.

Religion, then, is the fitting of the mind and nature, revealed as a form of visual inscription. What does nature look like to the person and the culture whose ego is strong enough to affirm this relationship? Ruskin now turns to his survey of Western poetry and art, beginning with the Greeks—a very different nation indeed from the rigid systematizers of *The Stones of Venice,* for they have now come to represent the noble childhood of the religious imagination.[11]

According to Ruskin, Homer does not use the pathetic fallacy because he does not need to animate the waves artificially. For Homer there is a god in the water, yet he is not the same as the water. The elements scatter and perish, but the gods are indivisible and imperishable, taking from time to time a human form. This fact is not really a debasement of the idea of divinity, Ruskin says, since the Greeks always sense an "exaltation in the spiritual and immortal body; and of a power proceeding from the visible form through all the infinity of the ele-

[11]For the relationship of pathetic fallacy to the historical survey of landscape, see Jay Fellows, *The Failing Distance: The Autobiographical Impulse in John Ruskin* (Baltimore: Johns Hopkins University Press, 1975), 45–48. In general Fellows argues that Ruskin resists the "autobiographical impulse," the temptation to collapse landscape and self. Landscape history in *Modern Painters* III is an early version of *Praeterita*, an "efficacious" autobiography that resists the temptation to collapse self and world by correlating the personal past with history; but a second kind of autobiography is the pathetic fallacy, which "does not so much answer needs as create problems." Fellows argues, as I have, that the pathetic fallacy represents a deficiency of self, an imbalance between self and world.

ment ruled by the particular god." Ruskin insists on the literalness of this conception. When Diana goes to hunt with her nymphs in the woods, her action does not mean that the moon and stars have passed through the trees but rather that "there is a living spirit, to which the light of the moon is a body . . . and that this spirit sometimes assumes a perfect human form, and in this form, with real arrows, pursues and slays the wild beasts, which with its mere arrows of moonlight it could not slay." The deities are quite frankly "blue-eyed—white-fleshed—human-hearted" (v, 224–227)—very much, we assume, like the White Lady. The Greeks, then, have reverence for all of nature, seeing no part of it as dead, yet they are unsentimental about it and make good practical use of the wood and the water; they are both more religious and less materialist than we because they believe that the spiritual inhabits matter and conversely that the elements are fields radiating from the human form divine. And such a religion is possible because of the Greeks' conception of themselves; their familiarity with the gods is a sign "not so much . . . of misunderstanding of the divine nature as of good understanding of the human. The Greek lived, in all things, a healthy, and, in a certain degree, a perfect, life." "Unhappy love, disappointed ambition, spiritual despondency . . . , had little power over the well-braced nerves, and healthy flow of the blood" (v, 230). Not surprisingly, the Greeks, at home in nature, cultivated the beautiful parts of the earth into gardens and groves, humanizing their landscapes as they had already humanized their gods. In this manner they created Arcadia.

Ruskin is here partaking in the code of the English schoolboy, who associated the heroes of his textbooks with athleticism—the very life Ruskin had himself missed as a youth. But this callowness is only the mask of the larger meaning. As the moderns imagine God removed from lifeless nature, "upon a cloudy throne," they have similarly beclouded their minds and undervalued their physical selves, fancifully giving to nature the vitality they lack; they must project themselves. The tragedy of modern life is that humans cannot affirm themselves *or* nature—the two failures are inseparable. The Greeks give to Diana the kind of body they have, which is also projection; the difference is that Diana is the image of an energy really in nature and the Greeks project from a center of affirmation—they are godlike people. The Greek experience of nature is a healthy Narcissism; the Greeks' agriculture might be called an active contemplation of themselves.

For the first time Ruskin enters imaginatively into a human-centered and pre-Christian experience of the world. The anthropocentrism of the pathetic fallacy paints the world with human sorrows and desires, but the indulgence is based on deprivation, a projection from a re-

pressed center. Putting the Greeks alongside the moderns and reasoning, with Ruskin, antithetically, we see that the pathetic fallacy is not so much a mental weakness as an ego weakness. And it is also a physical weakness—a disorder of the stomach, as Ruskin conjectures at one point. Liberated by the chastity of beauty and muscle that the Victorians mistook for a release from repression, and surrounded by the erotic exuberance that is still the hope of post-Freudian romantics, Ruskin's Greeks are able cheerfully to labor, to battle, and to pass from the earth. But the modern restlessness is also a flight from death: the earth is not our life-giving mother.

In fact the modern spirit is peculiarly homeless—a point Ruskin must have felt with particular clarity in the 1850s, living once again under his parents' roof yet no longer "at home." The formula he repeated at Vevay—"I am in Switzerland"—succeeded only for a moment in recapturing the vanished Switzerland that was his spiritual home. Consequently, *Modern Painters* III abounds in images of stable centers: the white flame of the Alp, with its garland of associations; the Greek gods, concentering the diffused element of which they are the embodiment; the soul of the "great man," incorporating within himself the still point of the turning world. And the book also abounds in images of homecoming—Peter making for the opposite shore, Odysseus making for his island kingdom, and finally, in the climactic meditation on Dante, the Christian pilgrim who crosses a brook into the Earthly Paradise. Dante is for Ruskin's natural history of the imagination what the Gothic is for Venetian history—the apex of the three-part movement that stands in opposition to the fallen present. Dante's *Purgatory*, similarly, is the shadowy analogue of Ruskin's own self-educative argument in *Modern Painters* III, which receives a symbolic resolution in the image of Matilda in the garden. Dante's Paradise, in turn, becomes the moment that gives meaning to the pattern of time, the spiritual reality of which the modern landscape love is but the insubstantial dream.

Ostensibly, Ruskin is reading Dante for evidence of how the most representative medieval mind viewed nature. In the course of that reading he pauses with the pilgrim by the wood surrounding the Earthly Paradise—a wood that is "pathless," unlike the rigidly geometrical structure of hell, because (like the instinctive temperance of Gothic energy) "the perfectly purified and noble human creature, having no pleasure but in right, is past all effort and past all *rule*." The subsequent passage Ruskin calls the most important lines "in the whole circle of poetry": a little brook flows, bending the grass to the left, and on the other side is a pure maiden, singing and gathering flowers. She is Matilda, the type of the active life, as Beatrice is the type of the con-

templative life. Earlier, Dante had been prepared for this encounter by his dream of Rachel and Leah, also types of the active and passive life. Leah speaks:

> "for my brow to weave
> A garland, these fair hands unwearied play;
> To leave me at the crystal mirror, here
> I decked me."

Bur Rachel stands all day before her glass, "charmed no less / Than I with this delightful task." The point Ruskin stresses is that the sisters are types of the *unglorified* active and contemplative life: Leah took pleasure in her own labor, but Matilda in the works of God; Rachel took pleasure in the sight of her own face, but Beatrice "in the sight of *God's face.*" He continues: "The active life which has only the service of man for its end, and therefore gathers flowers . . . is indeed happy, but not perfectly so. . . . But the active life which labours for the more and more discovery of God's work, is perfectly happy, and is the life of the terrestrial paradise, being a true foretaste of heaven, and beginning on earth, as heaven's vestibule" (v, 275–279). Rachel and Leah belong ultimately to the dream of earthly life, but Matilda (who reflects the twofold personality of Christ in her eyes) mediates between this earth and eternity and represents "the expression of man's delight *in God's work.*" Now, the Greek "contemplated his own beauty and the workings of his own mind," whereas the Christian "contemplated Christ's beauty and the workings of the mind of Christ" (v, 279–280).

The four images of seeing bring the whole second part of the book in place. In his discussion of the pathetic fallacy, Ruskin cited a sadistic ballad by Casimir Delavigne, in which a vain young woman of wealth named Constance, preparing herself at a mirror for a ball, is consumed by the "devouring" flames of her hearth. Constance is a good instance of how Ruskin's examples themselves form an interlocked argument, since Constance looks backward to the denunciation of French art, prurient and self-absorbed, and forward to the dream of Rachel and Leah. We may think of her as occupying the bottom of a scale of seeing, which ascends through Dante's two sisters to Matilda, and finally to Beatrice, who sees most widely of all—God's face itself. This scale, of course, corresponds to the ranking of poets, beginning with those who use neoclassical personifications with complete coldness and ending with inspired prophets like Dante. The two scales resemble Plato's twice-divided line, also rising from illusion to contemplation of the divine, with the upper line representing Dante's division between earthly and heavenly. In Ruskinian terms the Earthly Paradise is the region of the Gothic, since the flowers in Matilda's hands correspond to

the Gothic "hold on nature"—the decoration of space with sculptured leaves and garlands—while Lethe corresponds to the acceptance of imperfection.

Ruskin's famous prose ode to grass—a sermonic gloss on Dante's single lines describing the grass bending under the waves of Lethe—at once enacts the process of visionary ecstasy and celebrates with Matilda the works of God's hands. Beginning with a single blade ("examine for a minute, quietly, its narrow sword-shaped strip of fluted green"), he builds the most ambitious of all the book's concentric garlands, piling image on image in an exultant breathlessness that stops only when he has converted the natural world into a pattern of Christian typology. From the single blade he moves first to the pastoral life and its associations ("The Fields! ... All spring and summer is in them ... , the power of all shepherd life and meditation"); then, from the peace and bounty of the familiar and near, he moves outward to the regions of prophecy: "Look up toward the higher hills, where the waves of ever-lasting green roll silently into their long inlets among the shadows of the pines; and we may, perhaps, at last know the meaning of those quiet words of the 147th Psalm, 'He maketh grass to grow upon the mountains.'" Then, after this apotheosis, the grass loses all specific location and becomes a moral type, literally words of God, the words being "cheerfulness" and "humility":

> You roll it, and it is stronger the next day; you mow it, and it multiplies its shoots, as if it were grateful; you tread upon it, and it only sends up richer perfume. Spring comes, and it rejoices with all the earth,—glowing with variegated flame of flowers,—waving in soft depth of fruitful strength. Winter comes, and ... it will not pine and mourn. ... It is always green; and it is only the brighter and gayer for the hoar-frost. [v, 287–290]

The exposition concludes in a hurly-burly of biblical references and associations until Ruskin emerges with a complete description of grass in relation to the physical and spiritual life of man: it is the emblem of spiritual food (as manna is a foreshadowing of the true bread); a pledge that, for the Christian, glory is won through affliction and power through humility; the type of human life in its excellence and passing, since it is both enduring and beneficent; finally, a physical source of food, rest, and clothing.

By blanketing the habitable earth with the mark of divine benefi-cence, Ruskin defines the region of human interaction with nature, the Earthly Paradise prepared for humans by the Christian dispensation. But the movement of emotion in this passage—from factual catalog to pathetic animation to typological seeing—revises the doctrine of the pathetic fallacy, or at least presents it in a new light. For the faithless modern, the pathetic animation of nature is at best a consolation, at

worst a mere writing of one's inconstant and wistful moods upon the face of the world. But in Ruskin's Christian ode, meekness and joy are constant "characters" of the grass independent of the seer's mood, as are types themselves—and types, as George Landow has noted, give uniform meaning to those natural symbols that we would otherwise animate, if at all, by whim.[12] Dante stands here for the supreme expression in Western literature of the typological tradition. Religion becomes the generalized form of prophetic seeing made available to the community of the faithful: by reenacting Dante's pilgrimage, Ruskin the pilgrim can also reenact the visions of Dante the prophet. But the symbolism of the *Purgatory* provides Ruskin with yet another purpose. Matilda, the type of the sanctified active life, leads Ruskin back to art (she represents "man's delight in God's works") and therefore to the Gothic, an art that is also labor, so that she reconciles symbolically the conflict between the active and the aesthetic life as well as that between faith and works. Singing in the garden, she represents not the pain of labor but the spiritual peace attendant upon it; in other words, by sanctified labor, the griefs and losses that to the modern are inexpiable are consummated by a release from guilt and a symbolic entry into that place where the original loss is restored. For Ruskin Christian joy remains ultimately more attractive than pagan joy, since in its drama of submission, repentance, and absolution, it also provides a myth of compassion. The whole drive of this chapter is toward self-fulfillment through works: Dante shows that love of nature is also love of humans because a single blade of grass speaks also of the human being's ultimate duty. Under the force of such joy, *Modern Painters* III now turns into narrative, an autobiography uttered in the present tense, even though the first person is not used. At its close, we enter with Ruskin into a place "where the grass of the earth was bowed down, in unity of direction, only by the soft waves that bore with them the forgetfulness of evil" (v, 293).

"Of Modern Landscape" descends from Eden into the wilderness of the modern world, that region from which God has withdrawn and left human vision clouded and human hands idle. Taking Scott as the greatest of the moderns and the exemplar of their characteristic experience of nature, Ruskin finds modern landscape to be cloudy and indistinct, the modern character faithless and melancholy. What then *is* the value of landscape—of "landscape," that is, in the sense of a tender and sentimental love of flowers and brooks and hills? He pursues this question by tabulating data—listing the names and comparing the characters of the great moderns who have and have not known the landscape feeling—and then by offering the lovely, well-known ac-

[12] See Landow, *The Aesthetic and Critical Theories of Ruskin*, 415.

count of the visionary gleam as he knew it himself when a child in Scotland and then as he watched it fade with adulthood. But the overt connection of his experiences with the Immortality Ode implies a self-criticism, since he identifies himself with a poet of the second order. The landscape feeling, he continues, is "wholly a separate thing from moral principle, and may or may not be joined to strength of will, or rectitude of purpose" (v, 372). It is often, however, the saving grace of those characters that are otherwise morbid or weak in temperament. The account is balanced and sober, but since Ruskin had first appeared before the public to reveal God's face in the face of nature and to claim for landscape painting "gigantic moral power," the new modesty has the force of a dramatic reversal. That reversal, of course, does not stand unqualified. In the same chapter that damns with faint praise the "ruling passion" of his own life, the passion that led to his "chosen field of work," he asserts that the love of nature is "the most healthy element which distinctively belongs to us." Turner, the first great landscape painter, has established a "science of aspects"—the science of things as they appear to humans—which may restore to us the primordial vision that Baconian science, however honest its aims, has taken away: "It is better to conceive the sky as a blue dome than a dark cavity, and the cloud as a golden throne than a sleety mist" (v, 386–387). But the present book is at an end. "How far art is capable of helping us in such happiness we hardly yet know; but I hope to be able, in the subsequent parts of this work, to give some data for arriving at a conclusion in the matter" (v, 384). The vision arises in the distance, but the road before it remains clouded.

Is the quality of doubt in this book more impressive, finally, than its faith? To summarize briefly, its faith rests, first, on art as the union of heart and head. Children today, Ruskin notices, are generally discouraged from loving nature or learning to draw, so that the boy who can see is "passionate, erratic, self-willed, and restive against all forms of education; while your well-behaved and amiable scholars are disciplined into blindness and palsy of half their faculties" (v, 377). As in the Renaissance, head and heart are divorced, each repressed for the sake of the other—which is a cause, as Ruskin surely recognized, of his own loss of landscape feeling. But the artist is a seeing-and-feeling creature, and Ruskin is trying through his myths of seeing to provide models for saving the emotions from extinction. A great school of art is metaphorical for a moral possibility: the great naturalist sees facts and so achieves resolution, common sense, and a sincere, strength-giving connection with the deep heart of things; the Greeks see themselves in the divine, and so live as gods, serenely, proudly, and courageously; the medievals, reading in nature the language of types, find triumph in their own sacrifice, and live confidently in the revelation of the Re-

demption. Each way of seeing draws from Nature a power of Being gained by submission; the pathetic fallacy draws from Nature, as best, sympathy in grief. But art, second, is the unity of heart, head, and *hand*, so that each way of seeing leads back to the practical life. *Modern Painters* III struggles to bring together vision and works yet does not finally claim that great art by itself or the landscape feeling by itself can achieve this synthesis. A book that begins with an artist-centered aesthetic develops into an exploration of human-centered religion, ending not in a proof of God's existence but in a hypothesis about human greatness: that the perfectly centered human spirit may attain the unity of seeing, thinking, and doing that is true religion.

Such is the book's hope, but its mode of argument is tentative, dialectical, paradoxical. Paintings, we learn, are but shadows, and actions are stronger than pictures, yet the dawn of true religious art may be upon us. The landscape feeling belongs to the dreamy and irresolute, yet the love of nature is the best thing about us. The modern love of nature has ended in cloud worship, yet we shall see in nature God's face. Turner has founded a science of aspects, but it is not clear how far art can help us. Still, we need pursue these lights and shadows no farther: Ruskin does so for us in fearsome chiaroscuro in the very next volume, which proves to be the second phase of a single pulse, a single, immense meditation.

Of Mountain Beauty: The Modern Grotesque

In Ruskinian phenomenology, religion, the expanded sense of the term "landscape," is the history of the human imagination and its possibilities through changing cultural conditions. The faith of *Modern Painters* III rests on the transformation of ontological questions—about God's existence, for example—into a hypothesis about the fitting of mind and nature: the relative uniformity of the vision of nature through time, from the Greeks even to the great but faithless moderns, is an earnest that the world exists for us as permanent imaginative possibility. In short, *Modern Painters* III demonstrates how there can be a natural history of the imagination.

The historical anomaly most troubling to this project occurs in the second chapter devoted to Dante, which is ostensibly a survey of rock imagery in the *Inferno*. Ruskin reminds us that the love of mountains is a peculiarly modern taste: scenery we should delight in seemed to Dante "adapted only for the punishment of lost spirits." Consequently, the landscape of his hell is cloven into rocky chasms, without brightness or color. What seems to the moderns—and to the ancient Hebrews—the most concentrated sign of the divine presence seemed to the great-

est Christian poet the sign of divine absence; Dante's Via Mala, moreover, is equivalent to Turner's St. Gothard, which gave him "the elements of his most terrible thoughts in mountain vision, even to the close of his life" (v, 296). The paradox calls into question not only the romantic sublime but the uniformity of religious myth itself.

In one respect *Modern Painters* IV is an extended meditation on this problem, a necessary supplement to the argument of *Modern Painters* III that develops into Ruskin's profoundest exploration of religious doubt. To follow him we must, once again, forge through an apparent miscellany of topics that are spectacularly uneven in interest. After five chapters on Turner's art in general, Ruskin provides a "transitional" chapter entitled "The Firmament," then proceeds through more than 250 pages of descriptive geology (somewhat resembling the architectural lessons in *The Stones of Venice*) before concluding with the famous pairing, "The Mountain Gloom" and "The Mountain Glory." But the remarks on rocks in Dante suggest to us that "mountain beauty" represents the material medium, so to speak, through which Ruskin will think out his new intuitions about faith, doubt, and imagination. He chooses stones and mountains for his medium because they are paradigmatic of the ambiguities of natural appearances in general, the objective correlatives, so to speak, of thought as a dialectical activity. In landscape as in architecture, stones may be either living or dead, tokens of the divine presence or the divine withdrawal. To the hard of heart, all things are lifeless as stones, but to the eye of faith, even the stones of the field rise together in living unity.

This stress on appearances marks a decisive shift from *Modern Painters* III. The two volumes of 1856 form a continuous argument, but a self-transforming argument that pivots on the phrase "science of aspects." The first tends to treat religion as the history of different modes of apprehending nature, different strong myths, so to say, degenerating into pathetic fallacy, which marks the modern failure of myth; the second volume tends to treat religion as the various modes of divine manifestation. Thus Ruskin barely finishes his chapter on cloudiness as a sign of modern faithlessness before starting a new volume in which cloudiness is viewed as the precondition of religious knowledge. In an analysis of the word "firmament" in the opening of Genesis, he explains that the firmament is the veil of clouds separating the earth from the blank infinity of space and therefore the medium, both metaphorically and literally, by which God accommodates Himself to limited human reason as a personality: "The Deity has stooped from His throne, and . . . in the person of the Father, taken upon Him the veil of our human *thoughts*, and permitted *us*, by His own spoken authority, to conceive Him simply and clearly as a loving Father and Friend" (VI, 110). But this is not God's only aspect. Of all created things, mountains

bear most vivid witness to Ruskin's culminating religious statement in this book: "Where the beauty and wisdom of the Divine working are most manifested, there also are manifested most clearly the terror of God's wrath, and inevitableness of His power" (VI, 416).

The same statement conveys the burden of Turner's art as Ruskin now understands it. It is as though Ruskin, having celebrated with Dante the vision of an Earthly Paradise, now descends with him to confront the witness of his gloomy precipices, discovering in that confrontation the only possibility of genuine religious myth for modern times. That myth must be tragic, as he shows in the important chapter on the "noble picturesque." The noble picturesque is the expression "of *suffering,* of *poverty,* or decay, nobly endured by unpretending strength of heart," not (as in the fashionable picturesque) the conversion of those subjects into a form of pleasurable quaintness. Ruskin introduces this distinction by contrasting the old tower of Calais, an enduring example of noble picturesque ruin, with the English preoccupation with gentility, tidiness, and smallness of scale—each trait symptomatic, ultimately, of the denial of history. The English have only a "living present, consisting merely of what is 'fashionable' and 'old-fashioned'; and a past, of which there are no vestiges." Hence in England "the dead are dead to purpose." "But with us, let who will be married or die, we neglect nothing. All is polished and precise again next morning; and whether people are happy or miserable, poor or prosperous, still we sweep the stairs of a Saturday" (VI, 13–14). Once again Ruskin defends architectural memory as a way of preserving life, but by ranging the noble picturesque against fashionable English forgetting, he attacks not only the suppression of the past but also the suppression of suffering.

To experience one's own humanity, in other words, is to confront one's own suffering and to bind oneself, in pity and terror, to the facts of human suffering in general. Ruskin is in the position, at last, of understanding Turner as a tragic artist (as he might have done for Wordsworth also had he not already relegated Wordsworth to a secondary class of minds). His chief example is Turner's *Goldau,* a watercolor depicting a glorious sunset over a village that had once been devastated by earthquake, which suggests, in Ruskin's words, "an acute sense of the contrast between the careless interests and idle pleasures of daily life, and the state of those whose time for labour, or knowledge, or delight, is passed forever. . . . it is in the same tone of thought that he has placed here the two figures fishing, leaning against these shattered flanks of rock,—the sepulchral stones of the great mountain Field" (VI, 381). Such an art transcends the sensibility even of the well-meaning lover of the picturesque, which in an implicit self-portrait Ruskin describes as a person of "slight tragical feeling" and "humble

and romantic sympathy" (VI, 21), who will nevertheless lend a hand to practical benevolences—rather like the lover of landscape in the preceding volume. Such a person's love of ruins is nostalgic; the elegiac power of *Goldau* draws, on the other hand, on the unflinching strength of mind that Ruskin associates with the first order of poets, such as Homer. But Turner's power of acceptance is in a sense more awesome than Homer's, representing not pagan stoicism so much as a Hebraic negative capability, the simultaneous recognition of divine wrath and divine blessing. This is of course the Burkean sublime as well; even so, Ruskin still avoids the term, choosing instead to define the picturesque as a parasitical mode of the sublime—parasitical because in depicting ruins and scenes of rural poverty, the artist transfers to small objects the formal qualities of sublime objects (such as jagged lines and rough textures). In this way he inscribes human artifacts with sublime associations while giving landscape new affective value: the mountains are endowed with historical language, the language of pathos, and this region becomes coextensive with all that fashionable English society must suppress. *Goldau,* then, epitomizes the landscape of *Modern Painters* IV, which is essentially a ruin—that is to say, a grotesque.

The revelation toward which Ruskin's argument builds—that this habitable earth is fallen and a ruin—gives ironic fulfillment to his theory of the symbolic grotesque, which if we consider it again for a moment illuminates the character of his second Dantean journey of discovery. The theory of poetic inspiration in *Modern Painters* III differs only slightly from early romantic formulations except in the peculiarity that Ruskin retains the term "grotesque" for divinely inspired allegorical visions and links those visions with the contemplation of evil and the free play of fancy, specifically the kind of play exemplified in Gothic sculpture. One reason for this is no doubt Ruskin's own experience of a Gothic interior as the sculptured equivalent of an eerily pleasant "Gothic" nightmare. With its griffins and gargoyles lurking in odd corners, half shadow and half stone, a twilit cathedral could seem like a twilit grove, with its leaves and branches about to leap into phantasmagoric life—as they do, for example, in Wordsworth's "Yew Trees," which Ruskin cites admiringly:

> ghostly shapes
> May meet at noontide; Fear and trembling Hope,
> Silence and Foresight; Death the Skeleton
> And Time the Shadow; there to celebrate
> As in a natural temple . . .
> United worship.

But the definition of "grotesque" is that which combines the ludicrous and terrible. By linking sublime allegory, such as the Divine Comedy

and the biblical Apocalypse, with the imaginations of humble and superstitious travelers, Ruskin deliberately risks blurring the distinction between fancy and genuine inspiration in order to reassert the Gothic acceptance of the Fall, his own version of the doctrine of accommodation—and he also takes an important step, as Elizabeth Helsinger has observed, toward democratizing the sublime.[13] Evil is somehow inherent in these revelations, not only because (in Ruskin's orthodox Evangelical explanations) God wishes to provide warning signs but also because to imperfect human sight, divine power is terrible and incongruous in aspect. The composite beasts of the Apocalypse are paradigmatic examples because the grotesque is itself a composite of the divine and the natural, like that other composite being, Christ. Thus, Ruskin concludes his chapter in *Modern Painters* III with a description of a "true griffin" copied from the cathedral of Verona, which springs convincingly to life by virtue of its forceful anatomical logic—the grip of the claws, the use of the teeth, the position of the wings. Thus realized, the griffin, combining the eagle and the lion, is the type of the human and divine attributes of Christ, "narrowed" to the grotesque of an animal crushing in its paws a writhing dragon.

But the fearfulness of divine revelation lies less necessarily in its content than in the nature of its appearing. Symbols in themselves induce awe:

> For even if the symbolic vision itself be not terrible, the scene of what may be veiled behind it becomes all the more awful in proportion to the insignificance or strangeness of the sign itself; and, I believe, this thrill of mingled doubt, fear, and curiosity lies at the very root of the delight which mankind take in symbolism. . . . [It is] the Divine Fear which necessarily follows on the understanding that a thing is other and greater than it seems. [v, 181–182]

This "insignificance or strangeness" is actually the perception of an excess of significance, the dreadful moment when the instability of meaning is about to break forth into an overwhelming recognition. For Freud the uncanny is the experience of a repressed desire embodied by an external agent or action as the revelation of what has been hidden,[14]

[13]For Helsinger the grotesque and ultimately the theory of allegory are extensions of excursive seeing (pp. 124–138). This interpretation is supported by Ruskin's reading of Dante and the diary entry of 1849, where nature bursts spontaneously upon Ruskin as a legible prophetic text. These episodes, I would argue, correspond to the shift in his self-presentation, from an inspired Evangelist and interpreter to a representative modern man in "The Moral of Landscape."

[14]Sigmund Freud, "The Uncanny," in *Collected Papers*, ed. Joan Rivière, 5 vols. (London: International Psycho-Analytical Press, 1949), IV, 368–407. The most penetrating brief discussion of the Ruskinian grotesque I have seen is Sprinker, "Ruskin on the Imagination." Sprinker compares Ruskin's knot of associations to Freud's description of dreams as containing a "navel," the cluster of associations close to the unconscious origin of the dream. "Just as Freud's primal scene is always confronted in a dream, a phantasm, a fiction, so Ruskin's conception of the grotesque as a representation of the truth (objec-

and indeed Ruskin comes close to this formulation at one point of his argument: in Joseph's dream, he says, the symbols of dominion "must have been afterwards felt by him as a distinctly prophetic indication of his own supreme power" (xi, 182).[15] In later years, of course, Ruskin became obsessed with projections of a much more horrific nature—the self confronted as serpentine, spectral, or skeletal—in each case the enactment or punishment of a forbidden impulse recalling the phrase "Sphinx Atropos" that brought *Marcolini* to its premature termination. But in specifically religious revelations, the characteristic form of Ruskinian grotesque is the recognition that something is a type, a local concentration of an infinite power of good or evil. We recall the uncanny sense of things in "The Vestibule" that revealed themselves ultimately as types of the Fall, and the rather different experience near the fount of the Brevent, when objects were charged with the terror of an imminent disclosure.

In *Modern Painters* iv Ruskin enacts his own theory of the grotesque imagination, but to unexpected and ironic effect. Leading his readers through a geological exploration of the Alps, he combines in himself the sensibility of the practical man and the seer, for his stones shadow forth an awesome reality greater and other than themselves. That vision is parodic of Leah's, since Ruskin sees darkly *and* face to face: the marks of divine wrath and the even more terrifying marks of divine absence combine with studied ambiguity Old Testament monotheism

tive reality) locates representation in a fiction, a phantasm, a figural rendering of that which is always real but never experienced except as something phantasmagoric." Sprinker continues his analysis in semiotic terms: "The grotesque . . . represents what is not there, and yet is there at the same time. . . . To put this problem in contemporary terms, we might say that Ruskin discerned in the grotesque a heterogeneity between the sign (the natural form from which the figure originates) and its referent (the spiritual truth that the grotesque figure represents). To be more precise, the signified (spiritual truth) is always in excess of the signifier (the natural form); it is this excess that the grotesque figures forth" (pp. 128–130).

[15] In an Oxford lecture Ruskin described some dreams that are precise examples of the grotesque, the first of which contains the familiar crossing by water: "The first was of a Venetian fisherman, who wanted me to follow him down into some water which I thought was too deep; but he called me on, saying he had something to show me; so I followed him; and presently through an opening. as if in the arsenal wall, he showed me the bronze horses of St. Mark's, and said, 'See, the horses are putting on their harness.' The second was of a preparation at Rome . . . for the exhibition of a religious drama. Part of the play was to be a scene in which demons were to appear in the sky. . . . There was a woman dressed in black, standing at the corner of the stage watching them, having a likeness in her face to one of my own dead friends; and I knew somehow that she was not that friend, but a spirit; and she made me understand, without speaking, that I was to watch, for the play would turn out other than expected. And I waited; and when the scene came on, the clouds became real clouds, and the fiends real fiends, agitating themselves in slow quivering, wild and terrible, over the heads of the people and the priests" (xxii, 445). These dreams show particularly well the relationship of dream experience to apocalyptic experience, since they both center on moments of anticipation before a manifestation of natural or demonic power, although only the first arrests the anticipation at that moment of indeterminacy described by Freud's theory of the uncanny and Weiskel's theory of the sublime.

and a modern myth of God's withdrawal from the world. But the grimmest evidence of all lies in the conditions of Alpine poverty. Here, in the emotional climax of *Modern Painters* IV, Ruskin transmutes the primitive terror of seeing the self as deathly and alien into a vision of the human race as ossified and abandoned.

His apparent purpose in describing the structure of mountains is to provide evidence of a consistent order and intention, even in those parts of creation that appear repellent, by likening God to a pictur-esque architect who sculpts in four dimensions. But this theodicy is hardly reassuring. Ruskin tells his readers that he has immersed a wine flask in a small Alpine stream and has counted twenty-four grains of sediment, proving to him that the annual erosion of Alpine soil is on the order of 80,000 tons. For Lyell such a calculation would suggest the scope of one form of change only; for Ruskin it suggests a single and irreversible change that defines the direction of natural history: "The hills, which, as compared with living beings, seem 'everlasting,' are, in truth, as perishing as they . . . , and it is but the lapse of the longer years of decay which, in the sight of its Creator, distinguishes the mountain range from the moth and the worm." The world is a pictur-esque ruin—"only the wreck of Paradise"—but the origin to which Ruskin's evidences point is as terrifying and inconceivable as the ulti-mate conflagration. His language mingles biblical and scientific allu-sions: "As we endeavour to penetrate farther and farther into departed time, the thunder of the Almighty power sounds louder and louder; and the clouds gather broader and more fearfully, until at last the Sinai of the world is seen altogether upon a smoke, and the fence of its foot is reached, which none can break through" [VI, 179]. The monkish fear of the mountains seems confirmed: at the edge of intelligibility lies either the deity or the void. But in the dialectical shift of this book—similar to the structural swing between hope and doubt in *In Memoriam*—images of metaphysical terror alternate with comforting pieties as though in complete dissociation from one another. Thus, he is able to claim at the beginning of "The Mountain Gloom" that the study of mountain form has shown every feature to be "calculated for the de-light, the advantage, or the teaching of men." Abruptly there follows one of Ruskin's most famous passages: a luxurious evocation of Alpine sublimity, bathed in light that seems the visible ministry of grace ("in its clear, consuming flame of white space, the summits of the rocky moun-tains are gathered into solemn crowns and circlets, all flushed in that strange, faint silence of possession by the sunshine"), juxtaposed against an image of human life utterly darkened and desolate:

For them, there is neither hope nor passion of spirit; for them neither advance nor exultation. Black bread, rude roof, dark night, laborious day,

weary arm at sunset; and life ebbs away. . . . their religion . . . mingled
with threatening, and obscured by an unspeakable horror,—a smoke, as it
were, of martyrdom, coiling up with the incense, and, amidst the images
of tortured bodies and lamenting spirits in hurtling flames, the very cross,
for them, dashed more deeply than for others, with gouts of blood. [VI,
385; 387–389]

The mountains have achieved at last the condition of hell, where Christ
himself appears not as the Redeemer but as the chief sufferer among
the damned. The circuit of human and divine is broken, with the men
as dead in spirit as those stones that are the type of all things cast out
and condemned. In page after page Ruskin pursues his negative epi-
phanies: a chapel in the mountains containing a heap of bones; a shrine
bearing images of demons; a Venetian actress wearing a death's head;
German prints depicting dislocated joints and dismembered bodies.
Ruskin's jeremiad hovers between loathing and compassion, as though
unable to confirm whether the hearts of men are hardened or God has
darkened His revelation. In his final word painting, he guides his read-
er through an Alpine village disfigured by every form of decay, then
pauses behind the episcopal palace to note "a *neglected vineyard,* of
which the clusters, black on the under side, snow-white on the other
with lime-dust, gather around them a melancholy hum of flies" (VI,
414). The town, ironically named Sion, is a Catholic bishopric, so that
the vineyard, powdery as a whited sepulchre, marks it as the type of
ecclesiastical neglect and by extension of all suffering permitted by
human indifference. But Ruskin has presented the earth itself as a ruin
abandoned by its Master; the mountain slum, then, becomes the tragic
reminder of God's promise, unredeemed, of a spiritual Zion.

The ambiguity of this passage, which is both an overt anti-Catholic
diatribe and a covert rebuke to the Creator who has withdrawn, typifies
the studied equivocation that pervades this book. For example, when
describing God's manifestation to humans as a personality that pun-
ishes and blesses, Ruskin writes, "This conception of God, which is the
child's, is evidently the only one which can be universal, and therefore
the only one which *for us* can be true" (VI, 111). But the religion of
Goldau is not a child's conception. Read on one level, Ruskin's argu-
ment reinforces at every turn an allegorical reading of nature as a
system of rebukes and rewards. Read on another level, the argument
denies every evidence of presence and purpose, building in "The
Mountain Gloom" to a climactic revelation of metaphysical evil. For
Sion is not a noble picturesque but the exposure of blank and mean-
ingless despair, demanding a response too urgent for the agencies of
even the greatest art.

"For most men," Ruskin wrote in "The Moral of Landscape," "an

ignorant enjoyment is better than an informed one." By fracturing his audience into "most men" and an implied noble or unhappy few, he betrays his fear of unbelief by adopting a studied vacillation between stoical skepticism and a set of childlike pieties he cannot trust either himself or his audience to abandon completely. Yet we should not exaggerate this equivocation. The chief question of the present book (that is, the proper effect of natural beauty on the human mind) is of the most serious importance for "most men" as well as for Ruskin: for even though he was soon to abandon his belief in God, he never ceased insisting on the absolute necessity of religious experience—that apprehension of human meaning in the natural world upon which, for him, both the moral life and the life of the imagination depend.

And so *Modern Painters* IV reconceives the world in mythical terms—this time through the eyes not of the Greeks or the medievals or the great moderns but of the ancient Hebrews. Never before had Ruskin entered so deeply into the spirit of the prophets, even so far as to reenact their ascent to the high places, the altars of the Lord. The Hebrew deity, in His wrath and his mercy, becomes the mythical expression of the radical ambiguity of natural appearances, just as Ruskin's dialectical movement of thought imitates the alternating blessings and cursings of Old Testament prophecy—or, more closely, the dialogues of Job. What man, Ruskin demands in "The Mountain Gloom," can "unravel the mystery of the punishment of NO sin? Can he entirely account for all that happens to a cab-horse?" (VI, 415). Like the Book of Job, Ruskin gives no direct answer.

Modern Painters III argued that religious myth held the power to provide meaning and affirmation in ages of belief. The fourth volume argues that great religious art in the nineteenth century must be tragic. It does not matter for such art whether we accept the geologists' hypothesis of creation or the biblical account of a forfeited paradise. The lesson of Sion is in any case the same: human redemption lies in human hands. And in either case the noble picturesque, both in landscape and in art, is a disturbing experience necessary to the soul's full moral awareness. This point Ruskin reaffirms in the strangely moving closing pages of "The Mountain Glory." For the coda to his book, he turns to the Bible, seeking instances of the spirit in communion with nature that can counterbalance the sundered communion of "The Mountain Gloom." He chooses three examples: the deaths of Aaron and Moses and the Transfiguration, which he pictures as the moment when Christ in his human character takes upon himself the human fear of death. That fear "had to be borne by Him, indeed, in a unity, which we can never comprehend, with the foreknowledge of victory,—as His sorrow for Lazarus, with the consciousness of the power to restore him; but it *had* to be borne, and that in its full earthly terror." (VI, 464–465).

Ruskin began his book by juxtaposing the forgetfulness of death—"the entire denial of all human calamity and care, in the swept proprieties and neatnesses of English modernism" (VI, 15)—with the tower of Calais, a picturesque monument to lost time. He closes his book with the biblical paradigm of the victory over death through a full confrontation of it, and the image of the Mount of Transfiguration as a memorial to the divine sacrifice, God's accommodation to man in the flesh.

To "most men" mountains may seem graced with the remembrance of the Good Shepherd, whom they may imitate through kindly deeds. But in the course of years Ruskin come to see even more clearly that there could be another form of imitation, by which the unique experience of Christ becomes the emblem of the highest human self-actualization: the fear of death joined with the victory over it, and the sorrow for Lazarus joined with the restoration of him. Tragic awareness means incorporating into the self the divine wrath and the divine mercy and so to become an adult, not a child—in the very act of accepting one's fallen mortality. Humankind must take the place of the deity that has withdrawn in order to rebuild the ruined earth. Doing so means that the science of aspects must center itself in the human mind, itself the locus of hell and chaos and Elysian fields. Such, at any rate, is Ruskin's mature humanism, expressed most movingly in the final volume of *Modern Painters*, when the "dark mirror" of the soul takes the place of the firmament:

> So that the soul of man is still a mirror, wherein may be seen, darkly, the image of the mind of God.
>
> "But this poor miserable Me! Is *this*, then, all the book I have got to read about God in?" Yes, truly so. No other book, nor fragment of book, than that, will you ever find; no velvet-bound missal, nor frankincensed manuscript;—nothing hieroglyphic nor cuneiform; papyrus and pyramid are alike silent on this matter;—nothing in the clouds above, nor in the earth beneath.
>
> Therefore it is that all the power of nature depends on subjection to the human soul. Man is the sun of the world; more than the real sun. The fire of his wonderful heart is the only light and heat worth gauge or measure. Where he is, are the tropics; where he is not, the ice-world. [VII, 260–262]

PART III /

WEALTH AND LIFE

The Economy of Beauty

Thus *all* the physical and intellectual senses have been replaced by the simple alienation of *all* these senses; the sense of *having*. The human being had to be reduced to this absolute poverty in order to be able to give birth to all his inner wealth.

—Karl Marx, 1844

When fame came to Ruskin in the 1850s, he made himself the center of a web of activities of which his books form only a part. First, he was a teacher: he held classes at F. D. Maurice's Working Men's College, tutored and lectured the rich, and wrote textbooks for an even larger audience, becoming in effect the drawing master of the nation. Second, he was a preserver: by undertaking to catalog the immense Turner bequest, containing over 19,000 sketches and paintings, he converted the works of England's greatest painter into an item of national wealth. Third, as a critic, patron, and friend, he encouraged the best young artists of his time with commissions and praise. In short he seized a peculiarly modern occasion—the hunger of a dominant middle class for the culture previously reserved for the rich—and forged a synthesis of roles even the Renaissance never knew. He was at once Vasari, Lorenzo the Magnificent, and one of the master craftsmen who trained Raphael or Giotto as well as a visionary and propagandist for art. But perhaps we might best call him a political economist of art, the fountainhead of a micro system that propagated beauty by means of money, ideas, and guidance. In many ways his activities acted out the proposals of his books and lectures, one great aim of which was to reconcile art and society in ways that would transform both. The social means of that transformation would rest on the imaginative extension of his economic micro system to the entire nation.

At its best, we might call Ruskin's patronage system a form of exalted Confucianism, based on the idea of paternity. We see this aspect most clearly in the case of his favorite protégés, Edward and Georgiana

Burne-Jones, whom he called his children, but always in some degree Ruskin's relations with young artists seem to have imitated his own relations with his father: the artists acted out his ambitions vicariously in return for encouragement and the right to give advice. They often saw him, in turn, as a combination of schoolmaster and fairy godfather, and to a young person of noble aspiration, the first meeting with Ruskin could be the revelation to him of the Promised Land of his powers. James Smetham, the painter, wrote, "Ruskin is a revelation of a new world . . . , one of the very noblest creatures that ever breathed God's vital air and the Chevalier sans peur and sans reproche who has cropped up like the flower which blooms once in a hundred years." The young Burne-Jones wrote to a friend, "Isn't that like a dream? Think of knowing Ruskin like an equal and being called his dear boys. Oh! he is so good and kind—better than his books, which are the best books in the world." "Jones," Ruskin exclaimed on first seeing the young man's sketches, "you're gigantic!"[1]

No charismatic style could be farther removed from that of Carlyle, and indeed it is tempting to see the two friends as opposite poles, answering opposite needs in the mid-Victorian generation seeking a principle of authority. One, gruffly and even harshly masculine, preached the gospel of heroism and sent his young men, so to speak, off to war. The other, who struck some as frail and feminine, preached the gospel of goodness and beauty, yet made people want just as strongly to sacrifice themselves to a noble ideal. In his influence on others, Ruskin called up enthusiasm rather than earnestness, as Walter Houghton has defined these terms, while Carlyle was the prophet of earnestness in an extreme form.[2] And if Carlyle dramatized in his personality some of the fire of a Scottish Covenanter, Ruskin could seem (to the eye of the beholder) surrounded with the glow of knighthood—or at least with that of gentility. Houghton remarks that earnestness is essentially Evangelical, while enthusiasm is essentially aristocratic. Unlike Carlyle, Ruskin usually pictures social perfection in aristocratic imagery, just as, in his own life, he fulfilled the dream not only of his parents but also of an entire class.

The class basis of Ruskin's appeal is indicated by the house that for a few years formed the nexus of his personal "economy." He returned to Denmark Hill at the end of his marriage, where he found life narrow and irksome, although it must have affected many visitors much as the country houses of his father's clients affected Ruskin as a boy. Callers

[1]Smetham's letter is quoted in Derrick Leon, *Ruskin, the Great Victorian* (London: Routledge and Kegan Paul 1949), 277; for Ruskin and Jones, see Leon, 245.

[2]Walter Houghton, *The Victorian Frame of Mind* (New Haven: Yale University Press, 1957), 264.

approached the mansion by means of a gravel drive past a lawn with an immense cedar of Lebanon; inside were agreeable footmen and servants and the lord and lady of the house—she no Scottish captain's daughter but rather a "ruddy, dignified, richly dressed old gentlewoman . . . who knows Chamouni better than Camberwell." It was the young lord who showed the guest the family treasures, hanging and unhanging them from the wall and talking all the while. The tour was apt to end in John's study overlooking the garden—a room thick, almost cluttered, with papers and sketches, precious manuscripts and specimens of shells and ferns, a museum within a museum that must have seemed, like his books, a collection of his best and happiest moments. James Smetham recalls speaking "about things I should be sorry to open my heart concerning to scarcely any; only of course he guided the conversation." This particular visitor left in a carriage (ordered by the elder Ruskin so that no damage would befall his sketches), feeling "in a sort of soft dream all the way home." The father bought the house and pictures, but the son filled the place with romance and forged its links with Lady Canning, the Marchioness of Waterford, or Broadlands, the home of Palmerston, but if the scene I have described represents the apex in the arc of the father's fortune, the same "fortune" in the son's hands flowed downward into unforeseeable regions. To Octavia Hill, an idealistic young woman trying to finance slum improvements, he said: "I have been given means, take some of them, live, set your mind at ease. But don't think I am doing you a personal favour, or a favour at all. I am but carrying on the work I was sent to do. I work for other generations."[3]

The complex psychological dynamics of the system by which Ruskin, fresh upon the dissolution of his own marriage, tried to create for himself an extended household and an extended progeny, are best seen in his relations with Rossetti—at once the oddest and most inevitable of his friendships. The relationship was inevitable, because Rossetti was a great English painter; it was odd because Rossetti's dissolute and self-destructive genius was as far from the piety of Ruskin's parents as the notorious household at Cheyne Walk was from Denmark Hill. Undoubtedly Rossetti appealed to Ruskin's susceptibility to sensuality—or at least to the combination of spirituality and squalor that Ruskin associated with Italy—and therefore to Ruskin's need to nourish and control. Rossetti was, according to Ruskin, "really not an Englishman, but a great Italian tormented in the Inferno of London; doing the best he could; but the 'could' shortened by the strength of his animal passions, without any trained control, or guiding faith" (xxxv, 486). Ruskin's

[3]Quoted in Leon, 232–233, 235.

letters characteristically combined extravagant praise with persistent criticisms of details—what Rossetti called his "pinpricks"—which came close to causing their rupture. For Ruskin's beneficence always involved a trade-off. His general view that social relations should be cooperative instead of competitive found its correlative in a territorial pattern of friendships, according to which everyone receives claim to a distinct "superiority." It seems that Ruskin, emerging from the disaster of his marriage, needed all the more to establish control over others and immunity for himself—a need that led him to failures in intimate friendship, to success in purely philanthropical relations, and to the belief in a paternal hierarchy as the only possible form of the Peaceable Kingdom. But another side of his authoritarianism was the real fear that the artistic passions were poor shepherds of themselves, a fear connected with his growing preoccupation in the 1850s with the evanescence of beauty. Indeed, it is hard not to see behind the images that close *Modern Painters* v—the Hesperid standing in the twilight or the fading stain on Giorgione's wall—the shape of the doomed Lizzie Siddal or the frescoes on the Oxford Dining Hall, executed on whitewashed brick. The Rossettis must have confirmed Ruskin's sense of an inherent fatality in the art gift as well as the sense, both anguished and hopeful, that he himself had the means to preserve life.

Both Ruskin's life and his books center in these years on the same issues—the interconnectedness of wealth and love and art and life. No document reveals more clearly the personal energies informing his work in the late 1850s than a letter he wrote to Rossetti by way of introduction, asking, among other things, for understanding in the face of his recent scandal:

> You constantly hear a great many people saying I am very bad, and perhaps you yourself have been disposed lately to think me very good. I am neither the one nor the other. I am very self-indulgent, very proud, very obstinate, and *very* resentful; on the other side, I am very upright . . . , exceedingly fond of making people happy, and devotedly reverent to all true mental or moral power. . . . I believe I once had affections as warm as most people; but partly from evil chance, and partly from foolish misplacing of them, they have got tumbled down and broken to pieces. . . .
>
> Now you know the best and worst of me, and you may rely upon it it is the truth. If you hear people say I am utterly hard and cold, depend upon it it is untrue. Though I have no friendships and no loves, I cannot read the epitaph of the Spartans at Thermopylae with a steady voice to the end, and there is an old glove in one of my drawers that has lain there eighteen years, which is worth something to me yet.[4]

4Quoted in Leon, 214–215.

Ruskin's candor shows through the elaborate self-presentation and the attention to effect. The letter proceeds in the manner of a contract, laying out the conditions of friendship along with a frank valuation of the goods offered; that valuation he then describes in terms of a mission: "I have a theory of life . . . , namely, that we are all sent into the world to be of such use to each other as we can, and also that my particular use is likely to be in the things I know something about—that is to say, in matters connected with painting." With regard to Rossetti, he believes he can make him "more happy" by "enabling you to paint properly and keep your room in order." The poignance of the letter comes from the need to know what he was sent into the world to do and also, obviously, from the implicit trade-offs it defines: the power to do useful good replaces the missing "friendships and loves," the self-indulgence makes bearable the isolation at the core of his life, and the strength of feeling for persons is replaced by the strength of feeling for things redolent of persons (an inscription, a glove)—persons, of course, from the past. The charge of coldness he answers with the assertion of his ability to give—not as a lover or even explicitly as a friend, but as a benefactor, acting out in material terms the greatest of Christian virtues. Above all the letter proposes a kind of cultivation of feelings, but it does so at a different angle, so to speak, from that taken by Mill in the fifth chapter of his *Autobiography*. Mill, engaged in social questions, found himself pathetically ignorant of "the perennial sources of happiness, when all the greater evils of life shall have been removed"; Ruskin was to make social action perform the aim of Mill's study of poetry, knowing that in a corrupt society even art fails as a perennial source.

I will argue in the next chapters that Ruskin's social thought has much to do with the proper management of affection—as do also his practical activities as a political economist of art. His activities and his books are joined by three general aims. First, through his patronage, he creates a concurrent flow of money, affections, and works of art that publicly establish the metaphor of emotional expression as gift giving, the earning and bestowal of treasure. Second, the system is built on a paternal relationship that, like the Confucian system, contains the pattern of all social relationships—teacher to pupil, ruler to subject, patron to workman, even husband to wife—which of course is ultimately the system of Gothic building. In each act of help Ruskin becomes the perfect father he longed for: he tried to give to others the palms he could not earn himself, to control in others what he could not control himself, and to preserve in others what was continually dwindling in himself. Third, the private economy exists through time. Each pound spent is also a seed planted; by spending for the future, Ruskin can redeem the past.

The Economy of Art

In 1857 Ruskin began his assault on the Benthamite "gospel" by taking to the lecture platform—with the effect, as his editors put it, of tickling the lion in its den. The "den" was Manchester, the home of laissez-faire economics; the occasion, the opening of the Manchester Art Treasures Exhibition; the result, the pair of lectures published as *The Political Economy of Art* and reissued as *"A Joy Forever" (and Its Price in the Market)*. The situation was almost too rich in irony. The fashionable art critic was invited to address a fashionable audience at the Manchester Athenaeum, which was surrounded at some remove by the hideous slums whose inhabitants, by their wretchedness and their labor, made possible the purchase of art for middle-class ostentation. The word "treasure" unconsciously underscored the contrast. Ruskin explores this and other paradoxes in an ironic tour de force that uses as a central "conceit" the comparison of artists and patrons with workers and capitalists and of artworks with shirts and grain.

The Manchester press was enraged, but the audience, to all reports, was pleased and with good reason. From the start Ruskin strikes a note of malicious yet disarming urbanity that combines the manner of a preacher playing with his text with that of a tutor putting paradoxes to a pupil.[5] Ruskin's subsequent rhetorical strategy is a shrewd alternation of flattery and abuse that both fulfills and undermines the expectations of the audience. Ruskin's rhetoric is so interactive—at one point touching the consciences of his hearers, at another point their anger, at another their aspirations—that the lecture becomes in effect a dialogue between a speaker and an audience-persona with whom in complex ways the speaker identifies. Superficially, Ruskin's procedure resembles a sermon or printed pamphlet, yet it is more wittily ironic than the one and far more intimate than the other (its "you" denotes a specific and present audience, not an impersonal one); in fact he refashions the lecture as a prose genre.

One of the "notable" characteristics of the age, Ruskin begins, is "the just and wholesome contempt in which we hold poverty. I repeat, the *just* and *wholesome* contempt; though I see that some of my hearers look surprised at the expression" (XVI, 15). The surprise comes, of course, from Ruskin's appearing to ally himself with his hearers against the Biblical religion they profess (and of course the contradiction between professed belief and commercial practice is the irony that makes possible all of Ruskin's social evangelism, as it does Carlyle's). But the sur-

[5]In an important essay, George Landow examines the rhetorical structure and mode of another lecture with far-reaching implications about Victorian nonfiction prose in general. See "Ruskin as Victorian Sage: The Example of 'Traffic,'" in *New Approaches to Ruskin*, ed. Robert Hewison (London: Routledge and Kegan Paul, 1981).

prise deepens when he claims that the Greeks also held poverty in contempt, which means that, despite their pretensions, the British are a people in love with poverty. The central irony is that, given his sense of "wealth" Ruskin is not being ironic at all, and the "answer" of the paradox turns out to be two key principles of Ruskin's social thought: that there is true and false wealth and that wealth essentially consists in the management of labor. Thus the contempt of poverty means the wish to eradicate it, and the love of true wealth means the wish to spread the arts and also to employ all the workmen of England. This exclusion of alternatives (one either loves wealth or hates it) wittily plays against the actual case, which is that the wealthy want wealth for themselves, not for others. (Even more subtly, it parodies the Socratic definition of the good as what everyone desires; how strange if one should then object that most people should not have the good.) Indeed, Ruskin's irony and tone are eminently Socratic—Socratic because of his exaggerated sense of the obviousness and simplicity of things. The condition of England is simply that of a housewife who has failed to give her servants enough work to do; Ruskin's audience has overlooked—absentmindedly, as it were—their true powers as governors of the nation, so that Ruskin's declaration of war on the lions of Manchester comes as an exhortation rather than as a rebuke.

> The notion of Discipline and Interference lies at the very root of all human progress or power; that the "Let-alone" principle is . . . the principle of death; that it is ruin to him certain and total, if he lets his land alone—if he lets his fellow-men alone—if he lets his own soul alone. . . . his whole life, in the contrary, must, if it is healthy life, be continually one of ploughing and pruning, rebuking and helping, governing and punishing. [XVI, 26]

The lectures, then, appeal to the "best selves" of the audience by a gentle mix of "ploughing and pruning"—or perhaps we should say "seeding"—the minds of his hearers.

When Ruskin turns to art, however, the manner changes suddenly to the melodramatic rebuke of the pulpit. "But your great men quarrel with you, and you revenge yourselves by starving them for the first half of their lives," he claims. People must praise them when they need it, in the "asphodel meadows of their youth," or it will be too late; what then can the painter do with "your sharp laurel crown" except "lay it on his mother's grave?" (XVI, 31, 33–34). And so on. The phrases marshal Ruskin's powerful feelings about childhood to induce an ideal paternal sentiment in his audience and to identify himself with them at the same time. In urging them to buy and preserve paintings wisely and to praise and blame artists judiciously, he endows his audience with his own expertise even as he appears to rebuke them. The effect is to confirm

beliefs, not to challenge them: no one in the room would quarrel about starving young geniuses or revering one's own parents.

Two pervading themes of the lectures are paternity and waste. The particular nurturing instinct Ruskin arouses is a kind of husbanding anxiety, a fear that things will slip or fade away and die. Thus the spirit of genius in its youth Ruskin compares to gold, emphasizing its scarcity ("You may lose it or you may gather it . . . , but the best you can do with it is always merely shifting, melting, hammering, purifying—never creating" [XVI, 30]). The second precious substance is the work of genius. The snow sculpture commissioned of Michelangelo by Pietro de Medici is the "perfect, accurate, and intensest possible type of the greatest possible error" in the use of genius: "to put itself into the service of annihilation—to make a cloud of itself, and pass away from the earth" (XVI, 39). But this is also the perfect type of the British use of artists—the British set artists to make cheap prints, for example, or inferior copies on paper made of "mere white and brown rags." The second lecture develops this theme with steadily increasing scope and intensity, expanding the region of the art economy to include first, the works of the great dead and second, the other nations of Europe. Thus, if the English people but knew it, Italy is the great garden and treasure house of their tradition as well—Italy, which, in a furious passage, Ruskin likens to a marble hall infested with monkeys. This neglect he lays to the account of his audience, who are properly members not of England alone but of "the great Christian community of Europe." Frantically preoccupied with getting and spending, they are like the manufacturer "who attended to his looms, but left his warehouse without a roof," leaving the rain to flood, the rats to frolic, the spiders to spin, the choughs to build—and still "keep weave, weave, weaving at your wretched webs, and thinking you are growing rich" (XVI, 75–76). At last the images of ruin—servants unemployed, operatives destroying their own work, warehouses collapsing, paintings falling to rags, gold nuggets of genius cast into the dust—build like a snowball into a vision of man replacing time as the Great Leveler: "I tell you, Time is scytheless and toothless; it is we who gnaw like the worm— we who smite like the scythe. It is ourselves who abolish—ourselves who consume: we are the mildew and the flame; and the soul of man is to its own work as the moth that frets when it cannot fly, and as the hidden flame that blasts where it cannot illuminate" (XVI, 64). This destructive energy, then, is subverted and subterranean, the *perversion* of energy; the last clause remarkably converts two metaphors of the soul's aspiration into a self-consuming embrace (the moth soul and the flame soul), while "frets" connects the palpitation of the moth with the gnawing of the worm and "blasts" connects the light hidden under the bushel with warfare and also with the blighting of grain. The whole

complex points to the scriptural passage that underlies Ruskin's argument: "Do not lay up for yourselves treasures on earth, where moth and rust consume and where thieves break in and steal, but lay up for yourselves treasures in heaven. . . . For where your treasure is, there will your heart be also" (Matt. 6:19–21).

This is the prophetic burden, in its negative aspect, of *The Political Economy of Art*. But if the analogy holds between artists and laborers and between art and wealth and between art economy and political economy, then the Manchester system is refuted—refuted, that is, by a change of heart. The new attitude to human work is aesthetic rather than exploitative, but aesthetic in an exalted sense: as a work of art is contemplated as an end in itself and as the labor of an artist is a creative expression, so is human life an end in itself and all human labor potentially creative. Throughout the lectures Ruskin relies on a dominant image to induce this response, the image of a structure enclosing precious objects. This structure pervades *The Stones of Venice* as well in the forms of the city and the church. In the lectures it varies more widely, beginning with the Art Treasures Exhibition itself and including a garden, a tastefully furnished household, a museum, Italy with its works of art, and the eternal temple of art, "the rough stones and the smooth all finding their place, and rising, day by day, in richer and higher pinnacles to heaven" (xvi, 64), and these, of course, have their antitheses in places where things decay. The expanding scope of the enclosures suggests that they also stand for the expansion of sympathetic concern, at the achievement of which Ruskin's audience would pull down the walls of the false treasure houses that separate rich from poor, sacred from secular, the slums of Manchester from the glitter of the Exhibition. This use of metaphor is exactly that prescribed by Shelley in the *Defense of Poetry*, although Ruskin's "legislation" is acknowledged.

A second group of images, the noble governors, is of particular interest because Ruskin uses it typologically. Two of the governors frame the first lecture as the first and last panels of a diptych frame the center. The first is the Perfect Wife of Proverbs, the "perfect economist, or mistress of a household," who divides her care "between the two great objects of utility and splendour: in her right hand, food and flax, for life and clothing; in her left hand, the purple and the needlework, for honour and for beauty" (xvi, 20)—a type, therefore, of the necessary balance in private life between use and pleasure and, in the life of nations, between useful products and beautiful products. (Ruskin's meaning depends also on some unquoted verses describing the wife who, like Britannia, weaves textiles for herself and for merchants, so that her household is a point of intersection, a "Queen among nations.") The balance of objects in the right and left hand is

the lecturer's arrangement: he has read the passage iconographically and schematically, as a medieval painter might, with the intention partly of balancing this composition against his second word picture, which frames the lecture at the other end. This passage describes Ambrogio Lorenzetti's fresco of *Good Civic Government*, with its central figure—the male counterpart of the housewife in Proverbs—surrounded by the Christian and pagan virtues in spatial relationships that suggest their importance as qualities of a governor. Ruskin notes that the virtue entrusted with public revenues is neither Charity, who is too "hot," nor Prudence, who is too "timid," but Magnanimity—"largeness of heart: not softness or weakness of heart, mind you—but capacity of heart—the great *measuring* virtue" (xvi, 56). This strength of heart, this impassioned judiciousness (the type also of divine "interference" as well as self-mastery) is the key to an economics of the soul—the same power as that of the deeply feeling yet immovable soul of the great artist, transcending both deadness of feeling and the heat of the pathetic fallacy.

In the third word picture, which is really an antithetical pair, Ruskin brings to a single point of focus his weblike vision of the British economy. First, the antithesis of the flax-spinning housewife of Proverbs: "you think it perfectly just that [the rich man] should . . . use his breadth and sweep of sight to gather some branch of the commerce of the country into one great cobweb, of which he is himself to be the central spider, making every thread vibrate with the points of his claws, and commanding every avenue with the facets of his eyes" (xvi, 100). But a page later comes the reversal: "wealth well used is as the net of the sacred fisher who gathers souls of men out of the deep. A time will come—I do not think even now it is far from us—when this golden net of the world's wealth will be spread abroad as the flaming meshes of morning cloud are over the sky" (xvi, 102–103). Suddenly the web is a net that unites men in charity, not destruction, in a gesture that is centrifugal rather than centripetal—acting out the paradox that to lose is to keep and that to throw out in giving is truly to bind together in saving. The golden net, Ruskin's final image of enclosure, contains the Brotherhood of all humans united in the Fatherhood of Him who is also the Son of men, the saver of life and the Savior of the faithful. The net is also cast into the future. Thus every act of giving repeats the divine act of creation, for the ultimate aim of wealth is to "prolong the existence, of the whole human race."

Like *The Stones of Venice*, this vigorous performance is a lay sermon in Coleridge's sense, using the Bible as a practical guide not to politics but to economics. Of the three figures I have discussed—Wisdom, the governor, and the fisherman—only one comes directly from the Bible, though all are familiar types of Christ. But the lectures also take the book of Proverbs as their specific model. Both works are direct ad-

dresses, composed of advice by experts in the field who rely for illustration on the figure of the capable housewife, who as Wisdom symbolizes the aim of the whole. According to Proverbs the gain from wisdom "is better than gain from silver and its profit better than gold. She is more precious than jewels, and nothing you desire can compare with her. Long life is in her right hand; in her left hand are riches and honor" (3:13–17). Riches and honor: the last clause is also Ruskin's last and the signature, so to speak, of his argument. Twelve years later he completed his portrait of Wisdom in *The Queen of the Air,* but in fact she remained, like Wealth and Life, his constant subject.

The Organic Body

What can be the function of art in a society indifferent to its ministrations? How can art, compromised by its relation to the sensual, still maintain the social good? If the face of Nature is darkened, what ought art to imitate? And where can human beings look for value and hope, if not in art or nature? These questions dominate Ruskin's thought in the late 1850s, the second half of his great decade, when the foundations of his earlier faith—Evangelical Christianity and the "gigantic moral power" of landscape—continued to crumble. More clearly than ever before, the subjects of art and religion become from him symbols of psychic and social integration. More accurately, he conceived of his subjects as organic systems or economies, the elements of which refer to more than one thing—to nature, to the soul, to society, to an aesthetic whole.

The Political Economy of Art used one version of this configuration—the treasure house or four-dimensional circulation of wealth—to establish art patronage as a category mediating between art and society. Ruskin had, of course, already developed the structure of this governing metaphor in the theory of Purity in *Modern Painters* II. In the final volume of the series (1860), in the chapter titled "The Law of Help," he developed the idea into an analogy between an aesthetic structure and a social structure. He defines "composition" as "the help of everything in the picture by everything"; a picture resembles an inanimate object, in which the atoms merely "cohere," less than a plant, the whole of which is affected if a part is removed. "The power which causes the several portions of the plant to help each other, we call life. Much more is this so in an animal. . . . Thus, intensity of life is also intensity of helpfulness—completeness of depending of each part on all the rest. The ceasing of this help is what we call corruption." Corruption, then, is the antithesis of life: "The highest and first law of the universe—and

the other name of life is, therefore, 'help.' The other name of death is 'separation.' Government and co-operation are in all things and eternally the laws of life. Anarchy and competition, eternally, and in all things, the laws of death" (VII, 205–207). The diamond, which is Ruskin's paradigmatic symbol for purity, is the perfect antithesis to the smoke or mud of carbon, in which the crystalline structure has lapsed into disorganization. Light is to dark as Divine presence is to separation, as purity is to corruption, as energy is to entropy, and as life is to death.

These antitheses dominate Ruskin's vividest writings in the late 1850s down to the last, apocalyptic chapters of *Modern Painters* v (1860), the general theme of which is the relationship of social decline to a decline in the arts. In a lecture of 1858 he asserted this connection in paradoxical form: "At the moment when, in any kingdom, you point to the triumphs of its greatest artists, you point also to the determined hour of the kingdom's decline" (XVI, 342). The reason lies both within and beyond art itself: "beyond" in the sense that art becomes damaging when "misused"—that is, by a system comprising artist, patron, and audience; "within" in the sense that the true subject of art in itself contains moral ambiguities. That subject Ruskin declares to be "organic form," meaning either landscape or the human figure, although in most contexts he means the second. The noble human figure is the type of vigorous and healthy life, but in its debased representation it becomes lewd and profane. Since Ruskin's own attitude to the sensuous remains ambivalent and confused, he resorts to the imagery of the organic and inorganic, which allows him to connect an attitude toward the human body with an attitude toward the human social body.

In the inaugural address to the Cambridge School of Art, he gives his most striking portrait of art misused, an epitome of the sensual Fall centered on the person of a Renaissance cardinal. The villa and garden of Cardinal Maurice rise far above Turin and the surrounding plain of the Piedmont—a landscape that bears "the whole legend of Italy's past history before it by the finger of God" beneath a sky of "unsealed scrolls" and "mighty missal pages of sunset after sunset." By contrast the walls of the villa are decorated with frescoes of the four seasons, loaded down, according to the cardinal's request, with "una copiosa quantita di Amorini." These vapid landscapes, with their nude putti infesting meadow, tree, and sky, render nature as an erotic fantasy, a puff of blinded vanity that plays against the mountain scriptures, with their unheeded warnings (XVI, 196, 192). The paintings and the now dilapidated villa form a character of the corrupt cardinal, who resigned his commission in order to marry his niece. A "born intriguer" who "lived a dissipated life, surrounded by artists and men of letters" (XVI, 191, editor's note), he destroys in the name of religion what the Renais-

sance had destroyed in the name of knowledge. (Oddly enough, the same cardinal commissioned the three great Veroneses in the Turin gallery—the power of which, for Ruskin, was "almost superhuman" in its noble depiction of human form.)

In the cardinal's sin Ruskin has begun to see sensuality as an expression of solipsism, or hoarding. Maurice has cut himself off from the body of nature and the society of man; the other name of death is separation, and so the judgment upon the villa is decomposition of its organic forms. Ruskin infuses the ruin with sexual horror: "The creeping, insidious, neglected flowers weave their burning nets about the white marble of the balustrades, and rend them slowly, block from block, and stone from stone: the thin, sweet-scented leaves tremble along the old masonry joints as if with palsy at every breeze; and the dark lichens, golden and grey, make the foot-fall silent in the path's centre" (xvi, 196). This antithetical garden performs the work of death like a vegetal Lamia: the flowers, insidious and weaving, are spiderlike or snakelike, the leaves are both sweet and palsied, the "dark" lichens seem to still the heart as well as the footfall.

The Swinburnean imagery of decomposition also resembles the fate visited upon modern England, which has misused beauty not by sensualizing it but by banishing it altogether. The sin in each case, once again, is denying organic bonds. "Modern Manufacture and Design," a lecture delivered at the opening of a School of Design in Bradford, is about the impossibility of any true school of design in a country that, if its commercial desires reach their logical extension, will soon be one vast infernal machine—in the south, lime kilns and brick fields to balance the coal pits in the Midlands, and in the Lakes, an immense quarry of slate and granite to supply the world with roofing and building stone. This state of affairs is of course not progress but decline, as Ruskin shows in a remarkable word portrait of a Bradford suburb.

In the foreground stands a seventeenth-century country house surrounded by stream and woods, now fallen into a common desolation: the garden is "blighted utterly into a field of ashes," the shutters hanging "in rags of rotten wood," the stream "soaking slowly by, black as ebony," the banks "trodden into unctuous, sooty slime," the furnaces of the city "foaming forth perpetual plague of sulphurous darkness" (xvi, 339). The landscape is antinatural, dominated not by machinery—as a similar scene would be in Dickens—but by decomposition, the reverse of the "law of help." Even the smallest detail anticipates the qualities of impurity as set forth in *Modern Painters* v—the qualities of formlessness, filth, darkness, and inanition. Things are, first of all, indistinct—"unregarded havoc of ruin," "shapeless rents," coiling clouds—and all substances have decomposed to lower forms: shutters to rags, the bank to slime. The river soaks instead of runs, its banished energy displaced

onto the diabolic foaming and coiling of the smoke. The only distinct objects are the industrial equivalents of land enclosure: instead of hedges, "slabs of square stone, like gravestones," reminding one of Blake's "chartered" streets. But Ruskin sets against this scene a second, forming a contrast sharper than anything in the pages of Pugin. The alternative "school of design" is supposedly Pisa in the time of Nino Pisano, but it really belongs to the timeless imagination, like a glimpse from the window of the Lady of Shalott. In Ruskin's Pisa are gardens, courts, and cloisters; a street that is really a line of palaces "inlaid with deep red porphyry, and with serpentine"; the most beautiful ladies Italy ever saw; and troops of knights ("horse and man one labyrinth of quaint colour and gleaming light"—rather like a stained glass window). This tableau displays the quintessence of "purity"—light, color, energy, and above all, life—not vegetable but human ("this scenery of perfect human life"), an animate earth mirroring a heaven equally animate ("every cloud that passed was literally the chariot of an angel"; XVI, 339–340). The utopian city is a human landscape: humans are to its streets as trees and blooms are to the Paradisal hills.

But we do not want a new Pisa, Ruskin says. "All that gorgeousness of the Middle Ages, beautiful as it sounds in description, noble as in many respects it was in reality, had, nevertheless, for foundation and for end, nothing but the pride of life—the pride of the so-called superior classes." For us, on the other hand, "there can be no more the throne of marble—for us no more the vault of gold—but for us there is the loftier and the nobler privilege of bringing the power and charm of art within the reach of the humble and the poor" (XVI, 341–342). In this light the dream of Pisa becomes the emblem or the myth of the good society—not a looking back but a looking forward to a human-centered world. Indeed all great art is such a vision, "the type of strong and noble life," because it sees truly; for the noble person looks "the facts of the world full in the face" and then "deals with them," becoming "no unconscious nor insignificant agent in consummating their good, and restraining their evil" (XVI, 287). Great art is the *type* (though not a sufficient cause) of a life open to anyone—a painter, a housewife, a governor, a laborer, a man of science—even though form (as the narrator of *Death in Venice* describes it) may be "hostile to morality—in that of its very essence it is indifferent to good and evil, and deliberately concerned to make the moral world stoop beneath its proud and undivided sceptre."

What might *our* "magnificence," in its "universality and its lowliness," look like? I have said that Ruskin's lectures to the wealthy do not rebuke them so much as they awaken them to their latent powers, and that awakening is the aim also of "Modern Manufacturing and Design." An essential step in the argument is Ruskin's denial of any essen-

tial difference between decorative art and "higher" forms; for just as, on the one hand, the sublimest works of genius can be decorative—Gothic sculpture, for example, or the walls of the Scuola di San Rocco—so the art, say, of manufactured articles depends also on spiritual concerns like "truth, tenderness, and inventive application or distribution" (xvi, 334). By closing the gap in kind between a cathedral and a domestic interior, or between Raphael's tapestry designs and a workman's designs for a shawl, Ruskin makes concrete and plausible his dream of a "magnificence" in widest commonalty spread. The audience at Bradford thus has an even heavier charge than the audience at Manchester, since the manufacturers are not simply patrons of geniuses but also the producers of any useful article that may be beautiful as well. Ultimately, their product is the "souls" of the public, as Ruskin makes clear in a very modern insight into the power of advertising to create false needs. The business of his audience as manufacturers, he says, is "to form the market, as much as to supply it"—not by "retarding the arts, tarnishing the virtues, and confusing the manners" of England but by becoming "its guides, counsellors, and rulers—wielding powers of subtle but gigantic beneficence. . . . Let such duty, such ambition, be once accepted in their fulness, and the best glory of European art and of European manufacture may yet be to come" (xvi, 344–345). That new glory might resemble something like the windows of Chartres that depict the tradesmen who paid for them: "There are smiths at the forge, curriers at their hides, tanners looking into their pits, mercers selling goods over the counter—all made into beautiful medallions. Therefore, whenever you want to know whether you have got any real power of composition . . . , try to conventionalize a butcher's or a green grocer's, with Saturday night customers buying cabbage and beef" (xvi, 328). The wealthy, arrogant young man who could think of trade and labor only in ironic terms, as antitheses to a romantic vision, has vanished. In his maturer vision, art celebrates the dignity of mankind in its works and days, acting as the organic emblem of a perfected commercial society.

Treasure

The image of the organic body is one form of Ruskin's vision of a new and revolutionary integration of art and society; a second form is the metaphor of art as wealth. This analogy implies, first, that art, like economic wealth, supplies a human need and so is the birthright of all, and second, that useful things, like works of art, should be well made and treated as the expressions of human hearts and hands. But the idea of preciousness also implies something not useful and not dis-

persed and so emphasizes the relations of art to the costly, the luxurious, and the exclusive.

In "The Lamp of Sacrifice," Ruskin justified the use of precious materials in architecture by arguing that churches could have human value only by an act of renunciation—by withdrawing the best products from the economy of useful objects. By implication beauty can signify only if it is sanctified, that is, set aside in a special category of the rare and costly. Ruskin retains these assumptions in the secular context of *The Political Economy of Art,* where his insistence on the production and flow of art is countered by an equally strong insistence on the necessary scarcity of precious things. He suggests, therefore, that his audience never buy copies, that the diffusion of art be limited by high prices, that painters train rigorously in "trial schools." He laments the passing of a true goldsmith's art in England, since for him gold has a sacramental and permanent character—it is, so to speak, the type of all types, since it has value in itself and as a symbol of value. "At every marriage, and at every birth, get a new piece of gold or silver if you will, but with noble workmanship on it, done for all time, and put it among your treasures; that is one of the chief things which gold was made for, and made incorruptible for." It is also the best substance for a young artist to train with, since it induces care and reverence ("he dares not scrawl on gold, and he cannot play with it"; xvi, 47, 46). These comments resurrect the dead metaphor of "social refinement" into a theory of enthusiastic moral influence: like the alchemical elixir, art touches into gold, or refines, the sensibility of the possessor and the creating artist. (The pun reinforces the hierarchical nature of enthusiasm, since the masses presumably can be refined only by those who have refinement.)

Gold, then, perpetuates in concrete form the relations of tradition and of social hierarchy. The precious materials of the tabernacle induced awe similar to that of contemplating the heavens, which it imitates in the form of the tent and its golden rings, and therefore also establishes the Mosaic theocracy. According to Blake's myth, Urizen created the heavens in the form of a tabernacle, which upholds the repressive alliance of priest, king, and Newtonian philosopher. Ruskin cannot, of course, agree that religious sacrifice has the same structure as social repression—it has instead the same structure as human interchange, of recognizing oneself as related to others, as we will see again in a moment. For him the difference between oppression and justice is the *use,* not the abolition, of property; and the symbols attaching themselves to property may signify oppression or mutual support.

Ruskin's art economy aims to establish a middle ground between two extremes—the extremes of art hoarded as a symbol of class oppression and art devalued by the mechanisms of a mass market. John Berger, drawing upon Walter Benjamin, has expressed a similar opposition:

The experience of art, which at first was the experience of ritual, was set apart from the rest of life—precisely in order to be able to exercise power over it. . . . What the modern means of reproduction have done is to destroy the authority of art and to remove it—or, rather, to remove its images which they reproduce—from any preserve. For the first time ever, images of art have become ephemeral, ubiquitous, insubstantial, available, valueless, free. They surround us in the same way as a language surrounds us. They have entered the mainstream of life over which they no longer, in themselves, have power.[6]

Ruskin could not foresee the extent to which photographs would overwhelm the public experience of art in the twentieth century, but his object of attack is the same as Berger's: the ability of an economic elite to render art powerless by dispersing it. For Ruskin the laissez-faire market submits intrinsic value to ready profits: cheap, hasty, ephemeral work is encouraged; reputations are inflated for their market value; artworks are converted into symbols of ostentation—degraded, that is, into mere commodities. For this reason Ruskin reinstitutes the values of artisanship and recommends that all artists be paid the same amount. (According to Ruskin the present system of unequal rewards incites competitive envy and eliminates all but the most talented producers.) Purchased and loved for their intrinsic value, works of art would then truly adorn the homes and public places of England.

The argument is crucial to Ruskin, since for him the false use of wealth signals the moment of a nation's decline, yet when we notice his giving friendly advice to manufacturers on the purchase of gold and jewels and expensive pictures, the distinction seems elusive. And so it is—in pessimistic moments, Ruskin doubted that it could be made. The point is that only in its character as wealth, as something rare and precious, can art sanctify. Every purchase is therefore a statement of what the owner chooses to express and affirm. An interior decorated in ostentatious bad taste signifies simply that the owner is in successful competition with others. He or she has no self to affirm, only the denomination of status, and makes purchases that have meaning as counters, not in themselves—they are inorganic, like money. But a well-adorned home grows from a genuine home love, the ability to love things outside of oneself, such as one's descendants, and Ruskin plays on this emotion in the Manchester lectures by calling national economy the "law of the house." Where one's heart is, there is one's treasure also. This notion of course implies class power, but without a conception of benevolent class power, the very notion of society is inconceivable to Ruskin. Social wealth is for him—as landed property was for Burke—a "sluggish" element preserving the texture of tradition and

[6]John Berger, *Ways of Seeing* (London: Penguin Books, 1972), 32.

substantializing the bases of social order. It can also sanctify communal bonds—in public decorations portraying the human figure, for example—even when it is not set aside for religious purposes. Reclaiming the physical body of society, it returns to man (in Marx's phrase) what is man's.

In the broadest terms, Ruskin's art economy seeks to overcome the opposition between artist and society of which romanticism is both the symptom and the protest. In particular it does so by addressing the problems raised by the collapse of the old patronage system—the world of Sir Joshua Reynolds and his predecessors, the world of the Pope and the court. The old system demanded that the artist serve a wealthy elite, but at least the demands were clear and the audience present and personal. The new system subjects the artist to impersonal market forces, governed by an impersonal audience that tends to buy artworks as mere symbols of wealth and position. The system Ruskin proposes instead also implies a theoretical orientation different from the romantic assumptions of his books on painting. According to the earlier description of art production, great art is the individual expression of a great mind, doomed by its superior vision to some degree of misunderstanding. The artist's subject is a revelation through symbols of the divine structure of nature and the religious destiny of human beings; inspiration comes suddenly, from beyond, when the artist is unselfconscious and oblivious to any audience. The artist's aim and subject are expressed by the metaphor of life. In the later account, the artist is a kind of worker or craftsman whose innate gift must be sternly disciplined ("sifting, melting, hammering, purifying" the art gift (XVI, 30)); the product is an artifact rather than a spontaneous expression, one that is relatively scarce and costly; the artist fulfills the desire of a patron or community for decoration, either of a home or a useful object or a public place. The first description stresses private inspiration, the second social usefulness. Can they be reconciled either in theory or practice?

Ruskin implies a reconciliation by providing an ideal image of an earlier period in history, one that like the present was not primarily an age of faith. Given his argument in *The Stones of Venice,* he is understandably tacit about that reference, but in the lectures of the late 1850s he clearly has in mind the Italian Renaissance—not the Renaissance of the yellow Dogaressa and the degenerate grotesques of Santa Maria Formosa, but the Pisa of Nino and the Venice of Veronese. If this period (as Ruskin viewed it at any rate) absorbed itself in the pride of life, it absorbed itself in the "splendour of life" as well—that paradox surely fascinated Browning, who depicted a prototype of Ruskin's Cardinal Maurice in his Bishop of Praxed and perhaps also a prototype of Ruskin's Veronese in Fra Lippo Lippi, with his vigor and dodges and

reverence for the "nobly animal." The system of workshops, patrons, and commissions permitted the flowering of a genius as wayward as Fra Lippo or Tintoretto. "Ghirlandajo was a goldsmith, and was the master of Michelangelo," Ruskin reminded his audience at Manchester; "Verrocchio was a goldsmith, and was the master of Leonardo da Vinci. Ghiberti was a goldsmith, and beat out the bronze gates which Michelangelo said might serve for gates of Paradise" (XVI, 46). From workshop to the Heavenly City: the progression captures precisely Ruskin's joining of genius and artist, of self-expression and decoration and of religious subject and social use. The Scuola di San Rocco and the Ducal Palace, we recall, are both secular institutions; and the Sistine frescoes, those prototypically sublime creations, are decorations.

The syntheses subtly but forcefully displace some tendencies in romantic criticism. Raymond Williams has suggested that the romantic doctrine of genius compensates for the poet's feeling of isolation and inutility, a feeling partly caused by an impersonal market that treats works of art as commodities like any other. For Williams, romantic theory tends to isolate an "artistic sensibility": "Under pressure, art became a symbolic abstraction for a whole range of general human experience: a valuable abstraction, because indeed great art has this ultimate power; yet an abstraction nevertheless, because a general social activity was forced into the status of a department or province, and actual works of art were in part converted into a self-pleading ideology."[7] Ruskin's metaphor of art as wealth moves away from the more self-isolating of romantic attitudes—the absorption in private and merely nostalgic emotions (criticized in "Of the Pathetic Fallacy"), and the contempt for the ordinary and the material—toward a view of art as a social activity. Art is the type of noble human life, that is, a paradigm and symbolic expression of it, and for that reason comparable with other paradigms and expressions of human nobility. Ruskin's art economy would therefore integrate art into the general social life, both as a profession and as a category, while at the same time revolutionizing the idea of a commodity, the idea of giving and possessing and using.

The metaphor of wealth then applies also to the private experience of art, which for Ruskin is inseparable from questions of its exchange and public use. *The King of the Golden River* is a fable showing that true possession comes of giving, or rather that giving and receiving are a single process—just as, for Portia, mercy blesses the giver and is "mightiest in the mightiest." The Manchester lectures make the point of the fable explicit and thereby anticipate one of the great ideas of *Unto This Last* by defining possession not as a legal or material fact but

[7]Raymond Williams, *Culture and Society, 1780–1950* (New York: Columbia University Press, 1958), 47.

as an open-ended activity, with benefits and consequences analogous to the interchange of affections. Wealth is anything so possessed. In an addendum to *The Political Economy of Art* Ruskin lists five kinds of valuable things: that which is necessary to life and must be labored for (food, clothing, and shelter); that which "conduces to bodily pleasures and conveniences"; that which "bestows intellectual or emotional pleasure"; and money. Only the fourth of these, he says, can be truly possessed, since one does not speak of a "wealth of air" and since "the things that give intellectual or emotional enjoyment may be accumulated, and do not perish in using; but continually supply new pleasures and new powers of giving pleasures to others. And these, therefore, are the only things which can rightly be thought of as giving 'wealth' or 'well being.' Food conduces only to 'being,' but these to '*well* being'" (XVI, 133–134). In some sense, then, "well" being is productive, like seeds or interest.

Probably Ruskin's vividest explication of this idea occurs in a passage in *Praeterita*, which, though written many years later, captures perfectly the spirit of his art economy. It appears in "The Grand Chartreuse," an extended meditation on religion and treasure that also describes his unconversion at Turin. His nature, he says there, is "a worker's and a miser's," for "though I am generous too, and love giving, yet my notion of charity is not at all dividing my last crust with a beggar, but riding through a town like a Commander of the Faithful, having any quantity of sequins and ducats in saddle-bags (where cavalry officers have holsters for their pistols), and throwing them round in radiant showers and hailing handfuls; with more bags to brace on when those were empty" (XXXV, 491). The importance of this image rests in its context: it follows a general account of Ruskin's interest in Catholicism and a particular recollection of his first missal, a "little fourteenth-century Hours of the Virgin, not of refined work, but extremely rich, grotesque, and full of pure colour." He then describes the well-illuminated missal in general as "a fairy cathedral full of painted windows, bound together to carry in one's pocket, with the music and the blessing of all its prayers besides." The whole train of thought unites fantasy ("caskets of jewels in the Arabian Nights" and Aladdin's palaces "with jewel windows"), sensuous splendor, religious devotion, and eroticism—particularly in regard to Rose La Touche, who in her connection with wealth and time is one of the leitmotifs of these late chapters of *Praeterita*. The image of Ruskin with a missal in his pocket, which he compares to a girl and her doll, gives way to Ruskin as a horseman with saddlebags of sequins and ducats. Wealth and the virgin are united as things one loves, both sanctified—the Virgin by her virtue, jewels by association with purity and with color, which Ruskin called the sanctifying element of creation; the blessings in the missal translate into the

spray of blessing falling from Ruskin's hand. The images also solidify time: the old gift (an Hours of the Virgin, suggesting time ordered by a cycle of deeds) issues in an ideal present, with the jeweled shower recalling the jeweled spray of St. Mark's. Once again preciousness is an arrest of the transient, a conversion of time from loss to gain. The missal, then, acts as the storehouse of memory, the incorporation specifically of a woman's benevolence, which issues also as power. The associations with Aladdin, the Commander of the Faithful, and a holster suggest masculinity, but the energy of giving is neither specifically masculine or feminine. The object in this sense becomes an icon, containing energy. The passage as a whole suggests that Ruskin has indeed substituted art for religion, or rather has incorporated religion into art, not in the fashion of the 1890s—not as the ritualization of sensuous experience in isolation from actuality and not as the delicious ache of Paterian impressionism—but as a means of ordering and channeling the moral energies. I offer this as a gloss on "the things that give intellectual or emotional enjoyment . . . , continually supply new pleasures and new powers of giving pleasures to others." Because the work of art is possessed iconically, as a source of magical power, possession becomes giving; the activity of having and giving, in other words, takes the structure of affection—and this, we have seen, is the burden of *The Political Economy of Art*. Ultimately, the association of love with economic interchange would revolutionize the present wage system and also the conception of human relationship of which, for Ruskin, the wage system is an enactment. For in the present economy, wages are given only as specific rewards, according to a capricious and irrelevant standard, forcing the worker into a competitive and exhausting subservience under the terms of which, so to speak, he can never be justified. He can be justified, however, when paid at a fixed rate—that is, unconditionally. Truly to possess a work of art, to possess it as the inexhaustible gift of a creative spirit, is analogous to the unconditional possession of love, a forgetfulness of evil that is also the power to bless and affirm others.

The analogy was valid for Ruskin, at least, as we will see again in discussing the experience of Veronese at Turin. The danger of such a view of art, of course, is that art (like money or any other fetishized object) can become a substitute for love, a magical preservation of the personal past and of individual autonomy conceived as a bulwark against the risks and rewards of human intimacy. Ruskin understood the risks only too well. Now, however, we should turn from Ruskin's private pleasure in art to his theory of the value it could hold for all, which will give us the chance to take a final look at his aesthetic theory in general.

At the beginning of his career Ruskin described paintings as occa-

sions for rapture, objects that efface themselves in order to induce overwhelming experiences of union with divine forces and the artist's own charismatic power. But in the 1850s he began to think of art as objects to be treasured, recognizing their character as stored experience—experience that can be appropriated, moved, shared, preserved—so that the aesthetic transaction moves in both directions, with artist and beholder mutually sustaining each other. Second, he began seeing aesthetic emotion not only as the ego's experience of power and fullness but also as the self's delight in affectionate and charitable feelings, for which having and giving offer a metaphor. Third, he began to value the sensuous qualities of art—color, pattern, precious materials, craftsmanship and other marks of labor—as a sacramental gesture, a response conferring value upon a particular activity or, in its broadest sense, affirming a social covenant. The object treasured may be as large as a cathedral or as small as a missal, a cathedral that can literally fit in a person's pocket; the relationship between the two suggests that the metaphor of treasuring (like the metaphor of sustenance) explains once again how the world is brought into the individual human being—how seeing is incorporating. The metaphor of art as treasure, in both its public and its private uses, suggests also that great art is related to crafts and decoration by degree, not by opposition: with a place made for inferior skill (as in a Gothic cathedral), great art loses its privileged isolation from the socially useful but without sacrificing its greatness. In romantic criticism this is a paradox for several reasons, one of which is that the self-expression of genius cannot always be and perhaps ought not to be efficacious for a communal audience. This conflict is resolvable only, if at all, in specific social circumstances, but Ruskin takes a major step in that direction by reinterpreting the romantic opposition of subjective and objective. For Ruskin that opposition is meaningless because all expression is representation of something outside the individual artist that is objectively knowable. The field of representation is an intelligible sensorium composed of facts and symbols that the critic can interpret. How much intelligibility rests in the structure of nature and how much in the structure of the collective human mind makes, finally, little practical difference. Even the most grotesque distortions and juxtapositions of inspired seeing can be interpreted according to a vocabulary of traditional symbols, most of them biblical types, as Ruskin showed in the allegorical exegeses of *Modern Painters* v. All good artists, then, from the humble draftsman to the inspired genius, express portions of the revelation, which in its variegated and collective pattern forms the human heritage, the decoration of the eternal city of man.

In discussing *Modern Painters* II I suggested that Ruskin's theories of imagination tended to settle into complementary poles of aesthetic experience, one associated with intellectual grasp, sublimity, and mas-

culine power, the other with contemplation, tranquility, and a sensuous, usually feminine, beauty. Although some artists are better described than others by a given set of terms (compare Angelico and Tintoretto and Turner, for example), Ruskin's developing metaphor of art as wealth makes clear that the polarity is really two ways of viewing art in general. Just as purity, the type of divine energy, may be regarded as a dynamic system or as a pure and luminous object, so every great work of art is at once a system of life or energy and a precious object containing that system—either an energy to be experienced in self-forgetfulness or an artifact to be treasured in the closest possible subject-object relationship. Wealth is life seen from a different angle. This schema, of course, imitates the structure of a symbol or incarnate word, which similarly contains the translucence of the eternal in the particular. If we step back very far, Ruskin's theory of art becomes a theory of incarnation by which art imitates the divine recognition, "And lo, it was very good." This is the reason why all great art is praise—praise not in the sense of blinkered optimism or even of a simple Christian piety but in the sense with which we began, a full-sighted affirmation of connection uttered in that hieroglyphic language through which subject and object become one.

Can art so conceived—indeed can any activity of full-sighted affirmation—endure in industrial England? Can the symbolic imagination perform the alchemy by which the inorganic body of England would be transformed into an energy of purity? Within a few years of the Manchester lectures Ruskin renounced this possibility; as happens so often with him, a moment of synthesis yielded before new pressures of thought and feeling. In 1858 he told the manufacturers at Bradford that great art was impossible in a polluted and inhuman environment. He had in the meantime discovered in the Turner Bequest a painter more disturbing and violent than he had permitted himself to discover before, a painter whose unsparing view of "the labour and sorrow and passing away of men" and whose savagely incessant mockery of the fallacies of hope brought him in his last years to a vision of Apocalyptic destruction. How could even the most benevolently disposed of Ruskin's Manchester audience possess as true wealth the terrible grotesques Ruskin revealed in the final volume of *Modern Painters*? The logic of his art economy, however optimistic in tone, could lead only to the open declaration of war on capitalist society that is contained in *Unto This Last;* for Ruskin understood more passionately and more precisely perhaps than any other thinker of his time the historical relationships of social production and artistic creativity. His theory of aesthetic wealth, then, is a contingent defense awaiting a social transformation, since to transform people's souls, art requires the instincts for sanctifying and remembering and revering and treasuring that are destroyed by a commercial system that cheapens its commodities as it

debases the sensibility of both producer and user. Art feeds the instincts for community; laissez-faire perverts them into selfishness. The years from 1855 to 1860 are the turning point of Ruskin's career, not because he switched subjects then—that shift is gradual and consistent—but because he abandoned altogether the hopefulness of the first stage in the three-part model of romantic self-development in favor of an acceptance of the Fall so uncompromising that it threatened to tear apart the very unity of self. Ruskin never wrote a crisis autobiography or indeed any book detailing the transition from despair to sober reconstruction but moved instead into a creatively unstable period dominated by apocalyptic images of hope and despair. Two important encounters during these years, occurring in the shadow of his growing religious disillusionment, crystallized the new transition. These were the experience of Veronese in Turin and the work with the Turner Bequest, issuing in the great final chapters of *Modern Painters* v.

Turner and Veronese

In later years Ruskin dated his unconversion, in terms that have remained convincing, to his discovery of Veronese's *Solomon and the Queen of Sheba* in 1858. In that memorable visit to Turin he encountered a "poor little wretch" preaching in a Waldensian chapel; a child on the beach ("half-naked, bare-limbed to above the knees, and beautifully-limbed, lying on the sand like a snake" [xxxvi, 291]); the great Veronese and along with it, military music, ballets, and in short all the "gorgeousness of life which the world seems to be constituted to develop." Both his published accounts focus on the contrast between Protestant exclusivity and an inclusive celebration of the senses, making clear that through Veronese he was converted to a secular humanism more than adequate to replace the faith he had to abandon.[8] The fruits of this discovery appear, among other places, in the defense of Venetian naturalism in *Modern Painters* v: "the painter saw that sensual passion in man was, not only a fact, but a Divine fact; the human creature, though the highest of the animals, was, nevertheless, a perfect animal, and his happiness, health, and nobleness depended on the due power of every animal passion, as well as the cultivation of every spiritual tendency" (vii, 296–297). His letters confirm the connection between art and healthy sensuality: "Nobody can be a great painter who isn't rather wicked—in a noble sort of way," he wrote Mrs. Browning (xxxvi, 292),

[8]For a comparison of both, see George P. Landow, *The Aesthetic and Critical Theories of John Ruskin* (Princeton: Princeton University Press, 1971), 281–285.

and on his return he wrote Norton that a great painter *"mustn't* be pious." In the same letter he adds that "at 39 one begins to feel a life of sensation rather too much for one" (XXXVI, 293)—implying perhaps that it is a life of *mere* sensation, without the depth of emotional fulfillment, that can seem "too much." Although the incident is well known, more needs to be understood about Ruskin's reading of the painting itself.

Against an ornate, classical backdrop—a central arch flanked by marble pillars and reclining statuary—stand at least two dozen figures, encumbered by a wealth of clothing, jewels, gifts, and animals, the whole of which rises at the left along the steps of Solomon's throne. To study this rich sequence, Ruskin erected a scaffold in order to make copies (the painting was hung too high for easy viewing). A young American painter later recalled the advice Ruskin gave him in the gallery: "He said 'Watch me.' He than looked at the flounce in the dress of a maid of honour of the Queen of Sheba for five minutes, and then he painted one thread: he looked for another five minutes, and then he painted another thread. At the rate at which he was working he might hope to paint the whole dress in ten years" (XVI, xl). In addition to the maid of honor, with her gold and white brocade, Ruskin did the queen's dog and the maid's servant, a black woman bearing "two birds, one of gold and one of enamel, with ruby eyes, for a present to Solomon."[9] For both of these he ordered frames for his father, with dimensions precisely indicated, thus possessing himself of portions of the painting.

Clearly enough, the picture represented for Ruskin the emblem of a perfect economy of the nobly animal and the nobly spiritual. Moving from right to left, we read the humans offering up the produce of the earth in tribute, that is, in sacrifice; moving from left to right, we follow the view of the God-like king downward through a chain of being, clear to the right corner, where the servant stands with her birds. Ruskin cannot but find it good. The king's court is the economy in miniature of a wise commercial nation, while the many animals allow the picture to mediate between the imagery of "The Nature of Gothic" and *The Political Economy of Art.*[10] What makes this painting genuinely religious

[9]Ruskin's drawing of the servant was displayed recently at the Fogg Museum in Cambridge, with the following comment in the catalog: "Although Ruskin relates his enthusiasm at his 'discovery' of this work in 1858, in Turin, this copy with its flat dead washes and unconvincing reproduction of Veronese's bravura highlights betrays nothing of that excitement. Only the pattern of the brocade and the minute delineation of the parrots with their balefully glittering eyes seem to have engaged his interest" (*Drawings of John Ruskin, An Exhibition Organized by Gail S. Weinberg* [Cambridge: Fogg Museum, 1979] 24).

[10]An image exactly intermediate between the organic structure of a Gothic cathedral and the organic structure of a human economy was provided by an actual building project. In 1856 work began on the Oxford Museum, an emporium for the study of

for Ruskin is the typological function of Solomon. (He appears again, along with the queenly housewife of Proverbs, in *Unto This Last*, and then both appear as the pair of perfect rulers in *Sesame and Lilies*.) Solomon is the wise ruler of the earthly kingdom as Christ is of the heavenly. At the high point of the Hebrew state, he built both a temple and a commercial empire. For guidance he prayed to Wisdom and so united in one person both wealth and the wise use of wealth—the two gifts that prompted the visit of the queen, when the two rulers exchanged emblems of their wealth. Cunningly, Veronese has placed a lion and an eagle beneath the king—"types of the Divine and Human power in Christ"—which led Ruskin to call the painter "full of mischief" and "full of dodges" (xvi, xxxix). The dodge would be that this typological union of divine and human also represents the union of animal and spiritual in humans, so that Solomon's wisdom is, among other things, erotic wisdom.

Ruskin makes this clear by his own set of dodges. Having spent weeks copying the servant woman—as though ostentatiously to proclaim the virtues of perfection and labor—he spirited her off to Denmark Hill, where she was reinstalled with her glittering clothes. Clearly enough, fine dress has become yet another sign for the erotic, yet another attempt to find in external forms a magical resolution of his unconscious contradictions. We have discovered another dimension of Veronese's importance for him. In *The Political Economy of Art* he says that "true nobleness of dress [is] an important means of education, as it certainly is a necessity to any nation which wishes to possess living art, concerned with portraiture of human nature" (xvi, 52). A year later he made his first public allusion to the Veronese in the Cambridge Inaugural Address, the very lecture, we recall, that set out to show how "refinements of taste" accompany the downfall of nations and that used the uxorious Cardinal as an example. Ruskin here refers to Veronese to justify his own love for gold brocade: "You may, perhaps, be surprised at this; but . . . I share this weakness of enjoying dress patterns with all good students and all good painters" (xvi, 185). Clothing is the decoration of the body, as art is the decoration of the body of a

biological sciences and built under the direction of Ruskin's friend, Dr. Henry Acland. It was the first major building to follow closely the principles Ruskin had laid down in his writings on Gothic, including the role of the workman. Disputes arose, however, between college authorities and the manner of decoration, and in an amusing incident, the most talented of the workmen, an Irish sculptor named O'Shea, was reprimanded by the Master of the University while carving an ornament. As O'Shea told it: "'What are you at?' says he. 'Monkeys,' says I. 'Come down directly,' says he; 'you shall not destroy the property of the University.'" O'Shea was let go, but not before he had painted a series of parrots and owls, apparently as a gesture of impudence. At Acland's orders, the heads were struck off (xvi, xlix–1). We might see in the episode an allegory of two voices within Ruskin himself—the imperious schoolmaster and the sportiveness of fancy.

nation: both are means of placing value on something, and in art a means of affirming the body in a way nudity cannot do, that is, symbolically. Ruskin's copying the gold and white brocade seems to act out two analogies, that between loving and treasuring and that between studying (since noble dress is a "means of education") and mastery of the sensuous.

Thus, in the lecture condemning Cardinal Maurice, Ruskin professes himself a lover of dress patterns, not simply (if at all) to defend himself against the attractions of nudity but rather to defend a system of cultural signs that place determinate value on what otherwise is frighteningly indeterminate. Clothing, moreover, is the expression or container of the presence beneath: dressing, like sublimation, like art, like civilization itself, is a blending of expression and restraint, and so a form of Wisdom. As with Carlyle, a philosophy of clothing is ultimately a philosophy of symbols. In the natural world, of course, phenomena half reveal and half conceal the soul they shadow forth (grotesque awe is the terror of revelation, the fear especially that more will be revealed than the mind can bear), but color, which is adventitious and so the type of love, the sanctifying element of the creation, confers value by means of beauty in the same way clothing confers value to the human body. To put it differently, noble dress is the sign that body and spirit are sanctified together, or again that true wealth is the expression of life. This fitting of body and clothes is the structure, finally, of all symbolism in a healthy economy: the symbols of wealth are also the symbols of life. But in a debased economy, the symbols of wealth are false because divorced from life, so that false wealth is both a disorder of the symbolizing power and an erotic disorder in the national soul.

It will turn out that Ruskin's qualification for preaching political economy after fifteen years as an art critic is his trained experience of the sensuous, as opposed to the bad economist's habit of inhumane abstraction—or, more precisely, Ruskin's trained experience in detecting universals embodied in the sensuous as signs, developed by this time into a skill in allegorical interpretation. In these same years, he also learned to read Turner allegorically, discovering in him a more disturbing form of Veronese's naughty "dodges." (Ruskin in fact took it upon himself to destroy a number of pornographic sketches discovered in the Bequest, a fact John Dixon Hunt has rightly associated with Ruskin's remarks about a great painter's wickedness.) It is as though Turner took upon himself the full burden of suffering and mortality for his times and the burden also of its dark sensuality; for the artist who appears at the climax of *Modern Painters* v does not present, like Veronese, a vision of the sensuous life integrated into the social life but an extreme vision of social and erotic disorder.

In the great meditation he called "The Two Boyhoods," Ruskin si-

multaneously traces the careers of Giorgione and Turner, which reached a climax in an apocalyptic antithesis transcending all particular historical experience: the Heavenly City on the one hand, of which Venice was once the type, and on the other, an encompassing negative of the creation painted in imagery borrowed, as Elizabeth Helsinger has suggested, from Turner's *The Angel in the Sun*—itself an ironic quotation, in all likelihood, of Ruskin's own figure of Turner as Archangel:

> The unconquerable spectre still flitting among the forest trees at twilight; rising ribbed out of the sea-sand;—white, a strange Aphrodite,—out of the sea-foam; stretching its gray, cloven wings among the clouds; turning the light of their sunsets into blood.
>
> Wide enough the light was, and clear . . . light over all the world. Full shone now its awful globe, one pallid charnel-house,—a ball strewn bright with human ashes, glaring in poised sway beneath the sun, all blinding-white with death from pole to pole,—death, not of myriads of poor bodies only, but of will, and mercy, and conscience; death, not once inflicted on the flesh, but daily fastening on the spirit; death, not silent or patient, waiting his appointed hour, but voiceful, venomous; death with the taunting word, and burning grasp, and infixed sting. [VII, 386–388]

The "English death" is a historical and a metaphysical condition, the condition of life searing and devouring itself, striking without warning or justice but again and again, at moments of despair and at the apparent fulfillment of earthly joys; it is the collapse of all meaning as well, the ultimate spread of the void across the heavens that also embodies, as Helsinger has shown, the pure destructiveness of the artistic will: "The defeat of hope . . . becomes progressively more terrible as the triumph of light and colour—the triumph of the artist—becomes more overwhelming."[11] This series of contrasts, perhaps the most powerful Ruskin ever put forth, is a series only, not a final statement, cast in the form of visions necessary to the great artist in particular historical circumstances. They are the apocalyptic possibilities hovering about the London that is Ruskin's as well as Turner's, emblems of the psychic destruction and creation necessary to both Ruskin and his nation in the present moment of their crisis.

In their totalizing power, these visions tremble on the brink of the unimaginable; they require stabilizing in order for Ruskin to render articulate the relationship of art to social renewal. In the following chapters, the culmination of seventeen years' labor, Ruskin reads Turner's painting as an intricate allegory of England's fall that may be

[11]Elizabeth Helsinger, *Ruskin and the Art of the Beholder* (Cambridge: Harvard University Press, 1982), 243.

read both diachronically and synchronically—as a myth and as a set of symbolic contradictions.[12] In "The Nereid's Guard" he argues that Turner's *The Garden of the Hesperides* is a religious allegory because it paints English religion as industrial Mammonism: the Serpent of Greek myth has become the "British Madonna" governing an unhappy isle, a "paradise of smoke" (VII, 408). In the foreground of the painting, the Goddess of Discord takes one of the Hesperidean apples, while the nymphs recline in a grove to the right. The images form a pattern of charged anticipation before the fatal touch, which, like Eve's, will set in motion the whole doom of human history. In his interpretation of the painting, Ruskin ransacks his memory of half a dozen Christian and classical authors in order to provide each element with antithetical meanings expressing all the painful ambiguities of emotional experience. Thus Juno, "the housewives' goddess," represents "whatever good or evil may result from female ambition"; the apples, which are her gift from the earth, are either "the wealth of the earth, as the source of household peace and plenty" or "the source of household sorrow and desolation" (VII, 396). The Hesperides, or nymphs of the sunset, are daughters of Night and therefore sisters of Night's other progeny, the Fates; thus, they are "a light in the midst of a cloud;— between Censure, and Sorrow,—and the Destinies" (VII, 393). "For though the Hesperides in their own character, as the nymphs of domestic joy, are entirely bright . . . yet seen or remembered in sorrow, or in the presence of discord, they deepen distress." In fact, as Dido recalls them, they are an enchantress "who *feeds the dragon*" (VII, 406). Only the Dragon receives no pair of meanings: he is for Hesiod the type of "consuming (poisonous and volcanic) passions" and for Dante, "Pluto il gran nemico"—"the demon of all evil passions connected with covetousness" (VII, 397, 400–401); Ruskin also associates him with Spenser's Garden of Mammon, where the Hesperidean apples grow. Against this darkness stand the nymphs, embodying bright color (which, according to Ruskin, Turner reintroduced into painting), which is also the type of love. Sexual love, "when true, faithful, well-fixed, is eminently the sanctifying element of human life: without it, the soul cannot reach its fullest height or holiness" (VII, 417). At last

[12]In his analysis of these pages, Landow shows that Turner used allegory deliberately and consistently throughout his career and probably had acquaintance with many of the poets Ruskin cites (pp. 434–442). See also Charles Dougherty's essay connecting the Turner paintings to Ruskin's later mythopoeia. The vision of *Modern Painters* v, he says, is "of a universe in which chaos is victor over harmony, the desert and the sea over the garden, the serpent over the woman, and death over life. . . By 1860 he had come to see the chaotic liberal, democratic world as a manifestation of the Fall, and he saw every bit of harmony, at any level, even a single work of art, as a precious manifestation of the Redemption" ("Of Ruskin's Gardens," in *Myth and Symbol: Critical Approaches and Applications,* ed. Northrop Frye et al. [Lincoln: University of Nebraska Press, 1963], 143).

Turner has come to "confess" the Hesperides; "but is it well? Men say these Hesperides are sensual goddesses,—traitresses. . . . Nature made the western and the eastern clouds splendid in fallacy. Crimson is impure and vile; let us paint in black if we would be virtuous" (VII, 413). Linking the sober hues of academic painting with Puritanism and an industrial "paradise of smoke," Ruskin converts the fall story into a defense of the senses, as he had in *The Stones of Venice*, this time pitting noble sexual love against the Dragon of economic greed.

"The Nereid's Guard" presents an allegory of the present crisis; the next chapter, "The Hesperid Aeglé," presents an allegory of hope, this time by leaping through several early paintings of Turner to create a composite icon. In Turner's *Apollo and Python*, the god battles a serpent similar but not identical to the Nereid's guard. The Hesperidean dragon was a "treasure-guardian. This is the treasure-destroyer,—where moth and rust doth corrupt—the worm of eternal decay." The second painting therefore represents "the strife of purity with pollution; of life with forgetfulness; of love, with the grave . . . , the struggle of youth and manhood with deadly sin" (VII, 420). Interestingly, Apollo takes the name of his enemy once his conquest is completed ("he is by name, not only Pythian, the conqueror of death;—but Paean, the healer of the people" [VII, 420]), an association that suggests a sanctifying of aggressive energies, or an absorption of destructive power for constructive use. The distinction between the two dragons appears to be that, as the treasure guardian is opposed to true wealth, the treasure destroyer is opposed to life—they are illth and death—and this point suggests that Ruskin has turned from the subject of sexual ambiguity to the ambiguous inherence of death in life and from a particular historical dilemma to a metaphysical conundrum. The leitmotif of this chapter is thus the nymph he names the Hesperid Aeglé—that is to say, redness, or "brightness of the sunset," the "colour which the sunbeams take in passing through the earth's atmosphere." As we might expect, he associates the type of Love with sacrifice: "colour generally, but chiefly the scarlet, used with the hyssop, in the Levitical law, is the great sanctifying element of visible beauty, inseparably connected with purity and life. . . . the fountain, in which sins are indeed to be washed away, is that of love, not of agony" (VII, 414–417).

These meanings, and several others, concentrate powerfully in the image of the Sybil Deiphobe, culled from two more paintings, which follows closely upon the account of Apollo and the Python to represent, at least by implication, the reward waiting upon the completion of heroic action. The closing sentences of the chapter read:

> And though that scarlet cloud . . . may, indeed, melt away into paleness of
> night, and Venice herself waste from her islands as a wreath of wind-

driven foam fades from their weedy beach;—that which she won of faithful light and truth shall never pass away. Deiphobe of the sea,—the Sun God measures her immortality to her by its sand. Flushed, above the Avernus of the Adrian lake, her spirit is still seen holding the golden bough; from the lips of the Sea Sybil men shall learn for ages yet to come what is most noble and most fair; and, far away, as the whisper in the coils of the shell, withdrawn through the deep hearts of nations, shall sound forever the enchanted voice of Venice. [VII, 439–440]

The "scarlet cloud," specifically, is some frescoes of Giorgione from which Ruskin has engraved a female nude to head this chapter—a figure he names, arbitrarily, "The Hesperid Aeglé" in order to combine the careers of Giorgione and Turner; but in fact she combines the careers of all artists in their eternal, half-won struggle against time. The Deiphobe of Greek myth represents a related idea: she has received from Apollo a grain of sand for every year of life (suggesting once again the color of sunlight through the earth's atmosphere), so that here dust—as in so much of Ruskin's later work, an ambiguous emblem—does not put the term to life but "measures her immortality." It is the mortal element but also, if seed, the promise of life. (The housewife Wisdom also bore a symbol of long life in her hand.) She is also Venice—no longer the fallen harlot of the earlier books but something closer to Blake's spiritual Jerusalem—"a city and a woman," the emanation of Albion. The composite of nymph, Sybil, and sea city looks to the future in two ways: as a symbol of generativity (bearing the Golden Bough) and as a symbol of prophecy, whose whisper is no longer the waves that toll a warning but the whisper from Pandora's box.

According to Ruskin, Turner was without hope because for him the rose always gave way to the worm. The technique of this chapter is to overcome hopelessness by converting antithetical ideas into symbols of fusion. In this way the profound enigmas of experience can at least be faced—the enigmas, in particular, of the inherence of mortality in sexuality, symbolized by the sunlight passing through the earth's atmosphere, and the inherence of death in the seed of generation, symbolized by the Sybil's handful of death. The emotional correlative of these symbols is the dominant mood of the chapter, the mood, so to speak, of elegiac hope akin to what Ruskin elsewhere calls the "majestic sorrow" of the Greeks (VII, 276). The chivalric imagery of the heroic combat and the pure woman (the conventional imagery, in Victorian times, of erotic deferral) permits Ruskin to convert the elegiac mood of *The Stones of Venice*—the nostalgia for a thing possessed but not possessed because it has passed—into qualified hope for a thing possessed but not possessed because it may be yet to come. In this way, he fuses

his own destiny with his nation's. Ruskin, looking backward toward sorrow and censure, may look forward also—to the battle that can convert his own suffering and wrath into a healing energy (imitating the allegory of Apollo and Python)—but with a hope compromised by the loss of youth and religion and other joys that may not come again; for his nation, the renunciation of opulence may bring about a "humble" but happier life spread unto the least. By so transfusing the goal of social action with erotic longing, "The Hesperid Aeglé" becomes an avowal of hope, which must be deferred; of renunciation, on which any realistic hope must be based; and of the instinct for preciousness, which alone can bring hope to fruition in deeds. Death and loss are not now the punishment of sexuality, even though the two are somehow connected—the mystery cannot be comprehended but can only be subdued by the concentrated gaze of majestic sorrow—because the seed that bears life also bears time and the ultimate conclusion of time.

The last defense of art in *Modern Painters* begins with the statement: "What the final use may be to men, of landscape painting, or of any painting, or of natural beauty, I do not yet know" (VII, 423). What, then has Venice and all "She won of faithful light and truth" to do with the condition of England? "Thus far, however, I *do* know," he continues. The world must be delivered from three great types of asceticism— monkish, military, and monetary. "A monk of La Trappe, a French soldier of the Imperial Guard, and a thriving mill-owner, supposing each a type, and no more than a type, of his class, are all interesting specimens of humanity, but narrow ones,—so narrow that even all the three together would not make up a perfect man" (VII, 424). (We notice that the monk, the soldier, and the Captain of Industry are the three heroic figures in *Past and Present,* the book to which *Unto This Last* owes more than to any other.) This threefold deficiency, above all, relates to contentment:

> There are, indeed, two forms of discontent: one laborious, the other indolent and complaining. We respect the man of laborious desire, but let us not suppose that his restlessness is peace, or his ambition meekness. It is because of the special connection of meekness with contentment that it is promised that the meek shall "inherit the earth." Neither covetous men, nor the Grave, can *inherit* anything; they can but consume. Only contentment can possess.
>
> The most helpful and sacred work, therefore, which can at present be done for humanity is to teach people . . . not how "to better themselves" but how to "satisfy themselves." It is the curse of every evil nation and every evil creature to eat, and *not* be satisfied. The words of blessing are, that they shall eat and be satisfied. [VII, 426]

To this statement, the prospectus of all his social philosophy, Ruskin appends the following verse from Proverbs: "There are three things

that are never satisfied, yea, four things say not, It is enough: the grave; and the barren womb; the earth that is not filled with water; and the fire, that saith not, It is enough!" The second and third of these terms are famished, the other two glutted, an arrangement that illuminates Ruskin's perception of Midas-like voracity, a starving desire that ever seeks the wrong objects to supply its hunger: the monk "loses" himself in vision or hope, the soldier "mortified" himself through destructive power, the merchant "mortifies" himself in "productive accumulation." Possession does not give content, however; "only contentment can possess." Near the opening of *The Political Economy of Art,* Ruskin had warned against a nation that "disdains to occupy itself in any sense with the arts of beauty and delight," since, as a result of this disdain, "the passions connected with the utilities of property become morbidly strong, and a mean lust of accumulation merely for the sake of accumulation, or even of labour merely for the sake of labour, will banish at last the serenity and the morality of life, as completely, and perhaps more ignobly, than even the lavishness of pride, and the likeness of pleasure" (xvi, 21). This is the legacy of Renaissance pride, the mysterious and willful turning away from the light that marks the central action of *The Stones of Venice,* yet nowhere in that book is it presented with such an inclusive range of social insight. Under such spiritual conditions, it is irrelevant to talk of art, for in a society of insatiable egos that "possess" all things as the grave, and that "consume" all things as the fire, art will also be swallowed up in death. But if humans can learn the true power of use, which is true wealth and which lies in meekness, then great art will become again the "type of human life," and beauty the type of the contentment that alone can truly love. In art, color is the type of love, and if, as Ruskin says, sexual love is properly the sanctifying element of human life, and if Mammonism is a disorder of the passions—the worship of a Serpent-Madonna that converts all passion into forms of avarice—then a regenerated society will rest on a healthy reordering of sensual passions, an integration of the nobly animal and the nobly spiritual. The new Venice—the prophetic whisper and the scarlet shadow of art—takes the form of a woman's body.

8 /

The Economy of Life

> The dreams of childhood—its airy fables; its graceful beautiful, hu-
> mane, impossible adornments of the world beyond; so good to be
> believed in once, so good to be remembered when outgrown, for then
> the least among them rises to the stature of a great Charity in the
> Heart . . . —what had [Louisa] to do with these? Remembrances . . . of
> how, first coming upon Reason through the tender light of Fancy, she
> had seen it a beneficent god, deferring to gods as great as itself: not a
> grim Idol, cruel and cold, with its victims bound hand to foot, and its
> big dumb shape set up with a sightless stare, never to be moved by
> anything but so many calculated tons of leverage—what had she to do
> with these? Her remembrances of home and childhood were re-
> membrances of the drying up of every spring and fountain in her
> young heart as it gushed out. The golden waters were not there.
>
> —Charles Dickens, *Hard Times*

In the opening pages of *Hard Times,* the novel Dickens dedi-
cated to Carlyle, the sadistic relationship of machine to man is imitated
by a teacher and his pupil. Commanded by Gradgrind to define a
horse, Bitzer jerks up and responds, "Quadruped, graminivorous. For-
ty teeth, namely twenty-four grinders, four eye teeth, and twelve in-
cisive," and so forth. The fragmented sentences and the enumerated
teeth reflect the oral-sadistic style of Gradgrind, whose verbal explo-
sions Dickens compares with those of "a cannon loaded to the muzzle
with facts." Since this "teaching" is antithetical to feeding, Gradgrind
acts out the biblical image of the father who gave his son stones for
bread—or, since the students are compared to pitchers, he fills them
with boiling oil instead of water: "Say, good M'Choakumchild. When
from thy boiling store thou shalt fill each jar brimful by-and-by, dost
thou think that thou wilt always kill outright the robber Fancy lurking
within—or sometimes only maim him and distort him?" Bullets instead
of seeds, drought instead of water, hollow vessel and maimed robber
instead of a strong self—of these unnatural substitutions Dickens
builds his tragedy of blighted growth and forfeited paternity, the pat-

tern of which extends beyond the classroom into all of Coketown: the "mechanical apparatus" of Gradgrind's jaw and the "elephant" of mills are alike emblems of mechanical oppression, while the empty jars in the classroom connect with the abandoned coal pits and other instances of hollowness into a general image of Nature undermined—the green fields made hungry as the grave. The Idol Reason, finally, blends into the Moloch machine of Coketown to form a single, horrific image devouring both child and workman alike. But weakness, not power, is the prevalent theme of this book. The factory is a "melancholy, monotonous elephant," and its opponent, a very frail thing, is the robber Fancy, which becomes for Dickens the guardian of morality and, finally, a synecdoche of the whole life of the Spirit.

We can only imagine the shock of recognition with which Ruskin must have read this book, for it contains the pattern of his own buried life. And it may have spurred him on to a boldly metaphorical style of attack in his own book on the Gradgrind system. In a well-known footnote to *Unto This Last*, Ruskin praises the essential "truth" of Dickens's method, which he likens to a "circle of stage fire";[1] but is not Ruskin's whole conception of political economists a mere caricature of vice, bereft of the novelists' license to fictionalize? In response to a letter suggesting that he moderate his language, he characteristically redoubled his attack, calling political economy the damnedest lie the Devil had invented, except for the "theory of Sanctification." "To this 'science' and to this alone (the professed and organised pursuit of Money) is owing *all* the evil of modern days. I say All. . . . It is *the* Death incarnate of Modernism" (XVII, lxxxii). These are the accents of the Carlylean prophet and of the centuries-old tradition of the sermon against Mammon, yet Ruskin's object is also John Stuart Mill and a very specific body of doctrine calling for specific refutation. The difficulty of Ruskin's contemporary audience remains our own. To simplify matters, we might call *Unto This Last* two books rather than one. On the one hand it is a contribution to social science—an argument for interference from a benevolent government and an attack on the worst features of competitive capitalism, using the logic of the economists to subvert their own principles. On the other, it is a moral and metaphorical argument, fusing the language of romanticism and Evangelicalism into a vision of redemption in the face of damnation, the damnation occasioned by both the Devil's lies of Mammonism and

[1]Ruskin's footnote on Dickens in *Unto This Last* reads, in part: "Allowing for his manner of telling them, the things he tells us are always true. . . . But let us not lose the use of Dickens's wit and insight, because he chooses to speak in a circle of stage fire. He is entirely right in his main drift and purpose in every book he has written; and all of them, but especially *Hard Times*, should be studied with close and earnest care by persons interested in social questions" (XVII, 31).

sanctification. The book may or may not therefore seem impractical. James Sherburne, for example, has stated unequivocally, "If Ruskin is sentimental and impractical, most forms of modern political and social organization are the same. For Ruskin outlines the shape of things to come more clearly than any other English thinker of the nineteenth century."[2] For most readers, however, the split persists, with the result that the book invites separate readings: the economist might choose to skim past the metaphors, the student of literature to skim past the logical arguments and practical proposals.

Ruskin would insist, of course, that the two must not be separated and that the attempt to separate them merely repeats the dissociation of sensibility—the professed incompatibility of the rational and poetic modes of thought—that lies behind the Devil's triumph over modern economic life. Ruskin's project is precisely to heal that breach by proposing (as he does from the beginning of his career to the end) a moral science, a partnership between passionate apprehension and analytical comprehension—and that science must speak the language of affections, the language, that is to say, of symbols. Here lies the odd triumph of the book. In many ways Ruskin's vision of abundance for all had already become familiar in advanced Liberal thought. (We have only to consider the ideology of the Free Traders, or the conclusion of Mill's *Principles of Political Economy,* which envisions a freely expanding economy released of the hierarchical restraints so important to Ruskin.) Ruskin's contributions as an economist have been ably evaluated by others.[3] I will look instead at his construction, in word and symbol, of a moral science. Here, as in so many other areas, his predecessor is Carlyle.

The Prophecy against Mammon

Underlying the traditional satire against avarice—particularly the satire against the swindler, with his tricks and sophisms and disguises—

[2]James Sherburne, *Ruskin, or, The Ambiguities of Abundance* (Cambridge: Harvard University Press, 1972), 237.

[3]Earlier appreciations of Ruskinian economics include John A. Hobson, *John Ruskin, Social Reformer* (Boston, 1898), and Charles A. Beard, "Ruskin and the Babble of Tongues," *New Republic* 87 (1936), 370–372. John T. Fain's *Ruskin and the Economists* (Nashville: Vanderbilt University Press, 1956) is the standard modern account of Ruskin and his tradition, including a mature assessment of his influence. See also Sherburne, 109–121. Both Fain and Sherburne find Ruskin mistaken in his view that the orthodox economists did not understand the abstract nature of their science or that they deliberately preached materialistic values. For Sherburne, the real difference between Ruskin and a writer like Mill relates to the system of ethics: "Ruskin cannot share a belief in liberty. He is unwilling to accept its divisive effects. Now, he values justice, unity, or even love more than liberty. This difference in ethical preference lies behind his conflict with the leading economists over the relationship of social forces and chains of causation" (p. 121).

lies the perception that money is a mode of signifying opposed to a prior, "natural" mode. This, of course, is the point of the opening scene of *Volpone,* where the miser worships his money as if it were a saint or god and Mosca opposes riches and fortune to wisdom and nature ("Riches are in fortune / A greater good than wisdom is in nature"). Jonson's complaint against money is substantially the same as Marx's well-known remarks, more than two centuries later, in his meditation on *Timon of Athens:* money "changes fidelity to infidelity, love into hate, hate into love, virtue into vice, vice into virtue, servant into master, stupidity into intelligence and intelligence into stupidity. . . . it is the universal *confusion* and *transposition* of all things, the inverted world." Money can transpose values because its relationship to things is arbitrary, or as Marx puts it, "abstract," and from this idea it is a small step to the attack, in another fragment of 1844, to abstract thinking itself: "The philosophical mind is nothing but the alienated world-mind thinking within the bounds of its self-alienation, i.e., conceiving itself in an abstract manner. *Logic* is the *money* of the mind, the speculative *thought-value* of man and of nature . . . , thought which is *alienated* and abstract and ignores real nature and man."[4] Just as the mental counterpart of the commercial economy of Jonson's time is a form of tricksterlike transposition, the mental counterpart of the industrial economy of Marx's time is an abstract and systematized logic set over against concrete experience in the same way that the system of capitalist production is set over against the concrete needs of the laborers and the works of their hands. To put it in a different way, human beings become units in a system, means toward a perpetually deferred end so divorced from concrete experience that the system seems but a monstrous and aimless functioning. "Machinery," Carlyle's term for systematized alienation, derives from the Greek for "means" or "contrivance." Although Carlyle tends to base his critique of machinery on scientific rather than economic thought, the two primary associations of his key word—the machine as a synecdoche of industrial civilization

[4]Karl Marx, *Early Writings,* ed. T. B. Bottomore (New York: McGraw-Hill, 1964), 193, 200. Marc Shell uses the phrase "money of the mind" in a fascinating study of the origins of the money system in ancient Greece (*The Economy of Literature* [Baltimore: John Hopkins University Press, 1978]). According to Shell, the money economy developed along with a new form of symbolic thinking. Like symbols (and like the bureaucracy surrounding or hiding the ruler), money is the manifestation of something kept hidden; for Plato, the logic of the Sophists, with their manipulation of the relationship between words and meanings, is a "money of the mind," analogous to the shifting relationship between currency and goods. This is Marx's complaint, and that of Ruskin as well, who as we will see develops a theory of language to counteract his opponents' "money of the mind." (Shell's discussion of the Greeks is actually of greater help in understanding Ruskin than his essay on *Unto This Last* in the same book.) For Ruskin's relations to Marxian man, see Robert Hewison, *John Ruskin: The Argument of the Eye* (Princeton: Princeton University Press, 1976), 137, although Hewison retracts his view in "Notes on the Construction of *The Stones of Venice,*" in *Studies in Ruskin,* ed. Robert Rhodes and Del Ivan Janik (Athens: Ohio University Press, 1982).

(Dickens's Moloch-like Idol) and Newtonian mechanics—suggest the conformity between social and mental structures implied in Marx's sentences about alienated thought.

In its broadest range, Carlyle's critique of nineteenth-century civilization treats mechanical thinking as one symptom of a pervasive system of false significances, which (in *Sartor Resartus*) he calls "old clothes" or "dead metaphors." Appropriately, the biographical section of the book, which is a cultural myth as well, contains an account of the fall into alienated language that Teufelsdröckh must redeem through the clothing philosophy—and which Ruskin must also redeem in the language of a moral science. According to Carlyle, the infant Teufelsdröckh lived in unity with nature and experienced natural objects directly as incarnate Words. But when the child went off to Hinterschlag Academy, he entered the main street of his new home and

> saw its steeple-clock (then striking Eight) and *Schuldthurm* (Jail), and the aproned or disaproned Burghers moving-in to breakfast: a little dog, in mad terror, was rushing past; for some human imps had tied a tin-kettle to its tail; thus did the agonised creature, loud-jingling, career through the whole length of the borough, and become notable enough. Fit emblem of many a Conquering Hero, to whom Fate . . . has malignantly appended a tin-kettle of Ambition, to chase him on; which the faster he runs, urges him the faster, the more loudly and more foolishly![5]

Each image—clock, jail, labor, and spanked dog—refers metaphorically to school and to the larger condition of which school is in turn a metaphor. "Steeple-clock" and *Schuldthurm* (the German word combines "guilt" with "steeple," or "tower") repeat the connections implied in the image of the dog, which as a figure for ambition combines spanking and time to suggest that the lessons of Hinterschlag ("back-slap") begin in guilt, as human life begins in Original Sin. This passage comes from the bag of fragments Teufelsdröckh has labeled "Scorpio," the eighth sign of the zodiac, represented by the animal that stings itself. To exist in time, then, is to be driven through life by the Devil, who is the Time Spirit of this World. Later suggestions in the book reverse this image to make man himself the tail or detachable appendage dropped by the Devil. (Teufelsdröckh's manner of appearing to his adopted parents and, of course, his name reinforce this idea.) Carlyle here draws close to Freud's vision of human society in *Civilization and Its Discontents,* according to which the instinctual renunciation necessary to economic life, experienced as guilt or unconscious aggression against the self, becomes one of the driving forces of social energy and the principal cause of organized aggression. But Carlyle also shows how the personal experience of guilt and helplessness is projected onto

[5]Carlyle, *Sartor Resartus*, Everyman Edition, (London: Dent, 1967), 29.

the cosmos as well. The youth's betrayal by Blumine and Towgood (or Toughgut) repeats the idea of expulsion and leads to his nightmare of a mechanical universe, in the face of which life itself is but an excrescence. The "spanking" of guilt is apotheosized into the machine-as-history, a chain of ineluctable necessity. This breaking of the human relations with nature and other humans has its counterpart in the subject matter of Hinterschlag—the dead languages with which the logicians stuff their students. Severed from their referents, words also become a mere lifeless structure.

But Teufelsdröckh's reconstituted faith provides a circular return to childhood by reasserting in different form the union of the human and the natural and of words and their referents. When in "The Everlasting Yea" the leaden bonds of necessity are recognized as the golden bonds of duty, Teufelsdröckh undoes his expulsion by becoming part of the whole, now experienced as an organism taking a human image. Man becomes the symbol of the All, and the aim of human effort is to manifest divine laws as the set of living metaphors that are human culture. Human speech, rightly used and understood, is also an organic system of metaphor evolving through time, for in Carlylean idealism, words are deeds, and deeds words, generating in turn the structures of social and economic life. For example, all Rothschilds and English national debts and the entire money economy spring from the moment an "old-world Grazier," sick of lugging his ox around, decided to stamp the figure of an ox (*pecus*) on a piece of leather to call it *pecunia*.[6]

In his fine analysis of this passage, G. B. Tennyson compares Carlyle's argument in *Wotton Reinfred* that the metaphorical origin of words strengthens rather than weakens their power to shadow forth truth, since all thought is metaphorical and abstractions are but faded metaphors. "What metaphor does for Carlyle is to *illuminate relationships*, to reveal connections between things not at first evident, and thus to suggest some vast and meaningful scheme in the universe."[6] It follows that in a society based on false verbal relationships, human connections will be lost. The isolation that for Carlyle is the most poignant symptom of the nineteenth-century malaise figures itself in a world of blank messages manipulated by "rulers" who are in actuality impotent paper pushers and jabberers—a world of paper money, paper parliaments, seas of ink, handbills, un-laws, doctrines, and a generalized "vague janglement," as he calls it in *Past and Present*. In this sense *Sartor Resartus* is a satire against pedantry and its eiron is Teufelsdröckh, a hermetic pedant who is in truth the one person in the book not a pedant because he is able to interpret things in their profound symbolic interrelationship.

[6]G. B. Tennyson, *Sartor Called "Resartus"* (Princeton: Princeton University Press, 1965), 266.

Unto This Last adopts these and other features of Carlylean satire: it opposes the mechanical conception of society to the organic, adopts a stance at once prophetic and ironic, and converts the objects of its attack into the stock figures of the malignant pedant and the false preacher. And it begins with a position already defined by Carlyle, proving first of all that the dismal science is in fact a disguised value system in competition with other "gospels," particularly that professed by his audience. Political economy, Ruskin writes, is a

> systematic disobedience to the first principles of its professed religion. The writings which we (verbally) esteem as divine, not only denounce the love of money as the source of all evil, and as an idolatry abhorred of the Deity, but declare Mammon service to be the accurate and irreconcilable opposite of God's service; and, whenever they speak of riches absolute, and poverty absolute, declare woe to the rich, and blessing to the poor. Whereupon we forthwith investigate a science of becoming rich, as the shortest road to national prosperity. [XVII, 75–76]

The contradiction between profession and practice Ruskin takes to be definitive of his public (and indeed, the audience that could respond to such a statement—an audience largely middle class and fervently Christian—is more or less *the* Victorian audience). Ruskin seized his occasion with exquisite instinct (the rage of his opposition shows that he hit home), but in his larger task of fashioning a language common to Christian ethics and social analysis, the moment of his opportunity is also a moment of great difficulty. Carlyle sought to teach his audience how to read phenomena as moral metaphors, but Ruskin had also to construct a moral science that could prove the political economists to be false on their own terms as well. His audience owed a double allegiance to the true gospels, but one was becoming increasingly persuasive, while the other had been neutralized into platitudinous familiarity. How could he rescue religious language from the context of hypocritical evasiveness? This task is precisely that of Coleridge in *The States-man's Manual,* and Ruskin's argument is similar. He must show that the Bible, accurately read and imaginatively experienced, is the truest guide to modern economics. He does so by overthrowing abstractions and constructing a mode of thought that is at once concrete, metaphorical, and scientifically valid—a new language that turns out to be the old language of religious myth.

Loving and Owing

Ruskin began publishing *Unto This Last* in monthly numbers of *Cornhill* until public protest called a halt to the series, forcing him to con-

clude his argument in a final, compressed installment. The book should therefore seem awkward in structure, yet the result is the most unified essay he ever wrote and perhaps his most ingeniously constructed. The four chapter titles signal a series of discrete topics: "The Roots of Honour" (on the social affections), "The Veins of Wealth" (on wealth), "Qui Judicatis Terram" (on economic justice), and "Ad Valorem" (on value and then, more briefly, on price, production, and consumption), but at the same time, each topic with its characteristic image pattern flows into the next, with the general effect of an argument that deepens and broadens, culminating in the concentrated grandeur of the final pages. Far from representing a change of course in his career, Ruskinian economics reaches its climax in a vision that is precisely the burden of all great art, the type of noble and perfected human life.

The first sentence of "The Roots of Honour" strikes the keynote of the book by attacking the assumption that "an advantageous code of social action may be determined irrespective of the influence of social affection" (XVII, 25). On the contrary, human beings are the proper subject of economics, and the motive force of humans is the soul, "the will and spirit of the creature." Economics, in other words, is properly a dynamic, not a mechanical, science. Mechanical science is the study of means and so views humans as means to an end, that is, as tools or machine parts to be "utilized"; dynamic science, on the other hand, studies the inward principle or power of its subject considered as an end in itself. Surely no economics can be scientific that founds itself only on moral injunctions, yet Ruskin's point is that no economics can be scientific that ignores them: "Treat [the worker] kindly without any economical purpose, and all economical purposes will be answered; in this, as in all other matters, whosoever will save his life shall lose it, whoso loses it shall find it" (XVII, 31). "Observe," he writes a moment later, "I am here considering the affections wholly as a motive power; not at all as things in themselves desirable or noble, or in any other way abstractedly good. I look at them simply as an anomalous force, rendering every one of the ordinary political economist's calculations nugatory" (XVII, 30–31). Ruskin here deliberately fuses the language of facts and the language of values by serious punning, using terms that may or may not be value neutral: "law," for example, may be a prescriptive or a descriptive term; "affections" may mean "passions" or "shows of love"; "moral" may mean "psychological" or "ethical." This deliberate confusion takes advantage of ambiguities in the language of nineteenth-century empiricism but also helps drive home the serious point that no social science can be a value-neutral enterprise. (In our own time, of course, we have learned again and again how class ideology presents itself as an objective science and in particular how im-

pulses to organized destruction parade themselves in terms such as "realism," "options," and "problem-solving.")

Ruskin then begins to show what a human-centered economics would look like by advancing his first practical proposal. Wages and length of employment, he says, should be determined independently of the demand for labor and should be fixed. This principle (as we have already seen in *The Political Economy of Art*) implies that the worker and his work are valued for themselves and, conversely, that money would have meaning as a standard of value, not as a mere register of market forces. Money would no longer be a confuser of values but an affirmation of value; moreover, it would cease to drive men into competition and so become the measure of their poverty but would act rather as a token of social bonding. From this proposal follows the most notoriously "impractical" of all the ideas in *Unto This Last*. The modern industrial enterprise, Ruskin says, should be founded on honor and fidelity such as prevail among "domestic servants in an old family, or an *esprit de corps,* like that of the soldiers in a crack regiment" (xvii, 33). The merchant would deserve this loyalty because the honor attaching to the professions—those of the soldier, the physician, the pastor, the lawyer, and the merchant—depends on an absolute duty opposed to the wish for gain, a duty that extends in extreme cases (as for the soldier) to dying for others. It follows that, since the merchant's relations to his employees should be as a father's to his sons, the merchant would in the case of a commercial crisis take as much or more of the suffering on himself than his men feel—"as a father would in a famine, shipwreck, or battle, sacrifice himself for his son" (xvii, 42). By thinking of merchants, soldiers, and pastors as governors of men, Ruskin answers the complaints he launched against these men as types at the close of *Modern Painters* v, written a few months earlier. The difference, of course, is that the three forms of asceticism (military, commercial, monastic) are replaced by a form of wealth—the wealth of having many sons—and the repressed energies are channeled into social bonds, "such affection as one man *owes* another" (xvii, 28). Ruskin called this bonding the Law of Help in *Modern Painters* v. In the last two pages of the essay before us, "is bound" appears eight times. True commerce is, in fact, "the most important of all fields," since the merchant "provides." The money-hungry ascetic becomes the man who feeds others. This final image represents a dramatic reversal of the first extended simile in the essay. Ruskin's caricature of a science based on greed is a science that reduces the body to soulless bones and plays games with death's heads and humeri (that is, with machine parts), but the new science is based on affection of an extreme and even a paradigmatic kind: "as a father would . . . sacrifice himself for his son." Self-sacrifice is the absolute antithesis of self-interest conventionally so

called, yet it is really the highest form of self-interest, since whoso loses his life shall find it—we might add, whoso would be filled shall first feed others—and this is simply the doctrine of the faith that all the English openly profess.

Ruskin's argument baffles readers to this day. Can Ruskin believe human beings to be so benevolent by nature? Can he be as naive as he seems? The response to such questions is the conclusion of the essay, a redoubled assertion of his own practicality: "All of which sounds very strange: the only real strangeness in the matter being, nevertheless, that it should so sound. For all this is true, and that not partially nor theoretically, but everlastingly and practically: all other doctrine than this respecting matters political being false in premises, absurd in deduction, and impossible in practice, consistently with any progressive state of *national life*" (XVII, 42). Here is the Carlylean stance, by which the speaker dismisses his opponent's views as outlandish and unheard-of while he himself simply repeats anciently accepted wisdom. And of course laissez-faire economics is new-fangled insofar as it claims to separate social philosophy from a purely empirical inquiry and then claims that a particular mode of social behavior is universal and "natural." Human beings are often selfish and base, but Ruskin's argument is not empirical; he is considering human beings from the viewpoint of their telos, or of what Marx would call the "fully human." Ruskin subtly signals this viewpoint by ingenious puns on the words "true" and "false." In phrases such as "true merchant," "true commerce," and "true science," "true" means "approximation to an ideal" but also combines the senses of "properly so called," "accurate," and "actually existing." Similarly, he says of any exclusively selfish commerce that "this which they have called commerce was not commerce at all, but cozening" (XVII, 39). Laissez-faire commerce therefore is untrue and so in a sense does not really exist. Ruskin's strategy here is of the first philosophical interest, since he is replacing an empiricist theory of meaning with an idealist theory—or more generally, is relinquishing descriptive language, in which words denote observed entities, for what Northrop Frye has called metonymic language, in which words are "put for" intangible realities.[7] Carlyle of course does the same thing in his historical philosophy when he calls present conditions "false" manifestations of eternal conditions that are "true," but more clearly than Carlyle, Ruskin challenges his opponents by implying that, for them, all metonymic language, including the language of the Christian religion, is "impractical." Like Plato in *The Republic*, Ruskin's aim is to show that entities such as justice are not only eternally "true" but also the only possible bases for a practical social policy.

[7]Northrop Frye, *The Great Code* (New York: Harcourt, Brace, Jovanovich, 1982), chap. 1.

The central opposition of the second essay is true wealth versus false wealth, and its revelatory climax is the statement that humans are the true wealth of a nation. To prove this point he distinguishes between political economy ("the economy of a State, or of citizens") and the false, or "mercantile," economy of individual acquisitiveness. The distinction attacks a second central tenet of the Manchester school (the first being that economics can exist as a value-free science) by denying that the selfish pursuit of wealth amounts to the greatest good for the greatest number. Ruskin assumes that any system of individual exchanges is a closed system resting on scarcity (we will see later what an open system looks like), so that every penny in one person's pocket means a loss for someone else; "mercantile" economy is therefore the science of defrauding or taking from others. He then defines money as debt ("a legal or moral claim," or in other words "an acknowledgement of debt . . . represent[ing] the labour and property of the creditor, or the idleness and penury of the debtor" [XVII, 50]). The poor are by implication the class of people owing debt to the rich, while the rich are the class of people who bear the guilt of gaining at the expense of others. To support this claim, Ruskin offers a fable illustrating the beginnings of an economic system. Two shipwrecked sailors find themselves in an uninhabited region and are forced to labor by themselves. One falls ill, so that the other must labor for them both. In exchange, the sick sailor pledges his future labor in the form of written promises—money. This fable no doubt confuses more than it clarifies, but it seems to serve Ruskin's purposes best by allegorizing the *psychological* reality of the money system. Somehow or other, one class of people has "legal or moral claim upon, or power over, the labour of others," so that debt and want are the fuel of the system ("The force of the guinea you have in your pocket depends wholly on the default of a guinea in your neighbour's pocket" [XVII, 44]). By exposing the ethical meanings implied in such standard economic terms as "debt," "owe," "earn," and "obligation," Ruskin once again implies that economics is a moral science. A just system, however, would not destroy the inequalities implied in the debtor relationship but transform them: the choice, he says, is between "melodious inequalities of concurrent power" and "the iniquitous dominances and depressions of guilt and misfortune" (XVII, 48). If Ruskin implies a link here between "dominances" and "guilt" and between "depressions" and "misfortune," then the business cycle appears to work like a cruel and capricious father, first compelling his sons and then arbitrarily punishing them without ever allowing them to work off their debt. But by offering the alternative of "concurrent powers," Ruskin suggests that there can be a good and mutually affirming system of indebtedness by which the owing of guilt can be transformed into the owing of love.

The transformation can occur, as we have seen, only if wages are fixed (further proposals will follow in the next essays) and only if private wealth can be made to further the public wealth. But these conditions imply a wholly new conception of wealth—a conception of wealth not as the quantity of an individual's possessions but as a *symbol* of the exchanges of goods and labor. And so there is true and false wealth: the "real value [of a "given mass of acquired wealth"] depends on the moral sign attached to it. . . . Some treasures are heavy with human tears, as an ill-stored harvest with untimely rain; and some gold is brighter in sunshine than it is in substance" (XVII, 52). Ruskin proceeds to a symbolic reading of wealth, of which two brief images are charged with particular passion. The phrase "lying image of prosperity set up, on Dura plains dug into seven-times-heated furnaces" puts Nebuchadnezzar's golden idol on top, so to speak, of the factorylike furnace where the young men were to be sacrificed, reversing the proper positions of men and gold (one standing above the earth, the other buried in the earth), while "the purchase-pieces of potter's fields, wherein shall be buried together the citizen and the stranger" (XVII, 53), repeats the reversal but extends the betrayal to include the Lord of life, that is, Life itself. In the anagnorisis of the final paragraphs, however, the ironic vision (in which gold commands the servitude and deaths of men) is reversed again, and man once more becomes the measure. It may be, Ruskin says,

> that the persons themselves *are* the wealth—that these pieces of gold with which we are in the habit of guiding them, are, in fact, nothing more than a kind of Byzantine harness or trappings, very glittering and beautiful in barbaric sight, wherewith we bridle the creatures; but that if these same living creatures could be guided without the fretting and jingling of the Byzants in their mouths and ears, they might themselves be more valuable than their bridles. In fact, it may be discovered that the true veins of wealth are purple. [XVII, 55]

Here "Byzantine," the conventional equivalent of "splendid," is analyzed into a pun, "Byzantine harness" and "Byzants," which together carry the concept of fetishism classically expounded by Marx. Value is centered on the inanimate objects by which men are devalued into beasts of burden, while the splendor or produce of the nation becomes the symbol of oppression ("bridle"): the beautiful is antithetical to the good. The emotional realities of money in a degraded system are also clarified: the jingling in the ears is a Siren's jingle, the fretting at the mouth a parody of eating, the jingling and fretting together a form of the carrot and stick, the tyranny of need and indebtedness. But in the reversal, humans become the ends instead of the means: "The final outcome and consummation of all wealth is in the producing as many

as possible full-breathed, bright-eyed, and happy hearted human crea-
tures." Ruskin illustrates his proposal for a manufacture of "Souls of a
good quality" by comparing the nation with Cordelia, whose "jewels"
were in fact her sons.

The reversal transforms the problem of guilt. The act of subordinat-
ing ends to means, by which humans are perpetually a means to a
fictitious end beyond themselves, parallels the experience of guilt or
indebtedness, by which a person labors indefinitely in expiation of an
ancient condition, and also the activity of "economizing," by which a
person renounces present pleasure in favor of an indefinite future
condition. The economic gospel, for both capitalist and worker, is a
permanent and life-denying asceticism. Money is the emblem of all
these things, the materialization of that denial and the token of the
debt forever to be worked off. The Byzantine harness is the analogue,
then, of Teufelsdröckh's iron bands of necessity, whereas the image of
sons as jewels is the analogue of the golden bands of duty: the second is
the emblem of freedom, since the debt has been erased in favor of the
affection men "owe" each other, and the humanity of the worker is
now affirmed, not perpetually to be earned.

Ruskin's utopian economics is of course paternalistic, exactly as
Dickens's and Carlyle's were, but in no simple sense. In part it pre-
serves what is best in classical economics (without Ruskin's ever saying
so). In the third volume of *The Stones of Venice,* for example, he defines
the "principle of brotherhood" in a "Gothic" rather than a republican
sense: "the souls that are unlike, and the nations that are unlike, and
the natures that are unlike, being bound into one noble whole by each
receiving something from and of the others' gifts and the others' glory"
(XI, 24). This statement is a moral version of division of labor as Adam
Smith conceived it—a guarantee of economic autonomy and efficiency
by the exchange of specialized skills. In "The Nature of Gothic" Ruskin
presented a good version of this system (in which the workman ex-
presses himself and so finds freedom by participating in an organic
whole) and a bad version (in which the workman is unskilled and un-
creative, and so is enslaved by a mechanical system). But the word
"inequality," performing the function that "imperfection" did in "The
Nature of Gothic," deliberately confounds economics with politics,
serving to rationalize a system of bourgeois control—and so, of course,
does the fable about the origin of money, which assumes as immutable
the present relationships of power in order to reform the present uses
of power. The theory of money and the dominant image of wealth as a
stream (which like water only moves by flowing downward from a high
source) suggest that Ruskin was unable even to conceive of a society
that was not hierarchical or of social cohesion not based on some form
of obligation of inequality. This failure of imagination derives, of

course, from Ruskin's class ideology—the good fathers would be people from his own class—and also, to a limited but definite extent, from his own experience of affection. In countless published passages and private remarks and deeds, Ruskin suggests that for him friendship is inconceivable without a recognition of difference, a recognition deriving no doubt from his internalized paradigm of love, which is filial. The letter to Rossetti shows with particular clarity how the mechanism of exchange—the exchange of money and labor and advice and praise—simplifies some of the risks of a truly mutual intimacy, permitting the affirmation of "concurrent powers" as long as Ruskin himself could define the terms of power. *Unto This Last* sets up a similar conception of ideal paternity that permits the workman or son the full expression of his powers, giving to the benevolent ruling class quite remarkable power to shape the souls of those in their employ. By wishing away the very possibility of class conflict, Ruskinian paternalism denies the principle that has underlain liberal political thought since Macchiavelli—that each class is the proper guardian of its own interests—and this is a serious limitation indeed. Yet Ruskin's comment that the brotherhood of man is inconceivable without the sonhood of man, by suggesting that the family metaphor in libertarian thought can crucially avoid the hard questions of political power, reminds us that the difficulty is not Ruskin's alone. Even for Marx, the relationships of power in a classless society remain undefined.

Ruskin's method of thinking about economics in terms of individual affectionate relationships thus runs the danger of imposing a new form of tyranny. Yet *Unto This Last* shows even more powerfully the dangers of thinking about economics in any other way. It shows the same about the use of metaphor in economic thinking. Economic abstractions enact the fallacy of misplaced concreteness by taking a part of the whole—economic "forces"—and reifying it as a self-enclosed system (a rise in demand means a rise in "value," overproduction means a fall in wages, and so forth) governed by a law of profit and loss presumed to be ironclad. The reification is possible because economists view money and wealth only as quantities, not as signs, which in fact they are. By starting out with the crucial perception that wealth is power over labor and therefore the materialization of human relationships, Ruskin is able to draw aside the "veil" of the abstraction to show the human beneath and then to read the "moral signs" of wealth as we might read the stones of a fallen city or the emblems in a painting by Veronese. The relationship of material goods to the people who use and produce them, in other words, is like the relationship of vehicle to tenor except that in false wealth the literal meaning may be absolutely opposed to the metaphorical or human meaning: some treasures are heavy with human tears. Ruskin strengthens this point by an image structure of his

own in which people and their products are visually all but indistinguishable. In each essay the common image is a circulating system in which the elements (money, products), the forms of energy (greed or affection, need and indebtedness) and the laws of motion (justice or injustice) can be provisionally separated. Such a separation, however, is ultimately like separating the dancer from the dance (wealth flows, men are wealth, justice flows like money). As in the language of religious myth, the "true" language of economics is concrete, combining subject and object. But I am anticipating Ruskin's conception of justice, to which he devotes another essay.

The Apotheosis of Justice

The close of "The Veins of Wealth" suggests that if children are wealth, the aim of a true economy is not only to share but also to produce and that a system of monetary exchange is wholly distinguishable from a system of production (even though Ruskin is unclear about the relationship between production and "mere" exchange). The first principle, based on scarcity, permits one person's gain only at another person's expense, but if wealth is a growing thing, the rules change—the economy becomes dynamic rather than static, and its components (money, wealth, affection, justice) circulate through four dimensions, nourishing and generating the ultimate product, which is life. Ruskin's conception of justice is similarly nourishing and generative.

"Qui Judicatis Terram" varies the structure of the previous essays by opening not with an attack on the false economy but with maxims of the true. The break in rhythm suggests that Ruskin has built enough of his argument to let the biblical message be heard in its proper context. But he surrounds his scriptural text with heavy irony: Solomon he describes anonymously as "a Jew merchant" reputed for "practical sagacity" whose writings "have fallen into disrepute, being opposed in every particular to the spirit of modern commerce," yet which may "interest the reader by their novelty" (xvii, 57). By converting Proverbs into an economic treatise and Solomon into a successful capitalist, Ruskin reveals the Scriptures as the paradigm of his own moral science while sharpening the opposition between religious precept and economic practice into a kind of battle of books. For most readers this battle is the least successful section of *Unto This Last,* since Ruskin is unable to avoid after all the appearance of turning from hard logic to self-righteous prescription. Ruskin's aim and design are nevertheless precise and deliberate: by integrating biblical imagery with his own metaphorical economics, he moves beyond metaphor to myth.

Justice is first of all moral law ("A fair day's work for a fair day's pay"

is a central example); second, it is a power of generating and increasing wealth. Ruskin's practical point is that if a workman is paid more than the minimum the market can bear, the workman can hire someone else to work for him with the surplus he has earned; the person hired can hire someone else, and so forth. The example is not convincing, yet the conception behind it—that the money supply is not a fixed quantity but a volume that fluctuates according to its use—is important and further permits Ruskin to view the employer as a kind of governor who "legislates" through his bestowals, not as a capitalist who simply hoards. This legislation, the principle of which we have already seen in Ruskin's art economy, stands against the laissez-faire belief that market forces are uncontrollable and subject to their own laws only:

> The waters of the world go where they are required. . . . No human laws can withstand its flow. They can only guide it: but this, the leading trench and limiting mound can do so thoroughly, that it shall become water of life—the riches of the hand of wisdom; or, on the contrary, by leaving it to its own lawless flow, they may make it, what it has been too often, the last and deadliest of national plagues: water of Marah—the water which feeds the roots of all evil. [XVII, 60–61]

The biblical allusions of this passage form a meditation on Exodus—appropriately, because the structure of that book resembles the typological structure of *Unto This Last,* and also because Moses as lawgiver is also, by divine favor, the nourisher of his people. (By his various miraculous conversions—the rock that yields water, the almond rod that flowers, the dead land that provides manna, the bitter waters of Marah that turn sweet—Moses shows what any employer can do by the uses of wealth.) Wisdom, which we have encountered before in Ruskin, also becomes a form of nourishment ("the water of life," "the riches of the hand of wisdom"). (The imagery and meaning of *Unto This Last* comes closest here to *The King of the Golden River,* particularly in the sudden appearance halfway through each book of the wise figure capable of turning the dry land into abundance and revealing the true relationships between gold and life.)

In fact Ruskin apotheosizes Solomon by elevating him, so to speak, from an obscure "Jew merchant" to the type of wisdom by calling up certain verses from the apocryphal Wisdom of Solomon and associating them with a passage in Dante. The light, Solomon wrote, is the "sun of justice," which shall rise with healing in its wings and must be accompanied by holiness, that is, "helpfulness" (XVII, 59–60). In the wake of this quotation Ruskin opposes the ignoble modern science to the divine law of prudence, which is also "jurisprudence":

> Which prudence is indeed of no mean order, holding itself, as it were, high in the air of heaven, and gazing for ever on the light of the sun of

justice; hence the souls which have excelled in it are represented by Dante as stars forming in heaven for ever the figure of the eye of an eagle; they having been in life the discerners of light from darkness; or to the whole human race, as the light of the body, which is the eye; while those souls which form the wings of the bird (giving power and dominion to justice, "healing in its wings") trace also in light the inscription in heaven: "DILI- GITE JUSTITIAM QUI JUDICATIS TERRAM." [XVII, 62]

Justice and holiness, traditionally conceived, rationalize the Blakean tyranny of king and priest, but Ruskin transvalues these values, so to speak, by redefinition, combining "holiness" with "helpfulness" and *rex* (ruling power) with *lex* (judging or measuring power) (XVII, 59n), so that government becomes a matter of helping and distributing. The Holy (Helpful) Ghost would be the type of both these virtues, and indeed, by linking the sun of justice, rising with healing in its wings, with Dante's eagle, Ruskin in effect converts the eagle of empire into a dove—a symbol, like Dante's, of the temporal and spiritual power, although since economics is at once a moral science and the provision of material benefits, Ruskin's image of the social body is really a joining of the nobly animal with the nobly spiritual. All the virtues, we might say, are materialized and all physical satisfactions spiritualized. The rulers are to the nation as the eye of reason is to the body, but Ruskin's republic is once again a physical entity as well—Solomon as preacher and provider merges with the Platonic philosopher-king—and in a certain sense also a democratic entity. For justice is embodied not in one man only but in all men of goodwill: "Which judging or doing judgment in the earth is, according to their capacity and position, re- quired not of judges only, nor of rulers only, but of all men" (XVII, 63). Both these mergings—the body of society with the spirit and the ruler of society with the citizen—are captured by Ruskin's image of the sun of heaven incorporated into the body as the light of the eye, so that this symbol, like the darkening glass in *Modern Painters* V, becomes the emblem of a secular faith. In these pages, then, Ruskin comes as close as any writer is likely to come to a poetry of economics—not at this point a doctrine but a reordering of thought and feeling bearing roughly the same relationship to the welfare state that *Prometheus Un- bound* bears to radical republicanism. Only through myth can a new heroic virtue be invented, in this case a secular version of the love that for Dante moves the sun and other stars. Ruskin's ideal ruler inciden- tally represents a fusion of his own identity with his father's, since the ideal merchant merges into the ideal preacher, a dispenser of wisdom and wealth. As Ruskin attacks the false economists in order to become a true one himself, he also absorbs the role of merchant into the role of writer. But what kind of writer Ruskin has become depends on the

fashioning of a metaphorical language that is both legislative and prophetic, since it is capable of forming "before unapprehended relations of thought." In his final essay he brings to a climax this prophetic use of language by first of all attacking the language of the false science.

The Light of the Body

In the preface to *The Political Economy of Art,* Ruskin boasted that the only economist he read was Smith many years ago. Hostile reviewers of *Unto This Last* leaped on the admission in order to discredit Ruskin as an ignorant amateur, with the result that, while preparing his fourth essay, he apparently read the classical economists with the purpose of refuting them. "Ad Valorem" opens with a cross-examination of these texts, particularly Mill's, in which Ruskin demonstrates once and for all that, if his own mind was analytical, he had little better than a schoolboy debater's notion of logic. As John Fain and others have shown, the procedure is to quote haphazardly and out of context, to leap on isolated words and phrases, and incidentally to plagiarize the language and ideas of his sources, including Ricardo and Smith—another example, presumably, of Apollo absorbing the Python.[8] But in one feature of this repellent section, the quarrel with Mill's definitions, Ruskin exposes a real issue.

His essential complaint is vagueness. Thus Mill defines utility as "capacity to satisfy a desire, or serve a purpose"; but what kind of desire and what kind of purpose? Wealth includes "all useful and agreeable objects," but is a horse useful when no one can ride? Mill never defines "possession," but for Ruskin there are degrees of possession, including, at one extreme point, the corpse of St. Carlo Borromeo, with its gold crosier and cross of emeralds. The word "value," "when used without adjunct, always means, in political economy, value in exchange." Does this mean, Ruskin asks, that the rudders of two ships are valueless because they cannot be exchanged? His quibbles are easily refutable if we accept Mill's own explicit justification for abstract language in the moral sciences. His procedure, he says in *The Principles of Political Economy,* is to use words that often have normative meanings descriptively, not prescriptively ("useful" and "agreeable" apply simply to whatever people consider useful and agreeable, not necessarily to what is useful or agreeable in itself), and then to restrict their usual meanings to specialized senses useful for a specialized study ("value" therefore means only value in exchange). These abstractions, Mill then notes, must be qualified by "disturbing factors" when applied practically.

[8]Fain has demonstrated this point convincingly by comparing passages (pp. 144–145).

Homo economicus is one of these abstractions: when the economist speaks of people as desiring wealth, he is not necessarily claiming that people invariably and in all circumstances act according to their self-interest.[9] (These of course are the "disturbing factors" that Ruskin calls "affections.") Mill's procedure conforms to the modified empiricism of his *System of Logic.* There he claims that definitions are not of things in themselves but statements about meanings people normally attribute to words, and that general concepts are summations of particular instances, referring only to the sums of those instances that, in fact, may cohere by virtue of resemblance into what we call "classes." It follows that generalizations are valuable for their usefulness in a particular context, not for their power to describe things in themselves. This inductive theory of truth of course has obvious difficulties. When asked to define the essence of something, am empiricist might list the attributes found most often in a given class, but what if the object to be defined were human? One possible definition is "any featherless biped," to which we could add any number of other attributes, but how could we decide which quality, rationality or bipedality, was more important to humanness? How, in other words, should Bitzer condense his definition of the horse?

From the economist's point of view, the question is how far the inductive method, useful for natural science, can be adapted to the study of human beings. It has often been observed that Mill uses analogies from physics in the *Principles* ("disturbing forces" is borrowed from the concept of friction in the physical sciences), but the analogy runs deeper. Any attempt to create generalizations on the basis of recurrence, which may then be used instrumentally—to predict or produce desired results—implies, first of all, the conception of a self-sufficient and interdependent system and, second, the possibility of abstracting things so as to quantify them. Number tends to be the common denominator of all phenomena, which then have to be somewhat artificially viewed as units—objects or motions. This idea suggests a second analogy. Marx, thinking of Hegel, called abstract logic the money of the mind. We might add that the inductive theory of meaning corresponds to the use of paper money in an economy. Like inductive generalizations, money translates objects into an abstract system of signification based on quantity; like inductive definitions, the relationship of money to things is arbitrary (definitions are what people take words to mean) and alters according to purposes outside the inherent value of things. For the capitalist and the scientist, things mean only what they need to mean for a specific purpose: as conceived by its

[9]For criticism of the idea of "disturbing factors" in applied economics, see Sherburne, 117–120. Mill's theory of meanings and definitions appears in the *System of Logic,* book 1.

romantic critics, utilitarianism permits people to change meanings for selfish ends.

Ruskin's reformation of language attempts to overthrow arbitrary meaning by forging a necessary connection between words and the concrete reality, which—since economics is a human science—is the subjective human experience of things. However obscurely expressed, the attack on Mill is a denial that humans can be the object of a study without being subjects as well. Ruskin begins his reformation with what John Rosenberg calls his "humanization of the concept of value."[10]

In classical economics the word "value" has relative meaning only. Like the word "is" in English grammar, it acts as the copula, putting things into relationship to each other. But in an actual economy the relationships shift like the croquet game in *Alice:* wages rise and fall according to "demand"; what fetched a pretty price yesterday is worthless today. Ruskin gives referential meaning to the term by means of etymology and word-association: "*Valor,* from *valere,* to be well or strong (ὑγιαίνω);—strong, *in* life (if a man), or valiant; strong, *for* life (if a thing), or valuable. To be 'valuable,' therefore, is to 'avail towards life.' A truly valuable or availing thing is that which leads to life with its whole strength" (XVII, 84). From this definition flow several oppositions—vanity to substance, "death, the Lord of Waste, and of eternal emptiness" to "Wisdom, the Lady of Saving, and of eternal fullness" (in turn associated with—of all things—the Madonna della Salute, also the name of a Venetian church), and wealth to illth. The effect of these

[10]John Rosenberg, *The Darkening Glass* (New York: Columbia University Press, 1961), 136. It may be useful here to give a brief outline of the fourth chapter, using Ruskin's four original categories. (1) "Ad Valorem" (on Value). To have value is to "avail towards life"; wealth, then, is value in the hands of the valiant, that is, of those who can nobly use what they possess. "Having" is a gradated capacity, since possessions can sometimes possess us; the business of political economy, then, is to teach wise consumption as well as wise production, which means use rather than "ab-use" and wise rather than foolish demand. It is a science not "of everything to every man, but of the right thing to the right man" (XVII, 88). (2) "Thirty Pieces" (on Price.) In any exchange there can be advantage but not *profit;* if one party profits, someone has cheated. What, then, determines a fair price? The price of everything depends on labor, and labor, the struggle of life with an opposite, is neither dear nor cheap, but an object requiring a great deal of labor is dearer than an object requiring less. Pricing is a complex calculation requiring four considerations, including "quantity of wish" to buy. (3) "Demeter" (on Production). Labor is positive, negative, or nugatory; the type of the first is childbearing, the type of the second, killing. Production is ultimately for the sake of consumption, that is, for life. Capital is also for the sake of consumption, so that all "essential" production is for the earth or for the mouth—ultimately for the mouth. On the other hand, the aim of the political economists is not mouthgain but moneygain, and the practice of the capitalists is the spreading of destruction rather than life. But there is no wealth but life. (4) "The Law of the House" (on Economy). The true national wealth is a happy and healthy people. Thus, instead of fearing overpopulation or the moral depravity of the poor, we should extend to them instead the affection and the bounty we would extend to our children and so build the nation anew.

associations is to center a cluster of meanings on a conception of well-being that is both physiological and spiritual. In the theory of language Ruskin assumes (to which I will return later), definition rests not in accepted uses of a word but in the various meanings that descend from a root, which are related to each other and to similar words in a cluster that is the verbal equivalent of a grotesque. These relations correspond to relations in the real world, a world which—exactly as in landscape—is a world of essences, that is, of spiritual and physical energies.

In an almost literal sense, then, Ruskin's language stands to Mill's as dynamics to mechanics. Mechanics studies the interaction of matter and motion; the new science of dynamics studies the modifications of energy. Each of Ruskin's terms is active—even "having," which is the "vital power to use"—and the discussion of possession modulates into a discussion of use and ab-use of wine, of the body, of material value in general. By contrast, the strongest "force" in classical economics—demand—seems not even a force at all: the economists, Ruskin says, mean by "demand" "the quantity of a thing sold" whereas *he* means by it "the force of the buyer's capable intention to buy" (xvii, 84n). Later, in discussing price, he says that "the regulation of the purse is, in its essence, regulation of the imagination and the heart," a regulation to be determined by "quantity of wish" and "quantity of labour" (xvii, 94–95). And since the buyer's labor is his money, every element in economic life—money, wealth, possession, labor, price, demand—becomes a manifestation of physical or moral energy capable of modification by other energies. All these energies are of course manifestations of human affections: Ruskin pictures the pattern of economic exchange as a materialization of character much as Pope does in the "Moral Epistles." The general term for these spiritual energies is Life, which takes the characteristic form of a struggle: "Labour is the contest of the life of man with an opposite;—the term 'life' including his intellect, soul, and physical power, contending with question, difficulty, trial, or material force" (xvii, 95). Again, "THERE IS NO WEALTH BUT LIFE. Life, including all its powers of love, of joy, and of admiration" (xvii, 105). But the activity of life is not only a struggle but a drive toward the creation of more life, since life is its own end. The motions of Ruskin's moral thermodynamics, therefore, take two typical forms: a pair of forces in creative opposition or fusion and a forward-bound or productive drive aimed at more strength and life. The simplest paradigm combining both movements is, of course, the union of man and woman to create a child.

The argument of "Ad Valorem" moves toward the triumph of Eros, as *Hard Times* ends in its defeat. In Ruskin's climax we see a new nation rising, like children coming to maturity and replacing the blocking

figures that had temporarily taken the place of wisdom and delight,[11] just as a productive economy takes the place of the old limited economy founded on mere fraudulent exchange.[12] In a sense Ruskin has just overthrown one set of blocking characters by refuting the bad economists, and we have seen that the third essay presents the wise ruler in the form of an allegorical portrait. The fourth essay presents an allegorical portrait of the bad capitalist by a reading of the Ixion myth:

> Capital is the head, or fountain head of wealth—the "well-head" of wealth, as the clouds are the well-heads of rain: but when clouds are without water, and only beget clouds, they issue in wrath at last, instead of rain, and in lightning instead of harvest; whence Ixion is said first to have invited his guests to a banquet, and then made them fall into a pit filled with fire; which is the type of the temptation of riches issuing in imprisoned torment,—torment in a pit, (as also Demas' silver mine,) after which, to show the rage of riches passing from lust of pleasure to lust of power, yet power not truly understood, Ixion is said to have desired Juno, and instead, embracing a cloud (or phantasm), to have begotten the Centaurs; the power of mere wealth being, in itself, as the embrace of a shadow,— comfortless . . . but in its offspring, a mingling of the brutal with the human nature: human in sagacity—using both intellect and arrow; but brutal in its body and hoof, for consuming, and trampling down. For which sin Ixion is at last bound upon a wheel—fiery and toothed, and rolling perpetually in the air;—the type of human labour when selfish and fruitless (kept far into the Middle Ages in their wheel of fortune); the wheel which has in it no breath or spirit, but is whirled by chance only; whereas of all true work the Ezekiel vision is true, that the Spirit of the living creature is in the wheels, and where the angels go, the wheels go by them; but move no otherwise. [XVII, 99–101]

In this thickly woven grotesque—Ruskin would produce a great many more, to the eternal confusion of his readers—the psychic substructure of his argument bursts to the surface, providing in cryptic

[11] In this respect, of course, *Unto This Last* presents the structure of comedy as defined by Northrop Frye in *Anatomy of Criticism* (Princeton: Princeton University Press, 1957), in particular 193, 181, 168–169, 171.

[12] Ruskin's discussion of catallactics, or mercantile exchange, has puzzled commentators. He writes, "Profit, or material gain, is attributable only by construction or by discovery; not by exchange. Whenever material gain follows exchange, for every *plus* there is a precisely equal *minus*" (XVII, 91). Why does Ruskin insist on the peculiar distinction between advantage and profit? and why does he not seem to allow for mutual advantage in an exchange? My suggestion is that by this time he has wholeheartedly given himself to the organic metaphor, which dictates that a system can only grow or decay. Exchange seems to belong to a mechanical system, where there is no growth and the quantity of available goods is fixed. His aim, obviously, is to stress production instead of the more traditional concerns of the orthodox economists, and this emphasis leads to a confusing quibble.

form a diagnosis of the human soul deformed by avarice. We notice first that the Centaurs show both of the vices of capitalism, rapacity and deceit, which they "inherit" from the father's two sins, murder and lust; yet they are parthenogenic offspring, the product of a man and a cloud, or of a man and his phantasm, so that although Ixion has produced a race he is still "fruitless and selfish," having actually propagated himself as so many sins. As for the first of these crimes, Ruskin's editors note that in the Pindaric source, Ixion is "the first among the heroes to shed blood of kin craftily" (like Cain in the biblical tradition), the kinsman being Ixion's father-in-law. An oedipal pattern now comes clear: Ixion kills his father-in-law, then indulges in forbidden lust—the original of the lust for riches (but with an odd reversal of the oedipal situation: "lust of pleasure" Ruskin attributes to the murder, "lust of power" to the attempted rape). Both sins combine delusion and violence. By implication, the avarice of the capitalist is a compelled repetition of kinsman murder (competition) and misdirected lusts (greed that cannot be satiated). Men kill their kin for money, but the unsatiated hunger turns them to beasts. Clouds and flatulence, moreover, become the type of vanity—desire unappeasable because misdirected: clouds issue in wrath and lightning, Ixion embraces a cloud, Geryon grasps the air, and in a footnote, Dante's Plutus collapses like a sail swollen with wind (which suggests to Ruskin "the sudden and helpless operation of mercantile panic"—boom and bust, in a word). The wheel of Ixion combines both the natural elements of his sins, fire and air, becoming in effect a mechanized storm cloud. Ixion has become his own bondage, since his body has turned into a machine, not a living thing—in contrast to the vision of Ezekiel, which, like an organic system, is empowered from within. The mechanics of guilt, in other words, is regressive, dooming the sinner to enact his transgression forever in symbolic form. By extension, the whole capitalist system is such an obsessive repetition, ruled (as Ruskin says elsewhere) by Tisiphone, the goddess of retribution. We have here in brief the connection between money, guilt, compulsion, and repetition traced by Freud as well as something else: the two crimes, the acting out of infantile fantasy by an adult, are themselves regressions. The spiritual perversion of Mammonism is a solipsistic relationship to time.[13]

Ixion is the tragic prototype of wasted labor and destructive life. In the immediately preceding passage Ruskin offers as a parallel to this myth an account of fruitless *goods*. Like the man who reproduces him-

[13]In *The Trauma of Birth* (London: K. Paul, Trench, Trubner, 1929), Otto Rank associated Ixion's wheel with fantasies of being enclosed perpetually in the womb. "The crime of these primal offenders [Ixion, Tantalus, Sisyphus] generally consists in rebellion against the highest of the gods, usually caused by the desire for his wife, the primal mother, as in the case of Ixion, who, moreover, is the first murderer of relations" (p. 133).

self by embracing a phantasm, unproductive capital, according to Ruskin, is an aggregation of bulbs ("root producing root; bulb issuing in bulb, never in tulip; seed issuing in seed, never in bread"); or again, Prince Rupert's drops, "consummated in powder" (these playthings are bits of ground glass that explode when dropped); or yet again, like a plowshare reproducing other plowshares: "however the great cluster of polypous plough might glitter in the sun, it would have lost its function of capital." But the true purpose of the plow is "to grow bright in the furrow; rather with diminution of its substance, than addition, by the noble friction" (xvii, 98–99). The covert sexual implications of this imagery recall Steven Marcus's discussion of "genital economy"— the Victorian belief that sexual energy is limited and in perpetual danger of diminishment—corresponding precisely to a conception of economics as a science of scarcity.[14] But for Ruskin, scarcity, both erotic and economic, is but the creation of hoarding. The image of physiological horror renders Benthamite "self-interest" into a gruesome pun (it is the self recreating itself in debased form like money), an antithetical generativity that is both sterile and monstrous, deriving from an absolute alienation of the body that then loses its proper function. (The "idiotic" body is useless to the state since, Ruskin tells us, "idiot" in Greek means "a person entirely occupied with his own concerns" [xvii, 87].) And of course the delusion of avarice is a vain wish to derive sustenance from one's own desires—the economists, for example, are "like children trying to jump on the heads of their own shadows; the money-gain being only the shadow of the true gain, which is humanity" (xvii, 102). Once again the airy produce of the pedant combines with the filthy produce of the miser. Finally, the parthenogenic product is destructive of life, issuing ultimately in war. Like a sexual perversion, "self-interest" is *un*natural, producing ultimately and on the largest scale the materialized form of the Death-instinct in our time.

To this morbid procreation Ruskin opposes the generation of life— human fertility integrated into the cycle of vegetation. As the bulb issues in flower and the plough labors for grain, so is childbearing the type of all "positive" labor: "While the wife is said to be as the vine (for cheering), the children are as the olive branch, for praise: not for praise only, but for peace (because large families can only be reared in

[14]Steven Marcus, *The Other Victorians* (New York: Basic Books, 1964; reprint 1974). Marcus's remarks follow an analysis of William Acton's popular manual, *The Functions and Disorders of the Reproductive Organs*, published in 1857: "The fantasies that are at work here have to do with economics; the body is regarded as a productive system with only a limited amount of material at its disposal. And the model on which the notion of semen is formed is clearly that of money. . . . Furthermore, the economy envisaged in this idea is based on scarcity and has as its aim the accumulation of its own product. And the fantasy of pornography . . . is this idea's complement, for the world of pornography is a world of plenty" (p. 22).

times of peace): though since, in their spreading and voyaging in various directions, they distribute strength, they are, to the home strength, as arrows in the hand of the giant—striking here and there far away" (XVII, 97–98). Rearing, not begetting, Ruskin says in a footnote: "The praise is in the seventh season, not in σπορητός, nor in φυταλιά, but in ὀπώρα" (XVII, 97n). In Galen's seven seasons, the year begins in spring, with the rising of the shoot in the ground, and ends with futaliá (planting). But by making the third season (opora, the dog days, or season of ripe fruit) the seventh, Ruskin imagines a year beginning with planting and culminating with the fruit—just as conception fulfills itself in the "flower" of the child. In antithesis to the Centaurs, who throw the arrows of disruption, the human family is at peace; its "arrows" are the slow strength of growth through time and space. But procreation is only a special case, though the perfect "type," of generativity, which is the dominant activity of the productive economy. Gradually the metaphorical weight of *Unto This Last* has shifted from wealth to life (which is wealth viewed from a different angle), conceived first as a nourished and flowing energy, then as a growing energy. In the rhythm of continuous growth, there are two "beats," production and consumption. Of true production, Ruskin says, there are two kinds: "one of the seed, and one food; or production for the Ground, and for the Mouth. . . . And since production for the Ground is only useful with future hope of harvest, all *essential* production is for the Mouth; and is finally measured by the mouth; hence . . . consumption is the crown of production; and the wealth of a nation is only to be estimated by what it consumes" (XVII, 101). As the seed is to the flower and as conception is to the child and as the arrow of desire is to fulfillment, so is production to consumption, a cycle that repeats along with the seasons. In *The Political Economy of Art*, the central image was the storehouse, or "true" granary binding past and future, which actually creates its "store" by giving out. The dominant schema of *Unto This Last* is a similar circulating system, in which true saving is distribution and wealth is consumed not by the moth and rust but by the human. I speak of the substance of that flow as energy rather than matter, because matter is understood through its parts (it is analyzed), but energy is understood through its manifestations; and the four essays, building on one another, have treated that energy as affection, wealth, just nourishing and growing life (food and man). The subject of bad political economy, however, is lifeless and inert matter—"money-gain" not "mouth-gain." To confuse the two is to repeat the punishment of Midas, for whom excrement becomes aliment, but in Ruskin's alchemy, nature is converted from excrement to the gold that truly nourishes.

No wonder that modern man needs to learn how to content himself. For the ideology miscalled political economy is at bottom an attack on

the body and its needs, a blocking of nourishment by the products of vanity and of the peaceful and natural circuit of life energy by the desires of vanity. The Mammonist gospel divorces body and spirit, starving both: the rich are told that the only pleasures are basely material, the poor that the only holiness is renunciation. Ruskin's response is to reintegrate body and soul, making nature man's spiritual body. That body is organic. In Ruskin's myth of Ixion, what cannot grow or change seems condemned to duplicate itself; what cannot participate in the social body must embrace its own vanities (hoard). The connection between the mechanical and the offalous asserts itself when we see that self-duplication and compelled repetition ("bulb issuing in bulb" in one image pattern; the race of Centaurs and Ixion's wheel in another) have their social expression in the factory system of "The Nature of Gothic"—men as parts, labor as palsied repetition. Ixion, I said above, has a solipsistic relationship to the past; the natural cycle, on the other hand, pushes ever forward—children are arrows pressing into the future. Eros belongs to the present, ever consummating itself in the future. Earlier, we saw that the debt structure of money binds the poor to the rich and that mechanical exchange decrees that every man's wealth is someone else's need. Ruskin nowhere says so explicitly, yet his own image pattern strongly suggests that the productive economy frees humans from the bondage of debt and want and therefore from guilt and repression. The social system no longer springs from an original weakness and debt. *Time is redeemed.* For if time is money, it disappears the moment it is spent; hoarded, it turns into the delusions of Ulro (as money turns to illth). But time redeemed is wealth. On St. Mark's, wealth comes alive in the marble spray, which is the arrest of the temporal flux; in the productive economy, time is not arrested but flows onward in wealth, like a golden river.

For there is "no Wealth but Life": "That country is the richest which nourishes the greatest number of noble and happy human beings; that man is richest who, having perfected the functions of his own life to the utmost, has also the widest helpful influence, both personal, and by means of his possessions, over the lives of others" (XVII, 105). This passage, the climax of all Ruskin's social thought, confounds material goods with spiritual and possession with power, by means of the biblical paradox that to lose oneself is to save oneself. It means that the split between subject and object is healed—that what one is, what one does, what one gives, what one loves, are in the state of fulfillment a unity. It means many things, in fact, for the tremendous power of the aphorism is simply *Unto This Last* concentrated into six words. We can sum up at least three of Ruskin's several arguments, however, by three paraphrases of "There is no Wealth but Life": it means, first, that all things are valuable only as they serve real human needs; second, that spiritual

fulfillment is the experience of life energy both given and possessed, both expressed and preserved; and third, that the only true aim of an economic system is the raising of children and the manufacture of souls. It has yet another meaning suggested by the pages that follow, which form a kind of coda envisioning the productive economy extending throughout the land.

The habitable zones of the earth, Ruskin says, will then "be loveliest in habitation."

> The desire of the heart is also the light of the eyes. No scene is continually and untiringly loved, but one rich by joyful human labour; smooth in field; fair in garden; full in orchard; trim, sweet, and frequent in homestead; ringing with voices of vivid existence. No air is sweet that is silent; it is only sweet when full of low currents of under sound—triplets of birds, and murmur and chirp of insects, and deep-toned words of men, and wayward trebles of childhood. As the art of life is learned, it will be found at last that all lovely things are also necessary;—the wild flower by the wayside, as well as the tended corn; and the wild birds and creatures of the forest, as well as the tended cattle; because man doth not live by bread only, but also by the desert manna; by every wondrous word and unknowable work of God. [XVII, 111]

What saves this passage from pastoral sentimentality is the multiplicity of its references. It seems that if the agricultural sector of the English economy is expanded to feed everyone adequately, the agrarian paradise will also correspond to a Paradise within, since an economy of abundance and cooperation will fulfill the spiritual craving of which the landscape hunger is one symptom and so, in a sense, will erase the divorce of city and country—partly because all production will follow an agricultural paradigm, that is, will be production for the mouth. Man will then be naturalized and nature humanized, because the love of beauty and the need of the body will be consummated at once, as aspects of each other. This immediacy of fulfillment, unknown in the fallen world except in the infant's bond with its mother, I take to be one meaning of "The desire of the heart is also the light of the eyes," a sentence worthy to stand beside a proverb of Solomon's or Blake's. But nature is redeemed as well: There is no natural wealth without human life, and no human wealth that does not flow from the life of nature. (In Blake's words, "Nature without man is barren.")[15]

[15]At this point Ruskin's social vision matches certain ideas of later radical visionaries. To Norman O. Brown, for example, "rigorously economical thinking" is a "morbid" impulse: "Abstraction from the reality of the whole body and substitution of the abstracted impulse for the whole reality are inherent in *Homo economicus*. In contrast, what would a non-morbid science look like? It would presumably be erotic rather than (anal) sadistic in aim. Its aim would not be mastery over but union with nature. And its means would not be economizing but erotic exuberance" (*Life against Death* [Middletown:

We come now to the last pages of all, in which Ruskin develops the theme of the "law of the house" through the familiar image of Wisdom: "thus it is said of Wisdom that she 'hath builded her house, and hewn out her seven pillars'; and even when . . . she has to leave her house and go abroad, her paths are peace also" (XVII, 113). Wisdom connects the house and the landscape, a center of peace expanding like ripples to make the world a garden and the household a world. The figure, as we have already seen in *The Political Economy of Art,* is a virtual commentary on the eighth and third chapters of Proverbs, picturing Wisdom both as housewife and as God's helpmate during the Creation. The phrase "the light of the eye" also alludes to her (Ruskin's editors compare it with Proverbs 15:30: "The light of the eyes rejoices the heart"), and there is perhaps an allusion to the creation passage in the description of the heavenly eagle "gazing forever on the light of the sun of justice." The eye of the eagle, we recall, is the just souls who are "to the whole human race, as the light of the body, which is the eye"; the "light of the body," however, is a phrase from the Sermon on the Mount ("The eye is the lamp of the body. So, if your eye is sound, your whole body will be full of light; but if your eye is not sound, your whole body will be full of darkness"). The image and the phrases return in the final sentences of the book, when Ruskin's poetic vision achieves its culmination:

> but luxury at present can only be enjoyed by the ignorant; the cruelest man living could not sit at his feast, unless he sat blindfold. Raise the veil boldly; face the light; and if, as yet, the light of the eye can only be through tears, and the light of the body through sackcloth, go thou forth weeping, bearing precious seed, until the time come, and the kingdom, when Christ's gift of bread, and bequest of peace, shall be "Unto this last as unto thee." [XVII, 114]

Wesleyan University Press, 1959; reprint, Vintage Books, n.d.] 236). And Herbert Marcuse, to cite a second example, maintains that the system of repressive sexuality is inherent not in the order of reality but in certain present conditions in social reality that he calls "surplus repression." He foresees an immense liberation of libido in the release of man from unnecessary labor and in a conception of labor as erotic bonding, and he proposes new cultural heroes to take the place of Promethean striving—Orpheus and Narcissus, the type of a new erotic relationship to the world. "These archetypes envisioned the fulfillment of man and nature, not through domination and exploitation, but through release of inherent libidinal forces. . . . the representative content of the Orphic and Narcissistic images was the erotic reconciliation (union) of man and nature in the aesthetic attitude, where order is beauty and work is play" (*Eros and Civilization* [1955; reprint, Vintage Books, n.d.], 160). Ruskin, of course, rejects any structural reorganization of the bourgeois class system, and the erotic content of his economics of the affections remains only implicit, but his symbolism does adumbrate a union of the human and natural worlds through procreative and productive energies and the sensuous enjoyment of human works. For Ruskin's view of scientific rationality as inherently aggressive and exploitative, see Chapter 10.

In an essay on the Crystal Palace, Ruskin had imagined paupers appearing at a London dinner party, as though to rebuke those who were taking bread from their dying lips. The aim of *Unto This Last* is to lift the veil of willful blindness separating rich and poor, living and dying—to make these unbidden guests members of a household that is also a nation—and so, if necessary, to exchange the blindfold for tearful sight and the selfish bounty for sackcloth. The penitent bearing seed personifies the imminent period of abnegation before luxury "innocent and exquisite" can be possible for all and so harkens back to the Sybil of *Modern Painters* v, seen in the twilight of mourning and bearing the dust of the future. But the penitent also resembles our forebears leaving Eden and looks forward to the seeing "face to face" and, perhaps, the resurrection of the body. For "Raise the veil boldly" suggests clothing as well as a curtain. The spread of wealth to all would then be the transformation of the social body into that perfect organic system of which the crystal and the individual human body are the types, just as the Sybil Deiphobe is the body, so to speak, of human hope.

If such is Ruskin's meaning, it is a fit conclusion to his vision of individual and social transcendence, in which erotic energy is released through social affections and productive labor and in which the human experience of the world as alienated possession is replaced by sensuous interchange. But the vision is always practical as well. Ruskin's title bears what he elsewhere called a materialist reading of Scripture: the biblical parable is an allegory of the kingdom of heaven, the "last" being the latest convert to Christ, whereas Ruskin's kingdom is fulfillment in this world, attainable only through effort and sacrifice. In its most personal aspect, his social gospel follows upon the renunciation of hopes the older gospel once sustained—a facing down of things seen through tears: the suffering of the poor, the withdrawal of God, the finality of death, the fear as well as the beauty of the body. This is the felix culpa of Ruskin's tragic humanism.

Considered in such light, *Unto This Last* stands at the end of a great cycle of books. If we consider all the major works of 1851–1860, which I have called Ruskin's great decade, it is possible to see a single large movement, broken at many points, that begins with the rise and fall of a Venetian Paradise and concludes in a qualified vision of a redeemed kingdom that will survive the judgment upon the old. If we think of the books as prophecies, *The Stones of Venice* fits the type of the prophecy against Tyre. The later *Modern Painters* follows the fall of Judah, mingling sorrow with comfort, and *Unto This Last,* finally, preaches the flowering of the desert and the building of the Temple—the Temple, specifically, of Solomon as beheld by Sheba, except that the new Jerusalem will be splendid in the extent, not the glitter, of its wealth and the new rulers will be Princes of Peace. We might argue that these works

comprise the most ambitious approach in Victorian literature to a national epic, the product, it is important to note, not of an eccentric dreamer but of a true son of his times. The power and failures of Ruskin's social vision, as well as its perplexing mingling of boldness and reaction, come largely from its being an expression, as epics are, of the national dream. Ruskin far more often opposed what his countrymen practiced than what they preached—the disparity between the two results in a mixture of rebuke and conciliation. For Ruskin, the Victorians preached the submission of women, laborers, and children, the sacredness of home, the purity of sex, the grace of social behavior, the possible greatness of the nation, the spread of the Empire, the increase of wealth, and the authority of the Bible; they practiced the greed of riches, the hatred of the body, the starvation of the poor, the pollution of nature, and the authority of "political economy." In assailing the pride of the nation, Ruskin was working in a long-established tradition; by taking with extreme literalness the professions of the nation, he appeared mad. *Unto This Last* is an attempt to purify that nation through rebuke. By the same token, the book that acts out the beginning of a filial rebellion also carries the image of the elder Ruskins within it: by speaking in the persona of a merchant of wisdom and a "helpful" saint, he absorbs and perfects his parents for his own purposes.

PART IV /

THE STRUCTURE
OF MYTH

The Currency of Meaning

That depreciation of the purist and elevation of the material school is connected with much loss of happiness to me, and (as it seems to me) of innocence; nor less of hope. . . . It may be much *nobler* to hope for the advance of the human race only, than for one's own and their immortality; much less selfish to look upon one's self merely as a leaf on a tree than as an independent spirit, but it is much less pleasant.
—John Ruskin to Charles Eliot Norton

In the 1860s Ruskin saw himself as a man in possession of an open secret. Although he swore a pledge to Mrs. La Touche never to write of it, his religious apostasy was well known to his friends. "I've become a Pagan, too"; he wrote Norton in 1862, "and am trying hard to get some substantial hope of seeing Diana in the pure glades; or Mercury in the clouds" (xxxvi, 426). This awakening to the cold, clear dawn of the Greeks, who were strong enough to accept the beauty of the earth by accepting its mortality also, he had presented to his readers in the final volume of *Modern Painters:*

And herein was conquest. So defied, the betraying and accusing shadows shrank back; the mysterious horror subdued itself to majestic sorrow. Death was swallowed up in victory. Their blood, which seemed to be poured out upon the ground, rose into hyacinthine flowers. All the beauty of earth opened to them; they had ploughed into its darkness, and they reaped its gold. . . . the fatal arrows rang not now at the shoulders of Apollo, the healer. . . . strangest comfort fill[ed] the trustful heart, so that they could put off their armour, and lie down to sleep,—their work well done . . . , accepting the death they once thought terrible, as the gift of Him who knew and granted what was best. [vii, 276–277]

This facing down pervades Ruskin's social criticism as well. Steadily we have watched him center more and more preciousness in the works of human hands: the beauty of the earth awakes with the fading of the monk's dream, and the reformer, incorporating all human suffering

into the scope of his concern, converts the earth power into healing. Bad conscience becomes social conscience. But just as characteristically, the tragic humanism of this passage swerves into a lullaby, and the Good Shepherd steals upon the slumbering scene. Is the "forgetfulness of evil" but the good child's reward for facing a temporary unpleasantness? Henry James, visiting Denmark Hill in 1869, thought he saw in Ruskin the image of "weakness, pure and simple. . . . he has been scared back by the grim face of reality into the world of unreason and illusion, and . . . wanders there without a compass or guide—or any light save the fitful flashes of his beautiful genius."[1] This emotional paradox—the acceptance of tragic humanism and the sensation of the child bereft and abandoned—reflects the complex crisis Ruskin faced in the middle of his life's journey.

At the Middle of the Road

In 1861 Ruskin wrote to Carlyle, "The heaviest depression is upon me I have ever gone through; forms so strange and frightful—and it is so new to me to do everything expecting only Death, though I see it is the right way—even to play—and *men* who are men nearly always do it without talking about it" (xxxvi, 382). "I . . . try to feel that life is worth having—unsuccessfully enough," he wrote Norton; "I sometimes wish I could see Medusa." "I am still . . . tormented between the longing for rest and for lovely life, and the sense of the terrific call of human crime for resistance and of human misery for help—though it seems to me as the voice of a river of blood which can but sweep me down in the midst of its black clots, helpless. What I shall do I know not—or if dying is the only thing possible" (xxxvi, 450). "I've been nearly as hard put to it before, only I wasn't so old, and had not the great religious Dark Tower to assault, or get shut up in by Giant Despair. Little Rosie is terribly frightened about me, and writes letters to get me to come out of Bye-path Meadow—and I won't. . . . as for that straight old road between the red brick walls, half Babel, quarter fiery furnace, and quarter chopped straw, I can't do it any more—Meadow of some sort I must have, though I go no further" (xxxvi, 367).

Ruskin is right: he had been "nearly as hard put to it before," but with the solace of youth and religious faith to fall back on; now he had to give up both solaces. Each renunciation, in its way, was a declaration of mature independence, which finally rendered the tensions between his parents and himself unendurable. Earlier, he had been able to forge compromises between his wishes and the parental will that left

[1]Quoted in Derrick Leon, *Ruskin, the Great Victorian* (London, 1949), 421.

unchanged the appearance of subservience, a condition sanctioned by the high value placed by his culture on filial duty. But as the son reached his forties the controlling behavior of the elder Ruskins seemed increasingly eccentric, both to Ruskin's friends and to himself—and he vacillated, frustrated by each possible solution and above all by the fact of his vacillation. The man who had scandalized England by his radical economics still submitted his writings to his father, a merchant, for approval; the man who defended the pagan acceptance of physical pleasure still asked his mother for permission to visit the theater. Wishing mightily for a "Roof" of his own, he continued to use the rooms he had occupied as a child; craving the affection of friends, he took solace in a girls' school, where he acted as resident tutor and substitute parent—yet his own father forbade the children to visit Denmark Hill. At the middle of his life's road, Ruskin had a great deal of the child to cast off, yet to do so would have risked the release of overwhelming feelings—loss, aggression, guilt—that his nostalgia kept carefully in check. To use a modern idiom, he was facing a mid-life crisis. This idea has been trivialized by an almost immediate overexposure, yet we should not be blind to the important conception underlying it—the degree to which we think of the self as a progress defined by cultural expectations and biological limits. Ruskin's experience of mid-life closely resembles the list of traits defined by recent researchers: a radical reconsideration of one's hopes and failings; a temporary revulsion from the career one has forged, which brands even substantial achievements as "mere" success; a gradual emergence of parts of the self previously repressed in the interest of that success—in the case of men, a side of the self seen as feminine.[2] The transition is painful, according to the amount of unresolved "business" from the past, and to Ruskin the accumulation of past business seemed insuperable. Earlier he dealt with crises partly by suppression, partly by reaffirming through orthodox faith and natural piety the fiction of original, innocent energy developing painlessly toward maturity—passing over, in other words, the moment posited by the autobiographical literature of his time as crucial and defined usually in terms of a religious crisis. The identifying mark of that crisis is the experience of the self *in extremis*, in need of radical renovation—and that partial destruction of the old self could only feel like death. "Carlyle says I'm moulting, and I hope that's all," he wrote in 1863. "But it has been a good deal like dying" (XXXVI, 454). But of course as long as his parents remained in control he could confess no unconversion except through a social allegory.

Ruskin expressed many of the conflicts in a crucial letter to Norton

[2]Daniel Levinson et al., *The Seasons of a Man's Life* (New York: Knopf, 1978), chap. 13.

of 1861. He was tempted, he tells his friend, simply to bolt from his difficulties—to live a life "like Veronese's" or to go "to Paris or Venice and breaking away from all modern society and opinion"—the cities, significantly, that he associated with Adèle. But he did not do so.

> Intense scorn of all I had hitherto done or thought, still intenser scorn of other people's doings and thinkings, especially in religion; the perception of colossal power more and more in Titian and of weakness in purism, and almost unendurable solitude in my own home, only made more painful to me by parental love which did not and never could help me, and which was cruelly hurtful without knowing it; and terrible discoveries in the course of such investigation as I made into grounds of old faith—were all concerned in this: and it would have been, but for the pain which I could not resolve to give my parents.

And later he adds, "I've had my heart broken, ages ago, when I was a boy" (XXXVI, 356–357).

The conflict, first, is between the parental will and the possibility of emotional satisfaction, specifically sexual love. Ruskin's love for Adèle dramatized an opposition between emotional fulfillment and the compulsion to work and study, partly at his father's behest. In some form this conflict symbolically structured most of Ruskin's books. After the failure of his marriage, Ruskin's villain becomes a kind of effeminacy fueled by religious purism, which withdraws into lascivious fantasies. Finally it becomes a whole culture destroying and defiling itself by a compensatory and lustful avarice. The activity unifying all these perversions is the careless destruction of life, first symbolized by works of art, then by workers. This destruction consistently induces the most powerful emotions Ruskin expressed in print. Here his career parallels Dickens's in many respects, except that what Dickens expresses as identification through overwhelming pity Ruskin usually expresses as identification through overwhelming, helpless anguish—an anguish over waste and loss and forfeiture that makes time itself a nightmare and drives him to equally strong longings for the personal and historical past.

These emotions arose not only from a stifled need to love but also from a stifled need for the power of self-affirmation that he associated with a father's precious giving. Clearly Ruskin wanted what no father *could* be—an unfailing source of guidance and affection who would nevertheless not try to guide him—and surely some form of parental repudiation is necessary to every growing person. What made the Ruskins' relationship so anguishing was the particular combination of affection and restraint. A son showered with affection and hopes yet raised to satisfy parental vanity; a love that nourished him yet distrusted and controlled him; a cash arrangement that parodied the

emotional relationship by giving the son freedom while keeping him dependent: these paradoxes surface in the nightmarish imagery of *Unto This Last*—the sons as harnessed beasts, the young men thrown into the furnace. His father, as Ruskin wrote to Acland after his father's death, "would have sacrificed his life for his son, and yet forced his son to sacrifice his life to him, and sacrifice it in vain" (XXXVI, 471). But was Ruskin sacrificed to controls or to an unattainable ideal? The letter to Norton cited above contains a characteristic list of might-have-beens:

> had my father made me his clerk I might have been in a fair way of becoming a respectable Political Economist in the manner of Ricardo or Mill—I suppose everything I've chosen to have been about as wrong as wrong could be. I ought not to have written a word; but should have merely waited on Turner as much as he would have let me, putting in writing every word that fell from him, and drawing hard. By this time, I might have been an accomplished draughtsman, a fair musician, and a thoroughly good scholar in art literature, and in good health besides. As it is, I've written a few second-rate books, which nobody minds; I can't draw, I can't play nor sing, I can't ride, I walk worse and worse, I can't digest. [XXXVI, 357]

Here Ruskin sets a repellent image of complete obedience—becoming another Mill as clerk in the wine trade—beside apprenticeship to Turner, the ideal father he constructed out of his needs, who would magically communicate strength of selfhood to him without ever interfering with his life.

In December 1863, less than three months before his father's death, Ruskin's resentment broke to the surface in a letter essential to understanding his heart and mind in these years:

> Men ought to be severely disciplined and exercised in the sternest way in daily life—they should learn to lie on stone beds and eat black soup, but they should never have their hearts broken—a noble heart, once broken, never mends—the best you can do is rivet it with iron and plaster the cracks over—the blood never flows rightly again. The two terrific mistakes which Mama and you involuntarily fell into were the exact reverse in *both ways*—you fed me effeminately and luxuriously to that extent that I actually now could not travel in rough countries without taking a cook with me!—but you thwarted me in all the earnest fire of passion and life. About Turner you indeed never knew how much you thwarted me—for I thought it my duty to be thwarted—it was the religion that led me all wrong there; if I had had courage and knowledge enough to insist on having my own way resolutely, you would now have had me in happy health, loving you twice as much (for, depend upon it, love taking much of its own way, a fair share, is in generous people all the brighter for it), and

full of energy for the future—and of power of self-denial: now, my power of *duty* has been exhausted in vain, and I am forced for life's sake to indulge myself in all sorts of selfish ways, just when a man ought to be knit for the duties of middle life. [xxxvi, 461]

Struggling to sort out the ambiguities of his past, Ruskin falls back on an explanation drawn from his parents' own beliefs—that mental distress is a form of physical exhaustion. As he imagines it, the fire of life and passion, strengthened by early discipline, is infinite, like an abundant economy, but when thwarted, becomes feeble, like a scarce economy, requiring constant nurture. The thwarting concerning Turner refers, as we have seen, to the watercolors, which Ruskin took as magical emblems of the painter's moral power but which also would have represented his own autonomy in his chosen sphere of competence. In the last sentence he throws his guilt over self-indulgence back on his father, an unfair enough move that nevertheless suggests how he turned money, the inadequate medium of his father's affection, into a form of passive retaliation. And it suggests how an inexpiable burden of obligation forced him into what could seem a futile alternation between duty and self-indulgence rather than activities purposeful and fulfilling in themselves—again like a false economy.

Consequently—it is perhaps the most poignant statement of Ruskin's life—he claims he does not need love. He wrote Rossetti, "I am grateful for your love—but yet I do not want love. I have had boundless love from many people during my life. And in more than one case that love has been my greatest calamity. I have boundlessly *suffered* from it. But the one thing, in any helpful degree, I have never been able to get, except from two women of whom I never see the only one I care for, is 'understanding.'"[3] It is often remarked that Ruskin's early lack of companionship made the normal give and take of intimate friendship difficult for him, but it surely means as well that he knew no paradigm of love other than the inequalities inherent in the relationship of parent and child. At best this could be what he called "harmonious inequalities" in *Unto This Last;* at worst it could turn into the kind of repressiveness he showed as a husband. But possibly his need to control Effie and to refuse any real obligations to her partly reflected his own fear of the subservience and obligation he already experienced in his parents' love. The occasional remark in his letters, self-pitying but no doubt genuine, that he could not imagine people "caring" for him suggests a radical uncertainty about his parents' love despite his claim that he had too much of it—a doubt whether he could be loved for himself apart from what he produced as the instrument of his parents'

[3]*Dante Gabriel Rossetti: His Family Letters,* I, 49, quoted in Leon, 349.

vanity. The alternative he excludes in the letter about love and understanding is love that is unconditional, yet many moments in his writings—in the description, for example, of sons as true wealth—seem to be the very emblem of love unconditional and inexhaustible. Another emblem, as I have suggested, is the fantasy of the childhood paradise that precedes the fall into loneliness, ambition, and insatiable need.

In the middle of his life Ruskin developed a new image of heart's desire. "I don't in the least know what might have been the end of it," he wrote Norton in the letter I have cited twice above, "if a little child (only thirteen last summer) hadn't put her fingers on the helm at the right time, and chosen to make a pet of herself for me" (xxxvi, 356–357). Ruskin had met Rose La Touche in 1858, when she was ten, though only gradually, it seems, did she attain a preeminent position in his affections. In 1866 he proposed to her and she asked to defer her answer until she came of age three years later. At that time her parents interposed, and Ruskin ultimately lost her, yet his desire for her, by this time obsessive, brightened and darkened the moments of his life, even after her death from brain fever in 1875. The idea of Rose—for ultimately she lived more vividly and intensely for him as an idea than as a person—in many ways repeated his earlier love for Effie and Adèle and also, perhaps, for his cousin Jessie, who had died with the first phase of his own childhood. Like Effie she was younger than he, which gave him the authority of years and the power to objectify and shape her as he wished; and like the others, she would have made an unsuitable match from his parents' point of view (even the match with Effie was opposed at first because of her relatively humble connections). But more than the others, Rose was to be the idol of his affections and, as Hunt has remarked, their "permanent focus." "I want . . . the sense that the creature whom I love is made happy by being loved: That is literally all I want," he wrote in 1866. "I don't care that Rosie should love *me*: I cannot conceive such a thing for an instant—I only want her to be happy in being loved."[4] Treasuring her as he had learned to treasure works of art, he seemed in one sense to repeat the errors of his parents in their controlling yet indulgent idolatry of him, yet the new love is in another sense markedly different: Rose is charged with no ambitious expectations other than being a thing in herself, thus receiving in a peculiar form the unqualified love Ruskin could not give himself except vicariously—she is in fact the vicarious object of his self-love, in particular of his own childhood as a timeless moment before love and duty, and the child's will and the parents' will, were irremediably divided. Possessing her Ruskin could repossess the perfect past in

[4]Quoted in John Dixon Hunt, *The Wider Sea: A Life of John Ruskin* (New York: Viking, 1982), 306.

his imperfect middle age, a joining that also reflects the doubleness with which he now began to view the world—a place on one hand of courage, combat, and duty; a place, on the other, of timeless and careless felicity, the domain, also, of the aesthetic. Yet Ruskin never possessed her; the more she was removed from him, the more he craved her. Here again he reenacted the past as a repetition compulsion: year after agonizing year he reexperienced the ancient connection of love and loss, passion and absence, fulfillment and denial, until at last Rose invaded his dreams and fantasies, to find a permanent home there.

Most generally, Rose is the embodiment of the unbroken heart, the love anciently thwarted and longed for, the life started over again. Actually, Ruskin constructed two benevolent female symbols: one powerful, protecting and maternal, visualized as a goddess or some other emblematic figure; the other a child inhabiting a permanent paradise of childhood. In either case she brings the unfallen past into the fallen present; the logos once located in nature now appears as a sexual other, but only after the fall has been recognized. She is desire and therefore the self made determinate. Rose enters Ruskin's books of the 1860s and 1870s and is inseparable from them as their radiating center. She is the center, that is, of a mythopoeic construction of the world that mediates between the energies of nature and the persistence of the desired, human other—a construction also of a language capable of interpreting all things as a continuous code of emblems. We turn now to Ruskin's theory of metaphor as it emerged in the context of his continuing interest in economics.

Coins and Words

I have argued that Ruskinian economics requires metaphorical exposition, partly because wealth is itself a sign and partly because economic disorders are also disorders of the affections, a connection best expressed in multivalent symbols. The self is an economic system, the economy an affective system. The identity of an individual includes what that person is economically, by virtue of is or her labor, buying and spending, and participation in a social system.

The problem for such an economics would lie in the failure to recognize what social problems cannot be usefully conceived in terms of a collective psyche—to recognize, in short, the limits of Platonism. *Munera Pulveris* enacts the breakdown in Ruskin's attempt to synthesize empirical and metaphorical language. These essays, first published in *Frazer's* magazine, continue to explore the problem of money and power begun in *Unto This Last*. Ruskin's thought remains genuinely utopian as long as he conceives of the state and the person as healthy

organisms, but once he follows Plato by comparing social hierarchies to emotional hierarchies, he shows himself completely unable to countenance rational social conflict or even a genuine balance of social interests. The rich he magically metamorphoses into a class of wise people and so avoids questioning the absolute sanctity of property rights. The subservience of the poor he then justifies along Carlylean lines, going so far as to repeat Carlyle's foolish argument for slavery in terms suggesting that slaves are for him merely symbols of psychic forces that must be repressed, just as in *Unto This Last* the oppression of workers was associated with psychic forces that needed to be liberated. Symbolic thinking here becomes a betrayal into abstraction, not a triumph over it. These essays are not altogether fruitless, yet they dramatize the limits of Ruskin's interest in political speculation. Consequently, the excursions into classical and biblical literature, which in the earlier book consummated the argument at several points, here seems an escape from the argument into a subject for which Ruskin had as yet no adequate means of expression. In the chapter on "Coin-Keeping," for example, he distinguishes between coin keepers or merchants and storekeepers or spenders—between, that is to say, his father's mode of economic activity and his own—but he seems unable to push this essentially psychological distinction toward a useful economic generalization. Instead he breaks suddenly into a reading of mythical images in Dante and the Greeks, each of which he interprets as an allegory of economic activity: Dante's Idol of Riches sings enchantingly, "but her womb is loathsome"; for Plato the Sirens are "phantoms of divine desire; singing . . . on the circles of the distaff of Necessity." Circe is the power of "frank, and full vital pleasure, which, if governed and watched, nourishes men" and "pure Animal life"; Scylla and Charybdis represent the "betraying demons" associated with "getting and spending"; and so forth (XVII, 212–213, 215). Again, in the following chapter, Ruskin interrupts his discussion of wise commerce to comment on Portia, whose speech on mercy he associates with the word "charity" and its many connotations.

The first of these excursions Ruskin prefaces with a well-known observation: "It is a strange habit of wise humanity to speak in enigmas only, so that the highest truths and usefullest laws must be hunted for through whole picture-galleries of dreams, which to the vulgar seem dreams only." What follows, he wrote in a late note, was itself at first a footnote but was "of more value than any other part of the book, so I have put it into the main text" (XVII, 208). Its importance is not at first evident, since the lessons Ruskin deduces from his interpretations are commonplace pieties. The point, rather, seems to lie in the linkage of vehicle and tenor: the images are generally sexual, the meanings economic (the word "charity" unites both realms). Specifically, the two

excursions appear to convert sexual ambivalence into a more tolerable form, first by associating it with true and false uses (of wealth and affection), then by splitting the female figure into the loathsome and unfulfilling on one hand and the pure and nourishing on the other. But throughout the book these two subjects—sexual and material economics—seem as disjoined as the two discourses Ruskin adopts to discuss them. The effect is rather like breaking through a surface of uncertain and frustrated argument into a freer, brightly colored space, a picture gallery of dreams. Many readers have found this disjunction to be a symptom of mental instability, but probably it is more useful to see it as a struggle toward a new language and an expanded region for that language. In the books that followed, Ruskin regained control over that language through two distinct genres: lectures like "Traffic" and "Of Kings' Treasuries," in which imagery once again adequately embodies an argument about social policy, and books like *The Ethics of the Dust* and *The Queen of the Air*, which take as their subject the development of myth.

The excursions, then, are indeed the most important parts of *Munera Pulveris*, not because of what they assert but because of the mythopoeic method they try to clarify. They give us the chance to pause and survey in general terms Ruskin's new way of reading the world as myth, which centers on a unit of meaning that is at once visual and verbal.

Throughout his volumes on art, Ruskin reads nature either as a set of organic unities or as a pattern of interconnections. These techniques develop into a polarity: on one hand, a theory of inspiration which, so to speak, shatters the ordinary metonymic relations among things and re-fuses them as symbols; on the other, a critical technique of reading surface features as though they were a "kind of maze or entanglement" (x, 163). The two procedures merge in a schema that we might call the Ruskinian unit of meaning. This unit is the concentration of related meanings and energies at a single point, which is not absolutely distinguishable from other points but acts as an emotional focus for interconnections that expand indefinitely throughout the human and natural world. Our fullest example so far is Dante's eagle, which concentrates words and images into a system of associations (the eagle of empire, the Holy Ghost, the light of the eye, society as an organism, and so forth, are the images; judge, lex, lego, rex, royal, and so forth, are the words); but word chains and image chains easily interact like cells exchanging genetic material, since all words are at bottom concrete (thus: holy/helping, Holy Ghost, eagle, "healing in its wings"). Ruskin's innovation in this book is to treat verbal definitions exactly as he had treated visual phenomena before in an attempt to provide meanings that are organically related to real spiritual forces rather than the abstract definitions favored by empiricists. As Elizabeth Helsinger has ably shown,

Ruskin derived his theory of etymology from contemporary philology, particularly Richard Trench's *Study of Words*,[5] but of course the roots of that theory lie also in Carlyle and, before Carlyle, in the Coleridgean theory of symbol and myth.

Ruskin's clearest statement of procedure appears in a note to *Munera Pulveris*, added in 1871 as an addendum to his allegorical discussion of Charity: "The derivation of words is like that of rivers; there is one real source, usually small, unlikely, and difficult to find, far up among the hills; then, as the word flows on and comes into service, it takes in the force of other words from other sources, and becomes quite another word . . . , a word as it were of many waters, sometimes both sweet and bitter" (XVII, 292). The etymology of "charity" follows in the form of a miniature narrative: the word began with the Greek *charis* ("grace," "divine gift"), then became confused with the Latin *carus*, and finally was weakened by modern sanctimoniousness to a form of almsgiving that implies not "grace" but "disgrace" in the receiver. And yet, Ruskin concludes, "the political economy of a great state makes both giving and receiving graceful"; and the "blessedness" of the giver in the Christian aphorism promises the "bestowal upon us of that sweet and better nature, which does not mortify itself in giving" (XVII, 293). Words, then, like architecture, bear the moral record of a civilization, but must be periodically purged of excrescences so that the original meaning may stand forth as a genuine reinterpretation—like doctrine in Newman's essay on development or like clothes in Carlyle's theory of historical institutions or indeed like the logos in any idealist philosophy that attempts to breach the contradiction between constancy and change. For Ruskin "divine gift" is the "true source" or Idea of Charity, which, rightly reinterpreted as true reciprocity of exchange, would revolutionize English economic life.

Ruskinian philology lets us see in more general terms the quarrel over definitions in "Ad Valorem." Empiricist definitions, we recall, are simply the customary acceptation of words: the terms of economic science refer only to observable instances, and generalizations are simply ways of classifying observable instances. Descriptive or empirical language is therefore analogous to money as a medium of exchange because money is a device for systematizing the exchange of labor and goods, just as empirical generalizations are ways of marshaling data into categories useful for specific purposes. But for Ruskin the real meaning may vary indefinitely from customary usage, just as the real meaning or "sign" of a given body of wealth may vary from its conventionally assigned monetary value. The key words of Ruskin's moral

[5]Elizabeth Helsinger, *Ruskin and the Art of the Beholder* (Cambridge: Harvard University Press, 1982), 255ff.

science, then, are moral terms, referring to qualities or forces rather than to the observable instances that manifest them more or less adequately. In this sense his terms are analogous to money as *a store of value*—a character of money that he stresses strongly. As a store of value, money concentrates labor into tangible form, creates social relationships, signifies indebtedness, and pledges future labor. More precisely, Ruskinian words are like gold coins, as they are for Trench, because they concentrate value historically insofar as one may read into them the record of their original significance, their subsequent usage, and their debasement. Words unite many waters, stamping with a dye the roar and flux of temporal experience. In words, as in precious coins, the numinous becomes numismatic.

Where do the real entities to which moral terms refer exist? They exist, first of all, as natural or physiological forces that are embodied in specific instances, just as a landscape painter embodies the energies of nature in concrete representations. We have seen already that Ruskin bases his key economic terms (value, wealth, and life) in physiological well-being; in his reading of art and literature, analogously, power, purity, heat, light, and life itself represent virtues. More accurately, they *are* virtues, containing physical and spiritual meaning together. It follows that empiricist terms, which merely abstract points of resemblance from classes of data, are inadequate to a true moral science, since moral ideas must be *felt*, not observed. Ruskinian language, then, is a form of physiological idealism, a continuous struggle to join subject and object in every act of conception. The treatment of "value" in *Unto This Last* is a good example. In its primary signification the word denotes things. Food, water, and light, clean rooms and a warm hearth, pictures, the thrust and curl of the garden vine, are things that "avail towards life"; but in its secondary meaning (which is its primary etymological meaning) of "valor," "value" denotes a subjective state, an experience of fullness, self-possession, and command of resources. Wealth-life proves to be not only a prime instance of the union of subject and object (the phrase joins both in hieroglyphic juxtaposition) but the paradigmatic instance of it. Truly to possess things is to know things in their human aspect and to know the self as substantial, as infinitely capable of incorporating the world into a unity greater than the individual ego with its separate history. Wealth-life or true possession is also the condition of all knowledge. The analogous term for Coleridge is Reason, except that what for Coleridge is impassioned thinking becomes for Ruskin a physico-spiritual condition, grounded in the subjective experience of good health and "well"-being.

Ruskin expresses this epistemological priority through the fiction of primary inspiration, which he takes to be the ultimate origin of moral meaning. But in moments of inspired apprehension, physico-spiritual

forces appear as personifications. The entities to which moral terms refer exist, then, not only in the system of nature but also in groups of religious and mythological symbols that develop historically but may be read as a synchronous system that is in effect the legacy of human culture. The visionary eye recognizes the universe as animate and moral categories as personal, as groups of life energies, so to speak, so that to understand a virtue we must "stamp" its power with a human shape. In the case of Wisdom, if we contemplate rightly the lady in Proverbs, we will "spin out" from her numerous aspects of the primary idea as we would trace the associated meanings of a word, noticing, for example, her wealth, the products of her right and left hands, her womanliness, and so on. In Christian thought, of course, that paradigm is most clearly knowable through the Incarnation. According to *The Stones of Venice*, the early Christians did not need either to categorize or to define moral ideas, and for a very good reason:

> They never cared to expound the nature of this or that virtue; for they knew that the believer who had Christ had all. Did he need fortitude? Christ was his rock: Equity? Christ was his righteousness: Holiness? Christ was his sanctification: Liberty? Christ was his redemption: Temperance? Christ was his ruler: Wisdom? Christ was his light: Truthfulness? Christ was the truth: Charity? Christ was love. [x, 368]

In *Unto This Last* Ruskin implicitly develops this point by using word associations to stress the divine elements of virtues, many of which have been secularized by use: for example, holiness/helpfulness (embodied in the Holy Ghost), provident/Providence, saving/salvation (through Christ's sacrifice), wisdom (through Solomon and other figures typical of Christ's rulership), and finally Life itself (Christ being the lord of Life as Satan, the paradigm of all the vices, is ruler over death). Thus Ruskin irradiates economy activity with the divine.[6]

Because Ruskin valorizes the "original" meanings of words that arise from visionary apprehension, etymology is ontology and therefore a criticism of modern life, providing the key for distinguishing true meanings from accrued false ones. For Carlyle (as for Shelley) words are polysemous in a relationship of meanings that is ultimately metaphorical. "An unmetaphorical style you shall in vain seek for," he writes in *Sartor Resartus:* "Is not your very *Attention* a *Stretching-to?*"[7] But

[6]A persuasive alternative account is given by J. Hillis Miller in "Myth as 'Hieroglyph' in Ruskin," *Studies in the Literary Imagination* 8 (1976), 15–18. Miller suggests that Ruskin struggled with the contradiction between the uniqueness of each individual fact and the need to establish unities, and he resolved the contradiction by grouping things according to metaphorical resemblance instead of subsuming them under general categories. "Ruskin's solution . . . is, then, a certain theory of myth. A myth for him, is a node, a knot, or interweaving of many branching figurative implications. A myth is the concentration of a great number of different facts in their resemblance" (p. 18).

[7]Carlyle, *Sartor Resartus,* Everyman Edition (London: Dent, 1967), 54.

for Ruskin the historical relationships of meaning in a word are not necessarily a relationship of primary concreteness to secondary abstraction. We need, for example, to recognize the "divine gift" in "charity," the "well" in "wealth," the "help" in "holy" and the "valor" in "valuable," but the substituted terms are not obviously more concrete than the concepts they redefine. They seem so, however, because the accepted or "tarnished" terms were in danger of becoming technical abstractions for the clergy and the economist. In Ruskin's hands, definition becomes, like preaching, an enhancement or reinterpretation of an original inscription, itself related to other inscriptions in ways complex enough to generate new combinations of thought. Creative definition allows us to envision the possible, not just to see the actual, as the pecus of Carlyle's grazier becomes the seed of the Rothschilds and the English national debt. Etymology combines history and prophecy.

Moral terms, then, concentrate the vague flux of historical experience into discrete and portable units—magic emblems that when analyzed yield portions of the infinitely braided structure of the world. From this point of view, the imperfectly realized project of *Munera Pulveris* comes clearer. The true money or "gifts of the dust" in that book are verbal emblems; the mythological digressions are abrupt transitions from one form of meaning to another—from the present, empiricist stage of meaning (when words simply describe observable instances and received values) to an original, metaphoric stage, when language expresses the union of subject and object. The late addendum on Charity, which joins the idea of charity with the image of an original source, acts as a miniature myth in addition to being an ontological example, since the stream image suggests how charity itself and the virtues in general are passed down from a divine source, like the meanings of words. By subsuming ideas of loving and giving under the Greek *charis,* Ruskin summarizes at a stroke his complex notion of original energy that takes the twin aspects of wealth and life, material abundance and erotic exuberance (and permits Ruskin to read sexual imagery from the classics as allegories of economics). Just as succinctly, it embodies the passionate logocentrism that dominates his thinking from the beginning of his career to the end—the division of experience into the fullness of divine presence and the foulness of divine withdrawal. Every word is at first the Word incarnate. For Ruskin the recapture of the Word is also the recapture of original energy at its source—a charismatic father, like Turner, capable of investing him with the earnest fire of passion and life, not a merchant-father caught in a struggle of almsgiving, implying disgrace in the receiver.

In 1840 Ruskin had planned a "new system of ethics in the form of a corrected and amplified Aristotle" (x, 374n). That intention never developed into a system at all but rather became a spiritual physiology, a

charismatic conception of the moral life. His leaps in *Munera Pulveris* from the perplexities of economic theory into the world of religious myth are but examples of a larger leap, from the domain of practical ethical difficulties into a Platonic realm of powers and virtues that when absorbed would create the inward disposition sufficient for moral perfection. In many respects his idealism makes him a retrogressive figure in the history of moral ideas, a theorist who needed to preserve the logos in forms of social and aesthetic order, taking symbols for realities, and investing with magical powers books and pictures and phrases. But in other ways the late writings are the most modern of all—in their very discordances, their almost self-confessed failure to cohere. After 1860 the unities of Ruskin's thought, centering on well-defined subjects explored in large volumes, appear to dissolve into heterogeneous concerns. More than before, he worked on many projects at once, gathering lectures, articles, and public letters together into books that seem fragments of a single, indefinitely evolving opus rather than complete works in themselves. The subject of that opus is myth, which, as Hunt observes, is the unifying center of Ruskin's otherwise aimless and harried ventures. In theory at least, myth is the code capable of describing all things in terms of a natural and cultural system.[8] But in the very act of mythopoeia, Ruskin seems to deny the possibility of coherence by gestures of willed playfulness that consort oddly with his dogmatic insistences. This serious play is a new mode in Ruskin's work to which we now turn.

[8]Ruskin finally gives us no complete code, although we find the habit of giving emblematic names to shorter lists of things throughout his works and in his diaries as well. Robert Harbison comments: "The emblematic mind of the Middle Ages unaccountably revived, we may think, which embroiders even geology and botany till they become a wearable jewelry of sensation, invested with permanence by matching, triangular, pentagonal, or septagonal structure, his symbol systems assigning numerical values to whole groups of sensations which locate them in a new time outside earthly time, a sequence not imaginary like numbers because it is concrete, but not shifting like sensation because it is numbered." In the diaries even parts of days receive "asymmetrical, ragged, but ringing names": "[This] is the rigidity of non-descriptive names again, misleading concreteness which reassures without summoning up, like baby talk which is palpable, clear, and meaningless even to Ruskin, which preserves the things without their associations, as perhaps, contrary to expectation, certain kinds of symbols do, freeing a bit of experience from some of the mud which usually clings to it" (*Deliberate Regression* [New York: Knopf, 1980], 87–88). In my discussion I have stressed the power of emblems to join chains of association in an indefinitely expansible code, but truth is biped, as Ruskin was fond of saying, and emblems are also ways of arresting experience as discrete entities, ways of appropriating rather than describing. For geology as a "wearable jewelry of sensation," see Chapter 11, n. 6.

The Goddess and the Child

> [Poetic] language is vitally metaphorical; that is, it marks the before
> unapprehended relations of things and perpetuates their apprehen-
> sion, until the words which represent them become, through time,
> signs for portions or classes of thoughts instead of pictures of integral
> thoughts; and then if no new poets should arise to create afresh the
> associations which have been thus disorganized, language will be dead
> to all the nobler purposes of human intercourse.
> —Percy Bysshe Shelley, *Defense of Poetry*

In one respect alone, Ruskinian play resembles the Decadent
movement. The Decadents recognized in their search for images of
determinate desire a kind of willful solipsism, a cultivated affectation
that renounces the old insistences on ethical seriousness. Ruskinian
play is also an implied admission, modern in spirit, that beliefs are but
necessary fictions or incomplete figurations. It thereby renounces the
quest for comprehensive meaning, but in other respects it is a solipsistic
clinging to the childish, a refusal to countenance the deepening meta-
physical chaos that more and more seemed to Ruskin the tragic mean-
ing of the nineteenth century.

The Looking-Glass World

The Ethics of the Dust (1866), Ruskin's first complete book on my-
thology, aims at several audiences and as a result has had none. It is
composed of a set of conversations between a lecturer and some chil-
dren at a boardingschool, which usually concern elementary lessons in
mineralogy. According to the first preface, the book is simply a stim-
ulus to young readers to study minerals, but the second preface clar-
ifies the book's relation to Ruskin's moral thought in general and to his
study of myths in *The Queen of the Air*. In other words, the book is a set
of Socratic dialogues held in a republic of girls, in which the philoso-

pher constructs fables that describe the world less than they induce the state of childlike wonder that for Ruskin is the basis of all moral and religious apprehension. For Ruskin personally the book represents a fresh start, taking as its literal setting Winnington Academy, his "second home" in the early 1860s.

In 1859 Margaret Bell, the principal of a girls' school in Cheshire, invited Ruskin to her academy in hopes that he would be a valuable resource for her pupils. He continued to visit Winnington for the greater part of the next decade, writing, lecturing on the Bible and geology, and even taking part in the dancing. The girls appear to have treated him with familiarity and affection, and he carried on a voluminous correspondence with a number of them, at the same time gradually developing his intimacy with the La Touche family of Dublin. As he described the school to his father, he might have been living in a tableau vivant, brilliantly colored: in the evening the drawing room is "brightly lighted with the groups of girls scattered round it"; their dark costumes, contrasted with the table cloth, "gives the kind of light and shade one sees in the pictures of the Venetians"; dinner "is very like one of the pictures of a Marriage in Cana" (xviii, lxiv–lxvi); the children blend with the flowers of the orchard, the ancient trees, the red brick "like porphyry in the clear sunlight after rain" (xxviii, lxvii). One evening a pianist came to do variations, inevitably enough, on "Home, Sweet Home"; the notes were "a *mist* of rapidity," "a murmur of a light fountain, far away," with the girls gathered round, "the eyes all wet with feeling" (xviii, lxx). The device of describing girls in purely aesthetic terms, characteristic of many earlier letters from Ruskin to his father, no doubt serves to neutralize erotic emotion but more importantly, perhaps, converts them into multivalent symbols. The references to porphyries, coral, chiaroscuro, and Veronese's *Marriage* convert Winnington into the unfallen Venice sacred to the memory of Adèle and, ultimately, to the ideal of his own forfeited child self. As a visitant in this garden of girls, he could relive the sweet anguish of loss and possession, himself part and yet not part of the scene, at once the perfect father rounding out this picture of perfect childhood yet doomed to be only a visitant, a moment in the lives of some young strangers in their ineluctable progress toward adulthood. And feeling sadness and age, he can paradoxically affirm the actuality of the ideal, setting a timeless child world over against the world of time, which he now sometimes calls "fate." As he wrote his father in November 1863: "It is curious that I feel older and sadder, very much, in now looking at these young children . . . and they are so beautiful and so good, and I am not good, considering the advantages I've had, by any means. The weary longing to begin life over again, and the sense of fate for ever forbidding it, here or hereafter, is terrible" (xxxvi, 459).

The aim of vicarious recapture is the aim of Ruskinian pedagogy, centering on the image of the pure stream and joining together interests that seem at first far removed from Winnington. One of his projects in the 1860s was to persuade the Italian peasants to irrigate the Alpine regions to prevent erosion and drought. His slogan was, "Every field its pond, every ravine its reservoir" (XIX, lvii). Torrents, he wrote in 1869, can be "not subdued—but 'educated.' A torrent is like a human creature—left to gain full strength in wantonness and rage, no power can any more redeem it; but watch the channels of every early impulse and fence *them,* and your torrent becomes the gentlest and most blessing of servants" (XIX, lvi).[1] In the lecture "Verona and Its Rivers" (1870), he imagines a symbolic transformation as a real transformation: the Lombardic plain, properly irrigated, will become "one paradise . . . , cascades, docile and innocent as infants, laughing all summer long" (XIX, 448), exactly as Gluck had restored the Treasure Valley in a much earlier fantasy. This dominating metaphor of the child spirit as a stream gives a new pedagogical emphasis to Ruskinian moral philosophy. The position is stated most succinctly in "Fairy Stories," an introduction to Grimm's tales, which were reissued in 1868 and illustrated by Cruikshank. Ruskin's essay is essentially a romantic attack on Evangelicalism, arguing that fairy tales are superior to didactic stories because they appeal to the imagination, to the child's innate sense of good. For Ruskin, children require no punishing conscience—and didactic tales merely internalize a punishing conscience, a sense of wickedness rather than a sense of well-being; instead, they require "any tradition of old time . . . animating for them the material world with inextinguishable life, fortifying them against the glacial cold of selfish science, and preparing them submissively, and with no bitterness of astonishment, to behold, in later years, the mystery . . . of the fates that happen alike to the evil and the good" (XIX, 235–236). Instead of enforcing precepts and warnings, fairy stories allow the child to internalize virtue, which is natural, a power like all the powers of the natural world when viewed imaginatively. True natural science is a moral science and therefore the basis of all moral education—and that is precisely the program of *The Ethics of the Dust.*

Ruskin's technique in these dialogues is to preface his little scientific

[1]He makes the same analogy in one of his letters to Winnington, which incidentally shows the slight sadism intermingled with playful geniality with which he addressed the children: "Now when the rivers are young, they are very noisy . . . , and their education is conducted by a great mountain called Ingleborough in a very severe way. The rocks of Ingleborough are full of deep holes; and whenever a young river gets quite unruly it is sent into a hole—as little girls used to be put in corners—and after running for a quarter of an hour or so in the dark, it comes out again, looking much subdued and quite quiet" (XVIII, lxviii). Ruskin sent a copy of this letter to his father.

lectures with puzzles or fables that induce an emotional response, usually wonder or disgust. For this reason, of course, the lessons must be dramatized in the book, not compressed for Ruskin's readers as a textbook. The first discussion concerns two valleys that are in different respects imaginary: Sinbad's Valley of Diamonds, which is make-believe, and a second Valley of Diamonds, which the Lecturer claims really exists. The first is wholly invisible, and when one child makes herself "invisible" by hiding behind a chair, the Lecturer claims she is still lost there. The second is present but not visible as a valley—it is, in other words, an allegory (as we are told in an appendix) of "the pleasures and dangers in the kingdom of Mammon, or the worldly wealth" (xviii, 206). People crowd around the narrow entrance, struggling to enter (as through the eye of a needle, an allusion to Christ's figure in the parable of wealth and the kingdom of heaven). Inside are heaps of diamonds that glitter like dew beneath brambles with blossoms of silver and berries of ruby, a mountain, composed of golden ice, on top of which sits Mammon, and trees full of singing serpents. The valley, then, contains both pleasures and dangers, as the world does, for example, to Blake's Thel in a poem that Ruskin probably knew at this time. Thel's response is in fact imitated by the youngest child, who is frightened of the serpents; the Lecturer replies, "And as long as you were yourself (not that you could get there if you remained quite the little Florrie you are now), you would like to hear the serpents sing" (xviii, 214). Once again, Ruskin's imagery weaves together connotations of lust and greed: "Pride, and lust, and envy, and anger, all give up their strength to avarice," as the Lecturer tells his adult readers (xviii, 217). The play on various senses of "real" and "invisible" has the effect of violating these distinctions and also establishes Winnington as yet another valley, the valley of innocence, which communicates ambiguously with make-believe and the adult world: the latter, we notice, is invisible in the added sense that the eyes of childhood must not look there. Instead of explaining his allegory, the Lecturer presents an item from the Valley of Mammon—two precious stones bound up in congealed gold dust, which the girls mistake (as innocence always does) for "a great ugly brown stone." Wealth, the Lecturer now explains, is either good or bad, according to use; generosity is natural to man, but covetousness is a disease, so that the covetous man becomes in the end "wholly inhuman, a mere ugly lump of stomach and suckers, like a cuttle-fish."

The conversation now takes a turn. Instead of resting in his condemnation of greed, the Lecturer talks about the chemical resemblance between charcoal and diamonds, until the girls demand a separate lecture from him on the subject of crystallization. The conversations

and fables that follow[2] develop new sets of oppositions until it becomes clear to the girls what the student of Ruskin knows already from "The Law of Help"—that "crystallization" is the chemical analogue to the absolute distinction in the moral life between purity and decay, affection and strife, life and death. But what then, the Lecturer asks—speaking still in chemical terms—is life? When one of the children "answers" this question by walking across the room, the Lecturer replies that, for the scientists, she has exhibited only a "mode of motion," that is, heat, but a truer answer links life with passion, the power of inspiration: "I don't know what the philosophers call it; we know it makes people red, or white; and therefore it must be something, itself; and perhaps it is the most truly 'poetic' or 'making' force of all, creating a world of its own out of a glance, or a sigh: and the want of passion is perhaps the truest death, or 'unmaking' of everything;—even of stones" (XVIII, 344–345). At one point the Lecturer reinforces the point by having the girls "crystallize" themselves, or create formations on the playground. This conversion of science into dance—the movement of molecules dramatized as crinolines pressing themselves into triangles and squares—is a moment of inspired bizarreness reminiscent of the Alice books. It nevertheless establishes the central analogy in the book: the girls are themselves crystals, the ultimate subjects of their own lessons and the apex of the natural world. Mythology, according to Coleridge, is "the apex and complement of all genuine physiology";[3] for the Ruskinian Lecturer, "You may at least earnestly believe, that the presence of the spirit which culminates in your own life, shows itself in dawning, wherever the dust of the earth begins to assume any orderly and lovely state" (XVIII, 346).

In deliberately destroying the Gradgrind distinction between the fac-

[2]These pieces are tedious but interesting in the one respect that they present in compressed form the method of reasoning through visual opposition that Ruskin had introduced in *Unto This Last* and elsewhere. The Lecturer invents a dream in which Egyptian laborers strain to convert bricks into a building, which they cannot do until a goddess (the Egyptian predecessor of Athena or Wisdom) magically transforms the bricks into a perfect pyramid, crimson and glowing, like a ruby. When the children then see the actual ruby, they understand "crystallization," the "formative power" of nature, and the true economy that opposes the Valley of Diamonds as an "imaginary" ideal. Here Ruskin combines his ideas about nature, religion, architecture, and society into a set of oppositions—crystals, gold, pyramid of ruby, noble building, harmonious economy, and so forth, on the one hand, and dust, dirt, bricks of clay, servile building, competitive economy, and so forth, on the other. These antitheses, belonging ultimately to the opposition of purity and corruption, clearly exemplify what Jacques Derrida calls the metaphysics of presence, since the second series is an absence of energy present in the first, just as divine inherence and withdrawal constitute purity and corruption. These antitheses *are* Ruskin's argument, which can expand to incorporate other elements as well. Winnington itself, which embodies the first series, stands to the Valley of Diamonds as presence to absence; it is "true" in the sense that Ruskin uses the word in *Unto This Last*.

[3]Coleridge, *Collected Works,* ed. Kathleen Coburn, 16 vols. (Princeton: Princeton University Press, 1969–), IV, pt. 1, 524.

tual and the fanciful, the adult and the childlike, and the objective and the subjective, Ruskin hopes to preserve the religious sensibility from the prosaic state of mind that is forced into atheism by scientific discoveries, like evolution. That state of mind is also Evangelical; the attack on scientific materialism is also an attack on Original Sin, the "wicked" propensity, as the Lecturer puts it, of considering oneself "dust." The Lecturer's moral injunctions systematically replace an ethic of earnestness with an ethic of enthusiasm, as Ruskin was also trying to do in his letters to Rose. The girls are told, for example, that self-sacrifice is in itself not a beautiful but a "mortifying" thing; that the monastic life is generally the source of vanity; that one must not examine oneself for faults; that the children are instinctively unselfish, not evil. In the unfallen garden of Winnington, the children are born into innocence, of which crystalline purity is, once again, the symbol: in girls and in stones, "All doubt and repenting, and botching, and retouching, and wondering what it will be best to do next, are vice, as well as misery" (XVIII, 264). The gerunds echo Ruskin's description to his father of his own heart (broken, mended, cracked, riveted with iron and plastered over), making clear that the aim of Ruskin's pedagogy is partly to extend the fantasy of an original purity, partly to reverse his parents' mistake of thwarting the fire and passion of life.

But that reversal bears a highly paradoxical relation to his own past, as a passage like the following, from "Fairy Stories," makes clear:

> A child should not need to choose between right and wrong. It should not be capable of wrong; it should not conceive of wrong. Obedient, as bark to helm, not by sudden strain or effort, but in the freedom of its bright course of constant life; true, with an undistinguished, painless, unboastful truth, in a crystalline household world of truth; gentle, through daily entreatings of gentleness, and honourable trusts, and pretty prides of child-fellowship in offices of good; strong, not in bitter and doubtful contest with temptation, but in peace of heart, and armour of habitual right, from which temptation falls like thawing hail; self-commanding, not in sick restraint of mean appetites and covetous thoughts, but in vital joy of unluxurious life, and contentment in narrow possession, wisely esteemed. [XIX, 235]

What, in this haze of sugary words, is being described? If such a child existed, who could stand it? And what does a phrase like "crystalline household truth" mean? Ruskin has blurred and softened for public consumption the retroactive advice he gave his father: the wish for stone beds and black soup becomes "unluxurious life" and "narrow possession," while the "fire and energy of Life" become "vital joy" and "bright course of constant life." The attack on Evangelicalism becomes a repudiation of "strain or effort," "bitter and doubtful contest," "sick

restraint," "covetous thoughts." The contradictions Ruskin wishes away are embedded in the paradoxical couplings of words: the child is to be both obedient and free, strong but peaceful at heart, self-commanding but joyful and content. As always for Ruskin, the internal harmony of impulse and restraint implies a perfect external relationship as well—the child is obedient "as bark to helm." In repudiating his parents' mistakes, Ruskin reproduces a child as placid and docile as his parents had wanted him to be, and he does so—as in his social philosophy—by denying conflict or uncertainty or compromise. When one of the children asks about the many "fearful difficulties" to be faced in "after life," the Lecturer need only advise prudence: "There is never any real doubt about the path, but you may have to walk very slowly" (XVIII, 267). But if virtue is an inner possession, and if it makes no mistakes and can afford no regrets, a person is left undefended against any possible failings; Original Sin is rejected at the cost of maintaining a belief in election, which implies a perfectionism as strict as the one Ruskin seems to reject. In this sense the sentimental dream of childhood is but a natural reflex from Puritanism.

There is no wonder that Ruskin overvalues the nursery virtues of pleasant demeanor. The sugared phrases that seem to give childhood its due ("offices of good," "armour of habitual right") in reality rationalize submission and reduce the range of moral action to a dollhouse scale, the only scale on which perfect behavior is attainable. Thus, in the chapter on "Home Virtues," the girls are told that their first "duties" are dancing, cooking, and wearing the dresses they sew for themselves. When chastised, they fold their hands and drop their eyes. At one point, "tidy" and "untidy" are substituted for "light" and "dark" as moral terms and seem, for the moment, to summarize the whole duty of girls. Ruskin's Winnington, in short, stands for a never-never land of harmony, before there ever broke out a contradiction between government and liberty, duty and desire, or the wishes of the parent and the child. Ruskin himself personifies the God of this world, who is also the Good Shepherd of Blake's *Songs of Innocence:* "God is a kind Father. . . . And we may always be sure, whatever we are doing, that we cannot be pleasing Him, if we are not happy ourselves" (XVIII, 290–291).

Obviously, Ruskin does not propose this ethic as the whole duty of *man*. In the chapter called "Crystal Virtues," crystals are pictured as brave males struggling against evil, like Apollo and the Python; elsewhere, the girls are shown the panorama of a mountainside with "agonized" marble, the emblem of creation "in travail," which they quite properly find terrible but are advised to accept with stoicism (the phrase from "Fairy Stories" is "submissively, and with no bitterness of astonishment"). In this regard *The Ethics of the Dust* simply repeats, for

children, the official morality of Womanhood, preached in Victorian pulpits, journals, and popular novels: women are to be chaste, pious, and passive, acting as an inflexible inspiration for those men who take upon themselves the dangers and rewards of moral aggression—and who may be fallible so long as they ally themselves with the purity of a female other. Ruskin's little book illuminates at least one of the many causes of Victorian sexual ideology, the contradiction between competing conceptions of virtue. Ruskin's career fiercely alternates between self-assertiveness and the recoil of guilt. The aggression that he took to be his mature duty as a writer—the indignation, the rage, the deliberate subversion of his parents' self-serving pieties—brought upon him the very emotional turbulence that, he believed, polluted and depleted the pure energy that was his life, the principle of continuity. The very rebellion that was his salvation called forth the guilt that threatened his perdition. *The Ethics of the Dust,* and Ruskin's depiction of women in general, retreats from ethical confusion by dividing two ideas about virtue—that it is heroic and that it is submissive—between two separate races, men and women. Victorian sexual ideology does the same, partly no doubt in order to rationalize the discordance between Christian ideals of humility and charity and the energies required for success in a competitive economy. But in Ruskin's case the division relates more clearly to his internal conflict between obedience and rebellion. Specifically, the characters of the child world dramatize two idealizations of Ruskin's mother—in himself as perfect teacher and in the children as perfect wives. Each figure fuses Ruskin with his mother and the present with the past, leaving Ruskin himself free of parental restraint. For the rest of his career the child world alternates with the "after life" of tragic heroism.

But the "little housewives" of *The Ethics of the Dust* must remain children for other reasons as well. The Lecturer is able to control them easily, dispensing gentle rebukes in a way to suggest he is half in love with their glistening eyes and flushes of shame; this tactic also permits him to reverse roles, pretending to submit helplessly to the children's teasing and ministrations. Since he is of "incalculable," that is to say, indeterminate, age, he may shrink and grow as the children grow and shrink, and we seem to see once again the boy Ruskin sharing his enthusiasms with a roomful of Adèles, this time captivated. Defined in this way, their love becomes unconditional, a mutual sharing that acts out the relations of crystalline structure and takes the place of sexuality. "I don't so much wonder," the Lecturer exclaims, "that people used to put up patiently with the dragons who took *them* for supper" (XVIII, 340), but the children are not dragons, and they will devour him only with their attention. He dislikes the French word for wife (*femme,* or "woman"), much preferring the English word derived, as he claims,

from "weaver." In a cryptic sentence, he tells the children, "You must be either house-Wives, or house-Moths. . . . you must either weave men's fortunes, and embroider them; or feed upon, and brink them to decay" (XVIII, 337). Between the devouring or corrupting beast and the subservient child lies no third alternative. The category subtly excluded from the book's pattern of antitheses is precisely that of adult sexuality. There is no place to grow up—no place, either, to grow old and die. The seed, Ruskin maintained again and again, is for the sake of the flower, not the flower for the seed; the flowering time must never yield to the seed time because the seed is the beginning of death—for the organism that bears it.

And so Ruskin converts his children into aesthetic objects, living artifacts that move in a kind of dance to the music of no time. Playing is, ultimately, the dominant motif of the book, as playfulness is the Lecturer's predominant manner—a manner that is often coy, self-indulgent, and repellent, but a mode, finally, that represents a necessary fiction or respite from the "grim face of reality," just as Blake's Beulah is the necessary respite from the wars of Eternity. But for Blake's Thel, paradise becomes the prison house of unreal existence. In a remarkable moment of self-irony, just as the Lecturer is preaching about dancing, cooking, and sewing, Ruskin has the children pretend he is dreaming at the fire, like a withered Narcissus caught by Naiads.

The Firmament of Mind

In *The Queen of the Air* Ruskin asks his adult readers to take Greek myths as seriously as the children in *The Ethics of the Dust* took their Lecturer's Egyptian allegories, and for the same reasons.[4] From the perspective of innocence, which is also sexual innocence, the structure of reality is dualistic, explicable by a set of allegorical fairy tales that reinforce the division. On the one hand is the childhood paradise, the defining emblem of which is the children as embodiments of crystalline

[4]*The Queen of the Air* receives extended treatment in the penultimate chapter of Raymond Fitch, *The Poison Sky* (Athens: Ohio University Press, 1982), a massive study of mythic and apocalyptic motifs in Ruskin. My book was completed before I had a chance to see Fitch's work, but his concerns and mine overlap at many points. Fitch proposes, for example, to interpret Ruskin's works "not as discrete objects but as moments of a process, a continuous signifying intention in which the private and the public writings appear to be dominated by the same archetypal symbols" (p. 13). In the course of his career, Ruskin's writing "seems to move increasingly, even within its topical fragmentation, toward symbolic and mythic integration, as if he were himself attempting to draw the obsessional, the poetic, and the mythopoeic into the confines of discursive prose" (pp. 24–25). Fitch divides the "archetypal" content of Ruskin's works into three general categories: Purity; the Fall; and the Hero-Serpent Conflict. The detailed analysis that follows takes as its scope the whole range of Ruskin's work but unfortunately relies excessively on lengthy paraphrase.

energy; on the other, the "after life," emblems of which are gold and serpents. But from the perspective of experience, the structure of reality is explicable by mature religious myth, which celebrates heroic virtue instead of submissive virtue, and conceives of a universal formative power in creative interchange with the serpent, or power of the earth. Ruskin chooses Greek mythology as his central example of religious apprehension and invites his readers to see the world afresh—to look upon "the stars, and hills, and storms" with "the earnestness of those childish eyes," that is, the eyes of the Greeks, the "children of men" (XIX, 300). But the Greek "childhood" really occupies the apex of spiritual development in history, as does the Venetian Gothic—the consummation of the first stage, when the strength of childhood and the autonomy of adulthood are fused.

All myths, Ruskin writes in *The Queen of the Air*, have three "structural parts—the root, and the two branches." The root is a physical phenomenon; the branches are, first, "a personal incarnation . . . , a trusted and companionable deity, with whom you may walk hand in hand, as a child with its brother or its sister," and second, a moral meaning. But the chief interest of myths lies in their highest development in the work of a great poet or artist. The mature stage of myth in Virgil or Phidias is therefore the consummation of human knowledge, standing to science not as fancies to fact but as a complete activity incorporating and transcending the limitations of scientific observation: "But if, for us also, as for the Greek . . . , the sun itself is an influence . . . of spiritual good—and becomes thus in reality, and not in imagination, to us also, a spiritual power,—we may then soon overpass the narrow limit of conception which kept that power impersonal and rise with the Greek to the thought of an angel who rejoiced as a strong man to run his course" (XIX, 302–303). In using the Nineteenth Psalm to articulate the experience of a Greek beholding Apollo, Ruskin is true to the unity of what Blake called the "poetic genius," except that unlike Blake, Ruskin insists on the complementary validity of scientific and imaginative perception. This complementarity he achieves by virtue of physico-spiritual parallelism: light, for example, is both a physical and a spiritual power, and life itself, an unanalyzable power, may be conceived scientifically as molecular interactions but imaginatively as "spirit."

For Ruskin the study of myths reveals the unity of the human imagination in its collective character, a unity ascertainable most clearly in the work of great and inspired minds. That unity in turn implies a structure of coherence in the universe, since the mind does not act without an object. But the unity of mind is Ruskin's ultimate ontological ground and not, as before, the objectivity of natural appearances. Thus he writes that "all true vision"

is founded on constant laws common to all human nature; that it per-
ceives, however darkly, things which are for all ages true . . . and that its
fullness is developed and manifested more and more by the reverberation
of it from minds of the same mirror-temper, in succeeding ages. You will
understand Homer better by seeing his reflection in Dante, as you may
trace new forms and softer colours in a hillside, redoubled by a lake. [XIX,
310]

The image of the "diminishing glass" in *The Stones of Venice* and of the
"dark mirror" in *Modern Painters* v clearly refers to fallen human per-
ception, but the present image stresses clarity rather than distortion,
the clarity gained by comparing various views. In a related figure from
"Fairy Stories," he compares the natural development of a mythologi-
cal tradition with a "flying cloud," which, though it changes, remains a
"sign of the sky"—"a shadowy image, as truly a part of the great firma-
ment of the human mind as the light of reason which its seems to
interrupt" (XIX, 236). Normally we would expect the cloud to stand for
fancy, half-concealing and half-revealing the sun of truth, but the pri-
mary meaning here is that the products of myth and the products of
scientific reason are equally "natural," equally "true." Both passages
deny the mirror model of truth, returning in effect to the assumption
implicit throughout *Modern Painters* I that interpretations are enhance-
ments rather than successively feebler reflections of reflections. As a
result, "primitive" myths, constructed in one set of historical circum-
stances, may be reinterpreted and reconceived for a new age, in exactly
the way that words require redefinition.

And so *The Queen of the Air*, drawing eclectically upon certain current
anthropological theories,[5] nevertheless stands as the culmination of
nearly thirty years of thinking about nature and representation, a final
attempt at conceiving all the modes of confronting nature as a single,
consistent activity of praise. The immediate origin of the book is a
lecture delivered in 1869 entitled "Greek Myths of Storm," but as usual
for Ruskin, the relation of specific topic to broader subject creates
organizational confusion. The first chapter incorporates the original
lecture. The second, "supplementary to the preceding lecture," studies

[5]For a summary of contemporary theories of myth, see James Kissane, "Victorian
Mythology," *Victorian Studies 6* (1962), 5–28. F. Max Müller, the leader of the philological
school of comparative mythology, lectured at Oxford and London in the 1850s and
1860s and receives mention in *The Queen of the Air,* but his view is the complete reverse of
Ruskin's. Müller traced the genealogy of Indo-Aryan myths through resemblances in the
names of deities and argued that myth making is a "disease of language" occurring
spontaneously under the primitive experience of awe, deities being the simple product of
grammatical requirements like gender and the need of a subject to perform an action.
For Müller the verb is of particular importance in the "deformation" of language. Rus-
kin, on the contrary, recreates the living presence of Athena by a deliberate accumulation
of verbs, reaffirming his belief that the universe is an incarnate language.

the "relations of Athena to the vital force in material organism," centering chiefly on birds, snakes, and plants. The third—"Various Notes relating to the Conception of Athena as the Directress of the Imagination and Will"—is a jumble of ideas on art and economics, mostly spliced together from other books. The chapter titles, which impose an imprecise but suggestive unity upon this miscellany, are composed of corresponding English and Greek phrases: "Athena in the Heavens," "Athena in the Earth," and "Athena in the Heart" correspond to "Athena Chalinitis" (the Restrainer), "Athena Keramitis" ("Ready for the Potter," as in *ge keramitis,* "potter's earth"), and "Athena Ergane" (the Worker). But who is this protean goddess? Most broadly she is the animating principle or "formative power" of nature—what Coleridge called the esemplastic power—which in Christian terms becomes Wisdom, the female counterpart of the creative Logos. Again, as air or spirit, she is the romantic muse, like Shelley's West Wind, literally "inspiring" the answering mind with the fierceness of will, at once creative and destructive, necessary to the moral and poetic imagination. Yet again, she is a specific combination of virtues and qualities, associated at once with specific myths and with Ruskin's own career: the confused third chapter is essentially an apologia for the writer's life, using the goddess as its guiding metaphor. Ruskin's Athena, then, is at one and the same time the object and creation of the religious imagination in general and also a particular figure, one among several in the Greek pantheon. In refashioning traditional materials into personal perspective, Ruskin is of course repeating a standard romantic procedure: we think not only of Shelley and Blake and Keats but also of Carlyle's Teufelsdröckh, who can describe the religious imagination in general only in terms of a specific subject (the clothes philosophy, acting as a trope for vision) and a specific persona with a biography. But just as clearly, the perspectivism, so to speak, of *The Queen of the Air* looks forward to twentieth-century habits of thought: Athena, we might say, is the ethos of Ruskin's philosophizing (as the Winnington pupils are the ethos of a different perspective in *The Ethics of Dust*), just as, for example, Don Quixote is the ethos of Ortega y Gasset's ontology, the specific personal and cultural context from which a person learns to grasp the world.[6] The book, then, is both an original act of myth making and a myth *about* myth making—an activity that, for Ruskin, takes its "root" in natural appearances. As a manifestation of nature, Athena is the Aristotelian "formative power" infusing matter, or again the breath of life infusing the inanimate clay, or yet again, the element of air acting on earth. This last point suggests a way of unraveling the

[6]Ortega y Gasset, *Meditations on Quixote,* trans. Evelyn Rugg and Diego Marín (New York: W. W. Norton, 1961).

complexities of the first two lectures. For Ruskin, various models of myth making draw from various classes of natural phenomena—specifically, from weather, plants, and animals, which we can now consider in order.

The first lecture attempts to map the heavens by classifying winds and clouds according to constant allegorical meanings, which as always for Ruskin exist in antithetical pairs. This firmamental map turns out to be a systematized version of the interpretations Ruskin suggested in *Munera Pulveris*, a system, that is to say, of energy economics in which the codes of emotion and wealth are interchangeable. For example, Aeolus, the steward of the winds, is prosperous with his fortress of brass and his twelve children, demonstrating "this idea of gifts and preciousness in the winds of heaven," but the Harpies, which are furious little whirlwinds, are "spirits of wasted energy, and wandering disease, and unappeased famine, and unsatisfied hope. So you have, on the one side, the winds of prosperity and health, on the other, of ruin and sickness" (xix, 312–314). The effect of this and other readings of storm myths is to convert meteorological phenomena into the firmament of the human mind—or rather that of a multiform energy both mental and passionate, which, when restrained and fulfilled by the agency of Athena or Wisdom, becomes life-as-wealth. But the most complex figure is Hermes, the cloud shepherd, whom Ruskin views as a kind of factotum for Athena. The character of this god varies from gentle and serviceable to deceitful. Certain epithets, according to Ruskin, suggest that physically Hermes represents "the silver cloud lighted by the sun," or the veiler of the light. Since his name means "impulse," he is also associated with all movements of air: he is "guide of all mysterious and cloudy movement" and "all successful subtleties" (xix, .324). Because in a slightly earlier passage Ruskin reminds us that fables are intricate arabesques representing the "truths of emotion," it is hard not to see Ruskin's Hermes as the free play of fancy, or in Freudian terms, the distorting agency by which the primitive instincts are filtered into consciousness, itself an infinite arabesque of words and thoughts. In Ruskinian terms he is the activity of the symbolic grotesque, capable, when bound firmly to the service of Athena, of giving body to the highest truths in the form of great poetry and art.

Ruskin's reading of the heavens tends to become an elaborate metaphor of the shape-shifting activities of consciousness, rendered stable in terms of spectrums of meaning that become polarities at their opposing ends. This is not the case when Ruskin turns to plants, or the relation of air (Athena) to vegetative growth, because now his myth making takes the form of associative chains, like atoms on a molecular strand, or rather like the endless growth and curl of a vine. For example, the olive,. sacred to Athena, is associated with Hercules, who

planted it on Olympus to form the Olympic crown, with the oil of the Panathenaic games, with the anointing of the stock of Jesse, with extreme unction, the Mount of Olives, Gethsemane, and many other things. Thus, through a single plant—"those twisted branches whose leaves give grey bloom to the hillsides" of Greece and Palestine (xix, 337)—Ruskin binds both of the Western religious traditions, crowning them with three peaks, Olympus, the Acropolis, and Golgotha. The olive may stand for several moral ideas, but its chief importance is not as allegory but as nexus, a paradigm of the eternal human activity of "culture" in both its senses—as the raising of crops from the fertile earth and as the attribution of social meanings to the created world. In this and other examples, which combine verbal and visual elements in a way familiar to us from Dante's eagle, Ruskin reconceives natural history and literary criticism as aspects of the same descriptive activity. Natural forms are the original materials of the poetic imagination yet cannot themselves be fully understood without reference to their cultural meanings.

Ruskin's second chapter, "Athena Keramitis," takes up the relations of Athena to the earth, or in other words, the incarnation of consciousness in organic material, but the new subject requires a new form of mythopoeic response. The first chapter set up an analogy between weather phenomena and the dialectical movements of mind and then between vegetation and the garlands woven by human culture, a binding activity made possible by the polysemous character of words. But the second lecture locates the unit of significance in nature itself, in the logos manifesting itself in antithetical forms. The vital force, Ruskin tells us, creates

> calcareous earth . . . separately, and quartz, separately, and gold, separately, and charcoal, separately; and then so directs the relations of these elements that the gold may destroy the souls of men by being yellow; and the charcoal destroy their souls by being hard and bright; and the quartz represent to them an ideal purity; and the calcareous earth, soft, may beget crocodiles, and dry and hard, sheep . . . representing to [man] states of moral evil and good, and becoming myths to him of destruction or redemption, and, in the most literal sense, "Words" of God. [xix, 359]

If the first chapter belongs to the associative imagination, the second belongs to the penetrative imagination, which reaches its mature stage in Ruskin's career in his invocations to the bird and the serpent. In the first of these prayerful meditations, he comes closest to the original ground of religious experience, permitting metaphor to arise by natural exfoliation from the heart of an observed object. The bird, he writes, is "a drift of the air brought into form by plumes," "a blown flame," the perfect type of breath or spirit "conscious of itself, conquer-

ing itself, ruling itself," and of the sky given form and voice. "As we may imagine the wild form of the cloud closed into the perfect form of the bird's wings, so the wild voice of the cloud into its ordered and commanded voice; unwearied, rippling through the clear heaven in its gladness." And it comprises in itself all the gifts of the Queen of the Air—light, color, sound, life, motion, restraint:

> Also, upon the plumes of the bird are put the colours of the air: on these the gold of the cloud, that cannot be gathered by any covetousness; the rubies of the clouds that are not the price of Athena, but *are* Athena; the vermilion of the cloud-bar, and the flame of the cloud-crest, and the snow of the cloud, and its shadow, and the melted blue of the deep wells of the sky—all these, seized by the creating spirit, and woven by Athena herself into films and threads of plume; with wave on wave following and fading along breast, and throat, and opened wings, infinite as the dividing of the foam and the sifting of the sea-sand;—even the white down of the cloud seeming to flutter up between the stronger plumes, seen, but too soft for touch. [XIX, 360–361]

Like Hopkins's windhover, this bird is the "symbol of Divine help" in the form of the Holy Spirit and the tongues of fire (XIX, 361), yet it is a pagan bird as well, concentrating the heavens into a single point that is also "infinite" and therefore coterminous with the motions of wind, cloud, fire, and sea, like Venice. These motions are Athena, the supreme artificer who weaves the air into the bird tapestry just as Greek myths weave winds, clouds, and passions into the arabesque of their pantheon: human speech and natural language correspond precisely. And so Ruskin closes his chapter with an invocation to Athena that does not name her directly but rather fashions her out of a string of verbs, each one a dot of paint: the formative power warms, shades, and cools; fills, sustains, and designs; cherishes, calls, waits, and feeds; spins, weaves, renews, flits, whispers, thrills; joins itself, becomes, enters into, commands, measures, molds, fills, and passes away (XIX, 386).

"This," Ruskin concludes, "was the Athena of the greatest people of the days of old." But at the same time Athena is a "companionable deity," not an abstract presence only. The connection between "spirit" as a generative power and "spirit" as a set of moral gifts constitutes Ruskin's particular perspective on the moral universe.

Our most direct experience of Athena is through the air we breathe, which is "purification, and health, and power" (XIX, 328); thus she has power over "blessings of calm, and wrath of storm." Spiritually, she "inspires" humans with strength for battle or with "habitual wisdom; wisdom of conduct and of the heart, as opposed to the wisdom of imagination and the brain; moral, as distinct from intellectual; inspired, as distinct from illuminated." In general she is "inspired and

impulsive wisdom in human conduct and human art, giving the instinct of infallible decision,and of faultless invention" (xix, 305–306, 346). In phrases like these, Ruskin attempts to compose qualities normally distinct into a fusion of opposites. For example, although Athena stands for Wisdom, she is associated with inspiration and passion rather than with intellect. She is "impulsive," giving "decision" that is at once instinctive and infallible. In another place, Ruskin couples "passion and virtue" with the "spirit" of man, the "central sign" of which is "endurance, or patience" (xix, 352), thus placing passion and patience in the same camp. The Greek *menis* passes through many transmutations. As the first word of the *Iliad,* it is usually translated "anger," but Ruskin instead supplies "will" and "zeal, or passion" and, through its Latin derivative *mens,* "mind." Most broadly, these conjunctions mix feeling with thinking and self-control with desire, just as in his natural allegory, Ruskin transposes onto air qualities normally associated with water, the emotional element. Thus Athena is on the one hand the restrainer, bridling Pegasus and bestowing calm, but on the other, the inspirer, the *menis* (will, mind, wrath, passion, zeal) of Achilles: "If he is to be calmed, it is she who calms him; if angered, it is she who inflames him" (xix, 333). The wrath, however, belongs less to Achilles than to the prophets, just as the wisdom of the goddess is closer to Solomon than to Apollo. Inspiration, zeal, justice, and the wisdom that begins in the fear of the Lord, properly belong to a Hebraic idiom rather than to a Hellenic one. We might say that *The Queen of the Air* is an attempt to reconcile the religions of Homer and Isaiah, lightening the Hebraic strictness of conscience by a glitter of the Adriatic and the tang of Alpine air.

This fusion helps us see by the bye the profound connections between Ruskin's study of myth and Arnold's contemporaneous excursions into social criticism and the study of religion. In temperament two men could hardly be more different. Arnold is among the wariest of thinkers, Ruskin among the most impetuous. The one dreaded being overwhelmed by what he called the multitudinousness of life as much as the other sought to plunge himself into it. For Arnold the accents of wisdom are tentative and reasonable; for Ruskin they are dramatic and paradoxical—eccentric in the root sense of the word. For all these differences, their broadest intentions are profoundly similar. Both men assumed that the best that had been thought and said composed a coherent corpus, offering a vantage point from which modern subjectivity could be judged. Both sought to transcend intellect and passion by a synthesis that Arnold called imaginative reason and Ruskin personified as Wisdom. Both men, skeptics with a deep religious sensibility, sought beyond blind faith and material evidences for a joy whose grounds are true. By suffusing heroic resolution with the fresh-

ness of the Aegean and the "deep wells" of the air, by locating in the physical experience of nature the perpetually renewing fount of cultural achievement, by touching morality, as Arnold might have said, with joy, *The Queen of the Air* performs its own act of poetic legislation, attempting to alter and enrich the perceptual field of its reader.

"In beginning the series of my corrected works," Ruskin writes early in the third chapter, "I wish this principle . . . to be made plain. . . . The faults of a work of art are the faults of its workman, and its virtues his virtues" (XIX, 389). *The Queen of the Air* was to be the first volume of a new edition of Ruskin's works and so would stand, in effect, as a general introduction. It would seem that the third chapter, entitled "Athena in the Heart" or "Athena the Worker," would be a brief casebook of Ruskin's own justification, picturing Athena as moving and working within him. Having distinguished her from Apollo, whose agency makes the work of man beautiful rather than moral, he in effect makes of her the muse of social reform and affirms the direction his career took with *Unto This Last*. The third part, then, is directly didactic, hammering out the particulars of the poetic "legislation" manifested in the earlier lectures.

Yet the emotional violence and slovenly disorganization of these pages come as a shock, an ominous precursor of the periodic derangements Ruskin was to suffer in his last two decades as a writer. At times he seems an irritable parody of Teufelsdröckh's editor ("I find by me a violent little fragment of undelivered lecture which puts this, perhaps, still more clearly" [XIX, 406]); at others, an avatar of Achilles himself, "a mortal whose name means 'Ache of Heart,' and whose short life is only the incarnate brooding and burst of storm" (XIX, 307). Inflamed rather than inspired, he becomes indistinguishable from the vengeful Hebrew deity whose words he puts into the mouth of Athena:

> in justice only she judges and makes war. But in this war of hers she is wholly implacable. She has little notion of converting criminals. There is no faculty of mercy in her when she has been resisted. Her word is only, "I will mock when your fear cometh . . . " for her wrath is of irresistible tempest: once roused it is blind and deaf,—rabies—madness of anger—darkness of the Dies Irae.
>
> And that is, indeed, the sorrowfullest fact we have to know about our own several lives. Wisdom never forgives. Whatever resistance we have offered to her law, she avenges for ever;—the lost hour can never be redeemed, and the accomplished wrong never atoned for. . . . Wisdom can "put away" sin, but she cannot pardon it; and she is apt, in her haste, to put away the sinner as well, when the black aegis is on her breast. [XIX, 399–400]

This is the vengeful Athena, whose emblem is the gorgon, the judger of men as the good Athena is their comforter. The gifts of one (health,

purity, brightness) ar precisely antithetical to the curses of the other (rabies, tempest, blind and deaf, darkness), who becomes as insane and pestilential as her enemies. Clearly enough, the wrath is Ruskin's own, recoiling more harshly upon himself than upon his enemies. In one revealing passage he brings himself before the judging eye of a Turner drawing: "As I myself look at it, there is no fault nor folly of my life,—and both have been many and great,—that does not rise up against me, and take away my joy, and shorten my power of possession, of sight, of understanding. And every past effort of my life, every gleam of rightness or good in it, is with me now, to help me in my grasp of this art, and its vision" (xix, 395–396). These are the words of a man on the rack, ravaged by the unrestrained superego that prosecutes wars of religion and is also akin to the demonic form of rationality Robert Lowell caught in his figure of the Roman Athena, the goddess of Empire: "Pure mind and murder at the scything prow / Minerva, the miscarriage of the brain."[7]

Conscience, "inspired" or internalized, approves when its demands are met and turns vengeful when they are not. Ruskin's Athena, the type of the Wisdom that begins with the fear of God, is both "within" and "without"—a divine lawgiver who punishes and rewards, and at the same time the inspiriting source of Ruskin's own voice, the ethos of a book that shifts from tenderness to fury. This radical splitting, which characterizes Ruskin's handling of the female figure throughout his career, we first noticed in *The Stones of Venice* in the alternation between virgin and whore. But ultimately Time itself is feminized, just as in the later book, Time is split between the eternal freshness of the Greek past and the terrors of a present experienced as perpetual bereavement. The poisonous rages of Athena are precisely the terrors of time banished from the Winnington world, where it is called "after life"; yet the two books, as I have suggested, are not contradictions but contraries similar to Blake's states of innocence and experience. The similarity is that, in both worlds, there can be no real forgiveness. Ruskin had written from Winnington, "The weary longing to begin life over again, and the sense of fate forever forbidding it—here or hereafter—is terrible." In the child garden, the girls are emblems of grace and so "ought not" to be capable of evil; for Ruskin at fifty, the laws of fate forbidding the renewal of life create the nostalgic dream of innocence on one hand and, on the other, a theory of myth renewing the ancient possibility of *propitiation*. This last possibility appears in a brief exchange between the Lecturer and one of the children in *The Ethics of the Dust*. The child has been describing the reaction of her little sister to the news that a friend had gone across the sea:

[7]Robert Lowell, "Beyond the Alps," in *Selected Poems* (New York: Farrar, Straus & Giroux, 1977), 56.

Then Dotty looked around the room; and I had just poured some water out into the basin; and Dotty ran to it, and got up on a chair, and dashed her hands through the water, again and again; and cried, "Oh, deep, deep sea! send little Allie back to me."

LECTURER. Isn't that pretty, children? There's a dear little heathen for you! The whole heart of Greek mythology is in that; the idea of a personal being in the elemental power;—of its being moved by prayer; and of its presence everywhere, making the broken diffusion of the element sacred. [XVIII, 353]

"The broken diffusion of the element is sacred": the phrase might stand as the epigraph for both books and as the master theme of Ruskin's half-despairing reassertions of the romantic faith during his final decades. For the broken diffusion is the brokenness of time as well and therefore of self. In 1868 Ruskin had written Norton, "In my genius I am curiously imperfect and broken. . . . And the greatest part of my life—as Life (and not merely as an investigating or observant energy) has been . . . a series of delights which are gone for ever, and of griefs which remain forever" (XXXVI, 555). The image of a crystal stream, symbol of Life as a continuous force of virtue, is one fiction of stability erected to countermand the vision of total loss; a second fiction is the persistence of "companionable presence" in nature. The meaning of *The Queen of the Air,* as both a public and a private statement, lies in its prayerful invocations to the goddess that has been driven off, enacted also by the child who propitiates the elements for the return of her lost sister. "All great art is praise": in Ruskin's work on myth, praise becomes an effort of recapture, and the ineluctable bereaving of time is converted into a two-faced goddess who can be propitiated and assuaged.

PART V /

WORKS AND DAYS

11 /

Olympian Lightning

"There is a tradition respecting this statue, that a Venetian lady was once so fond of looking at her mirror, that she habitually carried one to church with her in her missal. One day as she was gazing into it she saw the reflection of her own face change into that of a death's-head, and was immediately turned into stone as she sate."

—John Ruskin

"Neither shalt thou be afraid of destruction when it cometh. . . for thou shalt be in league with the Stones of the Field."

—Job 5:21, 22

Ruskin began his first lectures as the Slade Professor of Fine Art at Oxford in 1870. In 1871, the year also of his mother's death and the sale of his childhood home, he purchased Brantwood on Coniston Lake and proposed the establishment of an agricultural community to be called St. George's Guild, endowed with a tithe of his fortune and organized and publicized by him as its sole Master. These changes removed the external impediments of a decade earlier, when he was blocked by his parents' will and the problems of finding a roof of his own. With a home in the lakes, a podium for his ideas on art, and plans for a utopian community that might put at least some of his radical economics into practice, he was free fully to accept his vocation. Never before did he write so much nor intertwine his writings with such a multiplicity of projects, a multiplicity that has become the burden of his readers and his biographers. Without either the major insights or the dramatic turning points of his most creative years, the mass of writings from 1870 to the final breakdown of 1889 threatens to dissolve into a fathomless miscellany of fragmented and interrupted topics, while the projects and travels grow into compelled and repetitious busyness. His life also took on a new, tragic rhythm of sudden, debilitating attacks of illness alternating with periods of incomplete recovery. Faced with the

inexorable realities of illness and decline, he clung ever more resolutely to dreams of the past that provided intermittent shelter from his sense of failure and loss yet condemned him to an underlying solitude: even his most urgent projects, like Toby Shandy's, seem partly a private play, disguised recreations of older times and places. The wonder is not that Ruskin's late works are often disturbed and chaotic but that they contain so much that is genuinely innovative, challenging us to read them as new forms of utterance, new ways of interpreting and confessing experience.

Ruskin's passion for traveling and collecting, like his love for the rich and turbulent variety of Gothic, or the mosaiclike juxtapositions of the symbolic grotesque, fulfilled what John Dixon Hunt has called the idea of the world as museum. A museum, Ruskin remarked, is "neither a preparatory school, nor a peep show; but it may be made more delightful than either" (xxvi, 1); they are boxes of wonders and ways of teaching the world less as a system of classification than as an assemblage of paradigms. But a private collection would also be a gathering of memorabilia, a way, like landscape, of making the macrocosm coincide with the personal past: the "this is" becomes the "I am." The clutter of Denmark Hill, with its specimens of ferns and flowers and rocks, its manuscripts and books and paintings, became an even denser clutter at Brantwood, which Ruskin converted into a memorial by decorating it in his parents' taste and furnishing it with artifacts from the old home (a vindication, as Ruskin ironically remarked, of the associationist theory of beauty). But a more literal form of curatorship occupied him during these same years. At Oxford he set up four related series of drawings and paintings for use by his students; for the Guild museum at Sheffield he assembled minerals and other artifacts, as well as a series of translations he called "Bibliotheca Pastorum"; and for the British Museum at Kensington he arranged yet another geological series—all of this accompanied by theoretical remarks on curatorship and original designs for display cabinets. And the books themselves, as Hunt points out, become display cases for receiving all of heaven and earth.[1] As any subject potentially becomes any other subject, the "cases" become arbitrary subsections of a single, evolving opus, each topic (to change the metaphor) a strand in an infinite arabesque. Ruskin himself becomes the world of his books, giving himself to us in a flow of paintings and places, of memories and emblems and hopes.

[1]John Dixon Hunt (*The Wider Sea: A Life of John Ruskin* [New York: Viking, 1982]) has usefully integrated Ruskin's interest in cataloging with his attempts to order and plan his books (pp. 338–341). For a sketch of a Ruskinian design for a display cabinet, see p. 361; see also Robert Hewison, *John Ruskin: The Argument of the Eye* (Princeton: Princeton University Press, 1976), 173–175.

This new, informal intimacy is particularly characteristic of the books not drawn from Oxford lectures but composed rather of connected essays, reflections, or public letters that first appeared serially. Through these fragmentary public diaries, Ruskin accustoms himself to writing in the present tense, offering thoughts and impressions as they spin off spontaneously from his life activities and achieving in the process a continuous presence before a national audience. Space prevents me from considering more than a few works from Ruskin's later decades. I have chosen to focus on three. *Deucalion* and *Fors Clavigera* take the form of a polemical journal that includes occasional reminiscences of a carefully woven kind. From their shaped units Ruskin built *Praeterita*, the autobiography he wrote on the brink of night.

Myth and Science

Ruskin's insatiable curiosity about the created world unified his adulthood as well as the multitudinous enthusiasms of his childhood. His first publication was an essay on the color of the Rhine. Later, while continuing his art lessons at Oxford he attracted the attention of several men of science, including William Buckland, geologist and divine, who had contributed to the Bridgewater Treatises. *Modern Painters* I set the young man in his career as an art critic rather than a geologist, yet the five volumes of his massive work contain hundreds of pages devoted to the characteristic energies of rocks and plants, of wind and wave. He considered these pages to be of scientific interest in their own right, for he retained to the end of his life the model of scientific inquiry he had learned as a youth—an activity, predominantly, of description and classifying, possible at that time for the botanizing clergyman or the gentleman amateur exploring the Alps on foot. By the second half of the century, science had become almost exclusively the province of the professional experimentalist, who devised laboratory methods to explain what the senses alone could not perceive and the word poet could not describe. Yet Ruskin continued to collect and observe and describe, partly as diversion, partly as a serious contribution to science and the philosophy of science. Beginning in 1856 he published a number of notes and papers on such geological subjects as the banded formations of agates, the structure of the limestone Alps, and the varieties of silica. In the 1870s he began to draw his fragments together into books or book-length works in progress—*Deucalion,* the geological diary; *Proserpina,* the book on flowers; the Oxford lectures on the relations of natural science to art; and other miscellaneous lectures, including the famous pair on *The Storm-Cloud of the Nineteenth*

Century. Merely the mention of these reminds us that Ruskin is the unique example in English of a romantic writer who laid claim to scientific originality.

The Stones of Venice and *Modern Painters* IV contain an art critic's indirect responses to the "dreadful hammers" of Lyell and the Higher Critics, both of whom specialized in legible materials. The later scientific writings respond, sometimes directly, to Darwin, Huxley, and Tyndall—indeed, to the whole tendency of what Ruskin called "materialist science." Some such response was integral to his entire enterprise. The belief in a religious apprehension of nature—an apprehension of which Saussure, Wordsworth, Turner, the Bible, and the Greek poets, to say nothing of the pastimes and hopes of ordinary people of good-will, are but individual moments in a single articulation of praise—requires for its completion some notice of purely empirical knowledge. But Ruskin in his later years was hardly adequate, either by training or by temperament, to that response. His technical contributions are minor, his philosophy of science is reactionary, and his books are disturbed by private obsessions—the same that burst out in the psychotic episodes of 1878 and after. Nevertheless, Ruskinian science does not deserve the almost complete neglect it has received. Its chief interest lies in its character as drama—a drama, first, of romantic nature philosophy in a late encounter with scientific materialism and, second, of Ruskin's struggle against overwhelming emotional chaos, fought out through his faith in a sensuous language adequate to fixing and propitiating the created world. But the late essays first require an understanding of Ruskin's thinking about science as it evolved in the first thirty years of his career.

Modern Painters I presents nature as an infinity of divine thought which is humanly experienced as affective power, so that any good transcript of nature, such as a drawing, is necessarily both accurate and expressive. Far from suggesting a rivalry between science and art, as the romantics had conceived it, Ruskin denies the difference between them by assuming that the empirical investigator constitutes the model for the artist, since the man of science, by surrendering the self, achieves at once purity of heart and mastery of knowledge. This synthesis is in part a rejection of the romantic imagination in favor of virtues like watchfulness and sympathy, since imagination is for Ruskin the disturber, not the forger, of the bond between mind and nature. But by the 1850s he had to come to grips with the role of art in relation to imagination (the faculty that perceives what is not empirically present) and the role of science in relation to faith (the faculty that perceives God as not empirically present). *Modern Painters* III dramatizes in historical terms the broken harmonies of fact and fancy, thought and feeling, and truth and faith, with the aim once again of defining forms

of seeing that are both religious and true—an art that is not fictional and a science that is not impious. Even so, Ruskin refuses to ally himself with Wordsworth's contempt for analysis, partly because of his own early interests, partly because of his continuing respect for the scientific sensibility. For Ruskin the modern mind is represented best by a feeling person, whose indulgence of essentially nostalgic emotion marks a departure from literal truth, and by the sturdy, practical man of facts, who is more likely than the other to become a benefactor of the race. The inspired visionary, on the other hand, transcends both: great poets like Homer and Dante produce the myths by which the apprehension of nature becomes morally and culturally significant, joining the circuit between the matter of art (God's works) and the moral perfection of human life. But this appears possible only in an age of faith. Can such myths survive in an age of science?

Ruskin turns to the traditional romantic resolution of this problem. In a well-known passage in *The Friend,* which Ruskin may have read and remembered, Coleridge distinguished between the faculty that perceives the inward principles of things and the faculty that perceives only the phenomenal manifestations of those principles. The first he calls reason, "that intuition of things which arises when we possess ourselves, as one with the whole"; the second he calls mere understanding, "that which presents itself when . . . we think of ourselves as separated beings, and place nature in antithesis to the mind, as object to subject, thing to thought, death to life." Elsewhere he attacks the empirical sciences of the eighteenth century, particularly chemistry and taxonomy, precisely for missing the principle or essence of things; the chemist, for example, who "reduces the chemical process to the positions of atoms would doubtless thereby render chemistry calculable, but . . . he commences by destroying the chemical process itself, and substitutes for it a *mote dance* of abstractions."[2] The relationship of such passages to Ruskin's attack on secular rationalism is obvious enough, but Ruskin could not refute Lyell's theories, either in Coleridgean terms or in the kind of attack that Wilberforce was soon to launch on Darwin. Instead, Ruskin provides a somewhat tentative distinction in *Modern Painters* III between the science of essences and the science of aspects. The first, he writes, is useful in lifting the mind from "the first state of inactive reverie to the second of useful thought," but it is dangerous in that it "check[s] the impulses towards higher contemplation" and tends to "chill and subdue the feelings, and to resolve all things into atoms and numbers. For most men, an ignorant enjoyment is better than an informed one: it is better to conceive the sky as a blue

[2]Coleridge, *Collected Works,* ed. Kathleen Coburn, 16 vols. (Princeton: Princeton University Press, 1969), IV, pt. 1, 520–521.

dome than a dark cavity, and the cloud as a golden throne than a sleety mist" (v, 386–387).

Nevertheless, the poignance of this formulation is manifest, since the claims of knowledge and feeling run counter to each other: "useful" knowledge, which has been a greater benefactor to the human race than all the artists and poets who ever lived, may deaden the feelings. If by "essences" Ruskin means simply the undiscernible objects of inquiry—atomic processes, the magnitudes of space, the laws of physics—then the two "sciences" may simply complement each other, as for Coleridge, but as yet he omits mention of the severer challenges of modern cosmology to faith. That is precisely the topic of the next volume—but there, as it turns out, even the grimmest implications of modern science are no more disturbing than the present condition of humankind, as revealed to the compassionate and unaided eye. Consequently, both the geological chapters and the chapters on art drive toward a single, synthesizing idea—the revelation of overwhelming human need, which becomes the basis for both a humane practical science and a genuine tragic art. Such an art can survive the loss of orthodox belief, which Ruskin relinquished himself, even though he maintained his faith in nature as a presence, mysterious and living.

But in the 1860s Ruskin launched an increasingly bitter attack on science. He did so because his theory of natural myth had not only a pragmatic basis (the greatest minds have perceived nature imaginatively, so that it "is" so for us necessarily) but also a scientific basis, as firm as the fundamentalist's belief in a seven-day creation. According to Ruskin, the life force is a scientific reality that is, at the very least, probable; and for this reason the science of aspects derives from the science of essence. In *The Queen of the Air,* nature bears two separate but complementary descriptions, very much as in contemporary descriptions of mental activity. (Mental activity is, on the one hand, a continuum of states of consciousness, from which we construct the necessary fictions of self, free will, and moral responsibility.) In this respect Ruskin's view is consistent with that of many nineteenth-century natural philosophers who assumed life to be a mystical, unanalyzable force and so took refuge in the biological sciences against the mechanistic assumptions of physics and chemistry. But Darwin's theory of natural selection effectively put the term to romantic vitalism. According to Darwin, species, instead of evolving by some innate drive or telos, develop according to random, purposeless factors similar to those that govern the inorganic world. Ruskin may not have read Darwin in this light, but there can be no doubt of his response to another contemporary theorist, John Tyndall, who in his celebrated Belfast Address of 1874 triumphantly proclaimed the unbroken continuity of organic and inorganic processes. According to Tyndall, the highest achievements of

the human spirit are theoretically deducible from molecular activity in the primal cloud of gases. Although Ruskin leaves us no direct testimony, it is at least likely that Tyndall's materialism catalyzed his decision to make modern science the object of a new attack on nineteenth-century infidelity, continuous with his assault on political economy. As always, Ruskin's concern is less with the theories themselves than with the state of mind that would find in materialism an exclusive explanation of natural phenomena. This frame of mind, Ruskin believed, was hostile to the sanctity of life and the life of nature.

Tyndall appears peripherally in *The Ethics of the Dust* as the author of *Heat, A Mode of Motion,* a book that explained organic processes as the simple interaction of sunlight and complex molecules. In a lecture several years later, Tyndall fabricated an "artificial sky" by reproducing in a test tube the chemical processes occurring naturally in the atmosphere. In the introduction to *The Queen of the Air,* Ruskin juxtaposes Tyndall's "bit of sky more perfect than the sky itself" with a description of the Genevan Alps polluted by tourists, then concludes with an imprecation: "Ah, masters of modern science, give me back my Athena out of your vials, and seal, if it may be, once more, Asmodeus therein" (XIX, 292, 294). Asmodeus, in LeSage's novel, had escaped from a vial, very much like Satan in the garden, whom Milton compares with another, mythical Asmodeus. The allusions comprise the germ of a new Ruskinian fiction in which modern science, the latest incarnation of the spirit that denies, has despoiled the Swiss Eden and has rendered Eve captive. Ruskin broadened his attack two years later in the fifth letter of *Fors Clavigera.* There he refutes a botanist who had claimed in a lecture that there are, properly speaking, no such things as flowers—only modified leaves. In a sense, Ruskin says, the lecturer is right ("There are no such things as Flowers—there are only—gladdened Leaves"), but he proceeds to turn his adversary on his head by showing that "leaf, and root, and fruit, exist, all of them, only—that there may be flowers. [The lecturer] disregarded the life and passion of the creature, which were its essence. Had he looked for these, he would have recognized that in the thought of Nature herself, there is, in a plant, nothing else but its flowers" (XXVII, 84). In this Blakean antithesis between the truth of imagination, according to which there is nothing but the flower, and the false categories of "science," according to which there are no flowers at all, Ruskin closes his attack on two ideologies that specialize in denying the life and passion of the creature Man—Darwinian biology, which sees man as "a transitional form of Ascidians and apes," and laissez-faire economics, which describes man's "constant instinct" as the "desire to defraud his neighbor" (XXVII, 84,95). But Ruskin also sets these doctrines on their heads: "The real fact is, that, rightly seen with human eyes, there is nothing else but

man; that all animals and beings beside him are only made that they may change into him; that the world truly exists only in the present of Man, acts only in the passion of Man" (xxvii, 84–85). The conflict here is not between scientific fact and pathetic fallacy, since Ruskin upholds vitalism, the theory that both individuals and species develop according to a teleological energy. The anthropomorphizing of the plant is an emotional "reading" of its inner life that is at least consonant with the biological fact, a procedure somewhat similar to Coleridge's nature philosophy in *The Statesman's Manual*. The botanist, of course, had a reading of his own that was fallacious, since he confused the lower term with the higher exactly as the political economist does (the flower is no more a mere leaf than man is a mere animal or a digestive mechanism). Ruskin's description is, finally, an accurate account of the flower's aspect for the human viewer, which is a part of scientific truth—a truth possible when, as Coleridge writes, "we possess ourselves, as one with the whole," instead of separating subject and object in such a way that both become detached. The issue, then, is between good and bad science, that is, between two competing myths, only one of which makes place for the human—the issue, as Ruskin says, between "savoir vivre" and "savoir mourir."

What, then, ought the scope of scientific investigation to be? The Oxford lectures on the relations of science to the arts, written half a year after the *Fors* letters, are frankly reactionary. In opposition to the tendency of contemporary thought, according to which scientific inquiry should be separate from religious belief, Ruskin asserts what is essentially the traditional Christian argument about the use of reason. Science, he writes, ought to be the activity of a peculiar wisdom or "sophia," "the faculty which recognizes in all things their bearing upon life"; the wise man ought "to know himself, and his place; to be content to submit to God without understanding Him; and to rule the lower creation with sympathy and kindness." Ruskin infers that there is no place in science for speculation or what he calls theory: "It is not the arrangement of new systems, nor the discovery of new facts, which constitutes a man of science; but the submission to an eternal system, and the proper grasp of facts already known" (xxii, 144, 150). For the worth of theory is to be judged not by some abstract standard of objective truth but by its human effect, and the effect Ruskin cites is a nation bent on converting its meadows into railroads and its skies into smoke, on producing munitions and artificial famines, on stoning birds in the woods and vivisecting dogs in laboratories, and on discovering monsters in the earth.

These multiple evils, all of them the progeny of infidelity, drive Ruskin into an autocratic pipe dream, a symbolic return of the green and golden past through the forcible reinstatement of the science he

had known as a youth—the science of Saussure and Humboldt and *Modern Painters* I. Yet even here, his central intuitions partake of the romantic critique of secular rationalism at its most interesting. In the orthodoxy of modern naturalism, scientific truth is distinguishable, if not from the limitations of human perception, at least from the cultural assumptions of the observer, and also from technological uses. The restraint on these applications—on nuclear weaponry, for example, or genetic engineering—is a political and not a scientific problem. Ruskin, on the other hand, sees science as inextricably part of a nation's cultural life and insists that the organization of science, its technical applications, and even to some extent the model of the world that scientists present are cultural expressions. These are most clearly evident in the motive to power and the motive to abstraction. To prefer generalization to the description of particulars implies that the aim of science is intellectual mastery and therefore the expression of a culture's aggressivity. As Ruskin was quick to notice, the association of knowledge with aggressive prowess was very much a part of organized science among the Victorians. The controversies fought out in scientific journals could seem like an inflamed form of Mill's marketplace of ideas, and among the members of the Alpine Club, the peripatetic observer of old times was succeeded by amateur athletes testing themselves against the elements (Tyndall, for example, was a noted mountain climber).

These activities were for Ruskin expressions of industrial capitalism—a response, as he puts it, to "the demand of a sensual economy for originality in science" (XXII, 146). In his critique of the Renaissance spirit and of the economic theory it spawned, abstraction is simply the mental reflection of the will to power: one severs oneself from the phenomenal world in order to dominate it; but the aesthetic apprehension of things (what Ruskin once called the theoretic faculty) marks the spirit's bonds of sympathy and communion. Ruskinian science, then, counters knowledge as aggressivity—figured in *The Eagle's Nest* as a bird of prey—with knowledge as sensuous meditation, the humility that conquers pride. The undertaking of course means a return to the project of *Modern Painters* I—"wise art," as he tells his students, "is only the reflex or shadow of wise science"—except that, instead of arguing for factual knowledge as a condition of genuine aesthetic response, he now argues for aesthetic response as a condition of genuine scientific knowledge. Even the scientist must read the world as articulate speech. Thus the reform of natural science, like the reform of economic science, must show itself verbally, in a language that transcends the distinction between subject and object by evoking things in their full sensuous actuality. Ruskin is ambiguous about the scope of this reform, which shifts with his temper and audience. At times the energy of his

attack on abstraction allies him with the Coleridgean critique of Western science. At other times, his project seems appropriately modest, a way of making nature study useful and delightful. Science, for example, should conserve rather than exploit, not only through the essentially mnemonic activity of intimate description but also through practical beneficence: the whole aim of *Modern Painters* IV, he wrote in retrospect, was to make a case for Alpine irrigation in order to prevent erosion and flooding. Science ought also to be an act of teaching and dissemination. In his popular writings, Ruskin proposes to make available for all some of the joy and even playfulness he had known as a child. To do so he argues, among other things, for illustrations that are beautiful and accurate, nomenclature as clear and descriptive as possible, and essays that describe the "human" as well as the natural qualities of an object—the history of its uses and mythological associations. Much of the whimsy in these books comes from a deliberate questioning of the canons of seriousness, an attempt, as we have noticed earlier, to reconsider the whole category of play. What, he asks characteristically, directs the form of the leaf, making the fibers seek what they want "in woollen wrinkles rough with stings, or in glossy surfaces, green with pure strength, and winterless delight? There is no answer" (XIX, 378). From this perspective it is clear that the moral aesthetic is itself a defense of the play impulse as both expression and worship.

As has often been noted, Ruskin here anticipates, as dramatically as he anticipated anything, the ecology movement and the new forms of scientific journalism correlative to it. Like Ruskin, our contemporaries have tacitly reconceived science as a kind of attitude or interest rather than as a method of inquiry: key words like "environment," "ecology," and "conservation," with their connotations of nurture and cooperation, succeed the older paeans to technical progress and the virtue of intellectual curiosity. But just as obviously, Ruskinian science stands opposed to the essentially practical and cheerful spirit of the ecology movement. For him nature is not so much an ecosystem as a system of real Manichaean forces, whose appearances constitute a mythical structure similar, as it turns out, to a delusional system. As Ruskin's writings become increasingly obsessional, the term "literal" shifts from a phenomenological region, in which it refers to the invariability of human perception, to a region like that of the unconscious, where symbols become realities and thoughts become deeds. Just as, for the Evangelical, God must be recognized in order to be obeyed and Satan recognized in order to be defeated, so for Ruskin infidel science denies the existence of evil and the life of nature, only to discover diabolical forces in the form of monstrous bones and to assault the earth in a kind of rape. Forbidden knowledge now becomes the defilement of a literal mother and commerce with a literal devil. The system of nature, sen-

suous, personal, and Manichaean, is the embodiment of the human soul; the system of scientific abstractions is the collapse of psychic structure, viewed as a release of primitive, destructive energy. To enter the haunted region of Ruskinian science is to enter the region of the grotesque—the playing, sometimes fanciful and sometimes terrible, with an ultimate dread.

Ruskin coupled his two chief works of science by naming both after mythological personages—*Proserpina*, the book on flowers, and *Deucalion*, the book on stones. The titles suggest that their subjects are to be conceptualized in terms of myth rather than theory. According to *Proserpina*, which I will consider only briefly, plants are creatures that strain upward toward the light and downward toward the dark, like the seasonal goddess of the underworld (and like Ruskin's own Rose, now banished to the shades). At the same time Ruskin proposes a half-serious revision of Darwin, considering species in their "aesthetic" rather than their genealogical relations. The whole book is a kind of grave tweaking of the Darwinian nose, although in another sense, the nose being tweaked is that of Linnaeus. Linnaeus had classified flowering plants according to the sexual characteristics of its flowers, a procedure Coleridge had criticized because it touched only on superficial traits and not on the "constitutive nature and inner necessity of sex itself."[3]

Ruskin, on the other hand, replaces Linnaeus' Latin names for families with English neologisms derived from girls' names—a deliberately sportive gesture that has the serious purpose of connoting the "constitutive nature" of each family by anthropomorphizing them. He justifies his procedure, moreover, by the ruling dictum that the fruit and seed exist for the sake of the flower, not the flower for the sake of the fruit and seed: the flower, in other words, loses its sexual nature and gains an erotic one—it is to be enjoyed aesthetically, in and for itself, and not as the means to a reproductive end. But since the seed also carries within it the germ of death, *Proserpina* conceives of biological species in terms of a timeless pattern of aesthetic relationships, as in Eden before the fall and not in terms of a process of death and procreation proceeding through geological time. Like *The Ethics of the Dust*, *Proserpina* presents the world from the perspective of innocence rather than from that of experience—a looking glass world mirroring the real world of science and governed by the playful grotesque.[4]

[3]Coleridge, *Complete Works*, ed. W. G. T. Shedd (New York: Harper, 1884), I, 376. For Coleridge and Linnaeus, I am indebted to James Paradis, "Darwin and Landscape," in *Victorian Science and Victorian Values: Literary Perspectives*, ed. James Paradis and Thomas Postlewait (*Annals of the New York Academy of Sciences* 80 [1981]), 85–110.

[4]For a fuller study of the scientific works in general, see Edward Alexander, "Ruskin and Science," *Modern Language Review* 64 (1969), 508–521.

Deucalion, on the other hand, belongs to a different order of seriousness, for here Ruskin turns to the genuine combats of science, evolving along the way an extended rumination on the process of time.

"Lifeless Seed of Life"

In his introduction, Ruskin tells his readers that Proserpina and Deucalion are Greek myths of the betrayal and redemption corresponding to the Hebrew myths of Eve and Noah. Deucalion, survivor of a universal deluge, was told by the oracle that he could repopulate the earth by throwing behind him the bones of his mother, that is to say, the stones of the earth—"lifeless seeds of life," Ruskin calls them elsewhere (xxvi, 555). It follows that geology, like Turnerian landscape, is a kind of anatomy of our mother, but one that traces out the living lineaments, not one that analyzes her into dust. The antithesis of life and death also governs Ruskin's antithesis of myth to theory: myth records "a natural impression on the imaginations of great men" and theory "an unnatural exertion of the wits of little men."

> The writings of modern scientific prophets teach us to anticipate a day when even these lower voices shall be also silent; and leaf cease to wave, and stream to murmur, in the grasp of an eternal cold. But it may be, that rather out of the mouths of babes and sucklings a better peace may be promised to the redeemed Jerusalem . . . at the gates of the city, built in unity with herself, and saying with her human voice, "My King cometh." [xxvi, 99]

As in *Modern Painters* iv, stones emerge paradigmatically as antithetical signifiers, the things that may be either living or dead, while geology emerges as the paradigm of antithetical perception. In allegorical terms, the higher forms are dead at the present moment, as after the Flood, but the stones and the minerals (which, as Herbert says, marry "earth and plants" [xxvi, 344]) may knit together into a new race. Once again seeing, for Ruskin, is alchemy: the "eternal cold" of Dante's Caina (mentioned at xxvi, 346) is the ultimate "prophetic" vision of "theory," but the Heavenly City, like Deucalion's conversion of stones to seed, is the ultimate vision of the mythopoeic imagination—a new form of Wordsworth's "apocalyptic marriage" of mind and nature. The self can be redeemed only by knowing the world truly, and the world can be redeemed only by knowing the self truly. It follows that the writing of Ruskin's geological diary becomes part of its subject.[5] In

[5]Ruskin's method of publication was complex. Much of the material was adapted from lectures given at Oxford and elsewhere and was incorporated into a series of new

a playful moment, he claims he is presently planning seventy-four volumes (a Babel enterprise, evidently) and then calls his present works a "heap of loose stones collected for this many-towered city which I am not able to finish." *Deucalion*, then, as the "fragments of good marble . . . useful to future builders" (xxvi, 96), corresponds to the bones of the Mother and also, perhaps, to the sowing of the author's own seeds as the figurative offspring of the marriage. By attempting once again to make nature humanly available to human viewers and to rescue it from all in modern science that renders it abstract, frightening, and inhuman, Ruskin also attempts to vindicate his own way of seeing, his own right to speak as an elder statesman of the mountains.

Throughout the fragmented heterogeneity of *Deucalion*, Ruskin attempts again and again to construct an affective language that will compete with the scientists' purely empirical procedures. In one chapter he proposes to codify stones in the form of a grammar, and in another chapter, as an alphabet.[6] Most interesting for our purposes is the particular style, at once ruminative, associative, and elliptical, that becomes general in the writings of the 1870s and 1880s—the style that seems to present, as Rosenberg has remarked, the "lineaments of thought without the intervening medium of words."[7] One particularly homely and memorable example is the chapter on silicas of lava, an

queries, arguments, memories, and denunciations. It was then published in eight octavo volumes of "parts," containing two or three "chapters" apiece, extending from 1875 to 1883. The following synopsis gives an idea of the book's contents and their heterogeneity. A discussion of glacier flow in chapters 2–4 is interrupted by a personal reminiscence (chapter 5), then continues; chapter 7 is a lecture on the relation of precious stones to heraldry; chapters 8 and 9 are on crystallography; chapter 10 is a memoir of Forbes; chapter 11 returns to mineral classification; chapter 12 is a lecture on the streambeds of Cumberland; chapter 13 contains certain notes on silica sent by a friend; chapter 14, among other things, makes promises for the next volume that are not fulfilled. Volume 2 opens with a lecture on snakes, continues with a restatement of Ruskin's moral and religious principles to date, and ends with a poetic description of the forms of ice.

[6]When he was twelve, Ruskin tells us, he began a mineralogical dictionary "written in a shorthand composed of crystallographic signs now entirely unintelligible to me" (xxvi, 97); fifty years later he was arranging chalcedonies for a museum according to a numbering system "unseen by the public" ((xxvi, liii). These arcane schemes suggest an attempt not so much to provide descriptive categories as to encode the language of nature, transforming hieroglyphic objects into hieroglyphic signs that may then in some magical or alchemical sense master the chaotic flux of the experienced world. The most elaborate "grammar" in *Deucalion* is in the lecture "The Iris of the Earth," addressed to young women of means in a characteristic tone of saccharine condescension. Ruskin correlates the colors of gems with the traditional moral meaning of colors in heraldry, then advises the women to adorn their bodies like Tabernacles, so that the nation, composed of such jewels, may be as in Eden, rich in gold, bdellium (that is, crystal), and onyx. In the logic of the lecture, jewels are the primary signifier that renders three other systems interchangeable—women, the nation (Tabernacles), the natural order. In all these "grammars," and in so much of Ruskin's thought, the unacknowledged wish appears to be to control the world through signs, which are made ontologically primary to the things they signify.

[7]John Rosenberg, *The Darkening Glass* (New York: Columbia University Press, 1961), 187.

extended grotesque that quickly takes on the character of a diarist's private mutter. He has walked, Ruskin tells us, on "ghastly slags" of lava, where he practically burned his soles, slags that have congealed from the liquid state into

> ropy or cellular masses, variously tormented and kneaded by explosive gas; or pinched into tortuous tension, as by diabolic tongs; and are so finally left by the powers of Hell, to submit themselves to the powers of Heaven, in black or brown masses of adamantine sponge without water, and horrible honey-combs without honey, interlaid between drifted banks of earthy flood, poured down from merciless clouds whose rain was ashes.
> [XXVI, 234]

As in Browning's "Childe Roland to the Dark Tower Came," Ruskin builds his evocation of sterility by conjuring up absence. There is no honey or water, the clouds are not merciful, the flood is not a flood, the rain is not rain. The lava is kneaded, but it is not bread; it is cellular, but there is no life. The basic analogy of earth and water calls upon hunger and thirst, then denies it by the evocation of dryness. There is no moral pretext for the description, as there would have been in *Fors,* and yet it suits the mood of the rest of the chapter. There Ruskin's mind lurches back and forth in stubborn irritability. He demands answers, "with illustrative specimens," from the geologists. He rails at the infirmities of himself and others (he is "weary of . . . losing the powers of observation and thought which are connected with the complacency of possession, and the pleasantness of order" [XXVI, 236]). He harps on his age ("but I find silica enough . . . for my life, or at least for what may be left of it" [XXVI, 235]). In these dry thoughts of a dry season, rock seems transformed into the medium of prose, which then becomes its own subject, the condition of a particularly crabbed music.

But the most pervasive subject of Ruskin's tactile music is glacial ice. A glacier, he says, building a characteristic matrix of metaphors, is "a tide which takes a year to rise, a cataract which takes fifty to fall, a torrent that is ribbed like a dragon, and a rock that is diffused like a lake" (XXVI, 163n). But in a series of kitchen experiments, relating the frigid and vast to the cozy and domestic, he builds mountains out of blancmange and presses dough hills into folds; one "mellifluous glacier" of honey flowed across his plate through "magnificent moraines composed of crumbs of toast" (XXVI, 162). The Alps are themselves "one great accumulation of ice-cream" poured out like "melted sugar . . . on the top of a bride-cake." Remarks such as these fall into a strange mix of the earnest and the playful, as though Ruskin were parodying the scientists in the very attempt to upstage them. At another point he dines in a Swiss hotel, "disturbed partly by the invocation . . . of calamity on the heads of nations, by the howling of a frantic

wind from the Col; and partly by the merry clattering of the knives and
forks of a hungry party in the salon" (xxvi, 219). His remarkable aside,
revealing in a flash two worlds of consciousness, recalls his early re-
mark that, in the grotesque, the mind "*plays* with *terror,* and summons
images which, if it were in another temper, would be awful, but of
which, either in weariness or in irony, it refrains for the time to ac-
knowledge the true terribleness" (xi, 166). Here the clattering of knives
and howling of winds correspond to the avalanches of honey, as
though Ruskin were using the kitchen to shore up the fear of elemental
forces and the desolate world discovered by the natural sciences, but
his absorption with the ooze and fall of treacle also suggests something
else—an aging man's symbolic play with the inexorable, embodied in a
child's treat.

In the structure of *Deucalion* as a whole, the motion of ice unites the
flow of thought with the flow of time. Like time, glaciers fascinate
Ruskin because they move yet seem not to move. The Alpine snows, for
example, "will lie in the hollows like lakes, and clot and cling about the
less abrupt slopes in festooned wreaths of rich mass and sweeping
flow"; yet this charmed stasis is deceptive.

> Yet never for an instant motionless—never for an instant without internal
> change, through all the gigantic mass, of the relations to each other of
> every crystal grain. That one which you break now from its wave-edge,
> and which melts in your hand, has had no rest, day nor night, since it
> faltered down from heaven when you were a babe at the breast; and the
> white cloud that scarcely veils yonder summit ... has strewed it with
> pearly hoar-frost, which will be on this spot, trodden by the feet of others,
> in the day when you also will be trodden under feet of men, in your grave.
> [xxvi, 134–135]

To give a sense of such slowness, Ruskin cites measurements—the
glacier moves two feet a day, an inch an hour, three times slower than
the minute hand of a watch—then concludes, "Between the shores of
the vast gulf of hills, the long wave of hastening ice only keeps pace
with that lingering arrow [i.e., the minute hand], in its central crest;
and that invisible motion fades away upwards through forty years of
slackening stream, to the pure light of dawn on yonder stainless sum-
mit, on which this morning's snow lies—motionless" (xxvi, 135). "Mo-
tionless" brings us back to "yet never for an instant motionless" and
emphasizes the contrast between motion that is frozen ("sweeping
flow" and "breaking away," above) and ice that is moving, however
imperceptibly. One paragraph moves forward to death and backward
to birth, encompassing both limits of human time; the next paragraph
freezes forty years in a single view, yet collapses time at the mountain
peak, since the peak is at once forty years "back" and as recent as this

morning. Both paragraphs create an almost mystic sense of visual mastery over time even as the viewer is humbled before an object that will survive him almost indefinitely. The glacier, then, allows the viewer to put himself into an extraordinary and paradoxical relationship to time, while the icy flow finally becomes the flow of consciousness itself—inscrutable when examined, immense in its cumulative effect.

Around the glacier as a figure for inexorability, the book sets up a double scheme of historical discontinuities—between the human present and the remembered past, and between the human past and geological antiquity. Nowadays, according to Ruskin, tourists plunge through the Alps in trains, flourish Alpenstocks, and pass off seeing nothing. "We used to do it differently in old times," he declares, showing his audience Turner's first study of the Lake of Thun (XXVI, 111), where a boat sails peacefully across a crystalline surface. Both art and memory occupy a timeless region of imaginative experience, which is shattered in the present: the blindness of the mechanized tourist is a symptom like the visions of materialist science—the boiling of seas, the heaving of mountains, the extinction of monstrous beasts, all of which Ruskin would banish by a kind of visual bracketing. "I do not care,— and I want you not to care," he tells his students, "how crest or aiguille was lifted. . . . I do care that you should know . . . in what strength and beauty of form it has actually stood since man was man" (XXVI, 113). Seen in this way, the world is restored as an ancient and familiar place, "practically eternal," with its local traditions and names that endure for longer than we shall know: "But yonder little rifted well in the native whinstone by the sheepfold,—did the grey shepherd not put his lips to the same ledge of it, to drink—when he and you were boys together?" (XXVI, 121). The point is strengthened by a theoretical contribution of Ruskin's own: streams, he asserts, do not wear down their beds, but gradually fill up the valleys, so that in fifty years he has recognized no change in any of his "old dabbling-places." As in *Modern Painters* IV Ruskin insists that the earth's decline is inexorable: "All character is being gradually effaced; all crooked places made straight,—all rough places plain; and among these various agencies . . . none are so distinct as that of the glacier" (XXVI, 123). As interpreted by Ruskin, Lyell's three eras correspond roughly to his own theory of the cresting and decline of nations, so that *Deucalion* transfers to the Alps the time scheme of *The Stones of Venice*. Thus, he has it both ways: just as the glacier, when we watch it, appears to move and not to move, so does the clock of the earth. If we bracket at one end of the time flow the revelations of atheist science (a kind of Apocalypse before Creation) and at the other the equally hideous depredations of recent civilization, we will find the works of men most worthy of enduring figured in an Edenic valley that is "practically eternal."

So far Ruskin's quarrel with science seems but a vague attack on a state of mind, since he has found no means to question the methods of the geologists, or their findings, or their prestige as discoverers and theorists. This opportunity came in the controversy over glacial movement. In 1843 James David Forbes published the theory on which Ruskin's poetic description of glaciers is based—the theory that ice, although apparently brittle, behaves as a viscous substance when subjected to steady pressure. In the 1860s Tyndall, on the suggestion of Huxley, proposed an alternative view, drawing upon recent discoveries in mechanics, particularly Faraday's theory of regelation. The resulting controversy was bitter even by the standards of the times, partly because Forbes was accused of failing to acknowledge his predecessors. Of Forbes's challengers, Tyndall was by far the most distinguished. An articulate advocate of philosophical materialism and a brilliant physicist, whose theories had beneficent practical applications, he was also a passionate lover of nature—he had published his own record of Alpine travels in a poetic, descriptive mode not unlike Ruskin's—and the only scientist to become a close friend of Carlyle's. In several ways, then, he was Ruskin's scientific counterpart, if not indeed a type of the practical, sturdy man of science praised in *Modern Painters* III. Stung perhaps by unconscious rivalry, Ruskin chose to make Tyndall the focus of attack by entering the defense of Forbes, exactly as he had entered the defense of Turner thirty years before, picturing Tyndall as an arrogant johnny-come-lately and Forbes as the traduced representative of the "old ways," of a science modest, accurate, and loving. The hysteria of Ruskin's diatribe suggests the degree to which he displaced onto the glacier question his generalized rage at an atheistic and technological society and, more deeply still, the fear of his own diminished power and uncontrollable anger.[8]

[8]In a memoir published in 1884, a friend quotes some of Ruskin's opinions on modern scientists: "As regards my opinion of Tyndall, I admire his splendid courage (I am a dreadful physical coward myself . . .), and his schoolboy love of adventure . . . , naive to a degree—incurably so; but he has never felt himself to be a sinner against science in the least because of his all-overwhelming vanity. His conduct to James Forbes . . . was the outcome of the schoolboy feeling when he sees the Alps for the first time: 'Good gracious! no one ever saw this before; and I can tell the world all about it as no one ever did before!'. . . . But before long people will find that this theory was all decided before this conceited, careless schoolboy was born. And that is why I always attack him, and shall continue to do so until I die" (xxvi, xln). The attack seems to echo Ruskin's distaste for his own "snappish young-mannishness" thirty years earlier. I have studied the glacier controversy at greater length, focusing on the scientific issues at stake and on Tyndall's career and reputation as a whole, in "Ruskin and Tyndall: The Poetry of Matter and the Poetry of Spirit," in Paradis and Postlewait, pp. 217–246. Interestingly, Forbes's view has since prevailed over Tyndall's as the result of later "applications of thermodynamic principles to continuous deformation under stress," although Forbes's formulations were indeed somewhat vague, given the limitations of his measurements. See *Dictionary of Scientific Biography* (New York: American Council of Learned Societies, 1976), XIII, s.v. "Tyndall."

The centerpiece of his attack appears in "Thirty Years Past," which defines the glacier question as essentially a conflict between past and present and between vision and desecration. The chapter is as remarkable for its emotional disequilibrium as for its mastery of structure. The title refers to an incident in 1844, when Ruskin and his parents met Forbes by chance during their travels in Switzerland. (It also alludes to the subtitle of a Scott novel and therefore indirectly to the fact that Forbes was the son of Scott's "first love"; Forbes is thus made to occupy the timeless region of Ruskin's boyhood reading and his boyhood visits to Scotland.) The old geologist appears in this chapter through a haze of memory as he and the Ruskins fall into conversation in a hotel. Afterward we follow young John on a morning hike up the fresh slopes of yesteryear. The rest of the narrative interlaces past and present with the skill of the best *Fors* letters: Ruskin in the present reads Dante as his coach climbs the slopes (in the poem Bernard is looking down from Paradise upon an unused Jacob's ladder and the disarray of the order he founded), then beholds the sky clear over the Aletsch glacier ("the intermittent waves of still gaining seas of light . . . as if on the first day of creation" [xxvi, 226], or indeed as if looking down from the celestial spheres), only to have his epiphany befouled when a guide shows him a "*hôtel*" built by Professor Tyndall on the Bell Alp—a sight that stirred up "every particle of personal vanity and mean spirit of contention which could be concentrated in one blot of pure black ink" (xxvi, 227). The scientific Hotel is a nest of philosophical fleas, "puces des glaces," facing the house of Christian Hospitallers that now lies vacant. The connections in the passage are typically complex: the empty hospice recalls St. Bernard and the lapsed orders, a symbol of the age of faith like Arnold's Grande Chartreuse; Forbes appears as a great shape from the past, like Bernard, quiet, dignified, and absorbed; spiritual aspiration is succeeded by earthly ambition, as the "philosophers," prophets of a new religion of materialism, swarm over the glacier they desecrate like antithetical angels on a frozen ladder.

The image is a moment of Faulknerian horror, seeming to mark the death of the romantic dream of nature. As for Tyndall, he is a poor writer, a sloppy draftsman, and a dishonest controversialist—a "scum of vanity," "unsteadied by conceit, and paralyzed by envy," and so forth. The attack on Forbes's opponents is an attack on discontinuity, but the defense of Forbes is a defense of continuity, of which the discussion of continuous flow in nature is the unconscious emblem. In addition to the kitchen experiments mentioned above (themselves borrowed from Tyndall), Ruskin analyzes the process of flow by tireless verbal qualifications and distinctions. There is, for example, the "perfect and absolute plasticity of gold," "the fragile, and imperfect . . . plasticity of clay, and, most precious of all, the blunt and dull plasticity

of dough"; "the vigorous and binding viscosity of stiff glue," the "soft-ening viscosity of oil, and tender viscosity of old wine" (XXVI, 156–157). Or again: "You can *stretch* a piece of India-rubber, but you can only *diffuse* treacle, or oil, or water. . . . let [honey] be candied, and you can't pull it into a thin string. . . . You can't stretch mortar either. It cracks even in the hod, as it is heaped" (XXVI, 141). Exactly as in the attack on Mill, Ruskin attempts to crush Tyndall on his own ground by means of an apparent refinement of logic—he distinguishes, for example, be-tween "plastic," "viscous," "ductile," and "malleable." The reason Tyn-dall cannot see that ice could be viscous is his inattention to words and the phenomena that words reflect. By implication, however, Ruskin's use of language would refute not only Tyndall but the empirical meth-od as well. For Ruskin, verbal distinctions increase the mind's sense of concrete particulars in nature—the natives of Cumberland, for exam-ple, have six words for "valley" (XXVI, 244)—and also have a real corre-spondence to the forms of nature. The mark of bad science is the coinage of vague and ugly terms like "sub-aerial denudation"—a dis-solution of the passionate and concrete into the pompous and abstract.

The defense of Forbes is a reassertion of what we might call a moral empiric: the belief that scientific truth, like great art, can be the prod-uct only of direct and sensuous apprehension and an expression of the perceiver's moral state. Tyndall is wrong, finally, because he is a wicked and irreverent man. But his selfish conceit is also, in effect, an oedipal revolt directed against both nature and his predecessors. Ruskin, in attacking him as an arrogant schoolboy, exorcizes everything in himself that is unruly, contentious, and discordant and then, by joining himself with an ideal paternity represented by Forbes, heals the breach with his own past—the same structure as that of *Modern Painters* I. But now the sublime ecstasy that marked the union with Turner is replaced by a spot of time *remembered* as a vision.

"The Vale of the Cluse" narrates such a moment, an occasion of almost mystical rapture occurring on Ruskin's last walk through the valley in 1874. He has just returned from six months in Italy, a nation already delivered, it would seem, to the fiends: "monstrous and inhu-man noises . . . , wild bellowing and howling of obscene wretches . . . , clashing of church bells . . . dashed into reckless discord . . . as if wrung by devils . . . , filthy, stridulous shrieks and squeaks." Then, suddenly, he "found himself . . . , as in a dream," walking through the Swiss vale, a favorite spot of his youth, "unchanged since I knew it first . . . quite forty years ago." The sudden transition turns the experience into a vision, rendered with hallucinatory clarity:

> But presently, as I walked, the calm was deepened, instead of interrupted, by a murmur—first low, as of bees, and then rising into distinct harmo-

nious chime of deep bells, ringing in true cadences—but I could not tell where. . . . I turned about and stood still, wondering; for the whole valley was filled with the sweet sound, entirely without local or conceivable origin; and only after some twenty minutes' walk, the depth of tones, gradually increasing, showed me that they came from the tower of Maglans in front of me; but when I actually got into the village, the cliffs on the other side so took up the ringing, that I again thought for some moments I was wrong.

Perfectly beautiful, all the while, the sound, and exquisitely varied,— from ancient bells of perfect tone and series, rung with decent and joyful art.

"What are the bells ringing so to-day for,—it is no fête?" I asked of a woman who stood watching at a garden gate.

"For a baptism, sir." [xxvi, 151–152]

But soon the beauty and peace of Cluse (the "closed valley") will be lost forever, for a railroad is about to be thrown across it. When in his concluding paragraph Ruskin contrasts the "claims of all sweet pastoral beauty" with the "present state of science" ("dispute, and babble, idler than the chafed pebbles of the wavering beach"), he enacts for us the Betrayal and the Redemption: for the Cluse with its archetypal elements—the woman by the garden, the bells, the baptism—is the valley of the Edenic past and the baptism its temporary recapture. The waters of the sacrament, like the "refluent sea" of Jordan contemplated by Bernard, reverse the flow of time—the torrents and glaciers of the Alps, the falling rocks, the slow pollution of history that becomes one with the pebbly chatter of the materialists. Juxtaposed against that chatter, the discord in effect of damned spirits, is the valley's low hum like a single bell, the union of human and divine and also the music of the spheres as Bernard would hear it.

As in the garden of old, the diabolic agencies of the present bring the temptation to forbidden knowledge. In a lecture in Cumberland, Ruskin warns that the Mylodon, or giant sloth, was created by the devil and is now exhibited by "the fiends" in the British Museum (xxvi, 264), where it unnerves and brutalizes schoolchildren: they become what they see. The diabolical is also the subject of a lecture on snakes, entitled "Living Waves," which makes its way incongruously into a book on geology. First Ruskin warns his audience against the venom of snakes (his accounts of actual deaths by snakebite are repellent in their detail) and then, more important, against their significance as "hieroglyphs" of evil. Lest his hearers forget the latter, he shows them an engraving of Eden from Giotto and concludes with a bizarre account of young men stuffing themselves with serpentine knowledge until they turn into human sausages, goaded on by the vanity of well-meaning fathers: "And the fathers love the lads all the time, but yet, in every word they speak to them, prick the poison of the asp into their young

blood, and sicken their eyes with blindness to all the true joys, the true aims, and the true praises of science and literature" (XXVI, 329).

Ruskin's interest in the demonic hieroglyph had intensified in the 1870s into obsession: the *Fors* letters, which he wrote as a symbolic reenactment of St. George's struggle, had their nocturnal counterparts in the huge serpents he wrestled in his dreams, a protracted mental torment that reached its climax in 1878 with his first attack of madness. "Living Waves," delivered two years afterward, speaks with authority, then, on the question of demonic temptation; yet the snakes also embody in hieroglyphic concentration the phenomena of motion that Ruskin has been describing throughout the *Deucalion* series. The analogy between glaciers and serpents is not capricious. Any aerial photo will show the long, nestling arms of ice, marked by dirt bands that indicate the direction of invisible flow. Sometimes Ruskin makes the association explicit: the glacial torrent is "ribbed like a dragon," and even the Alps themselves may seem monstrous. We have already noticed the importance of grotesque connections in this book's descriptions—a lava specimen, for example, can be "an oolite with yolks of its eggs dropped out" or a "gaseous wasp's nest." The technique reaches an almost hysterical climax in "Living Waves," where Ruskin "classifies" snakes as lizards who have lost their legs, fish who have lost their fins, birds who have lost their wings, and honeysuckles with heads stuck on. The matrix of associations makes the object seem anomalous, while the formula of "like a this without a that" emphasizes disjunctions and vacancies, as though to show that all species, the beneficent and the sinister, if not indeed all valuations, shift perpetually in an arabesque of joinings and dissolutions that the serpent symbol cannot contain.

The obsessions of Ruskin's declining years—the adders of "Living Waves," the phantoms in the bedchamber, the demonic hisses and plague winds—seem far removed from the springtime exultation of *Modern Painters* I, yet they are simply more horrific versions of the primal energies in nature and man that have been Ruskin's concern at every point of his career. We have not yet considered the leitmotif of the serpent and its related ideas—religious dread, sinfulness, and time—in their central position in Ruskin's evolving myth. "Living Waves" provides a chance to do so before we return to the final episode of *Deucalion,* which in some ways calms the disturbed energies of that book.

Serpent and Grotesque

In *Modern Painters* I, the Ruskinian speaker tests his equanimity before extreme occasions of elemental fury that never become uncanny because they are always legible: sublime experience is always the warn-

ing or teaching of an Evangelical deity, even though the ecstasy of beholding arises from the terror of a potential indeterminacy. In the next volume, however, awe takes a slightly different form, arising from the possibility of fanciful associations repressed by the first volume's adherence to fact. The partially glimpsed serpent in Turner's *Jason*, for example, terrifies by its suggestion of the unseen, a terror that Ruskin links with the power of the deity and of the artist's overmastering intellect. But the artist's power is never quite overmastering, because it evokes and confirms a corresponding power in the viewer. Similarly, in the theory of the symbolic grotesque, Ruskin attributed sublime effects not to elemental phenomena in themselves but to those phenomena as signs of the unseen. Grotesque gaps and combinations are essentially a reshuffling of natural logic to reflect an underlying supernatural logic. This act of revealing follows the moment of dread at the ninth hour of the Apocalypse, the moment of uncanny recognition that things are not themselves but signifiers. I suggest that this thrilling dread is a person's own repressed desire experienced as alien—figured as objects that do not move of their own will but in accord with some inscrutable intent.

Prophetic art, in which the terror and beauty of the creation are partially accommodated to distorted human speech, requires in the seer a correspondent power to withstand and absorb. The art of the great naturalists, in which human evil is recognized for the purpose of redeeming it, requires a similar power to withstand and absorb, which in "The Nature of Gothic" is figured as organic energy—the prickly waywardness, rigidity, and exuberant redundance of vegetable growth. It is as though the inspired seer, having reconstituted his ego as the point of coherence in a landscape, may now reconstitute his ego as the point of coherence in the human community: in Christian terms, the believer, nourished by the true vine, absorbs Christ's power to suffer, affirm, and triumph. But although the old Adam, who fell, is reborn in a religion of mercy, the old enemy survives. If the unfallen Venice represents the condition by which desire and the object of desire are merged, the Renaissance pride of knowledge is the condition in which desire chooses a false object.

Ruskin's conception of pride as repression derives partly, I have suggested, from biography—from the loss of Adèle and from the emotional breakdown following the pressures of study at Oxford. The diary of those troubled months, which Ruskin divided into Head and Heart, reflects a deeper division with the family: the son, fusing his ambition with his parents', sacrificed his heart's deeper need—and this sacrifice he called in his book knowledge, venomous and puffed up. But as repression can stifle desire only by distorting it, Renaissance knowledge is paradoxically both ascetic and debauched. Just as the loss

of Adèle repeated an earlier, unconscious loss, so the knowledge gained from the famous wedding night, we may speculate, revived an earlier, unconscious fear, the primal recognition that puts the term to the childhood Eden. According to Freud, the child infers from the sight of the female body the father's power to castrate. In the over-determined symbol of the Renaissance spirit, sexual knowledge and the repression of desire—the two threats to the primal union of object and desire—fuse into a single principle of self-isolating separation, the activity of a castrated self that experiences itself and its creations as life-less husks. The principle of separation is also the death brought by the serpent into the garden, since, as Ruskin says, the other name of separation is death. The Renaissance, terrified of its own mortality, constructs monuments to death in life, converting the garden that was into a whited sepulchre. Against that principle, Ruskin proposes a liberating sublimation, an erotic communal bonding that expresses itself in the exuberance of great architecture.

The exuberance is Gothic naturalism, the ego's attempt, as I have suggested, to reconcile through acceptance the primitive dichotomies that structure *The Stones of Venice*—the antitheses of innocence and experience, purity and corruption, and communion and separation. The ego, in Norman O. Brown's phrase, must become strong enough to die; but this strength depends upon accepting the body and abandoning the unconscious attachment to the virgin mother, who binds the self to the infantile past through the terror of death viewed as separation. But the book retreats from this mature acceptance, because the horror of the corrupted city calls up its opposite, the fantasy of an unfallen, virginal spirit that guarantees her sons' greatness—and this is the ideal that Ruskin secretly married while he was publicly pledged to Effie.

But in the final volumes of *Modern Painters,* Ruskin developed at last the image of an ego strong enough to die, strong enough, that is, to wrestle with the death instinct that now governs the world. In myth the serpent, a detached phallic animal who knows, embodies both the oedipal desire and the punishment of the desire. Both potent and impotent, both living and dead, it moves with a power uncannily its own yet not its own, like a machine—or so it does in Ruskin's thought. In Ruskinian myth, history and cosmology fuse into a dialectic by which purity, the energized and radiant union of the parts of an organism, stands in prior relationship to corruption, the dissolution of parts following upon a withdrawal of divine energy. As an active agent, the principle of separation becomes the death instinct—a blighted and serpentine vegetable growth, for example, or a filthy beast that divides and proliferates horribly. In Ruskin's reading of *The Garden of Hesperides,* the painting collapses history by juxtaposing the garden at the

moment of rupture against the dragon of the present—the beast that seals off the valley and represents the culmination of human defilement through time. It is the "British Madonna," the final, lamialike transformation worked by the modern spirit upon the primary, natural union. But in a different allegory, Apollo triumphs over the Python by transforming the power of death into the power of healing. This and other examples suggest that life and death are set against each other not as separate principles but as transmutations of a simple, ambivalent force. Streams, for example, are pure when regulated but dragonlike—torrential and sterile—when not. The Hesperides, goddesses of twilight, are bright with the passing of the sun's rays through dust. The Sybil, holding the term of her life in a handful of dust, holds also her hope and promise. Death, acknowledged, is part of life.

In art the agency of these tragic affirmations is the noble grotesque, which Ruskin links to the acceptance of the fall through the imagery of the broken mirror. In Lacanian terms, the mirror stage, the fantasy of a unified ego presented in the image of a unified other, has been abandoned, but by presenting the brokenness of the human and natural condition, tragic art paradoxically presents the means to a new unity through connection, to be achieved temporally through purposive action. Apollo becomes the Pythean. In the primitive oedipal fantasy that this image expresses, the son absorbs the power and the knowledge of the serpent father, but the serpent as generative power is also the principle of mortality. We can now see the connection between the Python and Veronese's Solomon, who is also Christ and therefore the double-natured Griffin of the noble grotesque. Christ is the divinity who is also human, a god that triumphs and an animal that dies. Man, who is nobly human and nobly animal, becomes Christ. The ego strong enough to die is now free to redeem the broken world by converting illth into wealth—the eternal and self-affirming energy embodied in objects of determinate desire. In Ruskinian economics, repression, or the death wish that starves, is converted into erotic creativity, which nourishes. Masturbation, symbolized in fecal images, and sexual love, symbolized in images of flowing and generation, provide the physiological substructure of a new utopian myth. For Ruskin capitalism is like a compulsive onanism that parodies childbirth by filthy self-reproduction yet obeys the laws of Victorian genital economy, which is finite and self-depleting. But the abundant economy, achieving the promise of an inexhaustible energy, also fulfills the primitive narcissistic fantasy of self-reproduction by converting the primitive self into an organic community.

The symbolic form of this community is a garden paradise ruled by a king and his queen. But Ruskin's own struggle with the Python was emotionally catastrophic, and the anima of the English utopia re-

mained shadowy and distant. In his private life he fell back upon the fantasy of a child world in which Rose, the image of determinate desire, also reconstituted the nostalgic denial of death and time. His courtship of Rose depended on a ceaseless propitiation of a new set of parental withholders. Mrs. La Touche he called Lacerta, the serpent; the children in *The Ethics of the Dust* are, fortunately, make-believe dragons who can devour the Lecturer only with their childlike attentions—they have not yet seen the garden of after life, with its singing serpents, and so cannot become what they see. The little dragons (like the tiny chess queen that Alice holds in her hand) are a playful grotesque. Although Ruskin and the children are both parent and child, he is sole ruler. The garden, which is both present and past, is not so much preadolescent as pre-oedipal: what is banished is the castrated creature that can castrate, and what is denied is Turner's "hopeless" belief that there can be no rose without a worm. Yet that denial is only partial, because the child garden, like the pastoral, has meaning only in terms of what it excludes—the principle of separation. By splitting the world into two perspectives, the perspectives of innocence and experience, Ruskin defines the condition in which there may be a rose without a serpent, but the acceptance of the serpent in experience requires the compensatory fantasy of the child secluded in innocence.

The Queen of the Air, on the other hand, represents the timelessness possible to the world of experience—not the child garden but a prelapsarian Greece in which, as in the biblical Eden that Ruskin described in the letters to a college friend, death exists as part of a greater, dialectical harmony. In this book Ruskin reconstructs the dynamics of the Protestant sublime by imagining a feminized cosmos, personified by a deity of double aspect—the gorgonlike punisher or warrior and the angelic maiden or guardian—who also enters into generative union with an opposed power of pure matter, the dust into which the breath of life is breathed. Ruskin pairs his invocation to the bird, which we have examined above, with an equally beautiful invocation to the serpent, paradigm of the "earth-power":

> A wave, but without wind! a current, but with no fall! . . . one soundless, causeless march of sequent rings, and spectral procession of spotted dust, with dissolution in its fangs, dislocation in its coils. Startle it;—the winding stream will become a twisted arrow;—the wave of poisoned life will lash through the grass like a cast lance. . . . It is a divine hieroglyph of the demoniac power of the earth. [XIX, 362–363]

The bird, like a pagan god, is a center of energy from which emanates the sacred diffusion of the elements; the serpent, by contrast, lacks a center or even a determinate self: the word painting robs it even of its

unity as an organism ("march of rings," "procession of dust"), for it is the antithesis of unity ("dissolution in its fangs, dislocation in its coils"). Unlike the bird, which generates many metaphors each of which captures its essence—it is in this verbal sense the many in the one—the serpent is an indeterminate thingness that can be known only as an anomalous version of something else, a hieroglyph that paradoxically embodies no Word. This is the necessary aspect of nature that is forever an It, never a Thou, forever evading propitiation and definition.

The Queen of the Air presents the cosmos as pattern and process but occupies no temporal dimension: it occupies in some sense the mythic past, but in another sense the timeless realm of imaginative activity. The third part of that book, however, shifts dramatically into a kind of disturbed diary that is also a curse on the present—and this mode brings us, finally, to the *Deucalion* fragments of the 1870s, in which the world has been given over to the earth power, now seen as the active agent of fallen time. Ruskin's subtitle, *Collected Studies of the Lapse of Waves, and the Life of Stones,* refers to the flood and the rocks of the Deucalion myth, but "lapse" and "life" are also metaphysical forces, the one working on the other as water corrodes rock and age corrodes the spirit. On his first page Ruskin says that the excitement of heart and brain, if "temperate, equable, and joyful," tends to "prolong, rather than depress, the vital energies. But the emotions of indignation, grief, controversial anxiety and vanity, or hopeless, and therefore uncontending, scorn, are all of them as deadly to the body as poisonous air or polluted water" (xxvi, 95). As Ruskin suffered more and more the strains of fear and disappointment, as well as the organic malady that eventually destroyed his mind, he projected more and more of his fears onto a single diabolical idea. There are those, he wrote in "Living Waves," who believe in "another Kosmos, mostly invisible, yet perhaps tangible, and to be felt if not seen" (xxvi, 344–345). *Deucalion,* as we have seen, describes the present cosmos in the form of a wave moving and arrested—the babbling of the Yew, the ooze of treacle, the frozen flow of ice, the immobile ripples of stone, the sinister weaving of the serpent—from the sweet to the bitter, from the waters of life to the sting of death. The description of glacial snow collapses time so that forty years back is also the newest fallen snow, but those pure crystals will drag themselves inexorably to the last doom. As the Time-Spirit was for Carlyle the Devil of this world, time becomes for Ruskin the principle of separation, like the railroad that defiles Venice and seals off the valley of Cluse. The phallic railroad—for Turner as for Ruskin—is a mechanical serpent, a human product that masters its creator and brings upon the civilization of which it is the material emblem the curse of masturbatory capitalism—blindness, atrophy, pollution. Cap-

italism, finally, is the legacy of the bad fathers, whose blessing turns helplessly into cursing: "And the fathers . . . prick the poison of the asp into their young blood, and sicken their eyes with blindness."

The serpentine woman, the castrated thing that can castrate, finds her counterpart, then, in the phallic machine, the soulless thing set over against nature, whose motive power is in some sense external and therefore inscrutable, like the uncanny. Symbolized in the train, the Time-Spirit is the agent of separation, not from the past only but also from nature, the infinite, organically cooperative system from which it revolts yet of which, in the form of the serpent, it is a part. The triumph of the machine in the social world corresponds to the triumph of ungovernable forces in the economy of the soul. When Apollo no longer has strength to absorb the Python, the serpent becomes the emblem of the ultimate horror of the diffuse and undetermined, the disintegration of the self. This, for Ruskin, is the agent of the Betrayal: what, then, is the agent of Redemption? Great myth, Ruskin wrote, is the product of a mind "conscious of certain facts relating to its fate or peace." Fate or peace: so much of his passage into age and so much of the rhythm of his last books rest on these poles. In *Fors Clavigera,* Fate is the goddess of this world, enforcing the law of a debased economy; in *Deucalion* the scarce economy becomes the law of nature. In both books, the will to endure is a ceaseless agon fought with the hope of some distant or perhaps merely symbolic redemption, but an underlying pessimism, metaphysical rather than merely political, suggests that time is redeemable only by some form of visionary escape that more and more asserts itself against the diminishing possibilities of moral action. That escape rests on a new mode of memory, an experience of the past as transcendent vision.

In 1887 Ruskin wrote to a scientific friend, "For everything I thought I *knew* of minerals . . . has been made mere cloud and bewilderment by . . . Judd's address at the Geological of planes of internal motion, etc., and all my final purposes of writing elementary descriptions of them—broken like reeds." The fret of controversy gave way to resignation: "But, alas! I am not able any more but for the quiet of evening among the hills" (xxvi, lxiii–lxiv). The quiet of the hills at evening and Judd's planes of internal motion mark the distance attained in Ruskin's day between the two modes of perception, the sensuous and the analytical, that Ruskin had tried to synthesize as a geologist. The time was past when Saussure, Ruskin's "master in geology," could go to the Alps "as I desired to go myself, only to *look* at them, and describe them as they were, loving them heartily—loving them, the positive Alps, more than himself, or than science, or than any theories

of science" (xv, 476). The fragments of *Deucalion* are the wreck of that older vision. And yet the book ends in something of a triumph of the romantic imagination—a free-flowing prose poem on the forms of ice called "Bruma Artifex."

Like a diary entry, the chapter begins at a place and time—the hill garden of Brantwood after the frost of March 9, 1879. Everywhere beneath his feet, Ruskin tells us, clods and particles of earth have been thrust aside by minute "thread-like crystals . . . , presenting every form usual in twisted and netted chalcedonies," but so small that the "fringes of needle-points" melt as one breathes on them. These "coiled sheaves, or pillared aisles" represent "ice-structure wholly of the earth, earthy" (xxvi, 348), but show no vestige of stellar crystallization, such as that on the surface of lakes. Ruskin's thought next moves to icicles, "compact, flawless, absolutely smooth," that enclose "living leaves" in "clear jelly" without disturbing "one fold or fringe" ("and the frozen gelative melts, as it forms, stealthily, serenely, showing no vestige of its crystalline power, pushing nowhere, pulling nowhere; revealing in dissolution, no secrets of its structure"), and then to other forms of ice—to the "inelegant incrustations" of certain waterfalls and the "glass basket-making" of smaller cascades (xxvi, 350–351). For the marvel of ice structure is that its formation, unlike that of other crystals, is infinitely variable: it can bind its units "into branches or weave them into wool; buttress a polar cliff with adamant, or flush a dome of Alp with light lovelier than ruby's" (xxvi, 353). Thus from the paths of Brantwood outward and outward, the scope of Ruskin's beholding expands, stopping only at the high Alps themselves. Suddenly, in the last page, he is describing a Greek coin, but at this point the reader of Ruskin does not need transitions, for it is clear that the embossed image of Olympian lightning is a fitting culmination to the chapter—an emblem of the "distributed fire" that disturbs earth and sky and, in fact, "glows" through all of Creation. Ice, then, is not only an embodiment of mystery but also a manifestation of the divine artisanship and therefore one, in its ceaseless labor, with the Olympian lightning.

"Bruma Artifex" is a quiet masterpiece of Ruskin's late years, delighting as it instructs through a combination of precise description, undisturbed tone, and metaphorical language. As a personality, Ruskin refines himself out of existence, yet his voice remains everywhere, building with the gradually expanding kingdom of ice. The insidious movement of serpentine weaving finds its positive antithesis in the creative weaving of nature, another form of Athena's craft, and also in the tireless tracing of the observant imagination, acting here like the "silent ministry of frost" in Coleridge's poem. Ruskin has briefly achieved the miracle he predicted at the beginning of his book by converting a cold, dead landscape into a living world—a world in which

the frozen element is revealed as sharing the same energy as the fire of Zeus. At the same time, the chapter resolves the tensions between age and youth set up in earlier chapters by revealing the survival of imaginative power in the winter of Ruskin's years. This it would seem, is the season farthest from the freshets of spring—it has been, we notice, a late frost—yet the crystal of ice is also the crystal of young streams, just as the last season of every year closes upon the new in full circle. Finally, in the last page of *Deucalion*, Ruskin finds the strongest symbol in his book of the organic vision of nature that never completely left him. The Olympian lightning, held by an invisible, divine hand, flows upward into waves of flame and downward into three petals, a kind of clasp upon two kingdoms in nature, the air and the earth, the light and the dark—taking the form of a plant.

"Ruskin's Apocalypse"

Our Life is compassed round with Necessity; yet is the meaning of
Life itself no other than Freedom, than Voluntary Force: thus we have
a warfare.
—Thomas Carlyle, *Sartor Resartus*

Ruskin published the first letter of *Fors Clavigera*, addressed to
the "Workmen and Labourers of Great Britain," in 1871; it continued
as a monthly series until his first psychotic attack in 1878, then reap-
peared intermittently until Christmas of 1884. The complete group of
ninety-six essays, spanning thirteen years of his life and running to
more than 2,000 pages in the Library Edition, constitutes his longest,
most heterogeneous single book. How can we describe a work so vast
and formless yet so recognizably itself at every point? We might look
beyond literature for a parallel—to some colossal Tintoretto, for exam-
ple, had he gone mad and painted all of Venice with his reeling figures
and jagged, lurid chiaroscuro, then overwritten them with doodling.
As a literary genre the letters resemble many things partly, nothing
completely: they are something of a one-person magazine, like *House-
hold Words*, a set of tracts, like *Latter-Day Pamphlets*, a set of sermons, like
Newman's—something, in other words, of that distinctively Victorian
kind of series that represents an author's continuous presence before a
public. We may read them, again, as a series of prophecies marked by
spontaneous, private musings, as self-edited table talk with a polemical
purpose, or most simply as the largest of Ruskin's verbal museums.
They escape categorization chiefly because they defy boundaries al-
together, particularly the boundary that normally sets off formal struc-
tures from the affairs of life. The ninety-six essays mingle with supple-
ments—reports of the master of St. George's Guild, correspondence
with readers, clippings from newspapers. These in turn mingle with
the Guild projects, the museum and library in Sheffield, Ruskin's con-
temporaneous books (which they overlap at points), and the wealth of
dreams, events, and buried thoughts to which they make arcane allu-

sion—in short, with all the works and days of Ruskin's life. Above all, they are an ongoing project rather than a book, a way of translating the activities of life into a verbal order that in turn corresponds to an order of purposive action—specifically, the Guild, whose affairs the letters publicize and record. The Guild justifies the writing, the writing provides the organizing mythos of the Guild. But of course Ruskin ranges far beyond the Guild, seeming at times to forget it within a tissue of whimsicalities and preoccupations.

Does the book have an organizing center at all? Ruskin's editors, looking for a "designed whole," end up describing the work under six heads, the first of which is a "miscellany" (xxvii, xxx, xxii). Later critics, more fruitfully, have found a unity not in subject but in the particular energy of Ruskin's consciousness, which combines aim with a "desultory" method of composition. As Ruskin himself described it, *"Fors is a letter,* and written as a letter should be written, frankly, and as the mood, or topic, chances. . . . True, the play of it (and much of it is a kind of bitter play) has always . . . as stern final purpose as Morgiana's dance; but the gesture of the moment must be as the humour takes me" (xxix, 197). Both play and purpose are reflected in the protean title (the first word may mean "force," "fortitude," "fate," or "fortune"; the second "club bearer," "nail bearer," or "key bearer"). As John Rosenberg has remarked, "The title comes finally to represent the Fate which wove the tragic pattern of Ruskin's life and the Chance which led him to mirror that pattern with such an anarchy of accident and digression throughout the book."[1]

The pattern of fate and chance is most purposive in the structure of individual letters, whose complex unity of theme and feeling has only recently attracted scholarly notice.[2] The genre of the *Fors* letter mingles oratorical and confessional elements in a way peculiar to itself, yet it owes much to a number of influences, including especially Ruskin's own earlier experiments in public speech. Structurally and sometimes tonally, the Ruskinian lecture closely resembles the sermonic form Ruskin learned as a youth, which he described in *Modern Painters* I as the expression of a single truth, specifically, the biblical text on which the preacher comments. Many of the *Fors* letters similarly work

[1]John Rosenberg. *The Darkening Glass,* (New York: Columbia University Press, 1961), 186.

[2]See for example, Jay Fellows, *The Failing Distance: The Autobiographical Impulse in John Ruskin* (Baltimore: Johns Hopkins University Press, 1975), 99–111; John D. Rosenberg, "Ruskin's Benediction: A Reading of *Fors Clavigera,*" *New Approaches to Ruskin,* ed. Robert Hewison (London: Routledge and Kegan Paul, 1981); and Guy Davenport, "The House that Ruskin Built," in his *The Geography of the Imagination* (San Francisco: North Point Press, 1981), which also draws the parallel between *Fors Clavigera* and Pound's *Cantos* that I discuss below. Some of what follows draws upon my earlier essay, "Ruskin and St. George: The Dragon-Killing Myth in *Fors Clavigera,*" *Victorian Studies* 23 (1979), 5–28.

around a single theme or text (the quotation at the beginning, the image in the title, and so forth), and sometimes around a juxtaposition of phrases or texts. Most often they set contemporary follies ironically against an ideal image or fragment of the biblical revelation (this surely is Ruskin's chief formal debt to Carlyle, here and in other books). In rhetorical aim though not in form, the ultimate paradigm of the Fors letter is the Pauline epistle, as Rosenberg has noted,[3] and this is perhaps the most useful analogy of all: the Guild members and the class of workers everywhere correspond, in other words, to a particular church addressed by Paul and to the community of the faithful in general.

As an oratorical form, then, *Fors* is a pastoral letter but one also in which the struggles and experiences of the preacher himself—even his fancies, his obsessions, his travels and childhood memories—are presumed to have some paradigmatic value for the struggles faced by every Christian. The personal aspect of *Fors*, its character as a diary or confession, complements its character as exhortation and jeremiad. As Ruskin's polemical mode derives from the tradition of English Protestantism, his confessional mode derives from the related tradition of English romanticism. The *Fors* letter is in fact the nineteenth century's closest prose analogue to the romantic lyric, a dramatic interaction between mind and world by which an event or experience of place becomes emblematic of a movement of thought. But the relationship of each letter to the group as a whole has an equally close analogue in romantic poetry. As a *set* of pastoral letters, *Fors* draws its unity from the aims of the Guild and the condition of England. As a set of composed confessions or meditative lyrics in prose, it draws its unity from a pattern of images and motifs that comprise in broken form a comprehensive organizing mythos. (In the poetry of Eliot, Pound, Berryman, Lowell, and others, we are also confronted with a language of juxtaposed links and a fragmented structure that imitate the fragmentation of a culture once unified by an encompassing religious myth.) Most simply described, the "plot" of *Fors* is the St. George story enacted under the governance of the goddess Fate (whose ambiguous relationship to the hero owes more to Greek epic than to Christian tradition). Each letter, like a shard of glass, reflects more or less imperfectly portions of the completed design, as each Tennysonian idyll reflects Arthurian history and as any individual sermon reflects part of the total biblical revelation on which it comments.

Ruskin complained that Tennyson's epic should have concerned the present rather than a mythical past. The complaint receives its response in a prose epic, discontinuous and open ended, of which Ruskin

[3]John D. Rosenberg, "Ruskin's Benediction," in Hewison, *New Approaches to Ruskin*, 126–127.

is in one sense the narrator and in another the central actor, uniting in himself the principal personages of his sprawling allegory. How do these complementary fictional worlds, the private and the public, interact? It has long been recognized that the bulk of private allusions in *Fors* refer to Ruskin's love for Rose, a point most obvious in his repeated and riddling plays on her name. Yet the private myth, so to call it, does not so much allegorize the story of Ruskin's courtship as it reconstructs the psychic world that courtship creates. Exactly as in the case of Adèle thirty years earlier, Ruskin's love for Rose created for himself and those about him a drama with multiple and sometimes conflicting aims—and this private drama parallels the book's public, prophetic burden as well. By falling in love with an object distant and all but unattainable, Ruskin converted his present life into a condition always awaiting redemption, or rather, awaiting the restoration of an original state, since as paradisal child Rose stood for both future and past. As the obstacles accumulated, Ruskin's desire grew also more intense, and letters became important in his life as they had never been before—barrages sent first to Rose and her parents, then to intermediaries like the Macdonalds and the Cowper-Temples, in which he increasingly found himself justifying his chosen vocation as social reformer, his religious position, and his fitness to be a lover. Through the protracted agonies of desire and denial, which at some level of consciousness he must have chosen for himself, he became at once champion and supplicant, forever dependent upon unforeseeable bestowals of favor and rebuke. *Fors* began after the struggle had been essentially lost and continued beyond Rose's physical death, yet Ruskin kept the Idea of her always near him, enlisting not friends only but the English public in a cause now greater than himself. At the same time he absorbed into a verbal cosmos all the elements of the courtship—lover, loved one, forbidder, and the landscapes of frustration and nostalgic hope—organizing his own actions as in part the prosecutor of his fortunes and in part the pawn of cosmic will.

The justification of the man is also the justification of the nation in its ideal character of St. George. England is itself the blighted landscape forever about to be redeemed not literally by the sword of the saint but, through the Guild dedicated to him, by the plowshare of the husbandman that brings the promise of fertility and community. The public myth of *Fors* repeats the traditional legend of England, one that like the Greek myths has no primary text. As Ruskin argued in *The Queen of the Air,* myths are cultural products whose meanings evolve through time like a plant and vary according to the capacity of a person or nation for spiritual understanding. Thus, for the Greeks in the great age, Hercules was the "perpetual type and mirror of heroism, and its present and living aid against every ravenous form of human trial and

pain" (XIX, 299). Similarly, to the "mean" Englishman, St. George is no more than the emblem on a pub, but in his highest development, he is the Red-Cross Knight of Spenser, whose battle releases the captive Una and restores the aged Adam and Eve to their dominion of Eden.[4] Again, the story of St. Ursula (George's female counterpart with whom Ruskin associates Rose) begins as a crude folk legend; she finds her highest expression as the princess of Carpaccio's series. As myth criticism Fors "reads" and applies the old legends in the same way that a good sermon would elaborate on the life of Christ, converting familiar figures into present and living aids, but by implication the St. George story also embodies the moral idea of English history, manifesting itself in the nineteenth century as a dialectic between a polluted and chaotic industrial society and an original, true England that is stable, agrarian, and hierarchical. But lacking Carlyle's dynamic sense of history, Ruskin presents his proposals not as a new mythos but as a utopian vision reproducing the old in a form increasingly idealized, increasingly emblematic of private desire.

So far I have described the unity of Fors as a structure of themes and variations. But the book is also, as we know, written at the moment, as a letter or public diary that conforms to a pattern of events it partly sets in motion—it proposes, for example, and then comments on, the progress of the Guild—and partly obeys; it is both composed by Ruskin and dictated by Fate. We shall first, then, consider the elements of its static design and afterward the elements of its temporal pattern, following Ruskin in his pilgrimage from the hopefulness of the first call through a gradual relinquishment of public projects toward the longed-for peace of a world of memoir and musing.

If we combined the paintings that Ruskin reads at the end of Modern Painters V, we would see a monster belching smoke, Apollo in arms, a paradisal glade, and the Hesperides compressed into a shining Sybil. Fors Clavigera substitutes George and Ursula for the Sun-God and the Sybil and disperses the monster throughout the dark and blasted landscape of modern times. Ruskin's curse upon this land is relentless and thunderous. There exists, he writes, a "practical connection between physical and spiritual light" so that "you cannot love the real sun, that is to say physical light and colour, rightly, unless you love the spiritual sun, that is to say justice and truth, rightly" (XXVIII, 614). For Turner the Sun was God; but in the modern world, spiritual blindness and the

[4]For the St. George tradition in English literature, see, for example, Northrop Frye: "St. George's mission, a repetition of that of Christ, is by killing the dragon to raise Eden in the wilderness and restore England to the status of Eden. The association of an ideal England with Eden, assisted by legends of a happy island in the western ocean and by the similarity of the Hesperides story to that of Eden, runs through English literature at least . . . to Blake's 'Jerusalem' hymn" (Anatomy of Criticism [Princeton: Princeton University Press, 1957], 194).

smoke of the cities have contrived to remove the physical light from human eyes: "I believe that the powers of Nature are depressed or perverted, together with the Spirit of Man; and therefore that conditions of storm and of physical darkness, such as never were before in Christian times, are developing themselves, in connection also with forms of loathsome insanity, multiplying through the whole genesis of modern brains" (XXVIII, 615). The world is swept by a new thing under the sun, "a strange, bitter, blighting wind" made of "dead men's souls" (XXVII, 132–133), an industrial plague wind that makes of the day a "mere dome of ashes," like the skies over Pompeii (XXVIII, 463–464), but also merges, like the storms of *Lear*, with the storms of the mind: "plagues of the soul, and widely infectious insanities . . . , supernatural calamity . . . , grievous changes and deterioration of climate . . . , loathsome imposture and cretinous blasphemy" (XXVIII, 488). Writing from Venice, Ruskin claims that "this green tide that eddies by my threshold is full of floating corpses, and I must leave my dinner to bury them, since I cannot save." Comparing the "green tide" with the "black and sulphurous tides" of English rivers and with "Death, and Hell also, more cruel than cliff or sea," he presents a world on the brink of that Moment when "the Sea shall give up the dead which are in it, and Death, and Hell, give up the dead which are in them" (XXVIII, 757–758). In passages like this *Fors* truly becomes Ruskin's Apocalypse.[5]

The fallen nations worship the Dragon of Turner, who is both St. George's enemy and Mammon—a deity who wants to see people "fasting and in rags" (XXVII, 420) and whose foul traces can be found in the loveliest spots of English countryside. In the valley of the Lune, for example—a true portion of English "Holy Land"—Ruskin discovers its emblem on a metal bench: "the Devil's tail pulled off, with a goose's head stuck on the wrong end of it. . . . two of the geeseheads are without eyes" (XXVIII, 300). This particular mark of Satan is the work of manufacturers avid for profit: "the serpents of Kirkby are ordered and shaped by the 'least erected spirit that fell,' in the very likeness of himself!" (XXVIII, 303). Elsewhere, in a mood of frantic caprice, Ruskin parodies his own myth of Apollo "digesting" the Python by suggesting that England will develop a taste for "potted crocodile," as if in a heathenish Eucharist, and that the English rivers, "smoking," will be made to produce "quite a 'streaky' crocodile . . . , St. George becoming a bacon purveyor . . . , laying down his dragon in salt" (XXVII, 504).

But as winter is redeemed by spring and the desert by the blooming of the rose, so the diabolical landscapes of *Fors* alternate with paradisal glimpses brightened by a female presence—the Madonna perhaps, or a little girl in a cottage, or the unseen helping hand Ruskin usually calls

[5]The phrase is Frederic Harrison's in *John Ruskin* (New York: Macmillan, 1902), 183.

"Ursula" or "Little Bear" (her legend is the subject of Letter 71). "Crocodile," according to Ruskin, means "a creature that is afraid of crocuses," just as, according to Goethe, the Devil is afraid of roses (XXVII, 484–485), but each goddess or child or flower manifests the same timeless principle, which retains a personal connection with Ruskin's destiny: "I myself am in the habit of thinking of the Greek Persephone, the Latin Proserpina, and the Gothic St. Ursula, as of the same living spirit; and so far regulating my conduct by that idea as to dedicate my book on Botany to Proserpina" (XXIX, 385). "Rose" is one name for this spirit, but she is not the Rose, part real child and part imaginative projection, that Ruskin courted in the 1860s and covertly propitiated in "The Mystery of Life and Its Arts" and "Of Queens' Gardens." As queen, Rose was distant and withholding, partly resisting her own power "to heal, to redeem, to guide, and to guard." But the May Queen of *Fors* needs no coaxing: she is the object of heart's desire as the heart would conceive her, a principle of spiritual fertility who like Proserpina survives her own death year after year. She breaches the public and private worlds of *Fors,* then, at their extreme point of separation, at once the type of a redeemed land and the ghost of the woman who died in 1875. In 1874 Ruskin sequestered himself for three months in Italy with Carpaccio's "St. Ursula's Dream," in which the princess dreaming of her angel suitor becomes also for Ruskin the emblem of an eternal deathlike peace, like Ilaria di Caretto the "still-unravished bride of silence and slow time."

The May Queen is in bondage in this wintry world, her garden a place of memory and hope, yet still in his walks Ruskin enters upon geographical counterparts of spots of time that become, through heightened language, types of an elusive Eden, fading at the edges of the blighted present. Letter 19, for example, describes a clutch of spitting beggars and a spiteful boy in the square at Pisa, from which Ruskin escapes into the Val di Nievole, luxuriant with mulberry trees, corn, poppies, vines, maples, and the wild gladiolus. In this blissful valley lives a peasant family with two children named Adam and Eve. But almost as he beholds them they become memories. "If only you would not curse them," he tells his readers; "but the curse of your modern life is fatally near, and only for a few years more, perhaps, they will be seen . . . to pass, like pictures in enchanted motion, among their glades of vine" (XXVII, 309). Still, dearer to Ruskin's heart than Italy—dearer because it is the land of his fathers and the home of his favorite childhood author—is the Scottish Border, the "Land of the Leal," which still seems inhabited, in Ruskin's nostalgic vision, by the heroes and heroines of Scott's romances—a pastoral land of "exquisite clearness and softness" (XXVII, 594–595).

These two domains—the unfallen world and the wasteland, presided over by the maiden and the Dragon—meet each other in the institution

of the Guild, the practical equivalent of St. George's battle, which was to extend the domain of Eden by means of purposive labor. Ruskin envisioned the Guild on the model of a medieval corporation, perhaps like the Franciscan community he visited in Florence in 1845. (He was to stay there again in 1874, where he underwent a reconversion and dreamed he had been made a tertiary member of the order.) Again and again he insisted that his radicalism was authoritarian and hierarchical rather than liberal and democratic. In his first call he wrote, "We will try to take some small piece of English ground, beautiful, peaceful, and fruitful. We will have no steam-engines upon it, and no railroads; we will have no untended or unthought-of creatures on it; none wretched, but the sick; none idle but the dead" (xxvii, 96). Reactionary in aim, limited in scope so that it might be controlled by one erratic and sometimes confused person, the Guild ultimately disappointed Ruskin's hopes, never numbering more than a few dozen members during his Mastership. But what were Ruskin's hopes? In his suggestions he often failed to distinguish between practical aims and symbolic ones: he proposed, for example, a special group of companions, to be called the Monte Rosa Company after the "central mountain of the range between north and south Europe, which keeps the gift of the rain of heaven" (xxvii, 296). Like a magical incantation, the name converts the Guild into an image of Ruskin's private paradise, with its mount, its garden, its river, and its innocent maiden, linking Rose with his schemes for Alpine immigration and with Portia's recommendation of mercy. In a similar attempt to turn private needs into public ones, he insisted on calling himself a laborer, yet spent much of the 1870s in Switzerland and Italy doing St. George's work, poring over paintings and collecting precious minerals for the Sheffield museum. This confusion obviously reflects Ruskin's temperament but also a shift in his practical politics. Having abandoned the hope that his utopian economics could become a reality in his lifetime, he turned more and more to a series of paradigmatic gestures, good works that were at least marks of grace in the doer. In the imagery of *Fors* the Guild stands more convincingly for the means of individual rather than social salvation, taking the symbolic form of a paradise within as it is eternally shadowed forth in religious myth.

Most often, of course, that myth is explicitly Edenic. The fourth letter, for example, attacks in familiar Carlylean terms the division of England into two hostile classes, the "idlers" and "pillagers," then unites Midas-like greed with the pseudoscience that subserves it in a climactic image of a tree of knowledge that bears coins:

The saplings of the tree that was to be desired to make us wise, growing now in copsewood on the hills, or even by the roadsides . . . , blossoming into cheapest gold . . . , supplied punctually on demand, with liberal re-

duction on quantity; the roads themselves beautifully public—tramwayed, perhaps—and with gates set open enough for all men to the free, outer, better world, your chosen guide preceding you merrily, thus—with music and dancing. [XXVII, 77–78]

Ruskin's "thus" points to a reprint of Holbein's *The Expulsion from Eden,* showing Adam and Eve led out of the garden by the skeletal fiddler, Death. These are the fruits of the great "savoir mourir," which appear in the next letter as the botanist who did not believe in flowers; but this letter, written during the Festival of Merrie England, also contains the call to the founding of a Guild, conceived in the spirit of a new science of "savoir vivre": "Botany, though too dull to dispute the existence of flowers; and history, though too simple to question the nativity of men;—nay,—even perhaps an uncalculating and uncovetous wisdom, as of rude Magi, presenting, at such nativity, gifts of gold and frankincense" (XXVII, 97). The wisdom of the Magi is charitable rather than selfish; similarly, the "science" of the Guild will tend the earth instead of despoiling it and will place humankind once again in the center of the natural and moral world—the Christ of this new nativity, who is at once the new Adam, the Light of the World, the Ruler of the Redeemed, and the Dragon Killer of whom St. George is a type. Much later, in Letter 78, Ruskin formulates the unity of his works in terms of this utopian promise. *Modern Painters,* he tells his readers, "taught the claim of all lower nature on the hearts of men; of the rock, and wave, and herb, as a part of their necessary spirit life; in all that I now bid you to do, to dress the earth and keep it, I am fulfilling what I then began." The present work declares "the only possible conditions of peace and honour, for low and high, rich and poor, together, in the holding of that first Estate, under the only Despot, God, from which whoso falls, angel or man, is kept, not mythically nor disputably, but here in visible horror of chains under darkness to the judgment of the great day" (XXIX, 137–138).

From the echo of Genesis to the naming of the "great day," Ruskin orders his works in this passage as a kind of practical Bible outlining the spiritual destiny of his countrymen. Throughout *Fors* the imagery of sanctified action is sometimes martial, sometimes pastoral. The Companions, for example, are to be obedient soldiers (XXVII, 21) or a "band of delivering knights" (XXVIII, 538) whose labors are part of a righteous war—"the war with the Lord of Decomposition, the old Dragon himself,—St. George's war, with a princess to save, and win" (XXVII, 293). Yet the combat is chiefly a sublimated or "domesticated" warfare: Theseus, Ruskin reminds his readers in a quaint passage, returned from his voyage to invent vegetable soup (Letter 24), and St. George was the archetypal tiller of the soil, since his name, we learn in

an etymology that combines the themes of human and vegetable fertility, means "husbandman": he is associated with the Greek spirit of Agriculture, "to whom the dragon was a harnessed creature of toil" (xxvii, 481–482). This harnessing reverses the present tendency of the British economy, which has become an engine for bringing famine out of plenty and so metaphorically converting the fertility of the serpent into sterility. In its broadest sense Ruskin's agricultural myth is Carlyle's gospel of labor, the means of individual salvation as well as of social good. In the vineyard of the world, in which all men and women of goodwill are the "workmen and labourers," Ruskin places himself as both companion and paradigm: "I am so alone now in my thoughts and ways," he wrote in 1874, "that if I am not mad, I should soon become so, from mere solitude, but for my *work*. But it must be manual work. . . . to succeed to my own satisfaction in a manual piece of work, is life,—to me, as to all men" (xxviii, 206).

The dragon-killing myth, with its imagery of paradisal maiden, renewed land, and sanctified effort, bears a complex relationship to the personification of Ruskin's title. St. George represents the creative will, the domain of freedom and therefore of fortune, one of the translations of *fors*, but Ruskin also associates his goddess with Necessity, in the persons, among others, of the Greek Fates and the Hebrew Jael, who slew Sisera by pounding a tent peg into his skull. Destiny drives "the iron home with hammerstroke, so that nothing shall be moved; and fastening each of us at last to the Cross we have chosen to carry" (xxvii, 231). The purpose of *Fors*, then, is "to explain the powers of Chance, or Fortune (Fors), as she offers to men the conditions of prosperity; and as these conditions are accepted or refused, nails down and fastens their fate forever" (xxviii, 106).

In choosing his title, he associated the Horatian phrase with an Etruscan mirror case he discovered, decorated with the emblems of the Fates. No wonder he found this artifact so potently suggestive. The absent glass and the images of weaving, measuring, and shearing would have suggested most immediately vanity and its punishment (and also, perhaps, the related image of the hourglass with its death's-head emblem) and more generally, his pervasive horror of forbidden looking, both without and within, associated also with the Gorgon's glance and the fate of being cut off. His fascination with solipsistic states begins, as we know, with the Black Brothers, who are cast off as stones; later on he noted down the legend of the woman who stared at herself in a mirror (in church) until both she and her reflection became a death's head (the image reappears as the whited sepulchre in *Modern Painters* iv); in *Modern Painters* iii the woman in the ballad catches fire as she stares into her dressing glass. In *Unto This Last* the energies of capitalism, solipsistic and fecally self-reproducing, convert the earth

into the avenging goddess Tisiphone, whose law is an endless chain of punitive consequences that parody the endless system of capitalist indebtedness. The firmest link between Ruskinian economics and his late mythopoeic works appears, however, in a passage from *Munera Pulveris* on Charity. This goddess he associates with Shakespeare's Portia, the "type of divine fortune," with the law of "mercy, which is not strained, but drops as the rain," with the word "gate," and with the "blessed" sphere of Fortune in Inferno VII. He opposes her to the enmity of Shylock, the law of "merces," and the "fixed majesty of Necessitas with her iron nails" (XVII, 223–224). Athena, of course, acts out both laws: she is merciful like Portia when pleased, punitive like the Gorgon when angered. In *Fors* the two-natured goddess splits into Rose/Ursula, glimpsed from time to time like a splendor in the grass, and Fate the lawgiving divinity that gives and takes away. *Fors Clavigera* reaches its deepest level when these two psychic forces, loving anima and punishing superego, develop into the separate regions of time redeemed and time unredeemed, the one figure standing at the gate where the lost past and the promised future meet in vision, the other forever guarding that gate, forever shaping and disciplining the human will. This is Ruskinian mythmaking at its most powerful, neither political allegory alone nor a mere riddling of unconscious states but a fusion of both into a legend by which both natures, the inner and the outer, may be perfected as far as they can be and accepted as far as they must be. "Fortune," Ruskin writes, is "the necessary fate of a man. . . . To 'make your fortune' is to rule that appointed fate to the best ends of which it is capable" (XXVII, 28). Again, "the book itself should show you how to form, or make, this Fortune" (XXVII, 375). To turn fate into fortune is the fruit of labor, and since labor is life itself, *Fors Clavigera* is a book about the struggle to live.

Fors, as I have said, is written in the present tense. If the Dragon-killing myth represents its static pattern, Ruskin's own life, enacted through the agencies of will, chance, and fate, constitutes its agon, the weaving of that pattern into perpetually shifting forms. As founder of the Guild, he identifies himself most often with St. George (as in phrases like "everything St. George orders"), so that the saint objectifies his ideal self as prophet and teacher. But his private voice is more often the voice of one troubled, bereft, and vacillating, enacting the burdens rather than the powers of the seer and ultimately personifying the spiritual possibilities and contradictions of his times. At still other times the tragic mode is undercut by an antic disposition that is sometimes merely whimsical and sometimes close to the madness it mocks. The consciousness of *Fors* is, in other words, profoundly ironic by virtue of the very fluidity of its role-playing and the gaps it allows between the actual self and ideal forms.

Ruskin strikes the keynote of his autobiographical myth in Letter 4, already mentioned above. He recalls that Joseph Couttet, the guide his parents had employed for him in Chamonix, was often "fatigued and provoked" by the boy's "less cheerful views of the world" and so would whisper to himself, "Le pauvre enfant, il ne sait pas vivre!" (xxvii, 61). But the boy lost whatever joys he still had when he grew up and obtained the gifts of wealth and recognition: "When I was a boy I used to like seeing the sun rise. I didn't know, then, there were any spots on the sun. . . . When I was a boy, I used to care about pretty stones. . . . Now, I have a collection of minerals worth perhaps from two to three thousand pounds. . . . But I am not a whit happier, either for my knowledge, or possessions" (xxvii, 62). Ruskin, the apostle of Life who has himself lost that most precious of gifts, justifies himself not by the wisdom he has earned but by the very insistence, almost, of his unfitness. Yet even this gesture has its biblical paradigm, as in a passage where he echoes his namesake, the Baptist:

> Such as I am, to my own amazement, I stand—so far as I can discern—alone in conviction, in hope, and in resolution, in the wilderness of this modern world. Bred in luxury, which I perceive to have been unjust to others and destructive to myself; vacillating, foolish, and miserably failing in all my own conduct in life—and blown about hopelessly by storms of passion—I, a man clothed in soft raiment,—I, a reed shaken with the wind, have yet this Message to all men again entrusted to me: "Behold, the axe is laid to the root of the trees. Whatsoever tree therefore bringeth not forth good fruit, shall be hewn down and cast into the fire." [xxviii, 425]

The voice crying in the wilderness is the voice of one exiled from the past, for whom the gates of Paradise, like the gate of his parents' old home (xxviii, 79), remain closed. In this respect, the proposed Guild is Ruskin's link with a wider audience that justifies his expressions of a more personal regret—musings, most often, about the loss of homes and their symbolic substitute. Letters 31 to 33, for example, form a fragment of a life of Scott, which closes with Ruskin's reminiscences of the River Tay and his Scottish Aunt Jessie. The effect is to mingle Scott's childhood with Ruskin's own (he mistakenly calls Scott's Aunt Janet "Jessie"). When Scott had to leave his estate at Abbotsford because of his debts, he grieved, Ruskin says, "as for a lost sister." As Ruskin interprets Scott, the lost home and sister are also the loss of wholeness, the exile from one's true self that is the cruelest of all Fate's decrees. But Ruskin's old nostalgia receives a new poignance in *Fors*, which also records his awareness that he will die as the end of his line, without a companion. Letter 45 combines this theme with a further extension of the sense of exile, this time from Italy: "It becomes every hour more urged upon me that I shall have to leave . . . this spiritual land and fair domain of human art and natural peace,—because I am a

man of unclean lips . . . and therefore am undone, because mine eyes have seen the King, the Lord of Hosts" (XXVIII, 146). At the moment of writing, he is in Lucca, drawing once again the effigy of Ilaria di Carretto. Earlier, he has tried to persuade the sacristan of Assisi that Isaiah had had a wife, despite the sacristan's claim that he was the "castissimo profeta" (XXVIII, 145). It was Isaiah who appeared before the Almighty with unclean lips, but only Ruskin is fated to be castissimo. Once again, the prophetic burden is linked with the loss of a land and a woman and therefore with the Expulsion.

In Letter 65, perhaps the most impassioned expression of the expulsion theme, Ruskin's prophetic burden itself partakes of the darkness about him. He begins with an account of Abraham's sojourn among the Amorites, imagining the patriarch on a summit overlooking the Vale of Eshcol. But the Eden vista vanishes at once, to be replaced in Abraham's sight by a "horror of great darkness"—a vision of the destruction of Sodom and Gomorrah. In a sudden break, Ruskin describes his childhood summers among his Scottish or "Amorite" relatives in a season of felicity that parallels the patriarch's residence "under Salem, the city of peace." The conjunction establishes him as a modern Abraham foreseeing the doom of the English Sodom, "the Paradise of Lot." The recollections are interrupted by a sudden outburst:

> And I scarcely know if those far years of summer sunshine were dreams, or if this horror of darkness is one, to-day, at St. Albans, where, driven out of the abbey, unable to bear the sight of its restorations, and out of the churchyard . . . by the black plague-wind, I take refuge from all in an old apple-woman's shop, because she reminds me of my Croydon Amorite aunt. [XXVIII, 605]

The dark vision of Abraham, father of his race, slides into the cry of the child cut off from the light. In another letter from Assisi, he writes that he felt "entirely at home" living in the sacristan's cell because the room "is just the kind of thing I used to see in my aunt's bakehouse." "And now," he interrupts himself, "I am really going to begin my steady explanation of what the St. George's Company have to do" (XXVIII, 172–173). But the explanation turns out to be a "nursery tale"—the story of the Creation, which Ruskin calls the paradigm of all good works whatever. In contrast to the Divine labors, the works of humans upon nature have been destructive not creative—"the great reverse of Creation, and wrath of God, accomplished on the earth by the friends, and by men their ministers" (XXVIII, 177–178). As an example of a properly human labor, Ruskin mentions that he has dredged out the Wandel and stocked it with trout, a humble imitation of God's third labor, the "disciplining" of the waters. But the sources of being cannot be so renewed—even the Tay, he supposes in Letter 65, was long ago "bricked over, or choked with rubbish" (XXVIII, 605).

The pitch of such outbursts brought to Ruskin the awareness of yet another, the very grimmest, of the burdens of vision. "Does it never occur to me," he had asked in Letter 48, "that I may be mad myself?" (XXVIII, 206). In response to his own question, he takes refuge in noticing the greater madness of those about him: "for men who know the truth are like to go mad from isolation; and the fools are all going mad in 'Schwärmerei.'" He himself belongs to "the old race"—"children who reverence our fathers, and are ashamed of ourselves," yet who must live amid a "yelping, carnivorous crowd, mad for money and lust"—a crowd from which there is only one distraction: "it is impossible for us, except in the labour of our hands, not to go mad" (XXVIII, 206–207). The prophet driven mad by the follies of his age, and the related figure of Lear's Fool, perform a "bitter play" with the very limits of rational coherence. In 1875 Rose died of brain fever. Two years later, while studying *St. Ursula's Dream* in Florence, Ruskin received two separate gifts of flowers, which he associated with the emblematic dianthus and vervain in Carpaccio's painting, concluding that they had been sent him by the spirit of Rose herself. In Letter 74 he weaves "Little Bear," the two flowers, the painting of a Venetian water pitcher, and other elements into an eerily alogical pattern, in tone like a man murmuring to himself in a hushed rapture: the "invisible kosmos" had begun to claim him. Not until a year later, in February 1878, did the first breakdown come; for many months afterward all writing ceased.

When Ruskin recovered his active life again, he took up the series intermittently but without the energy or concentration of the 1870s. The final nine letters seem written from semiretirement: the mode of address suggests an audience like the children and neighbors at Coniston; the subjects are Plato's *Laws*, the proper education of children, the pleasures of the country. But two of the letters suggest the psychic cost of this retreat, forming between them a kind of tragic coda to the quest journey of *Fors*. Extremely good girls, he asserts in Letter 90, usually die young: "For my own part of grief, I have known a little Nell die, and a May Queen die, and a queen of May, and of December also, die. . . . And I could count the like among my best-loved friends, with a rosary of tears." He then develops a kind of economics of pulchritude, likening these deaths to "an enforced tax" to heaven and rebuking England for taking so little account of the number it has left (XXIX, 425). The climax of the discussion, reached at the end of the following letter, is a commentary on the end of *Romeo and Juliet*, which quotes the words of the Prince of Verona to the parents of the dead lovers: "That heaven finds means to kill your joys with love." Montague and Capulet, he continues, vowed to build monuments to their children, and he asks his readers to "meditate on the alchemy of fate, which changes the youth and girl into two golden statues." In thus seizing upon the Midas-

theme—the image that opens Carlyle's *Past and Present*—Ruskin reverses the dictum, "There is no wealth but Life." We sense that in these words, St George has lost the battle. Mammon, the Dragon, has converted life into gold, and the May Queen, unrestored to Eden, has been banished into the wasteland: "and your weary children watch, with no memory of Jerusalem, and no hope of return from *their* captivity, the weltering to the sea of your Waters of Babylon" (XXIX, 447–448).

These *Kindertotenlieder* seem to be breathed from an autumnal world of second childhood. Appropriately, the very last letter of all contains an account, not of a community of adults, but of an orphanage called "Valle Rosina"—"a Rosy Vale in Italy, rejoicing round its Living Rose" (XXIX, 519). Ruskin concludes:

> If the enemy cometh in like a flood, how much more may the rivers of Paradise? Are there not fountains of the great deep that open to bless, not destroy?
>
> And the beginning of blessing, if you will think of it, is in that promise, "Great shall be the peace of thy *children*." All the world is but as one orphanage, so long as its children know not God their Father. . . .
>
> Not to be taken out of the world in monastic sorrow, but to be kept from its evil in shepherded peace;—ought not this to be done for all the children held at the fonts beside which we vow, in their name, to renounce the world? Renounce! nay, ought we not, at last, to redeem?

The voice here is the voice of a Good Shepherd who has suffered the little children to come to him that he might nourish his own needs through them. These last letters are less a conclusion to the massive work that precedes them, less a reflection of the renewed conflict and hyperactivity of the 1880s, than a set of preludes to his autobiography. That final book is signaled by the commingling in the closing passage of the sacraments of baptism and holy orders, as though old man and child could be reborn together and the outer world be renounced in order that the inner world be redeemed: "surely out of its silence the mountains and the hills shall break forth into singing, and round it the desert rejoice, and blossom as the rose!" (XIX, 528).

The autobiographical myth of *Fors Clavigera* begins with a young boy mysteriously deprived of joy, proceeds through years of wandering and exhorting in the wilderness of the modern world in search of an elusive Promised Land, and concludes in a recapture that is also a retreat, when the Promised Land faces him as the mirror of childhood; the last word of the whole is "rose." So restless and various is that inconstant persona that the personages in the universe above and about him take the form also of psychic forces within a world coextensive with his consciousness. As St. George represents the concentering forces of integration and control, Ursula and the goddess Fate parallel

the internal contradictions between reward and punishment, posses-
sion and denial. As the May Queen becomes the internalized image of
desire, so the dark mother merges at times with the angry prophet,
who wields the hammer of invective (for example, "that so I may end
the work of nailing down scarecrows of idiotic soul, and be left free to
drive home the fastenings of sacred law" [xxix, 200]). In the image of
Morgiana's dance (xxix, 197), Ruskin's "grim purpose" is likened to
the poniard of Ali Baba's wife, seeking out the heart of the assassin—
an analogue of both the nail of Fate and the sword of St. George. And
finally in a casual phrase like "in the course of *Fors* itself" (xxviii, 409),
the life and the book, the myth and the style, become one.

Through the labor of writing Ruskin creates his own Fortune out of
Fate. At their finest, the letters blend public and private references into
carefully orchestrated meditations that turn an observed incident or a
fragment of thought into a revelation of cultural realities and of Rus-
kin's inner history at that moment. But the true power of *Fors Clavigera*
does not lie in its best individual moments. We have viewed it as a
massive pattern of variations and as the agon of a protean fictional self.
We need finally to view it as the drama of Ruskin's struggle for psychic
coherence against overwhelming disintegrative forces—the hammer
blows of an illness that could be staved off but not finally overcome.
The record of that struggle is frequently warped and splintered but
always energized by an urgent drive to communicate. Within that con-
text even the failures of coherence attain an eerie power to which the
usual canons of intention and control do not apply. There is, for exam-
ple, the bit of "mythic teaching" that immediately follows an anecdote
about a faithful dog:

> Indistinguishable, doubtless, in its bones from a small wolf; according to
> Mr. Waterhouse Hawkins; but much distinguishable, by St. Theodore's
> theology, telling of God, down, thus far at least, in nature. Emmanuel,—
> with us; in Raphael, in Tobias, in all loving and lowly things; "the young
> man's dog went with them."
>
> And in those Adriatic breakers, anger-fringed, is He also?—Effice
> quaeso, fretum, Raphael reverende, quietum. And in the Dragons also, as
> in the deeps? Where is the battle to begin? How far down in the darkness
> lies this enemy, for whom Hell beneath is moved at the sound of his
> coming. [xxix, 69]

Psychoanalytic insights might help us forge these broken links but
could not describe their affective power—the power of a speech free-
flowing yet broken into incantatory fragments and echoing allusions,
mute and emblematic as the crumbled juxtapositions of nature her-
self—the unheard speech, we might say, of deep answering to deep.
Long before writing this passage, Ruskin provided the symbolic gro-

tesque, the category that justifies its claim to literary interest, but for most readers it will be accessible, if at all, from the example of modern poetics. In particular Pound's *Cantos* rise before us when we read *Fors*, both as a whole and in part. Both works move from the landscape of hell and purgatory toward a visionary blessedness, in a course shattered but not defeated by emotional collapse. What endures in *Fors* is its sanity, its drive to find meaning in work and sustenance in a consolidation like that found by Pound: "What thou lovest well remains." And if Ruskin played at times with the figure of the inspired madman, he did so only to resist more resolutely the coming darkness that was finally ordained for him—he would have had no part in that retreat from the moral life that has masked itself in the romanticizing of mental illness. In one of his last utterances, Lionel Trilling attacked the modern delusion in words that may stand as an epitaph to what is bravest in Ruskin:

> no expression of disaffection from the social existence was ever so desperate as this eagerness to say that authenticity of personal being is achieved through an ultimate isolateness and through the power that this is presumed to bring. The falsities of an alienated social reality are rejected in favour of an upward psychopathic mobility to the point of divinity, each one of us a Christ—but with none of the inconveniences of undertaking to intercede, of being a sacrifice, of reasoning with rabbis, of making sermons, of going to weddings and to funerals, of beginning something and at a certain point remarking that it is finished.[6]

[6]Lionel Trilling, *Sincerity and Authenticity* (Cambridge: Harvard University Press, 1972), 171–172.

13 /

Time Present and Time Past

Through the unknown, remembered gate
When the last of earth left to discover
Is that which was the beginning.
—T. S. Eliot, "Little Gidding"

Ruskin's study at Brantwood looks out upon a sheet of sky-blue water and a graceful series of peaks that retain even in summer months their streaks of cloud-white snow. The view might be a Turner sketch—of Como or Chamonix or Geneva—but a day's ramble takes the walker through Wordsworth's country, and a week's ramble would extend northward into the braes and lochs of Scott's home and the ancestral place Ruskin called the Land of the Leal. His move north reversed his parents' sojourn of a half century before, from the fatherland into the metropolis of the modern world. The home of his old age, filled with a lifetime's memorabilia—including John James's watercolor of Conway that afterward hung over his son's bed—focused into a single point his filial and cultural heritage. In some ways Ruskin entered old age early. The pictures of him in his sixties resemble a man already past his threescore and ten: the beard is full and white, the face withered and abstracted. His countrymen were also ready to inherit him as a monument. The audience that bought out edition after edition of *Sesame and Lilies* and savored the purple patches collected in *Frondes Agrestes* were ready also to accept the Sage of Brantwood, the persona that succeeded the "Master" and the "Professor."

Sagedom is prophecy in retirement, the embodiment of a wisdom broad because shallow, serene because withdrawn. At best it is the voice of the heritable past, at worst the infirmity of noble mind. But of course neither serenity nor completeness nor blandness was to be Ruskin's portion in his last years, any more than they had ever been. The Gothic restlessness, the hunger for unattainable objects of affection, above all the contradictory need to control and be indulged, recreated at Brantwood some of the psychic relationships of the past. The Severns, who had to nurse and control him in his psychotic episodes, also had a will

of their own when he was well. As John Dixon Hunt has shown, Joan took it upon herself to censor some of his correspondence, to discourage certain visitors, and to impede some of his harmless afternoons with young girls in order to prevent scandal. Even before she took on this role, Ruskin had split her mentally into tender nurse and dragonlike tyrant: in his illness of 1878, she found herself the object of his rage, along with Queen Victoria, whom he suspected of trying to control him.[1]

Erik Erikson has described the final crisis of life as Integration versus Despair, the choice of accepting the life that has been lived, along with its mortal term, or of giving way to regret for the past and an overwhelming fear of decline. No career shows this final struggle more dramatically than Ruskin's. Storms are of course his dominant metaphor of emotional torment. The Brantwood diaries are among other things an almost perpetual weather watch, but his obsession expresses more than a hapless alternation of moods. *The Storm-Cloud of the Nineteenth Century* (1885), his finale as a lecturer, is often described as a thunderous purgation analogous to one of his own attacks, a symptom converted into a rhetorical tour de force. But is is much more. By assembling a collage of scientific testimony, personal observations, quotations from the poets, old drawings, and excerpts from diaries past and present, Ruskin attempts in fact to stake out a map of the heavens in all their moods through many years, testing his own impressions against as many external points of reference as he can manage, and so to contain the storm that cannot be wholly repressed.

Praeterita is Ruskin's final struggle to find in art the integration he could not achieve in life. The first three chapters appeared as reminiscent episodes in the *Fors* letters, which he then reissued as the beginning of a connected series in 1885. The aim of this last public journal, as he wrote in his preface, was diversion: "I have written [it] therefore, frankly, garrulously, and at ease; speaking of what it gives me joy to remember, at any length I like . . . passing in total silence things which I have no pleasure in reviewing, and which the reader would find no help in the account of" (xxxv, 11). This garrulous ease became a heroic effort, broken and resumed between attacks of the storm cloud. It was still unfinished in 1889 when he attempted a trip to the Continent that ended in a collapse in Paris. Still he was determined to write one last chapter to record his gratitude to Joan Severn, who took down the phrases he dictated, and with its last words all thought and all writing came to an end. He carried the candle clear to the brink of night.

To what genre does *Praeterita* belong? The forms of autobiography

[1]For the disturbances of Ruskin's final years, see John Dixon Hunt, *The Wider Sea: A Life of John Ruskin* (New York: Viking, 1982), 370–405.

depend partly upon the time of life that is their vantage point, since this is the narrative genre least able to efface the present time of its writing. The nineteenth-century crisis autobiography, which includes the two greatest poems of the age, is classically the product of the *mezzo del cammin* or slightly later, which interprets the author's struggles during his twenties to become the person he "is"—a person whose claims on our attention depend on the resolution of that crisis (Newman's *Apologia* is a departure in the respect that its central event takes place about twenty years later than most). The pattern of the central turning point is religious conversion, the mode confessional.[2] But Ruskin's temperament, "fretwork always," never defined itself from a single determinative moment, immersed as he typically was in a "to-day" that perpetually revised the todays before it. *Fors* is the closest thing to a Ruskinian confession, but its pilgrimage has no center. *Praeterita,* on the other hand, coming at the close of its author's lifework, presents itself as an episodic memorial to past joys and revered parents. Probably we should call this genre (after Carlyle's book, which may have suggested to Ruskin the project of his own) "reminiscences." These are the utterances, typically, of the Sage, revisitings by way of museum catalogs of the career laid out elsewhere. But despite its claim to be mere "sketches of effort and incident," *Praeterita* quickly develops into something more comprehensive and sufficient. This coherence required for Ruskin massive distortions. The two chief omissions, his marriage and his career as a social critic, bring in their train a multitude of other adjustments: Venice, for example, he relegates to the back lots of his labors (even the discovery of Tintoretto he calls a "luckless day"), to be supplanted by Rouen, Geneva, and Pisa, which he now calls the chief centers of his intellectual life. It has become a commonplace to notice what is nevertheless true, that *Praeterita* is the myth rather than the history of a life, an organic structure adapting itself to an old man's apparent needs for serenity.

Serenity is preserved by means of a dialectic between the unchanging self and time as bereavement. What the book indefinitely postpones, half-acknowledging and half-evading, is a permanent rupture within the family, which would disturb the memorial gesture Ruskin announces in his preface: "What would otherwise in the following pages have been little more than an old man's recreation in gathering visionary flowers in fields of youth, has taken, as I wrote, the nobler aspect of a dutiful offering at the grave of parents who trained my childhood to all the good it could attain." To preserve this spirit of recreation and re-creation, he erects the figure of a passive child, a kind of princeling

[2]For romantic crisis autobiography, see M. H. Abrams, *Natural Supernaturalism* (New York: Norton, 1973), 2.

guided through a world of wonders. We see him now rejoicing during vacations, now back at home laboring in "serene and secure methods of life and motions," now in occasional fits of willfulness that are suppressed and repulsed. This evasion is clear even with relation to landscape. The boy surrenders himself to the powers inherent in an external world, which he experiences as the mark of his future *work*. Ultimately, the young man's progress is blocked at the point of his approaching marriage, with all the griefs and conflicts it embodied, so that he cannot achieve the independence toward which most life narratives move: reverting to a longing for the old world of shelter and nurture, he is scared back from the grim face of adulthood—until, that is, the third part of the book, when we find him in mid-life and old age recreating the lost past in the present.

As a record of development, *Praeterita* is therefore a defeated and in many ways a depressing book. Fortunately, the genre it creates for itself permits another reading, one that transforms the conventions of selfhood, accuracy, narrative, and even pastness as these normally appear in autobiography. With characteristic penetration, Elizabeth Helsinger has noticed that the book's direction resists the progress it seems to narrate, comprising at the last a static pattern of imagery rather than the record of a pilgrimage, and that consequently the self of the book *resists development or change*.[3] We might equally well say that the world of *Praeterita* and the central personage in that world belong to romance. Like a romance hero, the self of *Praeterita* is not a developing personality but an *essence* confirmed again and again in each encounter with a world itself composed of essences, constituting the contentment which, as he wrote in 1860, was what men most needed to learn. The "look" of that world may be described most generally as clarity combined with radiance—clarity learned from Ruskin's detailed reading of paintings and landscapes; radiance described by Wordsworth as an apparel of "celestial light." Wherever the boy moves in the visionary past, beauty pitches her tent before him, effulgent with the divine energy he called purity. It is a crystalline world, as in a missal, without shadows or gradated hues or anything half-noticed or half-formed, but all in colors and outlines of the utmost distinctness. So intense is that clarity that the past itself seems present, viewed as it were

[3]"The Structure of Ruskin's *Praeterita*," in *Approaches to Victorian Autobiography*, ed. G. P. Landow (Athens: Ohio University Press, 1979), 87–108. See also Avrom Fleishman, "*Praeterita*: Ruskin's Enclosed Garden," *Texas Studies in Language and Literature* 22 (1980), 547–558, which traces the topoi of the garden and the fall; and Jay Fellows, *The Failing Distance: The Autobiographical Impulse in John Ruskin* (Baltimore: Johns Hopkins University Press, 1975), 183–187. Fellows argues that *Praeterita* is a triumph over the "inefficacious" autobiography, since Ruskin distinguishes between himself and the younger self who is the object of the book; the book is his "own best exit from himself." This approach differs from my own, as will be apparent.

through a magnifying glass—another country indeed, yet close at hand.

The effect I have just described impressionistically comes close to an activity of imagination Ruskin analyzed some forty years earlier, in a book he reedited in 1883. As we have seen, *Modern Painters* II (containing the theory of Purity) concludes its three-part anatomy of the imagination with a chapter on "imagination contemplative." According to Ruskin, when the mind summons before it the indistinct products of memory and association, the fancy recombines ideas according to the quality they have in common, but then, it will be recalled, Ruskin uses the word "indistinctness" to shift to a subject its apparent opposite— the distinct and stylized abstractions of early Renaissance art. The chief features of that school, exemplified in Fra Angelico, he listed succinctly in an addendum of 1883: "serenely luminous sky,—full light on the faces; local colour the dominant power over a chiaroscuro more perfect because subordinate; absolute serenity of emotion and gesture; and rigid symmetry in composition" (IV, 347). In intuitive terms, these gaps in thought are Ruskin's attempt to trace out a deeply sensed relationship between memory and vision—in particular the relationship between Wordsworthian meditation and Dantean mysticism—which bears close analogy to the intuitive unity achieved by *Praeterita*.

At the beginning of the same chapter Ruskin defines the structure of nostalgic associative memory. The charm of memory, he writes, is "more sunny and spiritual" than possession of things present, partly because memory retains sublime and impressive images over those with "sensual offensiveness."

> But of those parts of anything which are in themselves beautiful, I think the indistinctness no benefit, but that the brighter they are the better; and that the peculiar charm we feel in conception results from its grasp and blending of ideas, rather than from their obscurity; for we do not usually recall . . . one part at a time only of a pleasant scene, one moment only of a happy day; but together with each single object we summon up a kind of crowded and involved shadowing forth of all the other glories with which it was associated, and into every moment we concentrate an epitome of the day . . . , and so, with a kind of conceptive burning-glass, we bend the sunshine of all the day, and the fulness of all the scene upon every point that we successively seize. [IV, 290]

I have described a variant of this activity above as mythopoeic imagination, substituting for the dye image the schema of a magnetic center, an indefinite number of which would for Ruskin constitute the totality of the world as interpreted by the human imagination. In relation to *Praeterita* (which is the self-contained world of the visionary past), the image of the burning glass, which is to memory as the dye is to the

metaphorical faculty, provides the formula for converting Words-worthian nostalgia into a narrative technique more nearly the converse of the greater romantic lyric. Instead of using remembered land-scape—the farms and woods alongside the Wye, for example—as the stimulus for reveries that cluster around it, Ruskin reexperiences the past by fusing incidents and transposing effects onto new incidents and objects (as the imagination transposes the "shape" of certain qualities), so that the new object, as T. S. Eliot put it, becomes the "formula" for the particular emotion. A sequence of events translates itself into a pattern of objects redolent of new meanings, resembling in radiance and distinctness the art of Angelico. The technique of displacement and condensation is that of the dream, but the clarity and radiance are that of a vision. Moreover, like a vision but unlike many dreams, light and color are solid. The affect, that is to say, is intense and unam-bivalent: "bad" places absorb bad feelings, while "good" places focus and magnify good feelings, burning off or purging what gives "sensual offensiveness."

A signal difference between *Praeterita* and *The Prelude* is the com-pleteness with which Ruskin suffuses landscape with self, without the mediation of a separate imagination. This technique is different even from Wordsworthian spots of time, which appear as sudden interrup-tions of the normal and manifest their meaning through their strange-ness and otherness. But Ruskin recreates in his visionary moments a world that is always simultaneously foreknown and discovered. This procedure grows naturally, of course, from the rhythm of his for-mative years: periods at home alternated with travels designed as recre-ative releases, which the boy then absorbed by converting them into objects of study at home. The "celestial light" of Wordsworthian child-hood is structured crystallographically, so to speak, in Coleridgean symbols, which contain the translucence of the general in the particular and the eternal in the transient. Similarly, the unchanging self, in Rus-kinian terms, is a type of divine energy and a set of organic rela-tionships, like the translucent landscape it beholds—as he called it earlier, a purity of heart capable of receiving the light of divine revela-tion. To remember this self and this world-as-a-self is once again to become it. That experience is expressed in the most insistent leitmotif in a book built largely of leitmotifs. Hardly a chapter is without its rivers. Sometimes they surge and flow, sometimes go underground, sometimes trickle or dry up, only to burst forth elsewhere. They may be incidental, like the gush of the watercock in Hunter Street, or all embracing, like the Rhone at Geneva. The historical continuity of Being, the ecstatic possession of fullness that Ruskin called "Life," is the meaning of the river symbol in *Praeterita*. It is no doubt *because* Ruskin's sense of his own being was so discontinuous and because his

experience of gaps and losses and aimlessness and decline was so powerful, that he labored at the end of his career to construct a fiction of pure presence. As his Athena made the "broken diffusion of the elements" sacred, so the waters of *Praeterita*, always encountered with surprise and recognition, pervade and concentrate the broken diffusion of time.

In his essay on distant objects, Hazlitt suggests in somewhat different terms a similar relationship between fullness and memory. In long views, he notes, "Passion is lord of infinite space, and distant objects please because they border on its confines, and are moulded by its touch." This imaginative effect he compares to the effect of memory: "The instant the pressure of unwelcome circumstances is removed, the mind recoils from their grasp, recovers its elasticity, and re-unites itself to that image of good, which is but a reflection and configuration of its own nature."[4] Nostalgia, in other words, projects an ideal ego into the past, and time, like space, becomes the solid occupancy of the imagination. Ruskin joins both ends of his life—his parents' hopes for him at the beginning and the fame of his achievements at the end—recreating himself as a youth at the perpetual confluence of memory and hope, his future fixed, himself and the objects about him moving through a medium of time that is substantial because remembered, or rather recreated in the presentness of writing. As the hero of romance meets himself in the world about him, so the self in *Praeterita* has a structure like the world. The beatified self is a condition of strength and joy figured in the will's harmony with an approving moral self and with the object of its desire, like a harmonious internal family. The narrative of *Praeterita* is more or less continuous as long as the internal family and the external family whose relationships it resembles remain in essential concord.

With its fixation on his "serene and secure" years, *Praeterita* is the evidence of Ruskin's failure to relinquish his narcissism, passing abruptly as it does from the years at home to the meetings with Rose and other substitutions for the past. It is the evidence but not the reenactment of that failure. For *Praeterita* is also the creative outcome of his final struggle for the idea of a self accepted and completed. Reading the book in this light, we can accept its fragmentation and defeat by time, in order also to accept its transcendence of time, achieved at the end with a landscape of integrated emblems that takes the place of the earlier, remembered landscapes. Ruskin escapes solipsism by that pure symbolization of selfhood that in one form we call mystical experience and in another the self-enclosed region of the aesthetic object—my word for it here has been "vision." The final stage of

[4]William Hazlitt, "Why Distant Objects Please," in *Selected Writings* (New York: Penguin, 1982), 148–149.

Praeterita is not the completion of an aesthetic structure but the *drama* of Ruskin's conversion of memory into vision. Narrative time meanders and fragments as the heart of the book beats back, so to speak, beyond the personal past of Carlyle and Scott and the Borderland, until in a moment of rapture the breach between present and past—the breach also between the aged writer and his true self—is joined forever. Read in this way, *Praeterita* is no more incomplete than Michelangelo's slaves, struggling to realize themselves from the rough rock around them: in that ethereal suspension of marble, unreleased, unfinished, they find their freedom.

A look at some of the dominant patterns in *Praeterita* will conclude our consideration of some dominant themes in Ruskin's career. The emblematic titles of the first three chapters, "The Springs of Wandel," "Herne Hill Almond-Blossoms," and "The Banks of Tay," represent topoi or phases of early experience. The three paradisal elements of Edenic nature—water, garden, and distant hills—are perfectly realized near the aunt's house in Perth: "The idea of distant hills was connected in my mind with approach to the extreme felicities of life. . . .she . . . had a garden full of gooseberry bushes, sloping to the Tay." In childhood, mountains are distant, representing the enthrallment of possibilities waiting forever in reserve, but the other elements are near at hand. The aunt at Croydon also had a stream, the Wandel—a "spring of crystal water at the back door (long since let down into the modern sewer)," and Hunter Street had its watercock that "turned and turned till a fountain sprang up in the middle of the street" (xxxv, 15, 19, 21); but Herne Hill is the special preserve of the garden, described, we recall, as treasure, since it is for beholding instead of devouring: "magical splendor of abundant fruit: fresh green, soft amber, and rough-bristled crimson bending the spinous branches; clustered pearl and pendant ruby joyfully discoverable under the large leaves" (xxxv, 36). The fruit exists for the sake of the flower because the flower may be incorporated symbolically, that is, as an aesthetic object. This conversion, as we also noticed above, is the basis of both the child's discipline and the adult's career. The child who could amuse himself in tracing out the pattern in the rug is father to the man who conceived of the entire world as an arabesque to be traced and deciphered. But the enclosed world of enchanted wealth and measured days is balanced by a boundless world of erotic exuberance. Scotland alone is the child's true Paradise: the streamlets are "a perpetual treasure of flowing diamond," the fields are "corn of heaven," the days are "perpetual watching of all the ways of running water." At the center of it all is dark-eyed cousin Jessie. On the day before his Scottish aunt was born, Ruskin tells us that a woman friend surprised his maternal grandmother by coming into her room and "dancing a threesome reel, with two chairs for her

partners; she having found at the moment no other way of adequately expressing the pleasure she took in this mortal life, and its gifts and promises" (xxxv, 62). "The latter," he adds laconically, "failed somewhat afterwards"—and both Jessie and her mother die in a few summers. The extreme felicities of life are foredoomed to fail, and that failure closes the first movement, so to say, of the book, the three phases of which will repeat themselves again: the phase of water, standing for the primal identification of energies within and without; the phase of the garden treasure, standing for the world beheld and symbolized; and the phase of the Tay, standing for the union of selfhood and treasure—the union achieved in love and in vision.

These first losses become also the loss of the child self, the time of frolicking in Wordsworthian shores. The next chapters turn, appropriately, to the period of tutorships, ushering in a new alternation between learning and Continental travels that succeeds to the older rhythm of Herne Hill and Scotland. But before reliving his first view of the Alps, Ruskin provides a variant of the treasure motif that introduces the theme of mountains. During a summer in Wales, he recalls, his attempt at athletic skill was thwarted by parental anxiety for his safety: if only they had given him a Welsh pony and a Welsh guide, they "would have made a man of me there and then . . . and probably the first geologist of my time in Europe." (He neglects to mention that he did own a pony, Shagram.) Elsewhere he complains that he had no chance to break the "bare-backed horse" of his will, and he once wrote to Norton that he had had no youth, but in the present telling, the failure to ride a horse symbolizes the boy's thwarted struggle for manly independence, a block he soon afterward internalizes (in contradiction to the sentence quoted above) as the wish not to grow up at all: "I already disliked growing older,—never expected to be wiser, and formed no more plans for the future than a little black silkworm does in the middle of its first mulberry leaf" (xxv, 96, 103). A compensation comes, however, in the gift of some Peruvian specimens brought by a noted geologist: the parlor table was "loaded with foliated silver and arborescent gold. Not only the man of science, but the latent miser in me, was developed largely in an hour or two!" (xxxv, 99). "Foliated" and "arborescent" recall the "clustered pearl and pendant ruby" of the jewellike garden and produce a new tapestry of association—manliness, mountains, science, precious stones. The world outside the garden can also be possessed as treasure.

The following chapter draws on the same strand in its account of the family's first Continental tour, reaching its climax in the first sight of the Alps. The famous set piece derives its power from its slow preparation, the suddenness of the revelation (it bursts forth like the visual equivalent of the watercock in Hunter Street), and a magnificence so

intense it can only be rendered typologically: "They were clear as crystal, sharp on the pure horizon sky, and already tinged with rose by the sinking sun. Infinitely beyond all that we had ever thought or dreamed,—the seen walls of lost Eden could not have been more beautiful to us; not more awful, round heaven, the walls of sacred Death." Ruskin continues: "Thus, in perfect health of life and fire of heart, not wanting to be anything but the boy I was, not wanting to have anything more than I had . . . , I went down that evening . . . with my destiny fixed in all of it that was to be sacred and useful" (xxxv, 115–116). In the time scheme of *Praeterita,* imaginative seeing telescopes the future into an eternal, pristine present: "not wanting to be anything but the boy I was" and "my destiny fixed" parallel the historical juxtaposition of "lost Eden" and "sacred Death." The "work" prefigured here (Ruskin's mental development always takes the form of a "first" sight that fixes his purpose forever) is of course his reading of nature as Scripture, specifically his typological interpretation of the Turnerian sublime. The mountain fortress that is also a Heavenly City, imperishable (like the ideal Venice) in marble, apotheosizes the walled garden of home and inscribes the mother's teaching upon the face of the earth, as though the child world were but the momentary microcosm of which the biblical archetype was the eternal macrocosm. These "gates of the hills" transfigure human time, presenting in the awesome Otherness of their immensity and distance the image of the boy's own powers and ambitions, and of course this visual power compensates him for the loss of athletic prowess, further confirming his need not to grow up or away from his parents.

Spiritual power and physical desire are the two awakenings of Ruskin's adolescence. The several mountain ecstasies of *Praeterita* resemble one another but focus different emotional stages and so never repeat themselves; thus the record of the family's second tour (following more chapters about home studies) prefigures the coming of Adèle. The lessons of the youth's tutors (a kindly but inferior lot, whom Ruskin reduces by affectionate caricature) could not compare with the knowledge absorbed directly and visually, but this tour has as its true preceptor Byron, the "realistic" delineator of heroic loves. "The Col de la Faucille," the "gate" that connects the Jurassic Alps with Geneva, the castle of Chillon, and the Cluse beyond, opens up part of Byron's land and also Adèle's—the chapter is in part a tribute to Rouen and Abbeville, where Ruskin was to discover in Gothic the perfect blend of aesthetic form and communal remembrance. The earlier view of the Alps presented the exaltation of the ego in the form of a clear and overwhelming object. The present chapter presents the blissful loss of self through immersion in immediate surroundings. What first struck Ruskin about the Jura was the way innumerable streamlets seep

through the mountains to water the valley, much as the Golden River does:

> But no whisper, nor murmur, nor patter, nor song, of streamlet disturbs the enchanted silence of open Jura. The rain-cloud clasps her cliffs, and floats along her fields; it passes . . . but of rivulet, or brook,—no vestige, yesterday, or to-day, or tomorrow. Through unseen fissures and filmy crannies the waters of cliff and plain have alike vanished, only far down in the depths of the main valley glides the strong river, unconscious of change.

In this self-sufficient paradisal ecology, water seems the medium of an undifferentiated diffusion, the emblem also, perhaps, of the vital energy in its ceaseless, unconscious workings. The passage comes the closest of any in the book to evoking an almost prenatal continuum of self and world. The ego, it would seem, comes into existence as that part of the self that is *seen*—and Ruskin says he was most happy when "*nobody* was thinking of me," that is, his parents. "My entire delight was in observing without being myself noticed,—if I could have been invisible, all the better." Appropriately, the next sentence loses its syntax together with the discrete "I" that would normally control it: "The living inhabitation of the world—the grazing and nesting in it,—the spiritual power of the air, the rocks, the water, to be in the midst of it, and to rejoice and wonder at it, and help it if I could—happier if it needed no help of mine" (xxxv, 161, 166). The conclusion of the chapter reverses the visual perspective of the earlier Alpine description, for it is a Pisgah-sight, revealing not an emblem of divine Power but a "holy land" to be possessed and inherited: "to see and to possess royally such a kingdom! Far as the eye could reach—that land and its moving or pausing waters; Arve, and his gates of Cluse, and his glacier fountains; Rhone, and the infinitude of his sapphire lake" (xxv, 167–168).

The "holy Land of my future work and true home in this world" is a land of streams and a place of unsupervised freedom like the Tay. The new powers incorporated by reading Byron and beholding mountains prepare the way for a new-found power of affection as well. The French Jessie and her three sisters descend upon Herne Hill, subjecting John to an "Ash Wednesday" that lasts four years—a new, unrequited craving fiercer than that for the untasted fruit at Herne Hill. Once again, the rhythm of the book moves from release to restraint—in the chatty and rather even-toned chapter on Oxford—then back in the next to the final loss of Adèle and, with her, the landscape feeling. To cure himself he plunges into his father's edition of the *Idler* and is "secured" by Johnson's "adamantine commonsense" from being misled by his own "sanguine and metaphysical temperament."

At last, he says, Scott's country took him "well out of it all." In the symbolic geography of *Praeterita,* Scotland tends to stand for the ancestral land, where Ruskin reaffirms the union of his own desires and his parents' gifts; Savoy and Switzerland, the greater world of his intellectual heritage, for which his parents act as guides; and Italy, the place of temptation and dereliction. The burning glass of memory focuses Ruskin's truce with despair on the family's visit to Loch Katrine, with its nearby blaeberry bushes, "dark winding clear-brown pool," "entangled moss," and "arch of branches." This maternal river is the forest-darkened Lethe of *Purgatorio,* haunted like Dante's stream by a fair presence—Scott's Lady of the Lake. This Lethe, however, brings not forgetfulness but elegiac mourning; for the arch of branches metaphorphoses (by way of a phrase or two from the Immortality Ode) into Roslyn Chapel, the title emblem: "The blue of the mountains became deep to me with the purple of mourning,—the clouds that gather round the setting sun, not subdued, but raised in awe as the harmonies of a Miserere,—and all the strength and framework of my mind, lurid, like the vaults of Roslyn, when weird fire gleamed on its pillars, foliage-bound, and far in the depth of twilight, 'blazed every rose-carved buttress fair'" (xxxv, 233). The double allusion to Rose La Touche, the smoldering fires, the sunset, and elegy all attest to a desire unrelinquished, a rage and a grief inverted upon the suffering self, making it a memorial and a place of sacrifice to the parental will—an imperfect one, as Ruskin recalls, and therefore "polluted," like the sacrifice of the Black Brothers. The closing pages of part 1 show Ruskin walking with another female prospect, a Miss Wardell, in her garden at Hampstead—a dreamlike moment, like the opening of "Burnt Norton," in which the past and the might-have-been come together for a moment. There is, of course, no rational reason why Ruskin could not relinquish Adèle—his mourning, he insists, was foolish—but the fact of his lifelong failure in love permits the structure of *Praeterita* to posit this disappointment as irremediable, almost metaphysical, casting a kind of doom on the rest of his life. Characteristically, he describes love not as a relationship but as a precious gift to *him.* The three deaths that conclude part 1—those of Miss Wardell and two other beautiful young women—symbolize the death of his own youth (as Jessie's death had at an earlier stage), mingling also with the loss of the landscape feeling. Previously, nature in *Praeterita* was simply the landscape of the visionary past—experienced first by a Wordsworthian child and then by a kind of youthful Byronic prince as the extension of his own "untried faith." Afterward, the ecstasy comes as the expression of an earned position.

With the childhood paradise lost, part 2 presents a new dialectic, the elements of which appear early in the chapter entitled "Of Age" (am-

biguously connoting "coming of age" and "on the subject of aged-
ness"). In recalling the landscape feeling in its pure form, Ruskin
writes, "I took stones for bread, but not certainly at the Devil's bidding"
(xxxv, 219)—no, at his father's bidding, but the original meaning of
the phrase allows the reproach to stand even as it is denied. In the
condition of age, "stones" are first of all purchases—of precious miner-
als and of paintings. While preparations proceed for Adèle's marriage
in Paris—a catastrophe that occurs offstage, as in Greek tragedy, or
rather, in the back of the young man's mind—Ruskin turns twenty-one
and receives the gift from his father of Turner's *Winchelsea*—"a curious
choice, and an unlucky one. The thundrous sky and broken white light
of storm round the distant gate and scarcely visible church, were but
too true symbols of the time that was coming upon us." But the boy also
receives his first annual allowance of 200 pounds, seventy of which he
spends on the *Harlech*—a sum his father considered extravagant: "My
respect for his judgment was at this time . . . gradually diminished; and
my confidence in my own painfully manifested to him." And so *Harlech*
(the picture of a Welsh castle and village) was "safely installed in the
drawing-room on the other side of the fire place from my idol-niche:
and I went triumphantly back to [Oxford] and 'Winchelsea'" (xxxv,
255–257, 259). The triumph is ambiguous: the mutual love for Turner
brings father and son together as peers, also providing ground for
rivalry, but the triumph of Ruskin's superior judgment is self-defeat-
ing, since in the symbolic exchange he himself makes, the childhood
home remains his domain, while the future is "installed" with an ill
omen, the mark of his submission (through studies) and his indepen-
dence. The task of the coming years is to work out more successful
compromises between obedience and will, between his career and his
parents' wishes.

But as we know that task is beset by a near-catastrophe: Ruskin
suffers a hemorrhage of the lungs and is ordered to Italy by his doctor.
In Provence the family encounters some swollen rivers—an obscure
episode, judging from the diary of 1840—now converted by memory
into a ruined landscape of raging waters, burst banks, and vast, muddy
plains. (At one point, Mrs. Ruskin insists on being carried across a
stream in her carriage, an act by which she appears symbolically as a
mistress governing the waters.) Italy, swamped in dirt and sensuality, is
like the upper circles of Hell; at the far point of the descent, outside
Naples, the sulphur pits spew and bubble diabolically, and the black
sands of ancient volcanic eruptions seem to pollute the serene blue of
the Mediterranean. Having exorcised his rage and his desires for Adèle
by excoriating the country of her religion, Ruskin recovers his spirits
not in Venice (the "Paradise of Cities" where, according to the diary of
1840, he reconstructed her as an Ideal) but in Protestant Switzerland:

"I had found my life again"—that is, his internal harmony and the harmony of the family.

Following the exorcism comes the penance: six weeks at Leamington taking the water cure. The flats of Warwickshire suggest the flats of resignation—what Ruskin usually calls "humility"—figured in the placidity of the landscape: "a space of perfect England, not hill and dale . . . but hill and *flat*, through which the streams linger, and where the canals wind without lock" (xxxv, 303). This frame of mind provides the discovery, which he says made possible *Modern Painters,* of the need in great art for absolute submission to the tutelage of Nature, which for him is also a reaffirmation of Protestant piety. Ruskin does not seem to have derived this famous episode from memory, yet once again *Praeterita* speaks an emotional if not a literal truth. The scene he chooses is, of all places, Fontainebleau, where he deliberately flouts the monuments to Catholic despotism: "I missed rocks, palace, and fountain all alike, and found myself lying on the bank of a cart-road in the sand, with no prospect whatever but that small aspen tree against the blue sky." Lying literally in the dirt, he is "abased in that final manner" by tracing the exquisite beauty of line and composition in the humble leaves and twigs. The reward of submission is an "insight into a new sylvan world" (xxxv, 314). And so he achieves peace, as Carlyle advised, by lowering the denominator of desire: wilderness is reduced to the order of pattern, the pattern, essentially, of the carpet at Herne Hill, where the child was also able to "secure" himself by loss of self. His first book, *The Poetry of Architecture,* he published under the pseudonym "Kataphusin," "according to Nature," as though to assert (with a touch of arrogance) a relationship to the Deity that was unmediated by Princes and Popes. But self-abasement does not represent the whole impulse, as he half-admits in a suggestive aside: "In my savage dislike of palaces and strait gravel walks, I never found out the spring which was the soul of the place." Both fountains and palace reappear under a new guise when Ruskin's parents sell Herne Hill for the larger establishment at Denmark Hill, a move he views as a temptation in the "hour of all our weaknesses." As though to purify the new house, Ruskin decides to build a canal with locks, but it is not done after all, and the family is never more "at home"; twenty years later, "some water-works, on the model of Fontainebleau, were verily set aflowing" (xxxv, 314, 318). By symbolic action, Ruskin begins to take responsibility for his moral condition and his parents' as well.

The family's progress in the world soon receives a more dramatic fulfillment: the publication in 1843 of *Modern Painters* I and its triumphant reception. The Continental tour of 1844, which partly celebrated John's success, provides the occasion, in "The Simplon," for the most famous of all the set pieces in the book. The action of Ruskin's

burning glass is dramatic indeed, for the chapter focuses the meanings of the young man's achievement on a scene that seems truly timeless, a gathering of symbols rather than of specific memories. As Geneva is the high point of the book's geography, the publication of *Modern Painters* I is the high point of the family's fortunes, so that "The Simplon" becomes the central episode of *Praeterita*—occupying the place the Earthly Paradise occupies in Dante's Comedy. Ruskin first pictures himself entering the shop of the jeweler Bautte, dark, awesome, and difficult of access ("You told what you wanted: it was necessary to know your mind, and to be sure you did want it; there was no showing of things for temptation at Bautte's"), then emerging into the light of the open street with his parcel and a "sense of duty fulfilled, treasure possessed, and a new foundation to the respectability of your family." Next, as in a dream, the magical purchase is metamorphosed into the Rhone itself, flowing at the end of the street only a block away, like "one lambent jewel":

> its surface is nowhere, its ethereal self is everywhere, the iridescent rush and translucent strength of it blue to the shore, and radiant to the depth.
>
> Fifteen feet thick, of not flowing but flying water . . . the force of the ice is with it, and the wreathing of the clouds, the gladness of the sky, and the continuance of Time.
>
> Waves of clear sea are, indeed, lovely to watch, but they are always coming or gone, never in any taken shape to be seen for a second. But here was one mighty wave that was always itself, and every fluted swirl of it, constant as the wreathing of a shell. No wasting away of the fallen foam, no pause for gathering of power, no helpless ebb of discouraged recoil; but alike through bright day and lulling night, the never-pausing plunge, and never-fading flash, and never-hushing whisper . . . , glass of a painted window melted in the sun and the witch of the Alps flinging the spun tresses of it for ever from her snow. . . .
>
> There were pieces of wave that danced all day as if Perdita were looking on to learn; there were little streams that skipped like lambs and leaped like chamois; there were pools that shook the sunshine all through them, and were rippled in layers of over-laid ripples, like crystal sand . . . , and in the midst of all the gay glittering and eddied lingering, the noble bearing by of the midmost depth, so mighty, yet so terrorless and harmless, with its swallows skimming instead of petrels, and the dear old decrepit town as safe in the embracing sweep of it as if it were set in a brooch of sapphire.
>
> And the day went on, as the river; but I never felt that I wasted time in watching the Rhone. [xxxv, 326–328]

The whole scene could be an allegorical painting by Turner, with the sagelike jeweler at one side, the young man, river, and sporting maidens in the center, and the Alps and their Sybilline witch in the distance overhead. Yet it is also the book in epitome and in some sense tele-

scopes Ruskin's career. In the city nestling like a sapphire or brooch we recognize a northern Venice, spared the curse that fell upon her predecessor; in the flow of wealth and life, like a living vein through the Commonwealth, we recognize the climactic aphorism of *Unto This Last*. In the spun tresses of the Shelleyan witch, we recognize Athena, whose spinning is the creative principle in nature, here united with the tremendous force of ice, cloud, gladness, and time. In the unmoved depths and skimming surface, we recognize the mind of genius (like the mind of God, whose circumference is nowhere and whose center is everywhere). And in the crystal sand, sunlit pools, rivulets leaping like lambs and chamois, and Perdita, the lost one, watching, we have *Praeterita*, a book whose emblem would be a jewel or river as the type of Divine Energy: time without aging, power without wasting, the fullness of being and the fullness of time.

We must compress as many of these meanings as possible in a short space. By 1844 the family has passed through a number of changes, mostly deleterious. The parents have forfeited the home place in the interests of a doubtful respectability. The son, bereft of his adolescent love, has entered into a competition with his father over the purchase of paintings and consequently into an adulthood fraught with ominous choices—an adulthood stamped, however, with the success of a book conceived, he tells us, in the spirit of abasement before the laws of nature, though in reading it we are apt to have the opposite impression of a protracted paean to the will. We know from other sources that Ruskin focused his regret for the past on the loss of some drawings his father had been too timid to buy, a regret that burst out in one of the most poignant phrases of *The Stones of Venice* ("I do not wonder at what men Suffer, but I wonder often at what they Lose"). The boy who was to accomplish his parents' fondest dreams became also the man longing for a gift never given him, a lack that led him to fictionalize the mystery of life as a mystery of desolation and mischance. "The Simplon" draws together these elements and redeems them. Geneva becomes the family's spiritual home, a "point of patience" and a "mother-city" that parallels the quiet but all-powerful moral influence of Margaret Ruskin in her son's life yet remains pure of the family's temptation to riches—it is her "Paradise of Cities" as Venice had been Adèle's. It is also the center of Protestant Europe, the unacknowledged ruler of an ideal republic but without the narrowness and fanaticism of modern Puritanism. The jeweler Bautte, on the other hand (his name sounds like both "bought" and "boat"), springs from the mythopoeic consciousness:[5] stern,

[5]On this passage see Pierre Fontaney, "Ruskin and Paradise Regained," *Victorian Studies* 12 (1969), 347–356, which reads Ruskin's images as archetypes. For example, the river itself is "a symbol of God's creative power . . . , gathering all fulfillments—youth, bliss, eternity—into itself . . . , a river indeed 'spiritualized' into analogy with the 'pure

quaint, and decisive, he has about him something of the little King of the Golden River, something also, perhaps, of the enigmatic Turner, reclusive and difficult to please; in function, he is the perfection of the ambiguous art dealer Mr. Griffin, whom the elder Ruskin so distrusted; more generally he is a figure for the infallible guide. (He seems to predict Joseph Couttet, the mountaineer, whom Ruskin meets soon after and who murmured that the boy "ne sait pas vivre." "Had he been my drawing-master also, it would have been better for me: if my work pleased Couttet, I found afterwards it was always good" [xxxv, 329].) As Ruskin purchases the jewel from Bautte, so also he wrote the book that was his parents' fulfillment, becoming himself their best jewel, like the children of Cordelia. Yet in giving he also possesses, and in buying the gift for his family, he becomes them as well. The power of the jewel in other words is the power to incorporate the good parents as a unity of approving conscience and lovable ego. The gift bestowed when a person has "earned" a good conscience is the pearl of great price. The river, as emblem of the integrated self, contains all selves within it, strength with possession, wealth that is life. We have seen a similar pattern before—a passage, actually, from a later chapter, "The Grande Chartreuse," in which the missal in the pocket (with feminine rather than masculine associations) becomes the shower of wealth, the charity dispensed by the "miser." In both cases, possession of the symbol of selfhood is transformed into the self-as-a-world, which is also the power of affirming the otherness of the world-as-a-self. Needless to say, the book that truly achieves this miracle—the book that braids the flowers of the past into a memorial for the future, joining the parents within with the parents that have died—is *Praeterita* itself.

But Paradise regained is soon relinquished. Although the scene appears timeless, in part 2 of *Praeterita* ecstatic moments have two dimensions of meaning: a transtemporal meaning, in which they stand for permanent affirmations and emblems of felicity, and historical meaning, in which they repeat the structure imposed by the loss of Adèle. As the chapter follows the family in its long descent into Italy, the skies slowly darken with disillusion. The Lago Maggiore district, for example, is the "Eden of Italy," yet the peasants are left "to die, like the green lizards, in the blind clefts of their rocks, whence they see no God" (xxxv, 331–332). The lizards in their clefts, like the Serpent and fur-

river of the water of life, clear as crystal, proceeding out of the Throne of God and of the Lamb'. . . . the Rhone, the jewel, is also a figure of Paradise regained." In Ruskin's first publication, when he queried the cause of the Rhone's extraordinary perspicuousness as it flows through Geneva, he may already have had in mind the archetype of the city of God: "It issues from the lake perfectly pure, and flows through the streets of Geneva so transparent, that the bottom can be seen twenty feet below the surface, yet so blue, that you might imagine it to be a solution of indigo" (1, 192).

row in *Fors* and the recurrent images, in books and diaries, of fearful glacial cracks and folds, have no fecundity or vitality but are embodiments of neglect, sterility, and lingering, withering death. Adult sexuality is fallen in *Praeterita*, and the symbol of it is Italy. Other powers than Turner's, Ruskin says, were on him "even beyond his, not in delight, but in vital strength," by which he means the celebration of earthly pleasure and the human form in the Venetian painters. The closing sentence is from a diary entry written after the young man's first visit to the Louvre: "I shall try to paint a Madona some day, I believe" (xxxv, 339).

The Madonna is in this chapter a mother city, but in Switzerland, not Italy. How is Ruskin now to describe the Italian journey of 1845, with its momentous discovery of Tintoretto—in the very place he had made sacred to Adèle? Venice, combining in his memory the figure of the ideal beloved and the disaster of his marriage, stood for intolerable emotional ambivalences—the attraction of sexuality and the dread surrounding it, of defilement, separation, and death, all figured in the image of the virgin who is also a whore. But in the romance world of *Praeterita*, the hero, to be true to himself is true also to the symbols of his first object of love, like a chaste knight or priest of nature. In the book's purist structure, then, the heat and full-bloodedness of Venice is replaced by the austere and virginal beauty of Geneva—or of Lucca and Pisa as they appear in "The Campo Santo." These crystalline, moon-lit cities never fell from the innocence of faith: at the Campo Santo of Pisa, for example, Ruskin discovers the "entire doctrine of Christianity, painted so that a child could understand it. And what a child cannot understand of Christianity, no one need try to" (xxxv, 351). The inhabitants are also, predictably, childlike. They cluster around Ruskin as he draws and are innocently delighted to discover the beauty of the old frescoes, which they had taken for granted. Entering the unchanged cities of childhood, Ruskin takes the place of his own mother, giving Bible lessons to others in the form of a Good Shepherd. But this too passes; in Macugnaga he finds himself afflicted by paradox and futility, a sensation only exacerbated by the reading of Shakespeare, in whom he finds good and evil mixed "so inextricably and mysteriously, that not only the writer himself is unknowable, but inconceivable." And so on this trip "I had only discovered wants that any number of years could not satisfy; and weaknesses, which no ardor of effort or patience of practice could overcome" (xxxv, 376).

The "weaknesses" Ruskin had described to his father from Macugnaga centered, we recall, on the loss of childhood strength and the growing suspicion that pleasure in landscape depends on nostalgic associations superadded by the viewer. These worries he resolved symbolically by new discoveries about Venetian art—the beauty of the human form in Tintoretto, Angelico, and others and the presence within him of a "correspondent power" of response—both of which

seemed to lay the grounds for a mature vocation and probably also for marriage. From the perspective of *Praeterita,* such hopes could only seem futile and disturbing—and so also would the theory of mental association, which Ruskin affirms with joy in "The Lamp of Power." For after a lifetime of learning the limits of the merely human will, he reconceives nature in *Praeterita* as the embodiment of spiritual powers, capable of nourishing the heart—the childlike heart—that loves her.

But can purity of heart be indefinitely maintained? Ruskin returns home stricken with the guilt of all that was to come; like Newman in the *Apologia,* he falls ill just as his haven is in sight. "That happy sense of direct relation with Heaven is . . . in all cases, dependent on resolution, patience, self-denial, prudence, obedience. . . . Whether I was capable of holding it or not, I cannot tell; but little by little, and for little, yet it seemed invincible, causes, it passed away from me. I had scarcely reached home in safety, before I had sunk back into the faintness and darkness of the Under-World" (xxxv, 378). Even obedience to his parents' wishes is no solution, because the guilt has descended upon them as well. The next chapter titles are succinctly revealing. "The State of Denmark," alluding to Denmark Hill and to Horatio's suspicion of rottenness, requires no comment in the text; "The Feasts of the Vandals" refers to the endless round of dinner parties for London celebrities, a luxury that depends upon desperate poverty. Behind the winetrade stands the Treasure Valley of "Vandalusia," an Eden whose golden fruit is ravished again and again, yet Ruskin was equally impressed by the "poverty, and captivity, or, as it seemed to chance always, fatal issue of any efforts to escape from these [luxuries], in which my cousins . . . were each and all spending, or ending, their laborious youth" (xxxv, 409). There is no wonder that the "direct relations of Heaven" are lost: to escape the father's house is to risk one death, yet to dwell in it is to risk another, spiritual kind, the guilt of identifying with him or of repudiating him. In "Crossmount," Ruskin atones for a thoughtlessly wounding remark (about his father's penuriousness) by clearing a Scottish field of thistles. The emotional truth of these confused chapters is remarkable and convincing, revealing as they do the complex personal impulses behind Ruskin's radical economics: the need at once to repudiate his father and to exorcise the guilt of that repudiation by identifying with suffering and by "clearing out" the wilderness—in this case, significantly, the land of his father's birth. And with the approach of his marriage to Effie, we find a familiar emblem focusing all forms of domestic corruption. No one, he writes, could

> explain to me what Turner meant by the contest of Apollo with the Python, or by the repose of the great dragon above the Garden of the Hesperides.

> For such nearer Python, as might wreathe itself against my own now gathering strength,—for such serpent of eternity as might reveal its awe to me amidst the sands even of Forest Hill or Addington Heath, I was yet wholly unprepared. [xxxv, 430–431]

The serpent of eternity is the enemy of visionary time, as it is the enemy of the garden; the chronology of *Praeterita* breaks down into digressive chatter—but not before one more ecstatic experience, this one, unlike the others, frankly regressive. Like "The Simplon," "L'Hotel du Mont Blanc" belongs to a generalized past and also to a specific moment—the family's journey to Switzerland without Effie, the year after John's marriage. For the last time Ruskin pictures himself in that moment at which he would like to have lived all his life, the brink of adulthood. As he wrote at the time, "I repeated 'I am in *Switzerland*' over and over again till the name brought back the true group of associations, and I felt I had a soul, like my boy's soul, once again"—a soul unweakened by the Python. As though to resist the tightening coil of days, Ruskin interpolates his recollections with descriptive passages from his old diary, retarding the narrative pace. Slowly, ponderously, the family makes its way, page by page, from Folkestone to France to Geneva and then the Cluse, the valley of lost time: "A way is opened at last by the Arve, which, rushing furiously through a cleft affording room only for road and river, grants entrance, when the strait is passed, to a valley without the like of it among the Alps." Unlike the trains, which in their speed blot out the landscape they despoil, the carriage reveals everything in circumspect, its movements entering the languid movements of the prose, until time becomes entirely place. We are not surprised when the present tense of description becomes the present tense of narration as well: "The old people's carriage dips into the trough of the dry bed, descends the gentle embankment on the other side, and turns into the courtyard of the inn." The "old people"—a mythic race almost, rather than parents—take possession of a region composed of concentric spheres, the inner ones more sacred than the outer: the Alpine range; the valley; the town; the inn; the suite; John's room; and at last, John's (the boy's, presumably) window, commanding the whole range of the animate creation, from trees, fruits, and buildings, to the "creamy, curdling, overflowing seas of snow of Mont Blanc de St. Gervais." The garden is walled, like Herne Hill, but sown under the principle of "plant everything, and let what can, grow":

> the undercrops of unkempt pease, potatoes, cabbage, hemp, and maize, content with what sun can get down to them. . . . the roofs and balconies, the vines seem to think, have been constructed for their pleasure only, and climb, wreathe, and swing themselves about accordingly wherever they choose, tossing their young tendrils far up into the blue sky of spring, and

festooning the balconies in autumn with Correggian fresco of purple, relieved against the pendent gold of the harvested maize. [xxxv, 443, 445, 447–448]

This ecstatic passage flanks "The Simplon" on one side as the distant view of the Alps in part 1 flanks it on the other, each of the three moments apotheosizing in succession three elements of the childhood paradise—mountains, rivers, gardens. The earliest of these is prospective, the last retrospective, the most Edenic and domestic. The churning, surging, striving movement of vines compresses imagery from both "The Nature of Gothic" and "St. Mark's," displacing it northward in space and backward in time onto an eternal boyhood home, a final protest against the years of sterility and weakness to come.

Praeterita rejects the three-part pattern of the romantic myth of imagination—paradise, loss, and recapture—since the romantic self, centered in a power of will or imagination distinct from nature, accepts the loss of the child's self-as-a-world in order to reconstitute that world as a creative dialectic between the world and the mature ego. But *Praeterita* rejects the romantic imagination, presenting in its place a self composed of pristine, essential energy that is also a natural principle, the survival of which assures the potential recapture in toto of the self-as-a-world. Its movement is not tripartite, then, but a gradual, if interrupted, voyage of decline that returns full circle only at the end of life. In this regard it resembles, in painting, a series like Cole's *The Voyage of Life* and, in literature, *Peer Gynt* and, of course, the great novel it helped inspire, *A la recherche du temps perdu*. *Praeterita* importantly differs from these works in being written as a series, so that the writing, like the life, is capable of occasional recaptures and fresh starts. We see such writing in part 3, a fragment composed of four chapters that though marred by mental strain, nevertheless represent a new and final phase of Ruskin's indomitable inventiveness. More freely than before, these chapters mingle discursive talk with reminiscence, organizing disparate episodes according to problems or themes to be worked through. "The Grande Chartreuse," for example, opens with a dialogue in the mountain hermitage, where a monk tells Ruskin that the Carthusians did not come there to look at landscape, and concludes with the unconversion at Turin in 1858, when Ruskin chooses to affirm the life of the senses. The pivotal image—in which he pictures himself spewing jewels to a crowd while carrying a missal in his pocket—creates a pattern of meaning far richer, obviously, than any brief account can convey. The next chapter is a mirror image of the first that reverses geographical directions. It begins with apostasy in Turin, where Ruskin went to the ballet and brought home, "to my father's extreme amazement and disgust," sketches from Veronese's *Solomon and the Queen of Sheba*—petticoats,

parrots, and blackamoors—and concludes in a wondrous moment of joy, when he first met Charles Eliot Norton on the Lake of Geneva. The space between is occupied by sketches of the history of Switzerland, as though Ruskin were possessing it as his heritage, in all its sensuousness and communality of life, in opposition to the isolation and asceticism of the Carthusians. In the third chapter, Rose appears, and Norton's most recent communication is reproduced alongside Rose's first—the wonderfully high-spirited and precocious letter from southern France that Ruskin carried for years in his breast pocket, like a missal. In the midst of other matters, the elder Ruskin dies offstage, and Joan Severn enters to take his place as Mrs. Ruskin's companion: "And so it chanced, providentially, that at this moment, when my mother's thoughts dwelt constantly on the past, there should be this child near us,—still truly a child in her powers of innocent pleasure" (XXXV, 537–538). The last element of the childhood paradise begins to take her rightful place; for other people are important in these final episodes in a way they have not been before. Norton, a younger version of Ruskin who will carry on his work, is also his "first tutor"; Joan, appearing first as a new child in Denmark Hill, begins to care for him as a mother. (It even turns out that Carlyle had once received hospitality at the hands of Joan's grandfather.) As Scotland and Switzerland begin to center on Brantwood, new people appear to take the place of those who have gone, as though Ruskin were establishing an apostolical succession or pattern of symbolic inheritance. In the last chapter we are aware of Joan's presence in the room as he dictates, herself a treasure that this time will not be taken away. Like the fairy tale of fifty years before, Ruskin's last utterance is a gift to a young girl, written this time not for her but with her.

These givings and identifications prepare the final consummation of "Joanna's Care." The great circle of *Praeterita* seems to be closing by degrees, but Ruskin, digressing again and unconscious of time and reader and audience, does not seem to know it at first. All at once, he strikes upon an old theme, and the landscape of Scott and of the personal past are completely confounded: "but I may forget, unless I speak of it here, a walk in Scott's own haunt of Rhymer's Glen, where the brook is narrowest in its sandstone bed, and Mary Ker stopped to gather a wild rose for me." The mention of "rose," like an evil charm, sends him into a helpless harangue upon dancing—old "right" Scottish dancing and the debased fashions of the present. The whirling images of moving girls rise up without warning, like pure and impure desires contending feverishly for control of the old man's mind, and the ancient fury is upon him once again.

Then, as his mind is about to give way once more, something breaks

clear; without interruption and without pause, everything is luminous and calm. We are in the last paragraphs of the book:

> I draw back to my own home, twenty years ago, permitted to thank Heaven once more for the peace, and hope, and loveliness of it, and the Elysian walks with Joanie, and Paradisiacal with Rosie, under the peach-blossom branches by the little glittering stream which I had paved with crystal for them. . . . There used to be always a corncrake or two in it. Twilight after twilight I have hunted that bird, and never once got glimpse of it; the voice was always at the other side of the field, or in the inscrutable air or earth. . . . Happiest times, for all of us, that ever were to be; not but that Joanie and her Arthur . . . have been sorely anxious about me, and I have been sorrowful enough for myself, since ever I lost sight of that peach-blossom avenue. "Eden-land" Rosie calls it sometimes in her letters. Whether its tiny river were of the waters of Abana, or Euphrates, or Thamesis, I know not, but they were sweeter to my thirst than the fountains of Trevi or Branda.

"'Eden-land' Rosie calls it." Time is conquered; the restless, hungering spirit that animates *Praeterita* has found peace.

The last words Ruskin wrote, serene and unconscious as a mystical revelation, seem to float motionless on a glimmering surface, for no movement disturbs their ethereal hush. Like an old man on his deathbed, he murmurs a vision of the country he is about to enter; his words are what Lear would have said to Cordelia in heaven.

"How things bind and blend themselves together!" he continues, ever more softly. The crystal stream at Denmark Hill recalls the Fountain of Trevi and old Joseph Severn, Joanie's father: "he himself then eager in finishing his last picture of the Marriage in Cana . . . and delighted himself by painting the crystal and ruby glittering of the changing rivulet of water out of the Greek vase, glowing into wine." Severn had appeared much earlier in the book as a fountain of benevolence amid the corruptions of modern Rome. The wine of Cana was a symbol for Ruskin of the "sanctifying element" of love in its color of rose, so that old Severn seems to bless his daughter's marriage in spirit to his old friend, repeating the lesson of Veronese's painting that had enraptured Ruskin so many years before. Then Ruskin recalls visiting the Fonte Branda with Norton: "We drank of it together, and walked together that evening on the hills above, where the fireflies among the scented thickets shone fitfully in the still undarkened air. *How* they shone!"

Still the words seem to fade and fade, like the song of Ruskin's elusive bird. Having drunk the water of Cana from the Branda, Ruskin beholds yet another city: "How they shone! through the sunset that

faded into thunderous night as I entered Siena three days before, the white edges of the mountainous clouds still lighted from the west, and the openly golden sky calm before the Gate of Siena's heart, with its still golden words, 'Cor magis tibi Sena pandit.'" The gate and water and fireflies bring us back to the walled garden of Herne Hill, the springs of Wandel, and the dancing sand and darting minnows, but we recognize them from elsewhere: they are the waters of life, the angelic light, the City of God. This is Ruskin's final crossing. But although he makes his last word the same as Dante's, his lights are not the stars, nor are they any more the delusions of vanity; instead, they bring things together—the day and the night, the twinkling of skies and waters, binding and blending. They make the broken diffusion of the elements sacred, and they triumph like the light of his own spirit over the shadow of his madness and the endless night beyond: "and the fireflies everywhere in the sky and cloud rising and falling, mixed with the lightning, and more intense than the stars" (xxxv, 560–562).

Index

Abrams, M. H., 13, 40n, 71n, 97n, 311n
Alexander, Edward, 273
Angelico, Fra, 58, 79, 81, 82, 84
Apocalyptic imagery, in Ruskin: 48–49, 54–55, 58–59, 84, 151–152, 154, 188, 274, 297
Apologia pro Vita Sua (Newman), 311, 327
Aristotle, 37, 47
Arnheim, Rudolph, 37n
Arnold, Matthew, 122, 257, 258
Association of Ideas, 37, 78, 85–86, 132–133
Athena, 253–254, 256–259

Ball, Patricia, 37
Beard, Charles H., 196n
Benjamin, Walter, 72–74, 176
Berger, John, 176–177
Blake, William, 117, 220, 245, 248, 250, 253; *Milton*, 39
Brown, Norman O., 220n, 285
Bruns, Gerald, 77n, 87, 93–94
Buckland, William, 265
Burd, Van Akin, 83
Burke, Edmund, 83
Burne-Jones, Edward, 162
Byron, Lord, 19, 23, 35, 319

Canaletto, 41
Carlyle, Thomas, 94, 123, 129, 162, 196, 200, 203, 229, 253, 296; friendship with Ruskin, 135–137; doctrine of metaphor, 199; *Works: Latter-Day Pamphlets*, 292; *On Heroes, Hero-Worship, and the Heroic in History*, 162; *Past and Present*, 118, 192, 199, 306; *Sartor Resartus*, 197–199, 203, 229, 253, 296

City of God, as a motif in Ruskin: 50, 83–84, 88, 105, 188, 274, 325n, 332
Clegg, Jeanne, 91, 104n, 122n
Clouds: modern cloudiness, according to Ruskin, 149; myths of, 254
Coleridge, Samuel Taylor, 43, 246; and *Modern Painters* I, 43; Ruskin's knowledge of, 94–95n; on history, 95–97; on the philosophy of science, 267, 273; *Works:* "Kubla Khan," 68; *The Statesman's Manual*, 94–96, 97n, 118n, 200, 270 (Ruskin's possible reading of, 88–89n)
Collingwood, R. G., 64n

Dante, 81, 92n, 133; in *Modern Painters* III, 133–135, 143–145, 146, 148–149; in *Unto This Last*, 209–210
Darwin, Charles, 268, 273
Davenport, Guy, 293n
Dellamora, Richard, 81n, 95n
De Man, Paul, 55n, 139n
Derrida, Jacques, 246n
Dickens, Charles, 230; *Hard Times*, 194–195, 214
Domecq, Adèle, 22–23, 26–27, 230, 233, 284; in *Praeterita*, 318–319
Dougherty, Charles T., 25n, 189n
Dragon, as a motif in Ruskin: 189–190, 327–328; in *Fors Clavigera*, 297

Eden, 48, 105, 113n, 128, 222, 287, 296; Venice as, 106; as a motif in Gothic architecture, 108; in Dante, 146; in *Fors Clavigera*, 299–300; childhood as in *Praeterita*, 316–317, 318
Eliot, T. S., 314
Ellmann, Richard, 102n
Erikson, Erik, 31n, 310

Fain, John T., 196n, 211
Fall of man, as a motif in Ruskin: 93, 102–103, 111–113, 123; and childhood, 20; Renaissance as, 117–122
Fellows, Jay, 141n, 293n, 312n
Fitch, Raymond, 250n
Fleishman, Avrom, 312n
Fontaney, Pierre, 86n, 324–325n
Forbes, James David, 279–280
Freud, Sigmund, 28, 152, 198, 285
Frye, Northrop, 43, 105, 203, 215n, 296n

Giotto, 134
Glacier question, 279–281
Gombrich, E. H., 55n
Greeks, Ruskin on, 141–143, 147, 227, 250–251
Grote, John, 68n
Grotesque: in *Stones of Venice*, 104; and dreams, 151–153. *See also* Ruskin, theory of the grotesque

Harbison, Robert, 241n
Harding, J. D., 64–65
Harrison, Frederic, 297n
Hazlitt, William, 315
Helsinger, Elizabeth, 39, 68n, 73n, 92, 97n, 132n, 140n, 152, 188n, 236, 312
Herbert, George, 61
Hewison, Robert, 38n, 68n, 89n, 197n
Hill, Octavia, 163
History: Ruskin's sense of, 77; Coleridge on, 95–97; in *Stones of Venice*, 98–101
Homer, 141
Hough, Graham, 36
Houghton, Walter F., 162
Hunt, John Dixon, 13, 34n, 138n, 310n

Ilaria di Caretto (Jacopo della Quercia), 61, 79–80, 304
Imagination. *See* Ruskin, theory of imagination

James, Henry, 228
Johnson, Wendell S., 60n
Justice (economic), 208–210

Keats, John, 253
Kissane, James, 252n

Labor: as a form of creation, 169; as a form of affection, 202–203; and paternalism, 205–207; as a struggle, 214
Lamp symbol in Ruskin, 84–85, 88

Landow, George P., 57n, 80–81, 86n, 89n, 94, 137n, 166, 184n, 189n
La Touche, Rose, 180, 233–234, 287; in *Fors Clavigera*, 295, 306; in *Praeterita*, 180, 320, 330, 331
Leon, Derrick, 36n, 162n, 228n
Levinson, Daniel, 229n
Locke, John, 37
Lowell, Robert, 259
Lyell, Charles, 154, 266, 278

Marcus, Steven, 217n
Marcuse, Herbert, 55n, 139n
Marx, Karl, 88–89, 197, 212
Melvill, Henry, 94
Metaphor: Ruskin's theory of: in *Modern Painters* II, 67–68; in *Munera Pulveris*, 237–240; Carlyle's theory of, 239
Michelangelo: Ruskin on, 64–65, 69–70
Mill, John Stuart, 196, 211–212
Miller, J. Hillis, 239n
Milton, John, 71, 110, 115
Mirror symbol in Ruskin, 157, 251–252
Money: in *Stones of Venice*, 120; Ruskin's theory of, 204–206
Müller, F. Max, 252n
Myth, 140n; Ruskin's theory of, 234–240, 251–252

Nature: as forming the categories of art, 42–43; as fallen, 154; and myth, 251, 259–260; as a book of incarnate Words, 255–256. *See also* Science
Norton, Charles Eliot, 22; in *Praeterita*, 330

Organic body, as a motif in Ruskin, 89, 171–172; in *Stones of Venice*, 105, 121; the perfect society as, 174; and clothing, 187. *See also* Purity
Ortega y Gasset, José, 253
Oxford Museum, 185–186n

Paradis, James, 273n
Pathetic fallacy, 140–141
Plato, 203, 235, 305
Political economy: Ruskin's attack on, 166, 195, 200–201, 211–231
Pound, Ezra, 308
Praise, art as, 45–47, 183
Pre-Raphaelite Brotherhood, 81, 34
Prophecy: Ruskin's theory of painting as, 44, 46, 130, 284
Proverbs, Book of, 192–193, 221; and *The Political Economy of Art*, 169–171
Purity, as a motif in Ruskin: 30–31, 83, 88, 105, 171–172

Rank, Otto, 216n
Renaissance: in *Stones of Venice*, 118–122; and Ruskin's social theory of art, 178–179
Revolutions of 1848, 89, 90, 118n, 124
Ricoeur, Paul, 102
Rosenberg, John D., 14, 92n, 93, 111n, 118n, 213n, 275n, 293n, 294
Rossetti, D. G., 163–164
Ruskin, John, early reading, 18–19; childhood, 20–23; travels in Italy: 1840, 26; 1845, 61–66; 1848, 90–91; theory of landscape painting, 42–47; theory of imagination, 43, 67–70, 80–81, 132–133, 139–140n; theory of beauty, 59, 86n, 89n; discovery of Tintoretto, 64–66; theory of architecture, 84–89, 105–106; religious doubts, 99–100; marriage to Effie Gray, 124, 128–129; travels in Switzerland: 1849, 127–128; 1854, 129–130; theory of the grotesque, 138–139, 286; as "economist of art" in the 1850s, 161–165; friendship with D. G. Rossetti, 163–164; social theory of art, 167–169, 175–184; critique of capitalism, 175–177, 183–184, 192–193, 216–217, 271; unconversion at Turin, 184–185; and Veronese, 184–187; at "mid-life," 226–233; letter to his father (1863), 231–233; love for Rose La Touche, 233–234; theory of words and meanings, 236–240; on natural science, 245–246, 265–273; on the place of women, 248–250, 263–265; and St. George's Guild, 299; first mental breakdown (1878), 305; years of retirement at Brantwood, 309–310
Works:
"The Arve at Cluse" (poem), 60
Deucalion, 265, 274–283; theme of time, 277–278; visionary memory, 280, 281–282; serpents in, 282–283, 288–289; final chapter of, 289–291
The Eagle's Nest, 270–272
The Ethics of the Dust, 236, 242, 244–250, 259–260, 269, 287
"Fairy Stories," 244, 247, 252
Fors Clavigera, 131, 265, 269, 292–308; St. George in, 295–296, 300–301; Rose La Touche in, 295, 298, 305; the goddess Fate, 301–302; Ruskin as a character in, 303–306
fragment on the Brevent, 58–60

The King of the Golden River, 32–33, 179
"Leoni," 24–25n
Marcolini, 23–24, 27, 32, 125, 153
Modern Painters I, 31–32, 34–55, 57, 77, 266, 283–284; and phenomenology, 36–40; "deep seeing," 37–38; metaphorical structure of, 48–51; influence of Shelley, 53–55
Modern Painters II, 30, 56–57, 65, 66–72, 77, 82; imagination penetrative, 67–70, 139n; and Wordsworth, 70–72; imagination contemplative, 81–82; and *Praeterita*, 313–314
Modern Painters III, 18–19, 130–148, 266–267; on "realization," 133–135; and Carlyle, 133–138; and the grotesque, 138–139; pathetic fallacy, 140–141
Modern Painters IV, 148–157, 266, 272–274; and the noble picturesque, 150–151
Modern Painters V, 157, 171–172, 184, 187–193, 202
The Poetry of Architecture, 25, 322
The Political Economy of Art, 166–171, 176, 180, 186, 218
Praeterita, 18, 20–22, 27–28, 30, 39n, 180–181, 310–332; as autobiographical genre, 310–313; and the contemplative imagination, 313–314; "The Simplon," 322–326
Proserpina, 265, 273
The Queen of the Air, 131, 236, 242, 250–260, 268, 272, 287–288, 295
The Seven Lamps of Architecture, 84–89, 97
The Stones of Venice, 91–94, 96–98, 101–126, 134, 193, 206, 259, 266; as a Fall myth, 93, 102–105; typology in, 106–109; marriage metaphor in, 109; vine symbol, 109, 119–120; the Gothic, 109–113, 115–117; water symbol, 106–107; the Renaissance, 117–122
The Two Paths (lectures on art and society), 172–175, 179, 186
"A Walk in Chamouni" (poem), 60, 70
"Verona and Its Rivers," 244
Unto This Last, 192, 195–196, 200–222, 231, 246; theory of language, 201, 203, 211–214; allegorical interpretation in, 209–210, 215–217; value, 213–214

Ruskin, John James, 22, 63, 94, 100, 124–125, 229, 230–231; in *Praeterita*, 321, 325
Ruskin, Margaret, 21, 229; in *Praeterita*, 321, 324

St. George's Guild, 292–293, 299
Science, natural, 247, 266–273; Ruskin's attack on, 279–283
"Science of aspects," 147, 149
Scott, Sir Walter: in *Fors Clavigera*, 303; *The Monastery*, 17–18
Sermons, as theme and form in Ruskin's work: 34–35; and the theory of painting, 42; and the theory of architecture, 105–106; and *The Political Economy of Art*, 170; and the *Fors* letters, 293–294
Serpent symbol, 69, 190, 282–283, 327–328; as machine, 285–289
Severn, Joan, 310, 330
Shakespeare, William, 19, 302, 326
Shapiro, Harold I., 57n
Shaw, W. David, 67n
Shell, Marc, 197n
Shelley, P. B., 23, 48, 82, 133, 253; and *Modern Painters* I, 50, 53–55; *Works: Defense of Poetry*, 169; *Prometheus Unbound*, 54, 210
Sherburne, James Clark, 83n, 196, 212n
Solomon, 186, 208, 210, 222
Sprinker, Michael, 139–140n, 152–153n
Stange, G. Robert, 72
Stein, Richard L., 92n
Sublime, the, 41–42, 44–46, 128, 132n, 283–284; language of in Ruskin, 50–51, 53; human, 59, 67–69
Sussman, Herbert, 81n

Temperance, 116–117, 128
Tennyson, Alfred: *Idylls of the King*, 114, 294
Tennyson, G. B., 199
Tintoretto, 64–65, 69; *The Annunciation*, 80–81, 102
Townsend, Francis G., 92n
Trench, Richard, 237
Trilling Lionel, 71n, 137n, 308
Turner, J. M. W., 28, 31–32, 100, 147–148; art as ritual, 46–47; as Ruskin's image of the Archangel, 48–49; as a tragic artist, 149–150; as an allegorical artist, 187–192

Works: The Angel of the Sun, 188; *Apollo and Python*, 190; *The Garden of the Hesperides*, 189–190, 285–286; *Goldau*, 151; *Harlech*, 321; *Jason*, 69; *Juliet and Her Nurse*, 90; *Long Ship's Lighthouse, Land's End*, 44; *The Slave Ship*, 52; *The Upper Fall of the Tees*, 38, 40–41; *Winchelsea*, 320
Tyndall, John, 268–269, 279–281
Typology, biblical, 80–81, 94–96, 97n; Coleridge and, 95–96; and natural hieroglyphs, 128, 145; in *The Political Economy of Art*, 169–170; in Veronese, 186; in Turner, 190; in *Unto This Last*, 209–210, 221

Venice, 82, 50; and Adèle Domecq, 26–27; in 1845, 64; in *Modern Painters* I, 41, 56; after the Revolution of 1848, 90–91; and the Sybil Deiphobe, 192–193; in *Praeterita*, 311. *See also* Ruskin, *The Stones of Venice*
Veronese: Ruskin's response to, 184–186; *Solomon and the Queen of Sheba*, 184–186; *Wedding Feast at Cana*, 33
Volpone, 197

Water symbol in Ruskin, 30–31; in *Praeterita*, 314–315, 319, 322–325, 331–332
Wealth: art as, 168–169, 175–182; true and false (in an economy), 204–206; in a utopian society, 219–222; as a motif in Ruskin, 30–31; in *Stones of Venice*, 107–108; in *Praeterita*, 316–317
Weiskel, Thomas F., 59
Williams, Raymond, 179
Winnington Academy, 243
Wisdom, 117, 169–171, 212, 221, 239, 256–257
Wordsworth, William, 42, 57, 67, 69, 123, 128, 133, 140, 274; and poetic diction, 50; *Works*: Essay Supplementary to the Preface of 1815, 66, 67, 69, 70; *Guide to the Lakes*, 92; "Immortality Ode," 20, 123, 147; Preface of 1815, 70–71, 81; *The Prelude*, 314; *The Recluse*, 43, 69; "Tintern Abbey," 57, 81; "Yew Trees," 151

Young, G. M., 122